Constructions
of
Power and Piety
in
Medieval Aleppo

Constructions
of
Power and Piety
in
Medieval Aleppo

Yasser Tabbaa

The Pennsylvania State University Press
University Park, Pennsylvania

MM

Publication of this book has been aided by grants from the Millard Meiss Publication Fund of the College Art Association and The Barakat Trust.

Library of Congress Cataloging-in-Publication Data

Tabbaa, Yasser, 1948–
 Constructions of power and piety in medieval Aleppo / Yasser Tabbaa.

 p. cm.
 Includes bibliographical references and index
 ISBN 0–271–01562–4 (alk. paper)
 1. Architecture, Ayyubid—Syria—Aleppo. 2. Architecture,
Islamic—Syria—Aleppo. 3. Architecture and state—Syria—Aleppo.
4. Aleppo (Syria)—Buildings, structures, etc. I. Title.
NA1489.7.A43T23 1997
720′.95691′3—dc20 95–38039
 CIP

It is the policy of The Pennsylvania State University Press to use acid-free
paper for the first printing of all clothbound books. Publications on uncoated
stock satisfy the minimum requirements of American National Standard for
Information Sciences—Permanence of Paper for Printed Library Materials,
ANSI Z39.48–1992

For Pam, Karim, Leila, and Zeyna

Contents

List of Illustrations

All illustrations are by the author unless otherwise noted.

List of Tables

I have long hesitated to take on this project single-handedly: the number and variety of the monuments involved and their incomplete state of documentation were daunting in themselves. But the sheer amount of material I gathered during my many visits to Syria during the 1980s finally began to exert its own pressures and assert its own logic. Each visit to Aleppo and every completed piece of research contributed a new passage to the mosaic, which, despite its persisting lacunae, eventually acquired sufficient clarity and coherence to merit publication.

The preparation of this work has taken a long time, and I have incurred many debts from friends and colleagues both here and in Syria. Much of the fieldwork was done in 1988 and 1989, when I received a number of generous travel grants from the Aga Khan Program for Islamic Architecture at the Massachusetts Institute of Technology. I am also grateful to the Horace H. Rackham School of Graduate Studies at the University of Michigan for two summer grants that I received in 1990 and 1992. I also wish to thank the Millard Meiss Publication Fund of the College Art Association and The Barakat Trust for their generous support of this book.

But I am especially indebted to mentors and colleagues who have dedicated considerable time and thought to reading and commenting upon the manuscript. Oleg Grabar and Renata Holod read the entire manuscript and offered extremely valuable advice, contributing particularly to the expansion of its sociohistorical framework. Professors Priscilla Soucek and Ilene Forsyth offered valuable comments concerning individual chapters. Several portions of this work were presented as public lectures, and I am very grateful to colleagues who supported and critiqued these early efforts, including Richard Brotherton, Neil MacKenzie, and Nasser Rabbat, Scott Redford, and Gülru Neçipoğlu. I am also indebted to R. Stephen Humphreys, whose work on Ayyubid Syria has illuminated many passages in these pages, for his encouragement and support.

My work in Syria was greatly facilitated by various officers at the Directorate General of Antiquities and Museums, including Dr. Afif Bahnassi, Wahid Khayyata, Kassem Touwair, Abdulqadir Rihawi, Ali Simmaqiya, and the entire staff of the architecture department in Aleppo. Thanks to the vigor and openness of these individuals, I was allowed access to even the most obscure monuments and granted permission to make copies of many architectural renderings in the archives of the directorate. Many of these renderings and others—from published sources or from my own surveys—were later redrawn by Adam Deck and Brian Stackable, architecture students at the University of Michigan, and by Julie Perlmutter.

In its last stages, this project profited immeasurably from Margaret Lourie, whose superb editorial work sharpened the focus and clarified the meaning of numerous wordy or obscure passages. I am also grateful to Penn State Press; in particular, Philip Winsor for his tenacious support of this project and Cherene Holland for her careful attention to all details.

Several summers of travel took me away from my wife and children or brought them with me to places best visited in cooler weather and under less stressful circumstances. Although my children have not always understood what the fuss was all about, I hope that they will seek comfort in that the book is finally completed and that, in their own

List of Tables

Preface

Following her unerring instincts, the British traveler Gertrude Bell declared that "the finest buildings in Aleppo are due to the Ayyubids, and chiefly to El Malik ez Zahir, the son of Ṣalāḥ al-Dīn (Saladin), who ruled Aleppo at the end of the twelfth century."[1] A somewhat more scholarly opinion was voiced by Ernst Herzfeld, who concluded that "the fine and sober style characteristic of Ayyubid art . . . reaches its highest point under al-ʿĀdil and Ẓāhir Ghāzī."[2] For his contemporary, Jean Sauvaget, the beauty of the Ayyubid monuments of Aleppo resided in "the satisfactory realization of the program, the perfection of techniques, the impeccable handling of materials, and the monumental effect obtained by harmonious volumes and the play of bays over the large, smooth walls."[3]

Why has an architecture admired by travelers and scholars alike been so neglected by contemporary scholarship? One explanation may have to do with Aleppo's marginality compared to Seljuq Iran and Fatimid Egypt, generally considered the creative centers of medieval Islamic architecture. A second possibility is its uncompromising originality, a unique combination of severity and restraint that represents an almost total denial of the opulence and luxury generally associated with Islamic architecture. A third possibility is that, with the exception of the Aleppo citadel, no Ayyubid buildings can aspire to the size and greatness of such outstanding Islamic monuments as the Great Mosque of Damascus or the Alhambra Palace in Granada.

Their relatively modest size and restricted ornamentation aside, the Ayyubid monuments of Aleppo represent a number of new beginnings and significant developments. In them, we see the first and one of the most important courtly citadels, the earliest preserved *madrasas* and *khānqāhs*, and the greatest stereotomic innovations in Islamic architecture, including stone *muqarnas* and interlaced masonry. Indeed, in the late twelfth century, when the Great Seljuqs had been obliterated and the Fatimids were mere figureheads, Ayyubid architecture emerged in a relatively short period from a nearly forgotten corner of the Islamic world to achieve a position of dominance and influence in the surrounding regions.[4] Within its own limits, this is a truly great architecture.

1. Gertrude Bell, *Amurath to Amurath* (London: Macmillan, 1924), 12.

2. Ernst Herzfeld, "Damascus: Studies in Architecture—III," *Ars Islamica* 11–12 (1941): 38.

3. Jean Sauvaget, "L'Architecture musulmans en Syrie," *Revue des Arts Asiatiques* 8 (1934): 38.

4. Michael Meinecke, "Mamluk Architecture. Regional Architectural Traditions: Evolution and Interrelations," *Damaszener Mitteilungen* 2 (1985): esp. 167.

I have long hesitated to take on this project single-handedly: the number and variety of the monuments involved and their incomplete state of documentation were daunting in themselves. But the sheer amount of material I gathered during my many visits to Syria during the 1980s finally began to exert its own pressures and assert its own logic. Each visit to Aleppo and every completed piece of research contributed a new passage to the mosaic, which, despite its persisting lacunae, eventually acquired sufficient clarity and coherence to merit publication.

The preparation of this work has taken a long time, and I have incurred many debts from friends and colleagues both here and in Syria. Much of the fieldwork was done in 1988 and 1989, when I received a number of generous travel grants from the Aga Khan Program for Islamic Architecture at the Massachusetts Institute of Technology. I am also grateful to the Horace H. Rackham School of Graduate Studies at the University of Michigan for two summer grants that I received in 1990 and 1992. I also wish to thank the Millard Meiss Publication Fund of the College Art Association and The Barakat Trust for their generous support of this book.

But I am especially indebted to mentors and colleagues who have dedicated considerable time and thought to reading and commenting upon the manuscript. Oleg Grabar and Renata Holod read the entire manuscript and offered extremely valuable advice, contributing particularly to the expansion of its sociohistorical framework. Professors Priscilla Soucek and Ilene Forsyth offered valuable comments concerning individual chapters. Several portions of this work were presented as public lectures, and I am very grateful to colleagues who supported and critiqued these early efforts, including Richard Brotherton, Neil MacKenzie, and Nasser Rabbat, Scott Redford, and Gülru Neçipoğlu. I am also indebted to R. Stephen Humphreys, whose work on Ayyubid Syria has illuminated many passages in these pages, for his encouragement and support.

My work in Syria was greatly facilitated by various officers at the Directorate General of Antiquities and Museums, including Dr. Afif Bahnassi, Wahid Khayyata, Kassem Touwair, Abdulqadir Rihawi, Ali Simmaqiya, and the entire staff of the architecture department in Aleppo. Thanks to the vigor and openness of these individuals, I was allowed access to even the most obscure monuments and granted permission to make copies of many architectural renderings in the archives of the directorate. Many of these renderings and others—from published sources or from my own surveys—were later redrawn by Adam Deck and Brian Stackable, architecture students at the University of Michigan, and by Julie Perlmutter.

In its last stages, this project profited immeasurably from Margaret Lourie, whose superb editorial work sharpened the focus and clarified the meaning of numerous wordy or obscure passages. I am also grateful to Penn State Press; in particular, Philip Winsor for his tenacious support of this project and Cherene Holland for her careful attention to all details.

Several summers of travel took me away from my wife and children or brought them with me to places best visited in cooler weather and under less stressful circumstances. Although my children have not always understood what the fuss was all about, I hope that they will seek comfort in that the book is finally completed and that, in their own

way, they contributed to it. My wife, Pam Tabbaa, lived with this project longer than anyone else, listening to my ideas in their amorphous, freewheeling form and only approving them when they passed the law of common sense. I thank her profoundly for her unfailing support, but even more, for keeping me simultaneously focused on my work and my family. It is no small feat.

Note: The transliteration system used follows that of the *International Journal of Middle Eastern Studies* (IJMES). Familiar geographical names such as Aleppo, Damascus, and Baghdad, and dynastic names such as Abbasids, Ayyubids, and Fatimids, are used in their common English form.

Abbreviations

AARP	*Art and Archaeology Research Papers*
AAS	*Annales archéologiques de Syrie*; also *Les Annales archéologiques arabe syrienne*
'Adiyāt	*Majllat 'Adiyāt Ḥalab*
AI	*Ars Islamica*
An Is	*Annales Islamologiques*
AMI	*Archaeologische Mitteilungen aus Iran*
AO	*Ars Orientalis*
AS	*Anatolian Studies*
BEO	*Bulletin d' études orientales*
BIFAO	*Bulletin de l'Institut français d'archéologie orientale*
BSOAS	*Bulletin of the School of Oriental and African Studies*
DM	*Damaszener Mitteilungen*
EI²	*The Encyclopaedia of Islam*, 2d ed., 8 vols., in progress (Leiden: E. J. Brill, 1954–)
IC	*Islamic Culture*
IJMES	*International Journal of Middle East Studies*
IM	*Istanbuler Mitteilungen*
JARCE	*Journal of the American Research Center in Egypt*
MAE	*Muslim Architecture of Egypt*
MCIA	*Matériaux pour un Corpus Inscriptionum Arabicarum*
MIFAO	*Mémoires Institut français d'archéologie orientale*
MMAF	*Mémoires de la mission archéologique française au Caire*
REI	*Revue des études islamiques*
Répertoire	*Répertoire chronolique d'épigraphie arabes*, 16 vols. in progress (Cairo, 1931–)
SI	*Studia Islamica*

Introduction

Aleppo in the twelfth and thirteenth centuries stood at the vanguard of the urban and architectural transformations that characterized Islamic cities of the middle period. Following an extended epoch of cultural and political decline that concluded in the downfall of the Great Seljuqs, this period witnessed the rise of relatively stable dynasties that were largely responsible for the remarkable revival of urban life in Syria and the Jazīra, or upper Mesopotamia. Generally consisting of Turkish or Kurdish family confederacies, these "Seljuq successor states" ruled over largely autonomous city-states that directly benefited from their public and private architectural patronage. Whereas early Islamic empires usually expressed their grandeur and imperial ambitions by founding new cities with central congregational mosques and vast extra-urban palaces, these medieval dynasties—Zangids, Ayyubids, and Artuqids—asserted their power by refurbishing and modernizing existing towns and providing them with all the necessary institutions of urban life. With its large, well-preserved citadel and wide variety of pious institutions, Ayyubid Aleppo serves as an ideal case study of this pan-Islamic transformation in urban architecture.

This book deals with the architecture of the Ayyubids of Aleppo, the direct descendants of the great Ṣalāḥ al-Dīn (Saladin), who ruled over one of the most important provinces in the Ayyubid sultanate. It is therefore a book about a city, a dynasty, and a

group of closely related monuments that have largely escaped the attention of modern scholarship. Even more, it is a book that explores the highly significant architectural transformations of Ayyubid Aleppo by viewing them from a number of different perspectives, including urbanism, patronage, institutional development, and sectarian rivalry. While primarily focused on the architecture of Ayyubid Aleppo, these interpretive essays strive to achieve two additional purposes: to link the study of Ayyubid architecture thematically with the larger body of research in Islamic architecture and urbanism; and to provide a material basis for the social and political history of medieval Aleppo.

But why Aleppo and why a study restricted to a specific sector of its history, largely defined by a single dynasty? Although now secondary to Damascus, Aleppo was probably the largest and most important city in the entire region of Syria, the Jazīra, and Anatolia throughout much of the medieval period.[1] It is also a city that has amply preserved the record of its past architectural achievements, aided no doubt by an arid climate and a superb building tradition. Whereas such important Anatolian cities as Konya or Sivas preserve half a dozen twelfth- and thirteenth-century monuments, Aleppo can claim more than twenty. Thus the density of these well-preserved medieval buildings and the availability of a rich literature pertaining to them make Aleppo an excellent springboard for similar explorations in other medieval Islamic cities.

Although the Ayyubids ruled over Egypt, Syria, parts of Palestine, and the Jazīra, both historical precedent and methodological orientation led me to limit this study to Aleppo and its vicinity. Recent historical research has shown that the Ayyubid state was not a single entity but a loose confederacy in which the major cities of Cairo, Damascus, and Aleppo enjoyed a great deal of autonomy.[2] Lacking the military and bureaucratic resources to unite such a vast and varied domain, the Ayyubid state consisted of nearly independent city-states governed by prominent Ayyubid princes who eventually formed their own hereditary dynasties. For these reasons, almost all studies of the history and culture of the Ayyubids have conformed to these urban limits, a practice that has been followed here as well.[3]

Although dynastic periodization has recently been questioned by more than one writer,[4] its adoption for this book is not difficult to justify. The Ayyubid period can be

1. To my knowledge, no population estimates for Ayyubid cities have been made. Even those made for the late Mamluk and early Ottoman periods are quite approximate, but they do suggest that Aleppo was a more populous city than Damascus. See Ira M. Lapidus, *Muslim Cities in the Later Middle Ages* (Cambridge: Harvard University Press, 1967), 79, which gives the population of Aleppo c. 1520 as 67,000 and of Damascus as 57,000. Similar figures are given by André Raymond in *The Great Arab Cities in the 16th–18th Centuries* (New York: New York University Press, 1984), 7.

2. See especially R. Stephen Humphreys, *From Saladin to the Mongols: The Ayyubids of Damascus, 1193–1260* (Albany: State University of New York Press, 1977).

3. For example, Humphreys, *From Saladin to the Mongols*, and Herzfeld's studies on the architecture of Damascus and Aleppo.

4. Disenchantment with dynastic history, with its close attention to political events and short-lived episodes, was first expressed by Fernand Braudel, for example in *On History*, trans. S. Matthews (Chicago: University of Chicago Press, 1980), 11–17. For Islamic history, the matter has been indirectly taken up by Marshall G. S. Hodgson in the overall structure of *The Venture of Islam*, 3 vols. (Chicago: University of Chicago Press, 1974); and more recently by Marilyn Waldman, "Periodization and Islamic History" (paper delivered at Middle East Studies Association, 1990).

securely framed between two significant events, Ṣalāḥ al-Dīn's conquest of Aleppo in 1180 and the Mongol invasion of 1260. While the origins of the Ayyubid dynasty in Aleppo are somewhat ambiguous, its rise as an independent city-state within a large confederacy is a watershed in the city's history. The end of the dynasty at the hands of Hulagu in 1260 and its succession by the Mamluks of Egypt are totally unambiguous. The havoc and destruction inflicted on Aleppo by the Mongols not only put an end to the Ayyubids but also interrupted any significant architectural activity for more than half a century.

Compared to studies of other parts of the Islamic world, work on the medieval monuments of Aleppo was late in beginning, prompting M. S. Briggs to write in 1924 that "the monuments of Aleppo still await their historian."[5] In fact, Briggs's statement was slightly out of date: in about 1915 Moritz Sobernheim and Max van Berchem had begun epigraphic studies of medieval Aleppine monuments, though neither was especially interested in the architecture itself.[6] It fell to Ernst Herzfeld to take up this challenge, and from the late 1920s he dedicated his energies and manifold talents as linguist, epigraphist, archaeologist, and architect to its accomplishment. Although primarily dedicated to epigraphic and architectural documentation, Herzfeld's short studies on the medieval monuments of Damascus and Aleppo often contained brilliant comparisons and unexpected insights on a wide range of topics, from history and titulature to style and iconography.[7] It is also notable that whereas Herzfeld's work in Aleppo is organized chronologically in the traditional manner, his latest work on Damascus represents an important methodological advance that mediates between chronology and a thematic presentation. Rich in promise, these ideas had very little chance to develop within the restrictive format of the *Corpus* and thus remain buried within its overwhelming documentation.

Although K. A. C. Creswell was not directly interested in medieval Syrian architecture, his life's work on the medieval architecture of Cairo often led him to examine Syrian monuments. His meticulous plans and useful short descriptions of Syrian *madrasas* of the Zangid and Ayyubid dynasties generally complement the work of Herzfeld, although unlike Herzfeld he tended to dismiss medieval Syrian architecture, which did not usually fit his determinedly linear view of the development of Islamic architecture.[8] In fact, his obsession with neat chronology blinded him to regional differences and intrusive traditions, placing such periods at an even further remove from his highly influential view of Islamic architecture.[9] Although Herzfeld's contemporary, he favored the methods of an earlier generation.

5. *Muhammadan Architecture in Egypt and Palestine* (London, 1924), 124.

6. These studies were ultimately incorporated in the various volumes of *Matériaux pour un Corpus Inscriptionum Arabicarum* (MCIA).

7. MCIA, *Syrie du Nord*, Part 2, *Monuments et Inscriptions d'Alep*, 3 vols. (Cairo: Institut Français d'Archéologie Orientale, 1954–56).

8. For a lengthy multiauthored critical evaluation of Creswell, see *K. A. C. Creswell and His Legacy:*

Muqarnas 8 (1991). See also Yasser Tabbaa, "Survivals and Archaisms in the Architecture of Northern Syria, ca. 1080–ca. 1150," *Essays in Honor of Oleg Grabar: Muqarnas* 10 (1993): esp. 29.

9. For example, John Hoag, *Islamic Architecture* (New York: Abrams, 1977), where it receives only one page, 221; and Richard Ettinghausen and Oleg Grabar, *The Art and Architecture of Islam, 650–1250* (Harmondsworth: Penguin, 1987), 304–6.

While Herzfeld's and Creswell's investigations largely reflect the state of research on the medieval architecture of Aleppo, two geographical works illuminate the urban context of its medieval monuments. The first is Jean Sauvaget's masterly study of Aleppo, which draws on architectural, archaeological, epigraphic, and literary sources to present an integrated picture of the city's unfolding history.[10] The second is the joint work of Heinz Gaube and Eugen Wirth, an exhaustive study of the demography, economy, topography, and morphology of Aleppo.[11]

My work on the Ayyubid architecture of Aleppo picks up where previous research leaves off, while fully acknowledging the two-generation hiatus.[12] As I see it, the task is not only to build on the earlier archaeological studies but also to approximate the kind of architectural history being written today for other areas of Islamic and Western medieval architecture. Inasmuch as a full account of the critical buildings under discussion is essential to all interpretive studies, I have presented them with full graphic and photographic documentation. I have utilized the available architectural record, attempting to complete it wherever necessary. A substantial number of plans and other architectural renderings came from the archives of the Directorate General of Syrian Antiquities, while others were adapted from a variety of published sources. Most of these drawings have been redrawn and amended, whether by the addition of projections of vaults or the incorporation of new features discovered in recent acts of restoration. Other plans, elevations, and details based on the measured drawings that resulted from my own field surveys were also prepared for the present work. The vast majority of the photographs are my own. Whenever possible, they were taken under natural light conditions.

The model and inspiration for this book is Oleg Grabar's seminal publication on early Islamic architecture, *The Formation of Islamic Art*.[13] Like Herzfeld's work on Damascus, Grabar's book is organized around a set of themes and problems, which, however, differ from Herzfeld's in two significant ways: they are far more fully developed, and they represent a much more sophisticated awareness of the interpenetration of social history and artistic change. In effect, it is these themes, not architectural documentation, that propel and dominate the discourse. At times they directly engage works of art; at other times they provide evidence for social history.

Grabar's *Formation* represents the expansiveness of thought and luxury of conceptual theorizing that in art history are possible only in areas where foundation work has already been done. This is not quite the case for twelfth- and thirteenth-century Syrian architec-

10. Jean Sauvaget, *Alep, Essai sur le développement d'une grande ville syrienne des origines au milieu du XIXᵉ siècle*, 2 vols. (Paris: Paul Geuthner, 1941).

11. Heinz Gaube and Eugen Wirth, *Aleppo: Historische und geographische Beiträge zur baulichen Gestaltung, zur sozialen Organisation und zur wirtschaftlichen Dynamik einer vorderasiatischen Fernhandelsmetropole* (Wiesbaden: Ludwig Reichert, 1984).

12. This may sound like an overstatement since various members of the Syrian Directorate General of Antiquities and Museum have done important restora-

tion work on some of these structures. But, with few exceptions, these studies and their associated plans are not so reliable as those previously made by Herzfeld and Creswell. The recent book by Terry Allen, *A Revival of Classical Antiquity in Syria* (Wiesbaden: Ludwig Reichert, 1989), is far too problematic and idiosyncratic to be of much use. It does little to advance our knowledge of medieval Syrian architecture.

13. Oleg Grabar, *The Formation of Islamic Art* (New Haven: Yale University Press, 1973).

ture, where despite the works of documentation previously mentioned, a number of important monuments still lack graphic and photographic coverage, and others have only recently been excavated. Little preliminary knowledge of these monuments can be assumed, and all have to be freshly examined from archaeological, formal, and epigraphic perspectives. This book, therefore, represents a series of compromises between documentation and interpretation, between typology and monographic treatment, and between total coverage and thematic selection. My overriding concern has been to reweave the fragments of knowledge we have about Ayyubid architecture into a discernible pattern, constructing for it a new set of architectural paradigms that will engage the interest of contemporary art historians without trivializing the underlying archaeological work. If warp and weft are still discernible beneath the overlaid pattern, then this process has been successful.

A more traditional chronological approach would have placed all Ayyubid monuments in Aleppo according to a developmental scheme of increasing complexity. It is true that the thematic and typological approach adopted here might obscure the progressive development of architectural forms, but this is not a great concern for Ayyubid architecture, which changes little over a period of eighty years. Unlike the earlier Seljuq-Zangid phase,[14] noted for its numerous intrusions and high dynamism, the Ayyubid architecture of Aleppo represents greater maturity and draws on a deeper tradition. Its change is never a radical departure from established tradition or even a ready acceptance of foreign influences but rather a gradual process of refinement that occurs within specific monumental types and, there, within specific forms.

Discerning appropriate themes upon which to focus discussion would have been easier for early Islamic art, where such widely resonant ideas as "symbolic appropriation of the land" and "ideological warfare" are implicitly played out against an opponent who had not entirely left the land. In late twelfth-century Syria, however, the threat of the Crusades had been contained, and the will to eradicate them completely from the Levant rarely went beyond poetic exhortations and inflated titulature. Instead, the dominant discourses were largely internal, addressing the perennially important areas of politics, religion, and society. Politically, the Ayyubid dynasty of Aleppo was primarily concerned with establishing a legitimate, stable, and powerful government within the larger confederacy of the Ayyubids. Religiously, the dominating idea was still the Sunni revival, whose foundations in Syria had been laid down during the preceding reign of Nūr al-Dīn. Socially, the Ayyubids seem to have been keenly aware of the ethnic and sectarian divisions in Aleppo and to have developed a number of schemes to mitigate their intensity.

I have subsumed these ideas under the twin headings of "power" and "piety," suggesting in the book's title that these attributes of sovereignty were not immanent and timeless features of Islamic rule but rather actively constructed paradigms reflecting specific historical conditions. The pun on the word "constructions" was also intended instantly and directly to insinuate architectural production within the dominant historical parameters

14. I have previously dealt with this period in "The Architectural Patronage of Nūr al-Dīn Maḥmūd ibn Zangī, 1146–1174" (Ph.D. diss., New York University, 1982).

of politics and religion, or power and piety. Even more than in other periods of Islamic history, monumental architecture was central to the establishment of the Seljuq successor states, which generally ruled over politically unstable lands, rife with ethnic and sectarian dissent. The institutionalization of political and military power in the palatial citadel and of Sunni piety in the *madrasa* and the *khānqāh* therefore constituted the most central policies of these states, including the Ayyubids.

Applying these dominant ideas to the architecture of the period should not be seen as a way of relegating the monuments to the background or even using them as evidence for social and political conditions. On the contrary, this approach claims for architectural history its own turf within Islamic history and demonstrates that only through a detailed analysis and sustained interpretation of monumental architecture can a number of ambiguous historical concepts be literally grounded. For example, the debate over the "institutionalization of the *madrasa*" can only be fully apprehended by looking at its monumentalization; the question of "popular piety" cannot be adequately addressed without examining shrines; and the problem of "sectarian relationships" within the city gains substantial authority when viewed in the context of Sunni sovereigns' participation in Shi'i monuments.

The book is conceived as a series of essays on the central issues of Ayyubid architecture in Aleppo. Broadly speaking, it progresses from the general to the specific, beginning with questions of urbanism and patronage, then proceeding to the various institutions, monumental types, and important monuments of Ayyubid architecture. Historiographical introductions to each chapter foreground the main issues surrounding the institutions or monuments addressed, and subsequent discussion of these monuments highlights problems that require further thought. In view of its dual objectives and the varying foci of the questions involved, the book aims at a middle ground in which specific archaeological questions are framed within broader theoretical concerns, while these broader issues are grounded within the specificities of individual monuments.

The first two chapters examine the urban and social contexts of the Ayyubid architecture of Aleppo. Chapter 1 summarizes the urban history of Aleppo before and during the Ayyubid period. Based largely on Ibn Shaddād and the works of Sauvaget and Herzfeld, this chapter delineates the urban framework within which the monuments are situated. It also explores the sacred geography of Aleppo, a city whose long cultural history left both archaeological and mnemonic traces. By locating Ayyubid monuments within these two levels of the urban reality, I shall demonstrate that the city is not a neutral matrix in which the monuments happen to be situated but an active participant in their interpretation.

The social and political context of the monuments absorbs Chapter 2. A brief history of the Ayyubid dynasty opens a detailed discussion of the social structure of Ayyubid Aleppo and the involvement of its various social classes in architectural patronage.[15]

15. "Class" is used here with full knowledge of its problematic nature in Islamic society. It is meant to designate a relatively cohesive group of urban dwellers who share features of ethnicity, economic status, and learning.

More than other periods of medieval Islamic history, the Ayyubid period is characterized by a widening of the basis of architectural patronage to include not only the Ayyubid sovereigns themselves but also foreign court officials, native patrician families, and women of the Ayyubid court. By reintegrating the monuments with their urban context and their patrons, these two chapters help re-create the nexus of relationships that contributed to their creation; they also underline the value of monumental architecture as a cultural investment.

The core of the book locates the institutions of power and piety in Aleppo within its palatial citadel and its variety of newly developed religious institutions, especially the *madrasa* (theological college). Chapters 3 and 4 discuss the citadel, the single most important monument in the history of Aleppo. Although individual citadels in Syria and elsewhere have been studied, the creation of the institution of the palatial citadel and its decisive role in transforming the power relations within the city have received very little attention. Following a detailed discussion of these questions, Chapter 3 reconstructs the chronology of the medieval citadel and its physical and symbolic links with the surrounding city. It argues that the Abrahamic shrine within imbued it with a sense of sanctity while symbolically linking it with another Abrahamic shrine south of the city. It also suggests that the citadel's direct link with the *dār al-'adl* (court of grievances) just outside its perimeter enabled the Ayyubids to exert control over administrative and legal matters as well as to broadcast messages of piety and protection to the surrounding city.

Chapter 4 discusses the most significant formal features of the citadel palace and compares them to eight other contemporary palaces—some published here for the first time—thereby revealing a hitherto little-known Islamic palace type. Comparing this palatial type to early Islamic palaces exposes intriguing connections across four centuries that underline the persisting memory of an Islamic golden age for medieval dynasts. On the other hand, the great reduction in scale, also seen in religious and quasi-religious structures, suggests that the process of appropriation was hampered by the limited resources of these latter-day dynasties.

Chapter 5 looks briefly at the few congregational mosques built by the Ayyubids in Aleppo and its vicinity. The Ayyubids' relative inattention to the mosque is examined over against their enthusiastic patronage of *madrasas* and other specifically Sunni institutions.

The proliferation of pious institutions in Aleppo—including *madrasas*, *khānqāhs* (Sufi convents), and shrines—can be ascribed to the Sunni-Shi'i rivalry and to the transformation of formerly independent institutions into instruments of the state. A central theme in Chapters 6 and 8 is the split between the Shi'ism of some important citizens and the Sunnism of the state. On the one hand, this sectarian rivalry led the Sunni rulers to patronize Shi'i shrines, especially the magnificent shrine for al-Husayn (discussed in Chapter 6), a conciliatory gesture undoubtedly also meant to place a stamp of authority on a popular pilgrimage shrine. More important, the two sects competed in the creation of elaborate monuments and the staging of increasingly intricate religious ceremonies. For instance, the pronounced mystical orientation of the *madrasa* al-Firdaws (Chapter 8) and its unique eschatological inscriptions were probably developed in response to the complex and engrossing Shi'i veneration of saints.

The role of Syria in the institutional and monumental development of the *madrasa,* the Sunni institution par excellence, is a missing chapter in its history. Chapter 7 examines this binary development of the *madrasa* from its vernacular origins to its quasi-official character in the thirteenth century. It argues that as the *madrasa* was progressively institutionalized, it became increasingly monumentalized, often adopting features of palace architecture to express its new status as a state institution. Dealing primarily with the six remaining Ayyubid *madrasas* in Aleppo, this chapter also examines the religious and funerary dimensions of these *madrasas* and their functional requirements.

Two important innovations, the stone *muqarnas* and the interlaced marble spandrel, are also fully treated in Chapter 7. In translating the *muqarnas* vault and the interlace from stucco to stone, Aleppine masons had to solve complex geometric and structural problems. Embellishing the facades and *miḥrābs* of palaces, *madrasas,* and *khānqāhs,* these two forms called attention to these monuments and imparted a sense of unity to the architectural production of the period. Not surprisingly, these two features were widely disseminated in surrounding regions, a testimonial to the great fame achieved by Aleppine architects as well as to the significance of the forms themselves.

Chapter 8 discusses the *khānqāh* and the increasing influence of Sufism in late Ayyubid Aleppo. Through a detailed analysis of one remaining *khānqāh* and one *madrasa* (al-Firdaws) that most likely functioned as a *khānqāh,* this chapter probes the significance of this institution, whose members exerted substantial influence on the masses in medieval Islamic society. The strikingly evocative inscriptions of the *madrasa* al-Firdaws, with their eschatological vision and paradisiac allusions, provide a suitable closure for the chapter and the book.

The Conclusion reviews the role of the citadel and pious institutions in relation to other medieval Islamic cities, including Damascus, Mosul, and Konya. It proposes that these pious institutions fostered ties between the ruler and the ruled, creating pockets of allegiance among the patrician and learned classes, who could then be recruited to serve as judges, chroniclers, and court officials. With their recognizable image as well as features of plan and design derived from palace architecture, these institutions begin a cycle of urban transformation that culminates under the succeeding Mamluks. At a time when Arabic poetry and court culture had lost much of their earlier resonance, these institutions contributed to the creation of a later medieval Islamic culture, one more closely tied to the grandeur and beauty of monuments than to the eloquence of ideas.

Note on the Literary Sources

Studies of medieval Islamic architecture are vexed by the virtual absence of contemporary documents that bear directly on the monuments themselves. We have no information on their architects, no drawings nor treatises of building, no records of contracts with masons, and insufficient information about their patrons. This dearth is partly compensated by the availability of epigraphic and textual sources containing direct or ancillary

evidence for the study of architecture. Epigraphically, the Ayyubid monuments of Aleppo are generally not so rich as those of Fatimid Cairo nor even Mamluk Aleppo. With the notable exceptions of the citadel and the *madrasa* al-Firdaws, Ayyubid inscriptions tend to be limited to a foundation plaque of a few lines giving the name and titulature of the founder, describing the building act, and, more rarely, offering some *waqf* (endowment) information.

The Ayyubid period, however, is rich in secondary sources, including regional histories, dynastic chronicles, biographical histories, topographical histories, travel literature, and poetry. These sources have been discussed exhaustively by medieval historians, including Elisséeff and Humphreys.[16] It suffices here to point out those that bear most directly on architectural history. In this period regional and dynastic chronicles supersede the earlier universal histories, a reflection of the irreversible fragmentation of the Islamic world. First written for the tenth- and eleventh-century dynasties of eastern Iran, these two related historical genres enter Syria in the aftermath of the Great Seljuqs.[17] For the history of the Ayyubid dynasty generally, by far the most complete and reliable chronicle is Ibn Wāṣil (d. 1298), whose *Mufarrij al-kurūb* was written under the patronage of the late Ayyubids.[18] For the history of Aleppo, with emphasis on the Zangid and Ayyubid periods, the single most important source is Ibn al-ʿAdīm's (d. 1262) *Zubdat al-ḥalab*, brilliantly edited by Sami Dahhān.[19] In their unedited condition, the great biographic dictionaries of Ibn ʿAsākir and Ibn al-ʿAdīm are too cumbersome to use and possibly insignificant for architectural history.

By far the most valuable sources are the urban or topographic histories. Leading this category is Ibn Shaddād (d. 1285), whose five-volume work, all now edited, covers Damascus, Aleppo, Lebanon, Jordan, Palestine, and the Jazīra.[20] Comparable to, though less detailed than, Maqrizi's work on Cairo, this is unquestionably the single most important literary source for the study of the monuments of Aleppo, particularly their location, date, patronage, and usage. It is especially useful for monuments that no longer exist.

Ibn Shaddād's curious combination of history, topography, and biography is followed by

16. Nikita Elisséeff, *Nūr al-Dīn un grand prince musulman de Syrie au temps des Croisades (511–569/ 1118–1174)*, 3 vols. (Damascus: Institut Français de Damas, 1967); Humphreys, *From Saladin to the Mongols*; and especially idem, *Islamic History: A Framework for Inquiry* (Princeton: Princeton University Press, 1991), 25ff.

17. In Iran, one of the earliest and most important local histories, written c. 1060, is Abu al-Faẓl Muhammad Bayhaqī, *Ta'rīkh-ī Masʿūdī*, ed. A. A. Fayyāḍ (Mashhad: Mashhad University Press, 1350/1971). One of the first urban topographic histories is Ibn Funduq, *Ta'rīkh-ī Bayhaq*, ed. A. Bahmanyar (Tehran, 1938).

18. Jamāl al-Din Muhammad Ibn Wāṣil, *Mufarrij al-kurūb fī akhbār Banī Ayyūb*, vols. 1–3, ed. Jamāl al-Din al-Shayyāl (Cairo: Wizārat al-Thaqāfa wa'l-Irshād al-Qawmī, 1953–60); vols. 4–5, ed. S. A. F. ʿĀshūr and H. M. Rabīʿ (Cairo: Wizārat al-Thaqāfa, 1972–77).

19. Kamāl al-Dīn ʿUmar Ibn al-ʿAdīm, *Zubdat al-ḥalab fī ta'rīkh Ḥalab*, ed. Sami Dahhān, 2 vols. (Damascus: Institut Français de Damas, 1951–68).

20. ʿIzz al-Dīn Ibn Shaddād, *Al-Aʿlāq al-khaṭīra fī dhikr umarā' al-shām w'al-Jazīra*:

1. *Ta'rīkh Ḥalab*, ed. D. Sourdel (Beirut: Institut Français de Damas, 1953)
2. *Ta'rīkh Dimashq*, ed. Sāmī Dahhān (Damascus: Institut Français de Damas, 1956)
3. *Ta'rīkh Lubnān w'al-Urdunn wa Filasṭīn*, ed. Sāmī Dahhān (Damascus: Institut Français de Damas, 1963)
4. *Ta'rīkh al-Jazīra*, ed. Yaḥya ʿAbbāra, 2 vols. (Damascus: Wizārat al-Thaqāfa w'al-Irshād al-Qawmī, 1977–78).

Ibn al-Shiḥna (active 1400–1450)[21] and Sibṭ ibn al-ʿAjamī (d. 1479).[22] Although more useful for Mamluk monuments and urban transformations, these two works often supplement information in Ibn Shaddād and add a few monuments that he neglected. Indeed, Ibn Shaddād's and Ibn al-ʿAdīm's legacies lasted until the first decades of the twentieth century, when two related compendia on topography, history, and famous men were composed by Kāmil al-Ghazzī (d. 1933)[23] and M. Rāgheb al-Ṭabbākh (d.1951).[24] Their importance is twofold: they help locate the monuments within the changing fabric of the city; and they provide information about the state of preservation or even total disappearance of certain monuments.

Travel literature can also be gleaned for descriptions of the physical, functional, and ceremonial aspects of monuments as well as for short accounts of important personalities. Unfortunately, the period under consideration falls between the journeys of the two most important medieval Arab travelers: Ibn Jubayr, who toured in the early 1180s during the reign of Ṣalāḥ al-Dīn, and Ibn Baṭṭūṭa, who traveled in the 1330s, during the reign of the Baḥri Mamluks. But despite the early date of his journey, Ibn Jubayr remains an invaluable source on medieval Islamic culture. His perceptive remarks on cities, ceremonies, titulature, and court women are unequaled by any other account.[25]

Poetic output in the Ayyubid period was quite prodigious: some of the more important poets of the period found a home in Aleppo and a patron in the Ayyubid court. The main source for poetry under the Ayyubids is ʿImād al-Dīn al-Kātib al-Iṣfahānī, whose multivolume anthology covers the poets of Syria, Egypt, Iraq, and even the poets among the Ayyubid princes.[26] Poetry is also frequently included in works of history, such as Ibn al-ʿAdīm and Abū Shāma (d. 1267),[27] and even in urban topographies.[28] A recent work collects some of these fragmentary sources in a critical anthology of the most important Ayyubid poets.[29]

21. Muḥibb al-Dīn Abu'l-Faḍl Muḥammad Ibn al-Shiḥna, al-Durr al-muntakhab fī ta'rīkh Ḥalab, trans. and ed. Jean Sauvaget as "Les perles Choisies" d'Ibn ach-Chihna, Matériaux pour servir à l'histoire de la ville d'Alep, vol. 1 (Beirut: Institut Français de Damas, 1933).

22. Abū Dharr Aḥmad b. Ibrāhīm known as Sibṭ Ibn al-ʿAjamī, Kunūz al-Dhahab fī ta'arīkh Ḥalab, trans. and ed. Jean Sauvaget as "Les trésors d'or" de Sibṭ Ibn al-ʿAjamī, Matériaux pour servir à l'histoire de la ville d'Alep, vol. 2 (Beirut: Institut Français de Damas, 1950).

23. Kāmil al-Ghazzī, Nahr al-dhahab fī ta'rīkh Ḥalab, 3 vols. (Aleppo, 1922–26; reprint, Aleppo: Dār al-Qalam al-ʿArabī, 1991).

24. M. Rāgheb al-Ṭabbākh, Iʿlām al-nubalāʾ bi-ta'rīkh Ḥalab al-shahbāʾ, 7 vols. (Aleppo, 1926; reprint, in 7 vols., with an index, Aleppo: Dār al-Qalam al-ʿArabī, 1989).

25. I have used Ibn Jubayr in the Arabic original: Riḥlat Ibn Jubair (Beirut: Dar Sader, 1970) and in the English translation: The Travels of Ibn Jubayr, trans. R. J. C. Broadhurst (London: Jonathan Cape, 1952).

26. Kharīdat al-qaṣr wa jarīdat al-ʿaṣr:

1. Shuʿarāʾ Miṣr, ed. Shawqi Dayf, et al. (Cairo, 1951)
2. Shuʿarāʾ al-ʿIraq, 4 vols., ed. M. Bahjat al-Athari (Baghdad: Matbaʿat al-Majmaʿ al-ʿIlmi, 1955–81)
3. Shuʿarāʾ al-Shām, 4 vols., ed. Shukri Fayṣal (Damascus: al-Matbaʿah al-Hashimiyya, 1955–68)

27. Shihāb al-Dīn ʿAbd al-Raḥmān Abū Shāma, Kitāb al-rawḍatayn fī akhbār al-dawlatayn, ed. M. H. Ahmad, 2 vols. (Cairo: Wizārat al-Thaqāfa w'al-Irshād al-Qawmī, 1956–62); and al-Dhayl ʿalā al-rawḍatayn, ed. M. al-Kawthari (Cairo: Dar al-Kutub al-Malikiyya, 1947).

28. Indeed, the last chapter of Ibn Shaddād, Aʿlāq, 1:152–71, is an anthology of poetic descriptions of Aleppo and its citadel.

29. A. F. al-Hayb, al-Ḥaraka al-shiʿriyya zaman al-ayyūbiyyīn fī Ḥalab al-shahbāʾ (Kuwait: Maktabat al-Muʿalla, 1987).

Despite their limited applicability to architectural history, these textual sources situate the monuments and impart a special flavor to the period. They include specific information that directly pertains to monumental architecture as well as containing—often in the most unexpected places—references and allusions that illuminate the architectural landscape. For this reason, they cannot simply be read as standard reference works but must be engaged with some understanding of their overall structure and content. The occasional interpenetration of these various texts with the architectural text may not necessarily lead to a definitive interpretation of a specific monument. But such points of contact can go a long way toward enriching the discourse within which monumental architecture is located.

PART I

CONTEXTS

1

The City: Aleppo Under the Ayyubids

Aleppo inhabits a vast fertile plain in northern Syria, hemmed in by hills on the west and north and by the Syrian desert to the east. The southern extension of this plain blends into the grainfields and the olive and pistachio orchards that continue nearly to Hama and help connect this rather isolated city with the rest of Syria. Although partly fed by the Quwayq River, which flows south from the Taurus Mountain, Aleppo is not a river city like Cairo nor even an oasis city like Damascus. Rather, it seems to have been from the start a multifaceted city whose success was based on a combination of topography, agriculture, trade, and, above all, an industrious population. Indeed, this varied composition may have sustained its civilized life across millennia of continuous habitation.

The Ayyubids inherited a city and citadel with a long history and accumulated cultural remains, nearly all within the confines of a wall just over one kilometer per side. How did this extensive cultural accretion contribute to Aleppo's urban form under the Ayyubids, and in what respects did it inform their architecture? Specifically, how did this earlier history influence the location, form, even the significance of the structures erected by the Ayyubids in Aleppo and its nearby suburbs? There are two main components to this question: physical and commemorative. Physically, there is little question that such important features of the city as its fortified perimeter, its citadel, and its central place of

worship formed the matrix within which the Ayyubids built their own structures. Mne-
monically, the temples, churches, and shrines of the various preceding epochs also seem
to have left traces and associations that were revived, amplified, and transformed in the
Ayyubid period. Ayyubid architecture interacted with these two levels of the urban
reality, producing its own synthesis and cultural layer.

Although the city's history reaches back to the early second millennium B.C.,[1] the
Hellenistic-Roman period is the earliest to leave any significant urban remains. In the
aftermath of Alexander's conquests, Aleppo was allotted to Seleucus Nicator, who in the
early third century B.C. founded a city called Beoria, attracted no doubt by the natural
outcrop of the citadel (Fig. 1). Beoria was built according to a regular Hippodamean plan,
and surrounded by a squarish wall whose eastern side was intercepted at its exact middle
by the citadel mound. This was a decisive point in the history of the city; it provided
Aleppo with a truly urban character and form, laying down the foundations of urban life
for many centuries to come.[2]

Beoria fared well during the Roman and Byzantine periods, when a colonnaded avenue
and an agora were added to its infrastructure. Its stability and economic prosperity
attracted inhabitants from all parts: a Christian community established itself there at a
very early date; Jews took up residence in its northern sector; and Arabs of the Tanūkh
tribe settled in a suburb called al-Ḥāḍir, just outside the southwestern corner of the
ramparts (Fig. 2). The success of Christianity in the intervening centuries and its adop-
tion as the state religion of the Byzantine Empire does not seem to have caused any major
changes in the physical appearance of the city, except that a great cathedral dedicated to
Saint Helena was built by Justinian on the same spot as the Roman temple. Morally,
however, the civic fabric was already being tested by the fragmented religious allegiances
of Jews, various Christian sects, and pagans.

In 636 Aleppo surrendered peacefully to the Muslims, who signed a pact guaranteeing
the inhabitants their lives, possessions, and places of worship. As a result of this binding
agreement, the first mosque in the city was built just inside the Antioch gate, the western
gate where the Muslim army first entered.[3] Not until well into the Umayyad period was a
large central mosque—the present Great Mosque—built on the site of the Roman agora;
for quite some time it coexisted with the Christian cathedral just west of it. Unlike other
major Umayyad centers, such as Damascus and Jerusalem, Aleppo has no Umayyad monu-
ments, its Great Mosque having been totally rebuilt in the twelfth century and later.[4]

1. See the detailed discussion of Aleppo's ancient
history in Herzfeld, *MCIA-Alep,* 1–6; and Jean Sauva-
get, "Ḥalab," *EI²,* 3:85–87.

2. For example, the regularity and rectilinearity of
the entire bazaar network in Aleppo demonstrate that
its underlying grid was regular. See Sauvaget, "Ḥalab,"
85, and idem, "Esquisse d'une histoire de la ville de
Damas," *REI* 8 (1934): 421–80, where Sauvaget
demonstrates how a Roman colonnaded street was in
time converted into a medieval bazaar.

3. This little mosque was totally replaced in the

middle of the twelfth century by Nūr al-Dīn's unusual
structure, the so-called Qastal al-Shu'aybiyya.

4. The archaeology of the Great Mosque of Aleppo
remains poorly known. Its earliest phases do not seem to
have left any visible remains, and the late eleventh-
century minaret may indeed be its most ancient portion.
See, meanwhile, Herzfeld, *MCIA-Alep,* 1:143ff.; and
Terry Allen, "Some Pre-Mamluk Portions of the Court-
yard Façades of the Great Mosque of Aleppo," *BEO* 35
(1983): 6–12.

Decline set in under the Abbasids and, but for a brief period of relative vigor under the tenth-century Ḥamdānids, continued until the Seljuq invasion. The only major works generally attributed to the Ḥamdānids are some repairs in the citadel and the city wall, a large palace built west of the city, and a Shi'i shrine near it. The work on the citadel and the wall has been almost totally subsumed within layers of later rebuildings. The palace, erected by the great prince Sayf al-Dawla, has vanished without a trace, although Ibn Shaddād locates it in the Quwayq River valley about one kilometer west of the city wall.[5] The so-called *mashhad* al-Dikka, also begun by Sayf al-Dawla, was situated on a hill within sight of the palace. Interestingly, this shrine and a later one helped lend a Shi'i character to the western part of the city.

Aleppo entered its darkest phase after the Byzantine invasion of 962, which was followed by other Byzantine incursions, Bedouin raids, and repeated onslaughts by the Fatimids. The Fatimid occupation in 1015 brought no lasting stability, as it was immediately challenged by various Arab tribes, one of which, the Mirdāsids, actually controlled Aleppo in the second and third quarter of the eleventh century. Not surprisingly, this chaotic period so eroded the city's infrastructure that Sauvaget ascribes to it the wholesale dismantling of the Roman road network and the nucleation of the city (Fig. 3).[6] The architectural contribution of this period is negligible: only a single domed fountain in the courtyard of the Great Mosque remains from nearly 350 years.

Aleppo fell to the Great Seljuqs in 1078, remaining under their control for a little more than three decades. With their downfall in 1113, the city entered a critical new period, during which it was contested among various Turkish princes and *atābeks*, as well as plagued by Crusaders. After this phase of instability, Aleppo was officially given as fief to 'Imād al-Dīn Zangī, the famous warrior against the Crusaders, in 1129. Freed by him and his son Nūr al-Dīn Maḥmūd from the menace of the Crusaders, Aleppo could finally turn to repairing its damaged infrastructure and repopulating its depleted quarters. A prodigious builder, Nūr al-Dīn rebuilt the walls; refortified the citadel; expanded the Great Mosque; and founded *madrasas*, *khānqāhs*, and other Sunni institutions. During his reign, Aleppo regained some of its former glory, a process that continued uninterrupted under the Ayyubids.[7]

The revival of urban life during the Seljuq-Zangid period focused on a relatively small number of regions that were deemed important for pious, political, or economic reasons. These were the Great Mosque, the extramural *maqām* Ibrāhīm, and the citadel. The Great Mosque received its splendid minaret in the late eleventh century, making it the first important architectural monument in more than three centuries. In 1123, Ibn al-Khashshāb, who had taken effective control of Aleppo during an especially chaotic

5. Ibn Shaddād, A'lāq, 1:29.

6. See Sauvaget, *Alep*, pl. LIV, for a reconstruction of the city plan in the eleventh century.

7. A similar process of rebuilding and repopulation took place in Mosul during the same period. See Ibn al-Athīr, *Al-Ta'rīkh al-bāhir fī al-dawlah al-atābikiyyah*, ed.

A. Tuleimat (Beirut, 1966), 77. See also E. Ashtor, *A Social and Economic History of the Near East in the Middle Ages* (Berkeley and Los Angeles: University of California Press, 1976), 240; and Rashīd al-Jumaily, *Dawlat al-atābikah fi'l-Mawsil ba'da 'Imād al-Dīn Zangī* (Beirut: Dar al-Nahda al-'Arabiyyah, 1970), 263–65.

decade, ordered the conversion of the Byzantine cathedral into a mosque.[8] In addition
to weakening the local Christian community and banishing it from the center of the
city to the periphery, this symbolic act terminated centuries of Muslim-Christian co-
existence and constituted the heart of the city as purely Islamic. Finally, Nūr al-Dīn
restored and expanded the Great Mosque itself and organized the markets surround-
ing it.[9]

The Seljuqs, Zangids, and Ayyubids also attended to the region surrounding the *maqam*
Ibrāhīm, about one kilometer south of the city wall. The shrine, which predated Islamic
times and had long attracted pilgrims, became a burial site for Muslims who wished to be
interred in the vicinity of the ancient prophet; it thus earned the name *Maqbarat al-
Ṣāliḥīn*, or the cemetery of the meritorious. Its sanctity and great fame attracted the first
Turkish and Turcoman invaders of the late eleventh and early twelfth century, some of
whom chose to be buried in its cemetery while others erected their own mausoleums in its
vicinity and settled permanently to the north of it.[10] This sanctified region, which was
called al-Maqāmāt (the shrines), continued to grow under the Ayyubids and the early
Mamluks.

By the middle of the twelfth century, another quarter southwest of Aleppo, known as
al-Ḥāḍir after an earlier community with the same name, was settled by the Turcoman
armies brought to Aleppo by ʿImād al-Dīn Zangī and his son Nūr al-Dīn Maḥmūd. Their
arrival changed the character of al-Ḥāḍir from an encampment, which like the early
Islamic *amṣār* served to isolate the military from the urban population, to a more or less
permanent settlement.

The third region to be developed during the Seljuq-Zangid period was Taḥt al-Qalʿah,
or the quarter beneath the citadel. The fate of this quarter was directly tied to the
increasing importance of the citadel in the twelfth century, specifically its transformation
from a military garrison to a fortified palatial city (on this transformation, see Chapter 4).
As befitting their proximity to the center of power, the quarters surrounding the citadel
contained a disproportionately large number of aristocratic residences and pious institu-
tions. Generally speaking, the sector just north of the citadel was populated by the upper
classes, whereas the region to its south had a more official character, since it faced the
entrance block of the citadel. Such quarters, whether in Aleppo, Damascus, Cairo, or
elsewhere, created another prime residential location in addition to the area of the
congregational mosque and its surrounding market.

This development of the citadel and its surroundings began in earnest under Nūr al-
Dīn, who refortified it, rebuilt the shrine of Ibrāhīm within it, and also built a royal
palace. The Taḥt al-Qalʿah, particularly its western and northwestern portions, became
noted for its *khānqāhs*, the more official institutions of Sufi brotherhoods (see Chapter 8

8. For a discussion of this conversion and other anti-
Crusader acts, see Yasser Tabbaa, "Monuments with a
Message: Propagation of Jihād under Nūr al-Dīn," in
*The Meeting of Two Worlds: Cultural Exchange between
East and West during the Period of the Crusades*, ed.
Vladimir P. Goss and Christine V. Bornstein (Kalama-
zoo: Medieval Institute Publications), 223–40.

9. This addition has been discussed by Allen,
"Some Pre-Mamluk Portions," 6–12.

10. See Chapter 6 for the specific acts of patronage
by the Great Seljuqs and their successors.

for a discussion of the *khānqāh*). Nūr al-Dīn himself built three, all in the vicinity of the citadel, while members of his entourage built six more—five of them also close to the citadel. *Madrasas,* on the other hand, tended to be clustered closer to the Great Mosque and in the residential neighborhoods to its south.

The City Under the Ayyubids, 1178–1260

Aleppo underwent its most important transformations in the medieval period under the Ayyubids, and specifically during the reign of al-Ẓāhir Ghāzī (Fig. 4). Ayyubid architectural achievements focused on four areas: the waterworks (discussed in Chapter 2), the citadel (discussed in Chapters 3 and 4), the fortifications and extramural developments (both discussed here).[11]

Aleppo was perhaps always a fortified city, although its earliest stone fortifications probably do not predate the Byzantine period, specifically the time of Justinian, who had the walls rebuilt after the Persian invasion of 540. The Arab invaders entered the city peacefully in 637, without having to breach the walls. Neither Umayyads nor Abbasids took great interest in the wall and the citadel of the city, leaving both to deteriorate through natural decay and residential intrusions. In the tenth and eleventh centuries, the Ḥamdānid and Mirdāsid dynasties undertook minor rebuilding and restoration, although they seem not to have changed the basic character of the fortifications. The last important pre-Ayyubid building act took place under Nūr al-Dīn, who, after two major earthquakes in 1157 and 1170, restored some of the towers and built the *faṣīl,* or intervallum. This was a totally cleared area with a low earthen wall that stood about one hundred meters outside the city wall, surrounding it on all four sides.[12]

The total rebuilding of the enclosure began in earnest with the reign of al-Ẓāhir Ghāzī (1186–1216), who approached the task with his characteristic sense of determination, organization, and self-consciousness. He began by removing the *faṣīl* of Nūr al-Dīn (which must have outlived its temporary need) and rebuilding the northwestern and northern parts of the wall—the parts most susceptible to foreign attack—from Bāb al-Jinān to Bāb al-Naṣr (Fig. 4). As with the waterworks (see Chapter 2), Ghāzī parceled out the building of the towers on this stretch of the wall to his princes and military officers; each tower was thus identified with a particular prince who was allowed to inscribe it with his own name. Ghāzī next rebuilt the entire eastern wall, north and south of the citadel. The southern section of this wall was built a short distance to the east of the earlier wall in order to create a defensible site for the *dār al-ʿadl* between the two walls.[13]

This major rebuilding of the city wall seems to have followed the preexisting lines of

11. A fourth area was the bazaar, where we know that al-Nāṣir Ṣalāḥ al-Dīn II built two new markets east of the Great Mosque, one for the silk merchants and the other for the coppersmiths. Ibn Shaddād, A'lāq, 1, 14. See also Dominique Sourdel, "Esquisse topographique d'Alep

intra-muros à l'époque ayyoubide," *Annales Archéologique de Syrie* 2 (1952): 109–33.

12. Ibn Shaddād, A'lāq, 1:17, and Herzfeld, MCIA-Alep, 1:20–22.

13. This important point is discussed in Chapter 3.

the enclosure, which formed an approximate square with the citadel on its eastern side. Later in his career, and for reasons that are not altogether clear, Ghāzī decided to extend the wall substantially to the south and east. The southern extension may reflect his desire to incorporate the Qal'at al-Sharīf—a dilapidated fortress just south of the original city wall—within the enclosure. This in turn made it possible to connect the new wall with the *khandaq* al-Rūm, a moat built by the Byzantines when they attacked the city in the tenth century. This moat was filled and an earthen wall constructed all the way from Qal'at al-Sharīf to the northeastern corner of the old enclosure. Three gates were cut in this earthen wall: Bāb al-Maqām to the south, Bāb al-Nairab in the southeastern corner, and Bāb al-Qanāt in the northeastern corner. All were completed after Ghāzī's death by his son Muḥammad, who also rebuilt in stone significant sections of the earthen wall.

The expansion of the city wall in this manner was as extensive as it was unusual. The area enclosed by the wall increased by nearly 50 percent, about two-thirds of it to the east and one-third to the south. This created an overall shape that was nearly unique among medieval Islamic cities: the citadel was now surrounded on all sides by the wall instead of occupying one corner of it (never quite the case with Aleppo anyway).[14] This doubly fortified location would have increased the defensibility of the citadel but might have impeded the maneuverability of its forces. In general, it seems to be a sign of the increasing prosperity and stability of the Ayyubid rule in Aleppo.

Having surveyed the overall development of the enclosure under Ghāzī, we turn next to those gates, partly or wholly rebuilt in the Ayyubid period, that represent the peak of medieval military architecture. We begin with Bāb al-Jinān, then move clockwise to the gates in the first and second walls of the city, ending with Qinnasrīn and Anṭākiya, the two main gates of the southwestern and western enclosure. Bāb al-Jinān (gate of gardens) was located at a point where the Quwayq River nearly touched the enclosure. The gate was probably first built by Sayf al-Dawla the Ḥamdānid as a conduit to his palace but was restored by Ghāzī and rebuilt in the late Mamluk period. It has completely disappeared.

About 300 meters north of Bāb al-Jinān stood Bāb al-Farādis, better known as Bāb al-Faraj, or the gate of deliverance. It was first built by Ghāzī but closed immediately after his death, only to be reopened by al-Nāṣir Yūsuf II. It was finally torn down in 1904 along with the entire northwestern part of the enclosure in order to create a public square (also called Bāb al-Faraj) and facilitate traffic. In recent years its remains have been uncovered and are now visible in a ditch several meters below the present street level.

Bāb al-Naṣr stands about 650 meters east of the northwestern corner of the enclosure (Fig. 5a). Originally called Bāb al-Yahūd because of its proximity to the Jewish quarter, this gate was renamed by al-Ẓāhir Ghāzī and rebuilt in 1212 as the most important gate in the northern enclosure. The pre-Ayyubid gate seems to have had a straight axis and two doors, just like the gates of Badr al-Jamālī in Cairo.[15] As rebuilt by Ghāzī, it represents a

14. This arrangement differs from most medieval Islamic cities, including Damascus, Jerusalem, Mosul, Baghdad, Cairo, and Diyarbakir, all of whose citadels occupy a corner position with regard to the enclosure. It does, however, resemble the medieval plans of some central Anatolian cities, such as Sivas, whose citadel is also surrounded by the enclosure. See Albert Gabriel, *Monuments turcs d'Anatolie*, 2 vols. (Paris: Boccard, 1934), 1:fig. 86.

15. Herzfeld, *MCIA-Alep*, 1:29–30.

more complex version of the type generally built in the Ayyubid period. Of its two projecting towers, the left one is pierced by a single opening that leads to a vaulted space in which the axis of progress is turned to the right. This vaulted chamber is connected to a vaulted passage built within the thickness of the wall, from which one finally exits to the left. The gate therefore has a double, instead of the usual single, bent-axis entrance. Such complexity, while militarily desirable, was probably impractical for normal usage. In the late Ottoman period the double wall between the two towers was pierced in order to allow access for vehicular traffic. Like most gates in Aleppo, this one was magically protected by a shrine to a popular saint in one of its niches. Here two saints, the enigmatic al-Khiḍr and Abu'l-'Abbās, are commemorated.

The old eastern wall and all its gates, having completely disappeared, are known only from textual sources and from the streets on either side of the citadel where the wall once ran. The stretch north of the citadel had a single ancient gate, Bāb al-Araba'īn, which does not seem to have been rebuilt in the Ayyubid period. Ghāzī, however, had a subterranean passage made from the northern part of the citadel to this gate for use in emergencies.

Just south of the citadel, the situation was complicated by the extra walls and gates built especially for the *dār al-'adl*.[16] Before this important institution was built, the wall just south of the citadel had a single gate, Bāb al-Ṣaghīr, symmetrical to Bāb al-Arba'īn. When Ghāzī extended the eastern wall a short distance to the east, a second gate, also called Bāb al-Ṣaghīr, was built directly across from the first in the new wall. A short distance to the south, a third gate called Bāb Dār al-'Adl was cut through the wall connecting the old and new eastern walls. Finally, a fourth gate called Bāb al-Jabal made north of the *dār al-'adl* served as a secret passage connecting the Ayyubid palace with the tribunal.

Bāb al-'Irāq was originally located in the southeastern corner of the old enclosure. It was completely superseded in the Ayyubid period by Bāb al-Nairab, built directly east of it in the new eastern wall.[17] Bāb al-Nairab, which has completely disappeared, plus Bāb al-Qanāt and Bāb al-Maqām were all planned by al-Ẓāhir Ghāzī but finished by his son Muhammad. Bāb al-Qanāt, today called Bāb al-Ḥadīd, was totally rebuilt in 1509 by the last Mamluk sultan Qānṣūh al-Ghūrī (Fig. 5b). Bāb al-Maqām, on the other hand, still retains part of its original Ayyubid form, although it too was rebuilt in the late Mamluk period (Fig. 5c).[18] As we shall later see in greater detail, its original tripartite form was unique in all Aleppo and quite possibly in all Syria (Fig. 6).

Bāb Qinnasrīn stands in the middle of the southern wall at the point where it once abutted Qal'at al-Sharīf (Fig. 7a). It was probably first built by Sayf al-Dawla since the geographer al-Muqaddasi mentions it as early as 985.[19] It was, however, totally rebuilt in 1256 by al-Nāṣir Yūsuf II, who in fact renewed the entire southwestern portion of the

16. See Chapter 3 for a more detailed discussion of the *dār al-'adl*.

17. Ibn Shaddād, A'lāq, 1:20, referred to it as "an old gate" bearing an inscription of Thimāl b. Ṣālih b. Mirdās.

18. MCIA-Alep, 1:68.

19. Muqaddasī, Aḥsan al-taqāsīm fī ma'rifat al-aqālīm, ed. M. J. de Goeje (Leiden, 1906), 124–30.

enclosure, between the gates of Qinnasrīn and Anṭākiya. This gate was restored several times in the Burji Mamluk period; it has since lost its entire western tower and part of its eastern tower. Even with these losses and alterations, Bāb Qinnasrīn stands today as a masterpiece of medieval Syrian military architecture, second only to the gate of the citadel.[20]

In its original condition the gate consisted of two massive and unequal towers with chamfered fronts. The western defensive tower, 18.40 meters wide, was only accessed from the rear through an opening in the double curtain wall behind the gate. The eastern entry tower, 26.80 meters wide, contained the actual portal, with its typical Ayyubid form: a tall framing arch with a recessed door was originally topped by a lintel made up of huge joggled voussoirs with a relieving flat arch above it. The lintel was reinforced in the late Mamluk period by a flat arch that cuts into the earlier Ayyubid masonry. This portal leads to the first *dūrgāh*, a long tripartite hall with a cross-vaulted middle chamber that contains a door with a portcullis in its northern side. This door leads to another cross-vaulted rectangular chamber, which is also ingeniously accessed from east and west by the corridor between the double curtain wall. A third portcullised door opens to a final square chamber with two niches and a fourth door that gives access to the city. The gate therefore forms two sides of a large square enclosing between them an area once used for provisioning the defenders. It contained water wells and cisterns, flour and oil mills, a bakery, and an arsenal. All this made of Bāb Qinnasrīn "a fortress in its own regard."[21] This gate was protected by a certain Khalīl al-Ṭayyār.

Strategically speaking, Bāb Anṭākiya was the most important gate of Aleppo: it dominated the city's western wall, thus fronting the direction most susceptible to attack (Fig. 7b). One of the oldest gates in the city, it also passed through the most building phases. Sayf al-Dawla rebuilt it over its antique foundations, and it was restored again in the early eleventh century by the Fatimids. It was almost entirely rebuilt by al-Nāṣir Yūsuf II between 1245 and 1247 and underwent repairs in 1390, 1402, and 1422. It is protected by Shaykh 'Alī al-Rūmī, whose shrine lies in a chamber at the end of the southern tower.

This is the best preserved gate in Aleppo: despite its unfortunate present condition, it still retains both of its towers behind the shops and stalls. With the exception of a short section of eleventh-century masonry behind the two towers, the gate is an entirely Ayyubid structure, beautifully constructed from large stones. Its two massive towers (24 by 12.50 m each) have the chamfered fronts typical of late Ayyubid towers. The northern tower, with three vaulted compartments and an array of arrow slits, existed only to defend the entry. The southern tower is entered by turning right into a vast *dūrgāh* (15.40 by 7.20 m) that contains deep niches with arrow slits built into the thickness of the wall.

By the latter part of the Ayyubid period, therefore, Aleppo was superbly defended by its great citadel and an astounding array of refurbished gates and towers. The heart of the city was still the Great Mosque and the vast market surrounding it, but the citadel and its surrounding quarters already formed a secondary focus, somewhat more official and aristocratic in nature. Just south of the citadel extended the *maydān* al-Qal'ah, around which

20. MCIA-Alep, 1:62. 21. Ibn Shaddād, A'lāq, 1:19–20.

were located a number of official and quasi-official institutions, including the *dār al-'adl*, the *madrasa* al-Sulṭāniyya,[22] and other *madrasas* and *khānqāhs*. The Farāfra quarter just north and northwest of the citadel was perhaps the most aristocratic Muslim quarter in the walled city because of its proximity to the citadel and the abundance of water in its channels and fountains.[23] It also contained a disproportionately large number of pious institutions, including the *khānqāh* al-Farāfra.

Generally speaking, the northwestern quadrant of the walled city contained the largest proportion of non-Muslims (both Christians and Jews); the southwestern quadrant was mostly, though not exclusively, Muslim; while the entire eastern half of the city was exclusively Muslim.[24] Thus, the Jews had their quarter (*ḥārat* al-Yahūd) south of Bāb al-Naṣr, where their main synagogue, first built in the sixth century, is located.[25] The Christians, on the other hand, tended to live west of them near Bāb al-Faraj in the so-called *ḥayy* al-Naṣārā, although some lived near Bāb Antākiya, in close proximity to Muslims.

The quarters south and southwest of the Great Mosque and the bazaar—possibly the oldest quarters in the city—were mainly inhabited by Aleppine Muslims. These include al-Saffaḥiyya, midway between the citadel and Bāb al-Maqām, and Jallūm (the Upper and the Lower), beween Bāb Antākiya and Bāb Qinnasrīn. Though primarily residential, the former contained the city's two *bīmāristāns* (hospitals) and the latter a number of early *madrasas*, including al-Muqaddamiyya of 1169.[26] We have no information on any specifically Shi'i quarters, although the location of their main shrines due west of Bāb Antākiya suggests that they tended to gather in the western part of the city.

Of the newly enclosed quarters, those to the northeast (near Bāb al-Qanāt/al-Ḥadīd) were favored by the Turkish and Kurdish official classes, while those due east of the citadel (near Bāb al-Nayrab) were largely inhabited by newly arrived bedouins and farmers from the surrounding regions.[27] Although "urbanized" by its inclusion within the walled city and by the creation of *madrasas* and other pious institutions within it, this newly walled region remained sparsely populated, as we can surmise from its one hippodrome (*maydān* Bāb al-'Irāq)[28] and two cemeteries, which survived well past the Ayyubid period.

Several other *maydāns* were created in Aleppo during the Zangid-Ayyubid period, almost always located just outside an important gate (Fig. 4). These were the *maydān* al-Akhḍar inside the citadel; *maydān* Bāb al-Ṣaghīr (or simply al-Maydān) just outside the

22. This *madrasa* is also referred to as al-Ẓāhiriyya al-Juwaniyya (*intra-muros*). In order to avoid confusion with the extramural Ẓāhiriyya, I consistently refer to it in this book as al-Sulṭāniyya.

23. Al-Farāfra retained this distinction until the eighteenth century, when newer quarters were established north and northwest of it. See Qal'aji, *Halab*, 254–62.

24. Sauvaget, *Alep*, fig. 18, pp. 61–62.

25. Ibid. See fig. 17 in Sauvaget's *Alep* for a plan of this synagogue, today under restoration. See also Ibn Shaddād, *Halab*, 22, who also specifies the location of

the Jewish cemetery just outside of Bāb al-Naṣr.

26. Under the Ayyubids, Aleppo had just one hospital, built by Nūr al-Dīn around the middle of the twelfth century. See Herzfeld, *MCIA-Alep*, 1, 229–31. The second hospital, attributed to Arghūn al-Kāmilī, is generally dated to the early Mamluk period; ibid, 2:2.

27. For a detailed study of the quarters of Aleppo and their constituent population, see 'Abd al-Fattāḥ Rawwās Qal'ajī, *Ḥalab al-qadīmah w'al-ḥadīthah* (Beirut: Mu'assasat al-Risalah, 1989).

28. Ibid., 19.

entrance block of the citadel; and *maydān* al-Ḥaṣā outside Bāb al-Saʿāda, near al-Ḥāḍir.[29] These *maydāns* were primarily intended for military exercises, parades, and polo, providing a necessary release for the soldiers living permanently in the cramped quarters within their towers. Often, they also doubled as open-air markets on some days of the week. For example, al-Maydān at the foot of the citadel was also *sūq al-khayl* (literally, the horse market).

The existence of *maydāns*, cemeteries, and other vacant areas in parts of the walled city strongly suggests that extramural quarters were not created because of the scarcity of land within the walls. Rather, the creation and expansion of extramural suburbs south of the city was apparently motivated by two factors: the need to separate the Turkish, Turcoman, and Kurdish soldiers from the Arab population of the city and the wish to inhabit a region that was sanctified by its proximity to the *maqām* of Ibrāhīm. In these respects, the Ayyubids were simply continuing a trend that had been in effect since at least the Zangid period. But the growth of the Ayyubid army caused by the introduction of the private slave army of al-Malik al-Ẓāhir (*al-mamālīk al-Ẓāhiriyya*) and the Kurdish commanders (*muqaddams*) undoubtedly led to the expansion and increasing urbanization of these quarters.[30] Indeed, it seems that by the middle of the thirteenth century, the older quarter of al-Ḥāḍir had converged with the more recent developments of al-Ẓāhiriyya and al-Maqāmāt, forming a single extramural suburb. The region had its own bazaar, a specialized market catering to the needs of its military population, as well as its own horse market, around which were grouped a number of *khāns*, including the *khān* al-Sulṭān and the *fondaco* of the Venetian merchants.

This mercantile expansion was matched by growth in the number of religious and pious institutions. Ibn Shaddād's lists for the southern quarters of al-Ḥāḍir, al-Maqāmāt, and al-Ẓāhiriyya total 370 *masjids*, 40 baths, 6 *madrasas*, and 1 congregational mosque. At this point the southern quarters had become a somewhat independent urban agglomeration, perhaps providing a more pastoral alternative to the crowded conditions of the intramural city. This and other extramural quarters (*arbāḍ*) are very much in keeping with demographic expansion in other contemporary Syrian and Jazīran cities, including Damascus, Hama, and Mosul.[31]

With its fortified appearance, its dense but fragmented urban form, its ethnically and religiously divided communities, Ayyubid Aleppo resembled a host of other medieval Islamic cities, which differed from their medieval European counterparts primarily in their lack of municipal organization. They were cities "where one lived, not corporations to which one belonged." Their inhabitants were "town dwellers, not citizens in the legal sense of the word, for there did not exist a municipality that made laws and under whose jurisdiction one could come." But despite these deficiencies, medieval Islamic cities represented effective social entities, whose dwellers, though not legally united, nevertheless displayed considerable emotional attachment to their native cities and a strong desire

29. Ibid., 19–22; see also Herzfeld, *MCIA-Alep*, 1:19–20.

30. Sauvaget, *Alep*, 146–48.

31. Ashtor, *Social and Economic History*, 240. In Damascus, the main suburban development was al-Ṣāliḥiyya; in Ḥamāt, it was al-Ḥāḍir on the opposite bank of the Orontes; in Mosul, it was in the upper and lower *rabaḍ*.

to maintain order and prosperity within them. "As seats of the government or its representatives they guaranteed relative security; as local markets or international emporiums they provided economic opportunities; and with their mosques and madrasas, their churches, synagogues, and schools, their bathhouses and other amenities they contained all a man needed for leading a religious and cultural life."[32]

In medieval Aleppo, this attachment was quite often linked to the city's commemorative history, which equally resided in hagiographies and popular myths as in the physical artifacts themselves. This sacred geography drew on the deep cultural and spiritual associations of specific locations in the city and on the numerous patriarchs, saints, sufis, and other holy men and women whose charitable or miraculous acts constituted the pious history of Aleppo. Indeed, it is not an exaggeration to suggest that every significant location in the walled city and many outside of it were "protected" through their association with a particular memory, event, or saint.[33] This is especially true for the suburbs immediately surrounding the city, which even today carry the names of their patron saints, such as Shaykh Abū Bakr, Shaykh Khiḍr, Shaykh Fāris, and Shaykh Maqṣūd, all to the north; Sayyidna al-Ḥusayn to the west; and al-Maqāmāt (referring to Abraham) to the south.[34]

The walled city itself was also rich in commemorative sites and shrines, many of which were concentrated in the Great Mosque, the citadel, and the gates. As with all great sanctuaries in the Islamic world, the Great Mosque of Aleppo has preserved the record of its transformations from a pre-Islamic (here Christian) to an Islamic place of worship. The Christian history of the mosque is evoked by the shrine dedicated to Yaḥyā ibn Zakariyyā (Saint John the Baptist?) located to the left of the *miḥrāb*. It presumably contains the head of Yaḥyā, which was first discovered in Ba'albak and first preserved in the upper shrine in the citadel. In addition to this Christian relic, the mosque contains in its eleventh-century minaret a Shi'i inscription—a supplication for the Twelve Imāms— that recalls the Shi'i history of the mosque and the city. In short, despite its unmistakable Sunni character, the Great Mosque of Aleppo had elements that would appeal to Christians and Shi'i Muslims.[35]

The citadel has also retained some elements of its prehistory as a Semitic high place in spite of its total transformation in the Ayyubid period into a fortified palatial city. Its two shrines, the upper and the lower, were repeatedly rebuilt on the same location, retaining in the process some of their original commemorative associations. The upper shrine seems to have lost its earlier association with Yaḥyā ibn Zakariyyā when the saint's relics were

32. S. D. Goitein, *A Mediterranean Society*, vol. 4, *Daily Life* (Berkeley and Los Angeles: University of California Press, 1983), 5–6.

33. Aleppo was not unique in this regard. Indeed, Damascus also underwent a similar process of sacralization during the twelfth and thirteenth centuries. See Janine Sourdel-Thomine, "Les anciens lieux de pélerinage damascains d'après les sources arabes," *BEO* 14 (1952–54): 65–85. In fact the same phenomenon may be seen in other cities, as can be inferred from the

many shrines and pilgrimage sites described in 'Alī al-Harawī's well-known guide: *Kitāb al-ishārāt ilā ma'rifat al-ziyārāt*, ed. by Janine Sourdel-Thomine as *Guide des lieux de pelerinage* (Damascus, 1953).

34. See Qal'aji, *Halab*, 223–28.

35. Interestingly, this is exactly the case with the Great Mosque of Damascus, which also contains a shrine for Yaḥyā ibn Zakariyyā and another shrine for al-Ḥusayn.

removed to the Great Mosque and the shrine itself rebuilt as a Friday mosque. The lower shrine, however, continued as a commemorative shrine to Ibrāhīm until the Ottoman period.

The citadel actually contained a third shrine, this one dedicated to al-Khiḍr, "the mysterious Saint George of the Arabs." It is located in the entrance block, in a deep recess within the third dūrgāh, a practice that was followed in all the gates of the Aleppo enclosure. Thus, Bāb al-Ḥadīd (or al-Qanāt) contained an unknown shrine;[36] Bāb al-Naṣr housed two shrines, one for al-Khiḍr and another for Abu'l-'Abbās (31 and 88); Bāb Qinnasrīn held the shrine of Shaykh Khalīl al-Ṭayyār (63) Bāb Anṭākiya enclosed the shrine of 'Alī al-Rūmī (48); and Bāb al-Maqām had the shrine of al-Arba'īn, or Forty Martyrs, which was probably removed from the older Bāb al-Arba'īn after that gate had fallen out of use (18). These gate shrines, concluded Herzfeld, "exercised their protective power for the benefit of the entire city" (18). Drawn from pre-Islamic, Sunni, and Shi'i traditions alike, these saints represented an important aspect of the cultural accumulation of this ancient city as understood by its people. It was as if the city's sacred history stood in its defense in times of crisis.

Cumulatively, Ayyubid architecture left a lasting impression on Aleppo. The citadel was rebuilt; the wall was refortified and enlarged; the water network was greatly expanded; the suburbs were populated; streets and quarters were provided with fountains and baths; and dozens of shrines, mosques, madrasas, khānqāhs, and mausoleums were built throughout the city. Some of these pious institutions rested on earlier foundations and evoked historical personages; others were new institutions that reflected the new directions of Muslim piety during the period of the Sunni revival. By the end of the Ayyubid period, it may be said that Aleppo had regained much of the architectural splendor and economic vigor that it had known under the Seleucids and the Romans.[37]

36. Herzfeld, MCIA-Alep, 1:75. Subsequent page references are to this work.
37. Cf. Sauvaget, Alep, 152–53, who also compares Seleucid and Ayyubid urbanism only to favor the former because of its public monuments.

2

Society and Patronage

Very little of the considerable literature on Islamic urbanism has yet dealt with Syrian cities of the Zangid and Ayyubid periods.[1] Little is known about the topography of these cities, and even less about their social and economic conditions in the twelfth and thirteenth centuries.[2] Indeed, our meager knowledge of these issues has not substantially advanced since Sauvaget's masterly study of 1941, despite the more recent publication by Gaube and Wirth.[3] What follows is, therefore, a brief but necessary account of the political history and social structure of Ayyubid Aleppo and a much more detailed analysis of the architectural patronage by various social classes in the city: the Ayyubid sultans, members of the administration, patrician families, and women of the court. I have elected to deal with the patronage of women independently, despite their member-

1. Curiously both earlier and later periods of Islamic urbanism are much better known than the Ayyubid period. For example, there is nothing for Ayyubid Damascus and Aleppo comparable to Jacob Lassner, *The Topography of Baghdad in the Early Middle Ages* (Detroit: Wayne State University Press, 1970), or to Ira M. Lapidus, *Muslim Cities in the Later Middle Ages* (Cambridge: Harvard University Press, 1967).

2. See, meanwhile, Neil D. MacKenzie, *Ayyubid Cairo: A Topographical Study* (Cairo: American University in Cairo Press, 1992). Unfortunately, Michael Chamberlain, *Knowledge and Social Practice in Medieval Damascus* (Cambridge: Cambridge University Press, 1994), came to my attention past the time when I could discuss it in this study.

3. Sauvaget, *Alep*; and Gaube and Wirth, *Aleppo*.

ship in the Ayyubid court, because it represents a relatively rare phenomenon in Islamic architecture.

A Brief History

When Ṣalāḥ al-Dīn finally conquered Aleppo on 11 June 1183, he gave it first to his favorite son al-Ẓāhir Ghāzī, at the time only eleven years of age. Ghāzī presided as sultan over the largest *iqṭāʿ* in Syria for just six months, after which Ṣalāḥ al-Dīn transferred it to his own brother al-Malik al-ʿĀdil. This appointment was probably intended to appease al-ʿĀdil and to maintain stability in Aleppo at a time when Ṣalāḥ al-Dīn was preoccupied with conquest and the preservation of his far-flung empire. Just three years later in 1186, he deposed al-ʿĀdil, who was given Egypt, and reinstated Ghāzī as sultan of Aleppo.[4] This marked the true beginning of the Ayyubid dynasty of Aleppo, which remained with the house of Ṣalāḥ al-Dīn until the Mongol conquest in 1260.

The confused succession to Aleppo and al-ʿĀdil's increasing assertiveness in Ayyubid affairs after the death of Ṣalāḥ al-Dīn in 1193 contributed to a long period of hostility between al-Ẓāhir Ghāzī and his uncle. In the end their nine years of skirmishes resulted in very little change and brought no lasting gain to either sovereign. As his role in Ayyubid politics gradually diminished, al-Ẓāhir Ghāzī dedicated himself to the expansion and defense of the province of Aleppo. One facet of this administrative policy was to bring "the great castles of his realm under his direct control . . . thereby reducing or eliminating the autonomous role of the *muqtaʿs* of north Syria."[5] Through warlike and peaceable means, al-Ẓāhir Ghāzī was able to bring under his sovereignty the castles at Ḥārim in 1193 and al-Shughr in 1198, as well as the castles and towns of Manbij, Najm, and Apamea in 1201. In 1207 he took control of the important port city of Latakieh, opening for his kingdom an outlet to the Mediterranean Sea.[6] Not coincidentally, in the same year he signed the first trade treaty between the Ayyubids and the Venetians, to be ratified three more times—in 1225, 1229, and 1254—before the Mongol invasion.[7]

In order to resolve the tension with his uncle al-ʿĀdil, Ghāzī asked him for his daughter's hand in marriage. With the marriage approved, Ḍayfa Khātūn at the head of a great retinue was dispatched in 608/1211.[8] She was received in Aleppo in 1212 amid great festivities. In a special gesture of respect, al-Ẓāhir Ghāzī even rose from his throne and took a few steps to greet her.[9] They were married in the same year; in the following year

4. For a detailed analysis of these important events, see Humphreys, *From Saladin to the Mongols*, 53–61 and 98–103.

5. Ibid., 118–19.

6. This victory seems to have been commemorated by the erection in 607/1211 of a minaret whose inscription, along with all the others by al-Ẓāhir Ghāzī, is discussed in Gaston Wiet, "Une inscription de al-Malik Ẓāhir Ghāzī a Latakieh," *BIFAO* 30 (1931):

273–92. It is unique among Ghāzī's inscriptions in including the specifically anti-Crusader epithet "the vanquisher of the worshippers of the cross."

7. Sauvaget, *Alep*, 132.

8. "She had in her service 100 slave girls, all of whom were entertainers who played a variety of instruments, and 100 other slave girls who made all sorts of unusual crafts." Ibn Wāṣil, *Mufarrij*, 3:214.

9. Ibid.

Ḍayfa gave birth to the male heir that Ghāzī had desired, the later sultan al-ʿAzīz Muhammad.

Al-Ẓāhir Ghāzī died at the age of forty-five in 613/1216 and was succeeded by his three-year-old son al-ʿAzīz Muhammad. A regency council consisting of the princes and military commanders of the province was formed to deal with questions of guardianship and succession. They agreed, with the approval of al-Malik al-ʿĀdil, that "the reign should go to al-Malik al-ʿAzīz and after him to his brother al-Malik al-Ṣāliḥ, and that administration of the kingdom should be in the hands of the *atābek* Shihāb al-Dīn Ṭoghril."[10] Indeed, Ṭoghril, a freed slave of al-Ẓāhir Ghāzī, was the effective ruler of Aleppo for the next fifteen years and, for all practical purposes, its third Ayyubid sultan.

At the age of seventeen al-ʿAzīz Muhammad took actual control of the sultanate, retaining Ṭoghril as treasurer. Far less involved in Ayyubid affairs than his father had been and generally disinclined to warfare, al-ʿAzīz concentrated his efforts on the defenses and infrastructure of Aleppo and its citadel, where he completed works begun by his father. Indeed, his rule and that of his mother, who succeeded him, were generally marked by the withdrawal of Aleppo from the Ayyubid system to the south.[11]

Al-ʿAzīz Muhammad died in 1236 at the age of twenty-three, leaving as successor his seven-year-old son, the later al-Nāṣir Ṣalāḥ al-Dīn Yūsuf II. In view of the new sultan's age, government policy was set by a regency council consisting of the two amirs Shams al-Dīn Luʾuʾ al-Amīnī and ʿIzz al-Dīn ʿUmar b. Majallī, the vizier Jamāl al-Dīn al-Qifṭī, and Ḍayfa Khātūn's own slave Jamāl al-Dawla al-Khātūnī. The latter acted as Ḍayfa Khātūn's secretary and deputy at the regency council, whose decisions she ratified herself. In effect, she thus ruled Aleppo from 1236 until her death in 640/1243.[12] This would make her the first woman to govern an Islamic dynasty, predating by about fifteen years the far more notorious queen Shajar al-Durr, who ruled Egypt from 1250 to 1257 before being ignominiously killed.[13] But unlike Shajar al-Durr, Ḍayfa Khātūn did not have coins struck in her name and did not have her name pronounced in the Firday *khuṭbah*, the two main emblems of authority for any Muslim dynast. In other words, symbolically, the line of male succession in the Ayyubid dynasty of Aleppo continued uninterrupted despite her regency.[14]

The last Ayyubid prince of Aleppo, al-Malik al-Nāṣir Ṣalāḥ al-Dīn Yūsuf II (1243–60), reversed several decades of isolationism to become a major player in Ayyubid politics. Intent on restoring the glory of the house of Ṣalāḥ al-Dīn, al-Nāṣir pursued an expansionistic policy that at first met with enormous success. Within the first seven years of his

10. Ibid., 251.
11. For example, he was reluctant to join the massive Ayyubid expedition of 1234 against the Seljuqs. See Humphreys, *From Saladin to the Mongols*, 234, who also concludes that "Aleppo had become markedly dissociated from the Ayyubid system as a whole."
12. Ibid., 229–30.
13. A discussion of her monuments and a summary of her rise to power and terrible death are provided by Creswell, MAE, 2:135–40. Her monuments are also

briefly discussed in Doris Behrens-Abouseif, *Islamic Architecture in Cairo: An Introduction* (Leiden: E. J. Brill, 1992), 90–93.
14. One indication of her ephemeral status is that she is not mentioned under the list of the Ayyubid dynasts of Aleppo in C. E. Bosworth, *Islamic Dynasties* (Edinburgh: Edinburgh University Press, 1967), 60. Shajar al-Durr, on the other hand, is listed in the same book (63) as the first of the Mamluks.

reign he had occupied parts of the Jazīra, annihilated the Khwarazmians in 1245, conquered Homs in 1248, and finally taken Damascus in 1250. By 1250 he controlled a territory larger than that of any other Ayyubid prince, extending from the Khabur River to the Sinai Desert.

In December 1250 he attacked Egypt, motivated by his own personal ambitions as well as by the precipitous decline of the Ayyubid dynasty after the death of al-Ṣāliḥ Najm al-Dīn Ayyūb and the problematic succession of his wife Shajar al-Durr. In a battle that Humphreys has aptly described as "the strangest battle in the history of the Ayyubids," the larger and better equipped forces of al-Nāṣir suffered a series of disastrous defeats by the forces of 'Izz al-Dīn Aybeg. Humiliated by his cowardly and indecisive performance, al-Nāṣir retreated to Syria, which itself gradually slipped out of his control.

Al-Nāṣir spent his remaining years trying to reassert his authority over the Ayyubid domain while appeasing the Mongols, who were at the time regrouping for a major offensive against the Abbasid caliphate. Appeasement only slightly delayed the inevitable: almost exactly two years after the fall of Baghdad to the Mongols, Aleppo suffered the same fate on 25 February 1260.

> As the Mongols streamed into Aleppo, they began a campaign of slaughter and pillage that went on for six days, until the streets were choked with the slain, and a vast number of women and children were seized as slaves. . . . Ruined and half-deserted, Aleppo would not recover from the carnage for another century.[15]

Social Structure

The social structure of Ayyubid Aleppo largely conformed to the model of other contemporary Islamic cities, with a few significant variations. The city and province of Aleppo were governed by a Kurdish dynasty that commanded a largely foreign army. In their closest circle they employed an official class, al-khāṣṣa, a coterie consisting of eunuchs, slaves, freed slaves, and a smaller number of nativized foreigners from various Islamic lands. Employed as viziers, governors, regents, supervisors, and scribes, among other professions, these rootless officials owed their position and fortune to the sovereigns and were, as a result, seen as their closest allies. The native population of the city was presided over, and sometimes led, by a relatively small number of long-standing patrician families, a'yān, who derived their wealth from agriculture or trade. In addition to their wealth, these families also produced most men of the word, the 'ulamā', who in this period exercised considerable power and some degree of independence. They were employed by the state as judges, jurists, professors, administrators of waqfs, and supervisors of the market. Beneath this class lived an even less differentiated social grouping, al-'āmma, including at its upper end shopkeepers and artisans, at its lower end peddlers and common

15. Ibid., 349.

workers. It seems likely that the Sufi mystics, who were especially powerful in this period, were drawn from, and had the greatest influence over, this class. At the bottom of the social hierarchy was a despised underworld, a *Lumpenproletariat* that included the menials—e.g., street entertainers, funeral workers, scavengers, and beggars—and the criminal element.[16]

The two lowest Aleppine social classes were probably quite similar to their cognates in other Islamic cities. The ruling class, the army, and the notables, on the other hand, exhibited noteworthy differences. Although ultimately foreigners, the Ayyubid rulers of the late twelfth century were already several generations removed from their Kurdish origins. Al-Ẓāhir Ghāzī, the first sultan of the dynasty in Aleppo, belonged to the fifth generation of an Arabized Kurdish clan; his great-great-grandfather, Marwān, bore an Arabic name, suggesting that he was already somewhat acculturated. Indeed, out of more than twenty-five Ayyubid rulers in Egypt, Syria, and the Jazīra, only one, Ṭūrān Shāh, had a non-Arabic surname; among the Arabic surnames of the others, biblical names such as Ayyūb, Yūsuf, Mūsā, and ʿĪsā figured quite prominently. Most probably spoke fluent Arabic, and many were active patrons of poetry, history, and religious sciences. Indeed, a few Ayyubid sovereigns, including al-Ẓāhir Ghāzī of Aleppo, al-Muʿẓẓam ʿĪsā of Damascus, and some of the lesser princes of Hama, even composed Arabic poetry themselves.[17] In short, ample direct and ancillary evidence suggests that the Ayyubids of Syria, unlike the later Mamluks or even the contemporary Rūm Seljuqs, were substantially Arabized and that Arabic culture, more than their Kurdish heritage, formed the main component of their identity.

The Ayyubid army was just the opposite: it lacked any cultural cohesion, and its various ethnic components remained segregated from the native urban population.[18] Largely composed of Kurdish and Turkish horsemen and Turcoman and Arab infantry, plus the increasingly important elite corps of slave soldiers (*mamālīk*), the Ayyubid army tended to settle in the outskirts of cities, in regions with ample pasture and training grounds. Even the military commanders apparently kept apart from the cultural life of the period, and very few of them (none in Aleppo) were active in architectural patronage.[19] This situation seems to have changed in the late Ayyubid period with the increasing regularization of the slave armies, paving the way for the Mamluk armies.[20]

16. This construct is partly derived from Lapidus, *Muslim Cities*, 79–83.

17. Ibn Wāṣil, *Mufarrij*, 3:244–45. An entire volume in ʿImād al-Dīn's *Kharidat* deals with the poets among the Ayyubid princes: *Shuʿarāʾ al-umarāʾ min banī ayyūb*, ed. Shukri Faisal (Damascus, 1968).

18. For the composition of the Ayyubid army, but mainly focused on Egypt, see H. A. R. Gibb, "The Armies of Saladin," in *Studies on the Civilization of Islam*, ed. S. J. Shaw and W. R. Polk (London: Routledge and Kegan Paul, 1962), 74–90. It appears that the Ayyubid army maintained its diverse composition and its distance from the native urban population to the end of the period.

19. The situation seems to have been slightly different in Damascus, where some army officers were involved in building acts. See R. Stephen Humphreys, "Politics and Architectural Patronage in Ayyubid Damascus," in *The Islamic World from Classical to Modern Times: Essays in Honor of Bernard Lewis*, ed. C. E. Bosworth et al. (Princeton, N.J.: Darwin, 1989), 151–74.

20. These remarks are based on a paper delivered in May 1994 at the International Congress of Medieval Studies, Kalamazoo, Michigan, by Maya Shatzmiller. In this paper, Shatzmiller compares the composition and degree of integration of Ayyubid and Mamluk armies, proposing that the latter became increasingly integrated within Cairene society.

The patrician class of Aleppo differed from the a'yān of other Islamic cities primarily in its longevity and its accumulation of wealth over several generations. Central to the cultural life of all Islamic cities, in Aleppo this social class achieved a high degree of eminence and wealth, as well as an unusual measure of continuity, often spanning several centuries. It is impossible at this point to explain definitively why Aleppo and, to a lesser extent, Damascus differ in this regard from other Islamic cities. But one factor might be tentatively proposed: in addition to their land holdings, some of these families were involved in the recently revived trade with Byzantium and the Latin west, an economic sector that had not yet been monopolized by the state.[21] Humphreys has already demonstrated the importance of the Damascene notables for architectural patronage,[22] and indeed the Aleppine notables equaled, if not exceeded, their counterparts in Damascus.

Iqṭā', or Islamic feudalism, stood at the foundation of this social structure, unifying the ruling class, the military, and the a'yān of a medieval Islamic society. First conceived as a mechanism of tax farming intended to support the army, *iqṭā'* underwent two basic transformations in the twelfth century. Under the last Seljuqs it became "no longer just a tax concession, but also a landed property over which the military *muqṭa'* enjoyed, in exchange for his service, some administrative powers."[23] And during the reigns of Nūr al-Dīn and Ṣalāḥ al-Dīn it became a hereditary property, a veritable *mulk*, the protection of whose legal succession from father to heirs became the duty of the sovereign.[24] By the Ayyubid period, therefore, *iqṭā'* had become something like a long-term lease on a revenue-producing property; its main purpose was to provide military commanders with a steady income in return for equipping and training a specified number of horsemen.

Despite the relative power and independence of the *muqṭa'* (*iqṭā'* holder), Humphreys warns that he should not be equated with a western feudatory, stressing that "he was in reality simply another official, a delegate of the prince with no legal status of his own."[25] Indeed, the absence of a firm legal status and the overall impersonal nature of the *iqṭā'* have both stood in the way of understanding the *iqṭā'* system in all its variations. What we do know and what primarily concerns us here is that the system apparently met with considerable success at first, producing substantial profits for the ruling class, the military, and the patricians.[26]

In the medieval Islamic world expendable wealth and possessions were converted into social status primarily through the mechanism of *waqf* (pl. *awqāf*), or charitable endowments. Legally inalienable in perpetuity, *waqf*s were also the only secure way for the upper classes to protect their own wealth and perpetuate the status of their families. In its most

21. Ashtor, *Social and Economic History*, 241–42.

22. Humphreys, "Architectural Patronage," 165–68.

23. Claude Cahen, "L'évolution de l'iqṭā' du IX^e au XIII^e siècle," in *Les peuples musulmans dans l'histoire médiévale* (Damascus: Institut Français de Damas, 1977), 256. For a more recent statement, see Humphreys, *Saladin to the Mongols*, 371–75. For the significant changes of the *iqṭā'* under the Buyids and the Seljuqs, see Ann K. S. Lambton, *Continuity and Change in Medieval Persia: Aspects of Administrative,*

Economic and Social History, 11th–14th Century, Columbia Lectures on Iranian Studies, ed. Ehsan Yarshater, no. 2 (Bibliotheca Persica, 1988), 100ff.

24. Cahen, "Iqṭā'," 259.

25. Humphreys, *Saladin to the Mongols*, 375.

26. Ashtor, *Social and Economic History*, 236–37. In this overpessimistic presentation of the medieval Islamic economy, it is worth noting that the author makes a number of positive remarks about Ayyubid feudalism.

legal form, a *waqf* had to be based on the revenue derived from rightfully and unequivo-cally owned property (*mulk*), whether agricultural or commercial, and had to be intended for a public charitable purpose, such as the foundation and maintenance of a pious institution.[27] Derived from the patron's personal wealth, this charitable (*khayrī*) *waqf* could be made to fulfill his or her specific requirements, provided these neither contra-dicted the *sharī'ah* nor interfered with the public function of the institution.[28] For exam-ple, founders could certainly stipulate such matters as the juridical orientation of the foundation, the number of students and professors in it, their stipends, the food they were to be offered, and so on. They could also stipulate that readers should recite portions of the Qur'ān at their grave or that alms should be given in their name during religious holidays.[29]

While such *waqfs* formed the core of the system throughout the early and middle Islamic period, a new variation, best described as state *waqf*, was evidently introduced in the twelfth century, possibly by Nūr al-Dīn. Motivated by his struggle against Fatimid Shi'ism and by his desire to establish Sunni orthodoxy, Nūr al-Dīn diverted monies from the treasury (*bayt al-māl*) into *awqāf* intended to create new institutions, augment the endow-ments of preexisting ones, and rebuild the city's defenses.[30] Although somewhat outside the legal parameters of *waqf*, this practice was reluctantly approved by jurists and followed by Ṣalāḥ al-Dīn and other Ayyubid princes, greatly increasing the number and size of pious institutions. In other words, it seems clear that Ṣalāḥ al-Dīn and his successors transformed the *waqf* system into a means for furthering the aims of the Sunni revival and upholding their own political sovereignty.[31]

Patronage

Architectural patronage in the central Islamic world underwent significant transforma-tions in the twelfth and thirteenth centuries. Whereas before this period it tended to be re-stricted to the state and to involve mainly congregational mosques and palaces, the twelfth century witnessed a substantial expansion in the basis of architectural patronage and an increasing variation in the nature of the monuments being commissioned.[32] These pat-

27. Literature on *waqf* is vast. Claude Cahen, "Ré-flexions sur le waqf ancien," *SI* 14 (1961): 37–56; Makdisi, *The Rise of Colleges*, 35–74; Muhammad M. Amin, *Al-Awqāf w'al-ḥayāt al-ijtimā'iyya fī miṣr, 648–923/1250–1517* (Cairo: Dar al-Nahdha al-'Arabiyya, 1980).

28. *Waqfs* are generally divided into *khayrī*, or charita-ble, and *ahlī*, or familial. The latter, which refers to en-dowments made for the less fortunate members of one's own family, had no impact on architectural patronage.

29. Such stipulations are often explicitly stated in the foundation inscription: e.g. *Répertoire*, no. 3870 for the *dār al-ḥadīth* of Ibn Shaddād; and *Répertoire*, no. 3894 for

the *madrasa* al-Atābikiyya. Where such information is not stated in the inscriptions, we may safely assume that it was once recorded in the *waqf* document.

30. Amin, *Awqāf*, 62. This act is mentioned by most chroniclers of Nūr al-Dīn, including Abu Shama, *Rawḍatayn*, 1:26–27 and 42–44; and Badr al-Dīn Ibn Qāḍi Shuhba, *Al-Kawākib al-durriyya fi al-sīra al-nūriyya* (Beirut: Dar al-Kitab al-Jadid, 1971), 37–38.

31. Amin, *Awqāf*, 66–67.

32. Although this broadening of architectural pa-tronage is seen mainly in Syria and the Jazīra, it may have in fact occurred first in late Fatimid Egypt. Several small mosques and shrines were built under the

terns persisted into the fourteenth century, but in that century and later the social basis of patronage began to shrink in a gradual return to state domination.

Although the social and economic foundations of this interesting phenomenon have not been adequately explored for every city,[33] some underlying factors may be tentatively suggested. First, this outburst of architectural patronage occurred mainly in regions previously controlled by the Great Seljuqs and thus might be related to their urban administrative policy. Specifically, the Great Seljuqs founded no new cities but merely transformed extant ones by providing them with the institutions of urban life.[34] Second, the Great Seljuqs and their successors also seem to have contributed indirectly to this phenomenon by expanding the ranks of the administration and the judiciary and by encouraging this newly constituted service sector to follow their example. Third, as suggested above, the newly systematized laws of *iqta'* may have produced immediate benefits for those classes most directly involved in architectural patronage.[35] Fourth, the wealth and relative stability of Ayyubid cities apparently attracted scholars and sufis from Iran and Central Asia, who often dedicated part of their fortune (sometimes their own home) as *waqf* for a shrine or a *zawiya*. Finally, the wealth and independence of Kurdish and Turkish women of the court also seems to have found an outlet in architectural patronage.

The Patronage of Sultans

Al-Zahir Ghazi stands out as the greatest architectural patron in the history of medieval Aleppo. His name occurs on no fewer than twenty-four foundation inscriptions, of which more than half refer to his own works.[36] His extensive architectural patronage reflects his policy of consolidation and defense: it focused primarily on infrastructure and fortifications and only secondarily on pious foundations. Perhaps his most important and certainly his most farsighted act was the canalization and waterworks of Aleppo, whose water supply from *qanat Haylan* had become quite unreliable. These works are discussed in great detail by Ibn Shaddad:[37]

patronage of the viziers Badr al-Jamali, Ma'mun al-Bata'ihi, and al-Salih Tala'i'. Their example was followed by the women of the court, who founded a number of shrines for female Shi'i martyrs. See in particular the two articles by Caroline Williams, "The Cult of 'Alid Saints in the Fatimid Monuments of Cairo. Part I: The Mosque of al-Aqmar," *Muqarnas* 1 (1983): 37–52, and "The Cult of 'Alid Saints in the Fatimid Monuments of Cairo. Part II: The Mausolea," *Muqarnas* 3 (1985): 39–60.

33. The one exception is Humphreys, "Architectural Patronage in Ayyubid Damascus," passim.

34. Michael Rogers, "Samarra: A Study in Medieval Town Planning," in *The Islamic City*, ed. A. Hourani and S. M. Stern (Oxford: B. Cassirer, 1970), 154–55.

35. For the significant changes of the *iqta'* under the

Buyids and the Seljuqs, see Lambton, *Continuity and Change*, 100ff. See also ibid., 149–55, for the development of *awqaf* during the Seljuqs and later. See also Cahen, "L'évolution de l'iqta'," 25–52; and Ashtor, *Social and Economic History*, 237–40, which describes the Ayyubid period as "a prosperous age" that was accompanied by "expansion" and "a demographic upsurge."

36. The inscriptions of al-Zahir have been compiled and discussed by Wiet in "Une inscription de Malik Zahir Ghazi," passim. Wiet lists twenty-one inscriptions, to which should be added two inscriptions at the mausoleum of Shaykh Harawi, *Répertoire*, no. 3614 A and B; and one inscription at the shrine of Sidi Ghawth, published in *MCIA-Alep*, 2:272.

37. Ibn Shaddad, *A'laq*, 141–42.

In the year 605 (1208) al-Malik al-Ẓāhir Ghāzī . . . sent for craftsmen (ṣunnā')
from Damascus. He personally took them and showed them the source of the
qanāt of Ḥaylān, ordering them to measure how much water left it and how much
of it reached Aleppo. The craftsmen informed him that the level of water leaving
the source was 160 fingers and what reached Aleppo was only 20 fingers. They
then assured him that they would be able to provide sufficient water for all the
thoroughfares, roads, houses, madrasas, and ribāṭs of Aleppo, with considerable
excess to be used for orchards and fields. Al-Malik al-Ẓāhir therefore decided to
begin by repairing the course of the qanāt from Ḥaylān to Aleppo. . . . He
brought all the commanders (muqaddamūn) to the site, and they set up their
camps along its course. He had the qanāt measured from Ḥaylān to the gate of
Aleppo; it was 35,000 cubits (the cubit of carpenters which is one-and-a-half
cubits.) He then divided this length among his commanders, providing them with
craftsmen and laborers and supplying them with lime, oil, stone, and brick. It [the
qanāt] was completely repaired. It had been previously open without a cover. So
he had capstones made to cover it completely except for places intended for its
purification or to drink from it. The [new] course reached the gates of Aleppo in
58 days.

Ibn Shaddād goes on to describe the waterworks within the walled city and even in its
southern and southwestern extramural suburbs. This enormous project, which must have
continued throughout al-Ẓāhir's reign, entailed the laying out of a vast network of
underground ducts that brought water directly to all major pious institutions and private
residences in the city and, by means of cisterns (qasṭals) and fountains, to all market and
residential neighborhoods (Fig. 8). Although state funds were used for most of the
project, private initiative seems to have played a crucial role, especially in the building of
more than eighty qasṭals, which, according to Ibn Shaddād, were distributed throughout
the city.[38] In addition to their practical functions, some of these qasṭals and fountains had
aesthetic qualities and were thus intended to beautify the city.

Al-Ẓāhir's work on the fortifications of the city has been discussed in Chapter 1 and his
work on the citadel and its vicinity will be dealt with in Chapters 3 and 4. It suffices here
to note that in addition to refortifying the citadel, he built within it a palace, a congrega-
tional mosque, and a step well (al-sāṭūra), as well as restoring the maqām of Ibrāhīm. In
addition to the Aleppo citadel, he was responsible for major rebuilding at several other
fortresses, including Qal'at Ḥārim in 595/1194, Qal'at al-Muḍīq at Afamiya in 602/1206,
and Qal'at Najm in 612/1215.

Despite his preocccupation with the functional and defensive aspects of Aleppo, al-
Ẓāhir also paid considerable attention to religious monuments. He built two major ma-
drasas, al-Sulṭāniyya (also called al-Ẓāhiriyya al-Juwwāniyya), for Ḥanafīs and Shāfi'īs;
and al-Ẓāhiriyya al-Barrāniyya, or simply al-Ẓāhiriyya, for Shāfi'īs only. Al-Sulṭāniyya,

38. Ibid., 142–50. See also S. Mazloum, L'ancienne
canalisation d'eau d'Alep (Damascus: Institut Français de

Damas, 1959), for a detailed discussion of the premod-
ern canalization of Aleppo.

which contains his own mausoleum, was finished after substantial delay in 620/1223 by the *atābek* Ṭoghril, who added his own inscription with its *waqfiyya* excerpts to the portal. Al-Ẓāhiriyya, according to Ibn Shaddād, was completed in 610/1213 and immediately put to use.[39] But it bears no foundation inscription, which suggests that it was not fully completed.

Al-Ẓāhir was also a great patron of shrines, both Sunni and Shiʿi. In addition to restoring the *maqām* Ibrāhīm at the citadel, he rebuilt part of the *maqām* Ibrāhīm at Ṣāliḥīn, to which he added a minaret and portal in 610/1213. His name also occurs on three other Sunni shrines, two of which were simply founded during his reign, the third founded directly by him. The first two are the shrine of the famed traveler and ascetic Shaykh ʿAlī al-Harawī (d. 1215),[40] who founded his own shrine southwest of Aleppo; and the shrine of Shaykh Fāris (601/1205) in Bābilla, just north of Aleppo. The third was the shrine of Nabi Yūshaʿ at Maʿarrat al-Nuʿmān, an important site for visitation, rebuilt by Ghāzī in 604/1207.[41]

Al-Ẓāhir Ghāzī also ordered work done on three Shiʿi shrines: Sidi Ghawth near the citadel and the *mashhads* al-Dikka and al-Ḥusayn, west of the city. Sidi Ghawth, which has totally disappeared, was an early and highly venerated Shiʿi shrine, first built by Zangi in 1142.[42] The other two shrines, discussed fully in Chapter 8, were the mainstays of the Shiʿi community for several centuries. The older of the two, *mashhad* al-Dikka, dated back to the tenth century but underwent continuous restoration and rebuilding, including a phase by Ghāzī.[43] The *mashhad* al-Ḥusayn was begun under al-Malik al-Ṣāliḥ Ismāʿīl, but its first phase was evidently completed under al-Ẓāhir Ghāzī in 592/1196 (see below). The nearly equal patronage of Sunni and Shiʿite shrines suggests that al-Ẓāhir and his successors treated the two sects evenhandedly. But this was so only on the most popular level of piety. *Madrasas* and other specifically Sunni institutions certainly tipped the scale toward Sunni patronage.

Al-ʿAzīz Muhammad's reign effectively lasted only six years, hardly long enough to build on the same scale as his father. He did some work on the fortifications, generally completing projects begun by his father. He also rebuilt the palace in the citadel and contributed to the restoration of the Abrahamic shrine there. Finally, he restored parts of the *mashhad* al-Dikka and gave permission to the Shiʿi community to add a new wing and a large courtyard to the *mashhad* al-Ḥusayn (see below).

The architectural patronage of al-Nāṣir Yūsuf in Aleppo was largely restricted to fortifications, an art that had reached an entirely new level in his period, as is clearly seen in the gates of Anṭākiya and Qinnasrīn. Al-Nāṣir also seems to have taken special interest in the commercial well-being of the city; he is said to have built two markets east of the mosque.[44] Finally, the *bīmāristān* al-Nūrī of c. 1150 was evidently restored during his reign

39. Ibn Shaddād, *Aʿlāq*, 107.

40. See Janine Sourdel-Thomine, "Al-Harawī al-Mawṣilī," *EI²*, 3, 178. The same author has edited and translated into French al-Harawī's major treatise, *Kitāb al-ishārāt ilā maʿrifat al-ziyārāt* (Damascus: Institut Français de Damas, 1952–57).

41. Herzfeld, "Damascus-III," 7–9.

42. Ibn Sahddād, *Aʿlāq*, 1:42; and Herzfeld, *MCIA-Alep*, 2:271–73.

43. Ibn Shaddād, *Aʿlāq*, 50.

44. Ibn Shaddād, *Aʿlāq*, 1:14.

at the hands of one of the elders of the Banu al-ʿAjamī family.[45] It is unclear what this restoration or rebuilding entailed.

The Patronage of State Officials

The apparently limited architectural patronage of al-ʿAzīz and al-Nāṣir was more than counterbalanced by the patronage of the official class. I have selected as exemplars of this level of patronage Jamāl al-Dīn Shādbakht al-Nūrī, Shihāb al-Dīn Ṭoghril al-Ẓāhirī, and Jamāl al-Dawla Iqbāl al-Khātūnī—three men who occupied important administrative positions in the late Zangid, early Ayyubid, and late Ayyubid periods.

Shādbakht was an Indian freed slave of Nūr al-Dīn, appointed as lieutenant of the citadel at his master's death in 1174. He was instrumental in effecting a smooth transition from Nūr al-Dīn to his young son Ismāʿīl by making the great amirs pay homage to Ismāʿīl before informing them that Nūr al-Dīn had died. During Ismāʿīl's short reign, he continued as lieutenant of the citadel, also acting as treasurer and muqaddam of the Nūriyya mamlūks. During the two-year interregnum (1181–83) between the death of Ismāʿīl and the reign of Ṣalāḥ al-Dīn, he was stripped of all his positions and honorably exiled to the fortress of ʿAzaz.[46]

As lieutenant of the citadel, Shādbakht took special interest in the maqām Ibrāhīm within it. His name occurs on two inscriptions in the maqām: the first, dated 575/1179, mentions an act of restoration (ʿimārah) in the name of Ismāʿīl carried out under Shādbakht's supervision (tawallī); the second mentions an important waqf donation by him for the maqām.[47] Shādbakht also built two madrasas in Aleppo, one extramural and one intramural, both for the Ḥanafīs. The first of these has disappeared. The second, dated 589/1194, remains partly preserved as masjid al-Shaykh Maʿrūf.[48] Shādbakht also built a khānqāh in Ḥarrān.[49]

Summing up the biography of the atābek Shihāb al-Dīn Ṭoghril (d. 631/1233), Ibn al-Athīr wrote, with no little irony: "I know of no other Muslim governor with better conduct than him."[50] Yāqūt, also a contemporary of Ṭoghril, said: "He is without equal in our days in all the regions of the world, save the caliph al-Mustanṣir Billāh . . . for his generosity, justice, and mercy have exceeded all limits."[51] Indeed, the contemporary sources unanimously agree about the exemplary rule and noble qualities of Ṭoghril: his devoutness, justice, charity, and asceticism. As atābek, one of his main responsibilities was to raise al-ʿAzīz Muḥammad from infancy to young adulthood. The latter, however, seems to have turned against him soon after assuming the sultanate, an affront that led Ṭoghril to leave the citadel for his house in the city and abandon all official positions.[52]

45. Herzfeld, MCIA-Alep, 2, "Additions et Corrections," 470; and Répertoire, no. 4426.

46. There is a good summary of Shādbakht's biography in Herzfeld, MCIA-Alep, 1:128–30.

47. Herzfeld, MCIA-Alep, 1:128–29.

48. See below. It is curious that this madrasa bears such a late date—twelve years after Shādbakht's

exile—possibly suggesting that he remained somehow involved in the affairs of the city.

49. Ibn Shaddād, Aʿlāq, 3, no. 1:42.

50. Ibn al-Athīr, Kāmil, 12:314.

51. Yāqūt, Muʿjam al-Buldān, 2:285.

52. Ibn al-ʿAdīm, Zubdat, 3:211.

Ṭoghril was without doubt the most active nonroyal builder in the Ayyubid period. During his fifteen-year regency over Aleppo, he continued the main projects begun by al-Ẓāhir, namely canalization, fortifications, and the citadel. He built a great tower near Bāb al-Naṣr, restored the glacis of the citadel after an earthquake, and had a residence built for himself within it.[53] In 1232 he also completed al-Sulṭāniyya, the funerary *madrasa* of his master, and instituted its *waqfs*.[54]

From his private funds, Ṭoghril built at least three other religious institutions, an intramural *madrasa* for the Ḥanafīs, an extramural *madrasa* for the Ḥanafīs, and a *khānqāh* near the Bāb al-Arbaʿīn.[55] The most important of these was the *madrasa* al-Atābikiyya of 620/1223, which contains his mausoleum. Today called Jāmiʿ al-Kiltāwiyya, it exists in a highly fragmentary state just inside Bāb al-Ḥadīd at the northeastern corner of the enclosure. Its foundation inscription, located in the tympanum of a plain vaulted portal, is quite telling about Ṭoghril and perhaps about other men of his rank and position.[56]

(1) هذا ما تقدّم (2) بإنشائه العبد الفقير إلى رحمة اللّه وكرمه (3) الشاكر لما أفاض عليه اللّه تعالى من جملة نعمه أبو سعيد طغرل بن (4) عبد اللّه الملكي الظاهري تقبّل اللّه منه وأتابه مسجداً (5) تقام فيه الصلوات الخمس في أوقاتها ويسكنه المدرّس والفقهاء الحنفيّة (6) ما شرطه في كتاب الوقف وإن قدّر اللّه وفاته خارج مدينة حلب فيدفن فيه في الموضع المعدّ له (7) وتلازمه القراءة من القرآن العظيم على ماشرطه فلا يحلّ لأحد يغيّره عمّا وضع له ومن بدّله بعد ما (8) سمعه فإنّما إثمه على الّذين يبدلونه وذلك في شهور سنة عشرين وستّمائة

(Has proceeded to found this the slave, the needy to God's mercy and grace, the thankful for the abundance of favors He has granted him, Abū Saʿīd Ṭoghril son of ʿAbdullāh, al-Malikī al-Ẓāhirī—may God accept from him and recompense him—a mosque for God Almighty, where the five prayers are performed at their times, and which is inhabited by the professor and the Ḥanafī jurists in accordance with the letter of its endowment; and if God should ordain that he should die outside the city of Aleppo, that he should be buried in the place prepared for him—and that readings from the sublime Qurʾān should be continuous as he has stipulated; and no one will be permitted to change that which has been imposed [Qurʾān, II, 177]—and that was during the year 620/1223.)

The strictly bureaucratic and excessively pious tone of the inscription is typical of other public inscriptions of Ṭoghril, including the ones he added to the *madrasa* al-Sulṭāniyya at its completion (see Chapter 7). This austerity may have been simply a personal trait—the

53. This residence has not been identified, although it might very well be the small cruciform structure located just south of the main gate of the royal palace.

54. Ibn Shaddād, *Aʿlāq*, 1:103.

55. Ibid., 14, 96, and 121.

56. Herzfeld, *MCIA-Alep*, 2:386; 3:pl. cxxvɪb; *Répertoire*, no. 3894.

usual explanation in the sources—but it is probably also a reaction to the heavy burden placed upon this "son of 'Abdullāh," literally a man without a family, after his patron's death. Indeed, Ṭoghril's strict demeanor and excessive piety are also demonstrated in his disinclination toward poetry and poets—"we do not offer poets anything"[57]—and his apparent disapproval of figural representation. A silver-inlaid brass ewer made for him is nearly unique among similar ewers in being completely devoid of figural designs.[58]

Jamāl al-Dawla Iqbāl al-Ẓāhirī al-Khātūnī was originally a slave of al-Ẓāhir Ghāzī before becoming associated with Ḍayfa Khātūn, for whom he served as secretary and spokesman. Although he was an architectural patron of some note, none of his buildings has survived. He is known to have built the madrasa al-Jamāliyya for the Ḥanafīs,[59] a khānqāh (640/ 1242) in the taḥt al-qalʿah sector (94), four masjids in different parts of the city (60, 78, 89, 90), and a jawsaq south of the city (94).

Many points of similarity mark the patronage of Shādbakht, Ṭoghril, and Iqbāl, three slaves who attained considerable prestige and power in the Ayyubid state. First, all three founded madrasas: Shādbakht and Ṭoghril each founded one intramural and one extramural madrasa, while Iqbāl founded one intramural madrasa. Second, all five madrasas were for the Ḥanafī sect, to which the patrons presumably belonged. Third, all three founded khānqāhs, clustered as usual in the vicinity of the citadel. Finally, the two remaining madrasas of these official patrons are notably less impressive than those built by the patrician class, such as the madrasas al-Sharafiyya and al-ʿAdīmiyya. It is impossible to determine whether this indicates the relative wealth of the two classes or simply reflects their different priorities with regard to architecture. What seems clear, however, is that state officials tended to build a variety of small monuments in different parts of the city, whereas patrician families preferred a single institution to carry their name.

The Patronage of Patrician Families

In his long entry on Aleppo, Yāqūt singled out some of the noteworthy features of its patrician class. "The city," he commented, "contains several old households known for their wealth, which is passed on from generation to generation. They preserve their old heritage in contrast to other towns."[60] Indeed, the impressive size of the two remaining patrician-built madrasas and the numerous other monuments built by this class attest to the prosperity and relative stability of the notables during the Ayyubid period. Like its counterpart in other medieval Islamic cities, the aʿyān class consisted of extended families who were variously involved in agriculture, trade, and scholarship and who sometimes

57. Ibn Wāṣil, Mufarrij, 3:246–47, describes the disappointment suffered by the court poets after Ghāzī's death and the succession of his slave Ṭoghril. At least one famous poet, al-Ḥilli, left Aleppo and joined the court of al-Malik al-Ashraf in Damascus.

58. Esin Atil, Art of the Arab World (Washington, D.C.: Smithsonian Institution, 1975), 61–63; and Esin Atil et al., Islamic Metalwork in the Freer Gallery of Art (Washington, D.C.: Smithsonian Institution, 1985), 117–23.

59. Ibn Shaddād, Aʿlāq, 1, 120. Page references in this paragraph are to this work.

60. Yāqūt, Muʿjam al-Buldān, 2:286.

occupied quasi-official positions in the state, such as judgeships and professorships.[61] In addition to their prodigious architectural patronage, these families were best known as professors (*mudarrisūn*) of the many *madrasas* built during the Zangid and Ayyubid periods.[62] The most important patrician families in Aleppo during the twelfth and thirteenth centuries were Banu al-Khashshāb, Banu al-ʿAjamī, Banu al-ʿAdīm, Banu al-Muqaddam, Banu Shaddād, and Banu ʿUṣrūn. From these families I have selected for discussion al-Khashshāb, al-ʿAjamī, al-ʿAdīm, and Shaddād, the four families most active in architectural patronage.

The Banu al-Khashshāb stand out among the patrician families of Aleppo in being Shiʿis. They were also one of the largest and oldest families in the city, their roots reaching back to the tenth century when they are said to have emigrated from the region of Latakiya during the reign of Sayf al-Dawla (945–67). Leaders of the community and counselors to successive princes, they were nevertheless "too proud and too honorable" to accept any political position from these princes.[63] Perhaps the most important building act by a member of this family was the erection of the minaret of the Great Mosque of Aleppo before 1090 by the great *qāḍi* Abuʾl-Ḥasan Muhammad. A few decades later, the same judge was also responsible for inciting the people of Aleppo against the Crusaders and for converting four churches in the city into *masjids* as a reaction to Crusader atrocities committed west of the city.[64]

The influence of the Banu al-Khashshāb seems to have decreased in the second half of the twelfth century, due specifically to the anti-Shiʿi policies of Nūr al-Dīn and more generally to the widespread triumph of Sunnism in Aleppo. Overall, the family seems to have been ostracized from the vibrant intellectual life of the city; their name disappeared from all official and academic appointments, and not one member of the family built a single *madrasa* or *khānqāh*, specifically Sunni institutions. Indeed, the only major building with which their name is associated is the *mashhad* al-Ḥusayn, which was built collaboratively by the Shiʿi community after the death of Nūr al-Dīn (see below). In addition, the Banu al-Khashshāb erected their own family mausoleum, a standard practice for most patrician families.[65] This mausoleum was restored during the Ayyubid period, as evidenced by one remaining inscription:[66]

61. Much has been written about this social grouping, referred to variously as "patricians," "notables," "*aʿyān*," "urban notables," and "urban bourgeoisie," a terminological confusion that partly reflects the flexible nature of this class and our incomplete knowledge of its historical characteristics. See, for example, the classic statement on the topic in Hodgson, *The Venture of Islam*, 2:60–69 and 91–98; a concise definition based on a specific case study in Bulliet, *Patricians*, 20–27; and Oleg Grabar, "The Illustrated Maqāmāt of the Thirteenth Century: The Bourgeoisie and the Arts," *The Islamic City*, ed. A. H. Hourani and S. M. Stern (Oxford: Cassirer, 1970), 207–22. See also Humphreys, *Islamic History*, 187–208, which presents a detailed critical historiography of the related question of the *ʿulamā*.

62. Dominique Sourdel, "Les professeurs de madrasa à Alep aux XIIe–XIIIe siècle d'après Ibn Šaddād," *BEO* 13 (1949–50): 85–115.

63. Ibn Shaddād, *Aʿlāq*, 1:35.

64. Yasser Tabbaa, "Monuments with a Message: Propagation of Jihād under Nūr al-Dīn," in *The Meeting of Two Worlds: Cultural Exchange between East and West during the Period of the Crusades*, ed. V. Goss (Kalamazoo, Mich.: Medieval Institute Publications, 1986), 223–40. On Banu al-Khashshāb see also Herzfeld, *MCIA-Alep*, 3:291–95.

65. Ibn Shaddād, *Aʿlāq*, 1:140.

66. Herzfeld, *MCIA-Alep*, 2:292; and *Répertoire*, no. 4087.

(1) بسم اللّه الرحمن الرحيم إنَّما وليكم اللّه ورسوله (2) والذين آمنوا الذين يقيمون الصلوة ويؤتون (3) الزكوة وهم راكعون جدَّد عمارة هذه التربة (4) المعروفة ببني الخشَّاب تغمَّد اللّه ساكنها بالرحمة (5) الفقير الى رحمة اللّه الحسن بن إبراهيم بن سعيد (6) بن الخشَّاب في شهور سنة ثلاث وثلاثين وسُّمائة

(Bismillāh . . . Your friend can only be God; and His messenger and those who believe, who establish worship and pay the alms, and bow down [in prayer] [Qur'ān V: 55] Has repaired the construction of this mausoleum which bears the name of Banu al-Khashshāb—may God encompass its inhabitor with His grace—the needy for God's Grace, al-Ḥasan, son of Ibrāhīm, son of Saʿīd, ibn al-Khashshāb; during the year 633 [1235–36].)

In his 628/1231 obituary for Abu'l-Qāsim ʿAbd al-Majīd Ibn al-ʿAjamī, Ibn al-Athīr wrote: "He and his family were the leaders of the Sunnis of Aleppo. A man of ubiquitous chivalry, good temper, plentiful generosity, and great leadership, he enjoyed nothing better than to invite people to his dinner table."[67] Yāqūt described the same person and his family as "leaders of the Shāfiʿī community, and the greatest in rank, dignity, wealth, and prestige among all the people of Aleppo."[68] Indeed, the Banu al-ʿAjamī were quite possibly the most important patrician family in Aleppo during the entire Zangid-Ayyubid period. The family hailed originally from Baghdad, where its first known ancestor, Ḥusayn b. ʿAlī al-Karābisī (d. 862), was even then a Shāfiʿī jurist of some note. One of his descendants, ʿAbd al-Raḥmān b. Ṭāhir, was born in Nishapur and moved to Aleppo in 1041, where he became known, because of his place of birth, as Ibn al-ʿAjamī.[69] This date begins the illustrious history of this family, whose numerous members remained central to the official and intellectual life of the city well into the fifteenth century.

The prodigious architectural patronage of the Banu al-ʿAjamī begins with the first Sunni institution of the city, the famous madrasa al-Zajjājiyya, begun in 1122. Although Sharaf al-Dīn ʿAbd al-Raḥmān (d. 1166), the elder of the family in the first half of the twelfth century, is sometimes named as only the mutawallī (supervisor) of the building of the madrasa, he seems to have been the motivating force behind its contentious construction.[70] Having studied Shafiʿī jurisprudence at the madrasa al-Niẓāmiyya in Baghdad, he sought to endow his native city with a similar institution. He therefore convinced the Artuqid governor of the city, Badr al-Dawla Suleymān, to build this madrasa. It is possible that the

67. Ibn al-Athīr, al-Kāmil, 12:505.

68. Yāqūt, Muʿjam al-ud'abā', 16:42; quoted in Sami Dahhān's introduction to Ibn al-ʿAdīm, Zubdat, 1:20.

69. Anne-Marie Eddé, "Une grande famille de Shafiites alépins, les Banū al-ʿAǧamī aux XIIe–XIIIe siècles," Revue du Monde Musulman et la Mediterranée 62 (1991–94): 61–71. This is perhaps the only article written about a medieval Aleppine family, no doubt

indicating the originality of the writer and the importance of the Banu al-ʿAjamī family.

70. This madrasa, as discussed below in Chapter 7, engendered tremendous hostility among the Shiʿites of the city, who vandalized its construction site a number of times. In effect, Sharaf al-Dīn had to supervise its construction for nearly twenty years, long after its original patron had left Aleppo.

Artuqid ruler only provided seed money for this institution, for we know that the Banu al-'Ajamī augmented its endowment and later occupied its professorship, considering it one of their own foundations.[71]

Members of this family built three other *madrasas*, none of which has completely escaped the ravages of time. The first was the so-called *madrasa* at al-Jubayl, at the northern end of Aleppo's wall to the west of Bāb al-Ḥadīd. Built in 595/1199 by Shams al-Dīn Ahmad for both Shāfi'īs and Mālikīs, it also served as the main cemetery of the Banu al-'Ajamī. Known today as Jami' Ibn Zīr (a corruption of Abū Dharr), the original *madrasa* has been entirely swallowed up by modern construction.[72] The second *madrasa*, today known as al-Karīmiyya, is located in Jallūm, a short distance north of Bāb Qinnasrīn. It was built, or perhaps restored, in 654/1256 by 'Abd al-Raḥīm Ibn al-'Ajamī.[73] Only a *muqarnas* portal with an inscription remains from this *madrasa*. The third was the *madrasa* al-Sharafiyya, one of the largest and most elaborate Ayyubid pious institutions. Built in several stages during the first half of the thirteenth century, this *madrasa* occupies one of the most prestigious lots of the city, on the road connecting the Great Mosque with the citadel (see description below). The Banu al-'Ajamī also built two *masjids* and a *khānqāh*, the latter located in one of their houses.

Finally, perhaps the clearest testimonial to the family's status is one of their palaces, the so-called *matbakh* al-'Ajamī, which has miraculously survived until the present and is discussed at length below (see Chapter 4). It suffices to note here that in size and sophistication it was comparable to the palace of the Ayyubids in the citadel.

The early history of the Banu al-'Adīm resembles that of the Banu al-'Ajamī: they also originated in Iraq (Boṣra in their case) and moved to Aleppo in the ninth century. In fact, the Banu al-'Adīm were even nobler than the Banu al-'Ajamī since their genealogy could allegedly be traced back to Ibn Jarāda, a companion of 'Alī, and before that all the way back to 'Adnān, the first ancestor of the northern Arabs.[74] Their history in Aleppo spans nearly five centuries, during which various members of the family served successive rulers, including 'Uqaylids, Mirdāsids, Zangids, and Ayyubids.

The peak period of prestige and influence for the Banu al-'Adīm coincided with that of the Zangids, especially Nūr al-Dīn and his son Ismā'īl, with whom they shared the Ḥanafī *madhhab*. Kamāl al-Dīn's father Ahmad occupied the ranks of *khatīb*, treasurer, and judge during the late Zangid period. Interestingly, once Aleppo fell to Ṣalāḥ al-Dīn, Aḥmad was removed from the judiciary "because the state was Shāfi'ī, and the man and his ancestors were all Ḥanafīs."[75] This was only a temporary setback, and by the time of al-Ẓāhir Ghāzī the family was once again able to assume its position as leader of the Ḥanafī community.

71. Eddé, "Grande famille," 63, cites a telling anecdote in this regard. When Ṣalāḥ al-Dīn was taken on a tour of pious foundations in 1183 (the year he took Aleppo), it was discovered that the original inscription, which named its founder as Badr al-Dawla Suleyman, had been whitewashed and replaced by a new inscription in the name of Sharaf al-Dīn 'Abd al-Raḥmān.
72. Ibn al-Shiḥna, 118–19; and Sibṭ Ibn al-'Ajamī, 84.
73. Herzfeld, MCIA-Alep, 2:315–16.
74. The genealogy of this family and the biography of its most illustrious member, the historian Kamāl al-Dīn, were written by Yāqūt, his great admirer. That text has disappeared, but Yāqūt preserved most of it in his great compendium Mu'jam al-Udabā'.
75. Dahhan (after Yāqūt), 1:19.

Kamāl al-Dīn 'Umar Ibn al-'Adīm was not only the most illustrious member of the family but a true Renaissance man of the Ayyubid period. The greatest chronicler in the history of Aleppo, he also excelled in jurisprudence, poetry, and calligraphy. He was an extremely wealthy man who owned "vast country estates, considerable real property, many slaves, as well as horses and livestock."[76] Appointed as professor of the madrasa al-Shādbakhtiyya at the age of twenty-six, he eventually became professor at the madrasa al-Ḥallāwiyya, one of the most important Ḥanafī madrasas in Aleppo. In 634/1237 he dedicated a wooden miḥrāb to this madrasa; it stands today in a small iwan to the right of the main dome. Inscribed by the historian himself, it is one of the masterpieces of wooden marquetry and calligraphy in medieval Islamic art. His most important architectural act was the madrasa al-Kamāliyya al-'Adīmiyya, located outside Bāb al-Nayrab to the east of the city. This madrasa, which includes two mausoleums and a residence, compares favorably with the best of royal Ayyubid madrasas (see below).

Two exceptional scholars immortalized the name of Banu Shaddād: Bahā' al-Dīn Yūsuf Ibn Shaddād (539/1145–632/1235), judge of Aleppo and historian of Ṣalāḥ al-Dīn; and 'Izz al-Dīn Muḥammad Ibn Shaddād (613/1217–684/1285), historian and topographer of Syria and the Jazīra. Although the family was Sunni, their earliest documented act of patronage was a contribution to the mashhad al-Ḥusayn, whose construction was largely subsidized by the Shi'i community.[77] Their two other acts of patronage, the Shafi'i madrasa al-Ṣāḥibiyya (601/1204–5) and the dār al-ḥadīth (618/1221) of Ibn Shaddād— both founded by Bahā' al-Dīn Yūsuf Ibn Shaddād—are quite consistent with the family's sectarian affiliation.[78] The madrasa has totally disappeared, but the dar al-ḥadīth was still partly preserved during Herzfeld's survey, which provides a plan and the foundation inscription:[79]

(1) بسم الله الرحمن الرحيم هذه دار حديث أنشأها لقراءة الحديث وإقرائه وحفظه وسماعه (2) وإسماعه وتلقين القرآن العظيم وإقامة الصلوات الخمس في الجمعة على ما شرط في كتاب الوقف (3) في أيّام السلطان الملك العزيز وأخيه الملك الصالح وأتابكهما الملك الرحيم الزاهد العابد (4) طغرل ابن عبد الله عتيق والدهما السلطان الملك الظاهر غازي بن يوسف تغمّده الله (5) برحمته وكذلك يفعل بوالده الملك الناصر متوليّ دولتهم يوسف بن رافع بن تميم بن فضائل(6) في مدّة وقع آخرها في شهر ربيع الآخر سنة ثمان عشر وستمائة تتقبّل الله منهما نعمته ورضي عنهما

Bismillāh . . . This is a school for ḥadīth that was founded for reading the ḥadīth and for its teaching, its memorization, its hearing, and its recitation; and for

76. Ibn al-'Adīm, Zubdat, 1:xxi.

77. Ibn Shaddād, A'lāq, 1:51; the author attributes this act of patronage to his own grandfather Ibrahim b. Khalīfa. See also Chapter 6.

78. Ibid., 102 and 122. The madrasa has totally disappeared, but the dār al-ḥadīth was still partly

preserved until Herzfeld's time. His survey (MCIA-Alep, 2:283–86) shows a simple tripartite prayer hall and mentions an inscription in the name of the founder (Répertoire, no. 3870).

79. MCIA-Alep, 2:283–84; and Répertoire, no. 3870.

teaching the great Qur'ān, and for performing the five prayers on Friday, in accordance with what is stipulated in the act of *waqf,* during the reign of the sultan al-Malik al-ʿAzīz and his brother al-Malik al-Ṣāliḥ and their *atābek* al-Malik al-Raḥīm, the ascetic, the pious Ṭoghril son of ʿAbdullah, the manumitted slave of their father the sultan al-Malik al-Ẓāhir Ghāzī son of Yūsuf—may God encompass them with His grace, and may He do the same with regard to his father al-Malik al-Nāṣir—the prefect of their kingdom Yūsuf, son of Rāfiʿ, son of Tamīm, from the surplus of his fortune, during a period that ended in the month Rabīʿ II of the year 618 [June 1221], may God accept from him [this work] and be pleased with him.

No building acts are attributed to the historian ʿIzz al-Dīn Ibn Shaddād, possibly because, fearing the Mongol invasion, he was forced to flee Aleppo for Cairo in 1259.

There is considerable variation in the buildings commissioned by the patrician class of Aleppo, from a simple *dār al-ḥadīth* to one of the largest *madrasas* of the period. This perhaps reflects the relative wealth of the various families in this class as well as their commitment to the building of pious foundations. In general, their architectural patronage ranks next in importance to that of the sultans, ahead of the patronage of the viziers and *atābeks.* This unexpected ranking probably reflects the fact that the high-ranking officials were often slaves (sometimes even eunuchs) of foreign origin, whose wealth was both short-lived and restricted to their own persons. Patrician households, on the other hand, were large clans that represented several generations of accumulation. Their architectural patronage was often a collaborative and extended process, as clearly seen in the *madrasas* al-Sharafiyya and al-ʿAdīmiyya and even the *mashhad* al-Ḥusayn, which took more than fifteen years to complete.

The Patronage of Women of the Court

Two anecdotes from contemporary observers underline the power enjoyed by women of the court and the high regard in which they were held. The first is Ibn Jubayr's vividly detailed, awestruck account of his encounter with three royal women during his pilgrimage to Mecca in 1184. These three women, or *khātūns* as he called them, were Saljūqah, the daughter of ʿIzz al-Dīn Masʿūd, lord of Konya; the wife of Quṭb al-Dīn Mawdūd, the previous ruler of Mosul; and the daughter of Tukush Shah, the prince of Isfahan.

> Among the strange affairs that are discussed and listened to by men we witnessed the following. One of the aforementioned khātūns, the daughter of prince Masʿūd, . . . came to the Mosque of the Apostle of God—may God bless and preserve him—on the evening of Thursday, the sixth of Muḥarram, the fourth day of our arrival at Medina, riding in her litter (*qubbah*), surrounded by the litters of her ladies and handmaidens and led by Qurʾan-readers, while pages and eunuch-slaves, bearing iron rods, moved around her driving the people from her path until

she arrived at the venerated Mosque. Wrapped in an ample cloak, she descended and advanced to salute the Prophet—may God bless and preserve him—her servants going before her and the officials of the Mosque raising their voices in prayer for her and extolling her fame. She came to the small *rawḍah* between the venerated tomb and the pulpit, and prayed there wrapped in her cloak while the people who thronged around her were kept back by the rods. She then prayed in the *hauḍ* beside the minbar, and moving thence to the west wall of the venerated rawdah, sat in the place where it is said that the Angel Gabriel—peace be upon him—came down. The curtain was then lowered on her, and her pages, slaves, and chamberlains remained behind the curtain receiving her commands. She had brought with her to the mosque two loads of provisions as alms for the poor, and stayed in her place until night had fallen.[80]

The second account, from Ibn Wāṣil, describes a journey from Cairo to Aleppo taken by al-Malik al-Kāmil with two of his daughters.

In the year 629/1232 the sultan al-Malik al-Kāmil left Egypt in order to claim Amida [Diyarbakr] from its owner, accompanied by the elevated veil Fāṭima Khātūn, wife of al-Malik al-ʿAzīz of Aleppo; Ghāziya Khātūn, wife of al-Malik al-Muẓaffar of Hama; and also the judge Bahāʾ al-Dīn Ibn Shaddād. The companion Ghāziya Khātūn, mother of our lord the sultan al-Malik al-Manṣūr—may God bless his soul—arrived in Hama in great spectacle and ceremony. She embellished Hama by her arrival.

Meanwhile, Fāṭima Khātūn, accompanied by the judge Bahāʾ al-Dīn Ibn Shaddād and other dignitaries, continued toward Aleppo. On her way there, her caravan was ceremoniously received at several prearranged spots: the first in Hama; the second in Tell al-Sulṭān, where she was recieved by Ḍayfa Khātūn; and the third just outside of Aleppo, where al-Malik al-ʿAzīz Muhammad, sultan of Aleppo, came out to meet her. They rode back to the citadel of Aleppo together, with row upon row of soldiers flanking them.[81]

The anecdote attests to the wealth of medieval Islamic court women, their independence, penchant for ceremony, and proclivity toward charitable acts. Whether in public processions or in private moments of worship, these Zangid and Ayyubid princesses commanded a status rarely accorded to court women before them. While this does not indicate anything of their political power or legal status as independent agents, it does indicate that they enjoyed a "public" profile and notable presence. Although their person was hidden from view by veils, cloaks, and curtains, their actions were highly visible.

There are perhaps four factors that might have contributed to this situation and that might explain its exceptional nature within the medieval Islamic world. The first is that these were princesses, not concubines; that is, they were free women of noble origin, not just slaves in a harem. Two, although free status was no guarantee for social promotion,

80. Ibn Jubayr (Eng.), 207–8. For other accounts of the same women, see ibid., 189–90, 239, and 246.

81. Ibn Wāsil, *Mufarrij*, 5:29–30. See also ibid., 3:124.

Ayybuid princesses also enhanced their prestige by means of political marriages. This age-old institution was especially valued under the Ayyubids, who ruled over a large family confederacy consisting of quasi-autonomous provinces. Marriages within this family were often arranged in order to initiate, foster, or seal alliances among different members of the royal household. It follows, then, that court women, through marriage to their male counterparts, mediated the inevitable tension and fostered a sense of unity among members of the Ayyubid household.

Three, marriage to a prince or sovereign greatly elevated the status of a princess, who, without becoming a queen, was directly linked to a very powerful person. The fourth factor, the ultimate seal of status, was giving birth to a male child, a future prince or even ruler. Procreation was obviously central to the survival of the dynasty, but it also guaranteed the continued well-being and prestige of the princess, whose status was now that of *walidat sultan* or queen mother. This was such an important status that it was adopted by Dayfa Khatun and other princesses as an epithet designating status as well as protection.

As mothers and wives of sultans, court women enjoyed the respect of court officials and the protection of the guards; as pious and charitable women, they received the adulation of the lower classes. Indeed, it was through their charity and building acts—in Mecca, Medina, and their own cities—that these women are often remembered in the sources.

The architectural patronage of women in the Ayyubid period is unmatched in any other period of Syrian history. Although only a small number of these monuments has survived, the sources mention numerous religious, educational, charitable, and funerary monuments built by women in Aleppo and Damascus.[82] The extent of this kind of architectural patronage, the textual confirmation of some patrons' names, and the nature of their buildings make this an excellent case study of a little-known aspect of Islamic art.[83] The restricted time frame of this phenomenon (largely twelfth and thirteenth centuries) also raises questions about the circumstances and motivations that may have contributed to it.

In Syria, the rise of women as patrons of architecture coincides with the establishment of foreign rulers in its various cities, first Turkish and then Kurdish. One of the first architectural commissions by a woman in Syria was the *khanqah* al-Ṭawūsiyya in Damascus, built by the Seljuq princess Ṣafwat al-Mulk between 1104 and 1110. In addition to being a *khanqah*, this building served as a mausoleum for the princess's son Duqāq, who was buried there in 497/1104, as was she in 513/1116.[84] It seems, therefore, that in addition to founding a pious institution, Ṣafwat al-Mulk was also creating a mausoleum for herself and members of her family. We shall see that this combination of pious foundation—most commonly a *khanqah* or a *madrasa*—and family mausoleum finds particular favor among the women patrons of the Zangid and Ayyubid periods.

82. For Damascus, see the recent excellent contribution by R. Stephen Humphreys, "Women as Patrons of Architecture in Ayyubid Damascus," *Muqarnas* 11 (1994): 35–54.

83. A recent collaborative effort has already gone a long way toward rectifying our ignorance of this subject. See Esin Atil, ed., *Patronage of Women in Islamic Art*, in *Asian Art* 6, no. 1 (Spring 1993).

84. Herzfeld, "Damascus-II," 50–51; and Jean Sauvaget et al., *Les monuments ayyoubides de Damas*, 4 vols. (Paris, 1938–50), 1, no. 1:1–13.

Ṣafwat al-Mulk's example seems to have been followed by the great princess Sitt al-Shām (widow of Ṣalāḥ al-Dīn), whose *madrasa* al-Shāmiyya of c. 1185 in Damascus was perhaps the most famous of these family mausoleums. It consists of a mosque facing a rectangular courtyard and adjoining a large cross-vaulted mausoleum containing three cenotaphs. The middle one belongs to Nāṣir al-Din, Sitt al-Shām's second husband, who died in 581/1185. The northern cenotaph is that of her brother Tūrānshāh, the ruler of Yemen, who had died in Alexandria in 576/1180 and was transported to the *madrasa* al-Shāmiyya in 582/1186. The southern cenotaph stands over the remains of Ḥusām al-Dīn b. 'Umar b. Lājīn, d. 587/1191. The tomb of Sitt al-Shām herself is not known, although she may have been buried in an unmarked grave next to her husband.[85]

The third funerary structure in Damascus to be built by a woman of the court was the so-called *madrasa* al-Mu'aẓẓamiyya at Ṣāliḥiyya. The name of the building attributes it to the sultan al-Malik al-Mu'aẓẓam 'Isā, but Herzfeld has suggested that 'Isā's mother "was the actual foundress of the *turba*, which became a family mausoleum." In addition to her and her son's tombs, the building contained "the tombs of many of her brothers and relatives" (49–50).

Other significant buildings by women of the Damascene Ayyubid court included several *madrasas* and *khānqāhs*. The largest and most elaborate of these was the *madrasa* al-Ṣāḥibiyya (or al-Ṣāḥiba), built by Rabī'ah Khātūn (d.1245), sister of Sitt al-Shām (9–12). She was reportedly buried in her *madrasa*, but her burial spot is not marked by a domed mausoleum, an extremely rare occurrence in this period. The other two *madrasas*, both consisting of mosques with attached mausoleums, are al-Māridāniyya, built by Ikhshawīra Khātūn, wife of al-Malik al-Mu'aẓẓam (19–20); and al-Murshidiyya, built by his daughter Khadīja Khātūn in 650/1252 (64–65).

In Ayyubid Aleppo, where free-standing princely mausoleums were much rarer,[86] women's patronage seems to have found an outlet primarily in the building of *khānqāhs*. Indeed, six *khānqāhs* built by women are mentioned by Ibn Shaddād;[87] one of them, the *khānqāh* al-Farāfra, still exists. Interestingly, each of these *khānqāhs* was also intended for women ascetics, a fact that further underlines the centrality of Sufism in female piety.[88] Indeed Sufism, which did not require the same kind of knowledge and erudition as jurisprudence, was somewhat more open for women. Annemarie Schimmel, for example, has proposed that "sufism, more than stern orthodoxy, offered women a certain amount of possibilities to participate actively in the religious and social life."[89] The emphasis on a direct and personal path to the Divine, the prominence of emotional and ecstatic practices, and perhaps the possibility of celibacy may have conjoined to make Sufism especially attractive to medieval Muslim women.

85. Herzfeld, "Damascus-III," 38–42. Subsequent page references in text are to this work.

86. Ibid., 65–66. Herzfeld documented twenty Ayyubid *turbas* in Damascus, suggesting that the original number may have been twice that or more, but only one in Aleppo. No explanation has been presented for this great disparity in the expression of piety.

87. A'lāq, 1:95–96.

88. See a full discussion of this phenomenon in Annemarie Schimmel, *Mystical Dimensions of Islam* (Chapel Hill: University of North Carolina Press, 1975), 426–35.

89. *Mufarrij*, 3:213–14.

By far the most important woman patron in the Ayyubid period was Ḍayfa Khātūn, the regent queen between 1236 and 1243. Her arrival in 609/1212 in Aleppo, where she was sent by her father al-Malik al-ʿĀdil to marry her cousin al-Ẓāhir Ghāzī, is described by Ibn Wasil:[90]

> The *khātūn* arrived in Aleppo in great ceremony. She was received by al-Malik al-Ẓāhir along with the *amīrs* of Aleppo, its turbaned [i.e., scholars], and its notables. Her entry into the citadel was a famous day. She had with her of textiles, furnishings, and diverse jewellery what required fifty mules, 100 Bactrian camels, and 300 dromedaries to carry. . . . It also mentioned that she had in her retinue 100 slave girls, all singers who play different instruments; and another 100 slave girls who could make various wonderful crafts. . . . When she entered the court of al-Mailk al-Ẓāhir, he got up and took several steps towards her and showed her great respect.

Two important buildings are directly attributed to her patronage: the *khānqāh* al-Farāfra of 635/1238 near the citadel and the *madrasa* al-Firdaws of 633/1236 in the *maqāmāt*. The latter, although generally known as a *madrasa*, was referred to by Ibn Shaddād as "a mausoleum, a *madrasa*, and a *ribāṭ*, in which she endowed a large number of Qurʾān-readers, jurists, and Sufis." It will be shown below that its mausoleum and especially its *khānqāh* aspect were more important than its role as a *madrasa* (see Chapter 8).

What conclusions can be drawn from this survey of the patronage of Ayyubid court women? First, it seems that most buildings founded by women were built outside the city wall. This is certainly the case in Damascus and to a lesser degree in Aleppo. Second, the architectural patronage of women in Damascus surpassed that in Aleppo during the twelfth century, although the rise of Ḍayfa Khātūn and the foundation of the *madrasa* al-Firdaws in the first half of the thirteenth century seems to have reversed this situation. Third, in Damascus female patrons apparently took the lead in creating a new type of mausoleum, which I call the family mausoleum. The court women of Aleppo, on the other hand, seem to have been most concerned with founding *khānqāh*s.

Even without Ḍayfa Khātūn, the patronage of Ayyubid court women was demonstrably significant in quantity and quality. To what factors should we attribute this interesting and unusual phenomenon? In addition to the generally favorable conditions for architectural patronage, two gender-specific motivations seem to have led court women to be especially active in architectural patronage. The first was that, as Muslim women, they were prevented by the *sharīʿah* from passing their estate to their brothers and sisters. This condition may have impelled some of them to use up a portion of their assets in pious foundations that were implicitly intended to provide a fitting burial for their siblings and enhance the prestige of their natal families. The second—and this feature is better documented in Fatimid Cairo than anywhere else—was that women tended to conduct

90. *Mystical Dimensions of Islam*, 432.

much of their religious or quasi-religious activity at cemeteries. In Fatimid Cairo, this association seems to have determined the shape of their architectural patronage, which was primarily restricted to mausoleums of various male and female 'Alid saints.[91] A somewhat similar situation occurs in Ayyubid Damascus and Aleppo, where much of women's architectural patronage was also focused on funerary monuments that were often combined with *madrasas* and *khānqāhs*. Indeed, there are reasons to believe that the educational or mystical aspects of some of these institutions were secondary to their funerary and commemorative significance and that they were given the title of *madrasa* or *khānqāh* mainly to justify their *waqf* endowment.

This section has presented the diversity of architectural patronage in Ayyubid Aleppo by examining it at different levels of society: sultans, court officials, patricians, and women of the court. The system seems to have operated as follows: sultans were responsible for the infrastructure, the fortifications, and some pious foundations; officials sometimes completed unfinished royal works and also built their own pious foundations; patricians built pious foundations (especially *madrasas*) and family mausoleums; women of the court also built pious foundations (especially *khānqāhs*) and family mausoleums. All these classes, plus some lower-ranking members of society, built *masjids*, whose excessive number in Aleppo—more than seven hundred—renders them insignificant in architectural terms.[92] Leaving aside fortifications and waterworks at the upper end of the scale and *masjids* at the lower end, sultans provided just under half the total number of significant acts of architectural patronage; the remaining portion was provided by the other three sectors. The situation was similar in Damascus, although in both cities it was the Ayyubid court that created a favorable atmosphere for building, or as Humphreys has put it, "primed the pump."[93]

What seems certain is that the mania for building was ultimately related to the combined effects of the *iqṭāʿ* and *waqf* systems. The institutionalization of the *iqṭāʿ* in twelfth-century Syria must have put large sums of disposable income in the hands of the ruling and upper classes. But since some *iqṭāʿ* was not hereditary and since no fortune was ever immune from *muṣādara* (confiscation), a portion of this accumulated wealth was converted into charitable *waqfs*, which were inalienable by definition. In other words, officials, patricians, court women, and even sultans traded wealth for status, hoping in the process to gain in perpetuity what was sure to be lost through inheritance. In the process they laid the foundations for one of the most brilliant phases of medieval Islamic architecture.

91. For the early Fatimid period, see Jonathan Bloom, "The Mosque of Qarafa in Cairo," *Muqarnas* 4 (1986): 7–20. For the late Fatimid period, see Williams, "The Cult of 'Alid Saints, II," 39–60, passim.

92. Ibn Shaddād, *Aʿlāq*, 1:59–93. The astonishing number of *masjids* provided by Ibn Shaddād has no ready explanation. Most of these were small "chapel"

mosques in which people of a particular neighborhood, market, or institution could perform the daily prayers. The diminutive size of these *masjids* is perhaps suggested by the fact that ten of them are listed just for the citadel (ibid., 92–93).

93. Humphreys, "Politics and Architectural Patronage in Ayyubid Damascus," 172.

PART II

CONSTRUCTIONS
OF
POWER

3

Citadel, City, and Ceremonial

The citadel of Aleppo dominates the surrounding city in a way unequaled by any other medieval Islamic citadel. Although considerably smaller than the Cairo citadel and lacking the massive towers of the Damascus citadel, it easily outshines both through its sheer height, its unified exterior, and the impressive effect of its entry block. Built over a partly natural outcrop with numerous building levels, it soars above the city like a great cone with a chamfered top (Figs. 9–11). Its massive elliptical base, measuring 450 meters on its east-west axis and 325 meters on its north-south axis, tapers steeply to a smaller but still quite imposing ramparted ellipse, 285 by 160 meters. Rising to a height of nearly 50 meters with its ramparts intact, it would have seemed immeasurably more dominant when the entire glacis was still paved with enormous blocks of shiny limestone, portions of which are still preserved to the left of the entrance. Early thirteenth-century onlookers would have seen it with its glacis and towers intact, its moat full of water, and an enormous entry block separating it from the city.

The powerful image of the citadel proved irresistible for prose writers and poets alike. Their laudatory descriptions offer a contemporary appreciation of this unique monument.

Ibn Jubayr, for instance, offers a vivid evocation, although his visit in 1185 predated the major Ayyubid rebuilding.[1]

> Its fortress is renowned for its impregnability and, seen from a great distance because of its great height, it is without like or match among castles. Because of its great strength, an assailant who wills it or feels he can seize it must turn aside. It is a massy pile, like a round table rising from the ground, with sides of hewn stone and erected with true and symmetrical proportions. Glory to Him who planned its design and arrangement, and conceived its shape and outline. The town[2] is as old as eternity, yet new although it has never ceased to be. Its days and years have been long, and the leaders and the commoners have said their last farewell.

Poetic descriptions of the citadel, which begin under the Ḥamdānids and reach their zenith in the Ayyubid period, employ much the same imagery. In a panegyric presented to Sayf al-Dawla the Ḥamdānid, al-Khālidiyyān describes:[3]

> A citadel whose base was embraced by Pleiades
> while its peaks surpassed the zone of Gemini
> Its watchtower would be counted among the celestial bodies
> were it only to move in their courses
> On top of a soaring and rugged peak which has filled
> her with grandeur while it is from her filled with vanity

In an Ayyubid panegyric for al-Ẓāhir Ghāzī, the poet Ibn Abu'l-Manṣūr writes:[4]

> With spacious expanses and lofty peaks
> it has fatigued the viewer from seeing its summit
> Its extreme height and loftiness would almost
> stop the orbiting and encircling stars
> Arrogant, it laughs in the face of Time,
> who has long ridiculed such lofty buildings

These and other passages of prose and poetry praising the Aleppo citadel are striking for a number of reasons. The first is their quantity: the citadel receives by far the lion's share of poetic description, matched in this respect only by the city of Aleppo as a whole. The second is their high quality, at least for the period under consideration, which is not especially noteworthy for excellence in poetry. All this suggests that poets found in the

1. *Ibn Jubayr* (Eng.), 260.
2. It is not clear whether this part of the description refers to the town or the citadel.
3. Cited in Ibn Shaddād, *Ḥalab,* 170; my translation. Al-Khālidiyyān were the two brothers—Abū ʿUthmān Saʿīd and Abū Bakr Muḥammad—who were poets in the entourage of Sayf al-Dawla. It is usually impossible to distinguish the work of one from the other. See Charles Pellat, "Al-Khālidiyyān," *EI²*, 4:936–47.
4. Ibn Shaddād, *Aʿlāq,* 1:170–71.

Aleppo citadel an inspiring subject and that the Ayyubid court actively promoted this poetic mixture of *ekphrasis* and panegyric.

The third significant feature of this poetic output is its relatively few but consistent images, which despite their predictable hyperbole are still quite powerful. The citadel is invariably described as dominant, lofty (reaching the stars), well built and designed, impregnable (except by the one being panegyrized), and resistant even to the ravages of time. Some of these images are traditional, harking back to the descriptive poetry of the Abbasid period; others are original and seem to reflect the increased militarism of the period of the counter-Crusades.[5] In either case, however, the imagery is entirely appropriate for a citadel that was the ultimate mechanism of control in times of peace and the final defense when the city (and dynasty) were under attack.

Interestingly, the same penchant for exaggerating the height of the citadel and the strength of its defenses also informs the few surviving works of art that depict it: a sixteenth-century painting by the Ottoman court artist and author al-Matraqçı (Fig. 9); an eighteenth-century engraving by Drummond (Fig. 10); and an eighteenth-century wall painting at the 'Azm palace in Hama.[6] All three representations portray a towering and impregnable structure that dominates and dwarfs the city beneath it.

Appealing as it might be, this highly charged poetic and artistic imagery of power is problematic in two respects. First, the citadel of Aleppo was not simply a military garrison but the center of government and administration. As such, it needed to interact with the city and the population on a number of levels. How was this crucial interaction between citadel and city accomplished, and what physical structures were employed to facilitate it? The second problem has to do with the palace within the citadel, which like all buildings of its type projected an image of luxury and opulence, not militarism and brute force.[7] The poets are no help in resolving this apparent conflict; as much as they extol the powerful qualities of the citadel's exterior, they laud its interior as luxurious, opulent, serene. An image of power and dominance therefore envelops and protects an atmosphere of royalty and elegance.

These visually arresting contrasts between impregnability and linkage, militarism and luxury may be taken at face value as an accurate reflection of the distant and strained relationship between ruler and ruled in the Islamic Middle Ages. Foreign dynasties, in this case Kurdish, rule an Arab population; their illegitimate status and distance from the population pervade the semiotics of the very architecture of power that they create. While this crude linkage between architecture and society is generally valid, I question here and nuance this seemingly stark separation between the enclosed and the displayed, between citadel and city, and consequently between ruler and ruled.

The work of urban historians and geographers can help resolve this paradox. Lapidus, for example, maintains that despite the overall reclusiveness of medieval Islamic dynas-

5. For a discussion of the sources of Ayyubid poetry, see, most recently, Hayb, *Al-Ḥarakah al-shi'riyyah*, 167–72.

6. Illustrated in Sauvaget, *Alep*, pl. xlvii.

7. Some of these questions have been previously discussed in my "Circles of Power: Palace, Citadel, and City in Ayyubid Aleppo," in *Pre-Modern Islamic Palaces*, ed. Gulru Necipoğlu, in *Ars Orientalis* 23 (1993): 181–200.

ties, they were actively involved in the welfare and control of their subjects.[8] They ruled their highly diverse populations not solely through the anonymous application of force but by effecting a delicate balance between power and piety, aloofness and involvement, dominion and justice. According to Lapidus, "regime and society did not confront each other, reacting only on the interface between them; rather they permeated each other, the stronger pressing its way through the structure of the latter" (78). Elsewhere, he elaborates on this symbiotic process by proposing that "the established order of Mamluk cities was based on a condominium of two elites," such that "the local notables ['ulamā' and tujjār] were guardians of the values of Islamic society and were entrusted with the intricacies of local affairs, while the tasks of defense and control of the urban economy were vested with the Mamluks" (142). The work of urban historians in Aleppo may be supplemented by the efforts of urban geographers, especially Sauvaget and, more recently, Gaube and Wirth. In addition to their greater reliance on graphic means for illustrating and summarizing their findings, geographers have also explained how the city of Aleppo functioned through its various military, political, economic, religious, and educational institutions. These historical and geographical studies, therefore, provide an essential context within which to interrogate the monumental architecture of the city.

The Citadel as a New Urban Form

Our first series of questions must address the transformation of the citadel in Islamic cities of the later Middle Ages from a military outpost into the center of the court and the administration. How did this come about? What institutions of the classical Islamic period did the citadel replace, and how were these new institutions housed in this new form? What were the implications of this transformation for the Islamic city, and specifically for Aleppo? None of these questions has been adequately discussed in studies of Islamic urbanism, even though the citadel was, after the Great Mosque, the most important institution and pole of attraction in medieval Islamic cities.[9]

With a few notable exceptions, the earliest forms of Islamic urbanism, the amṣār, apparently had neither a citadel nor walls.[10] From the beginning, the center of these garrison towns was dominated by the mosque of the city and the palace (Dār al-Imāra),

8. Lapidus, *Muslim Cities*, esp. chap. 3.

9. Michael Rogers, "Sāmarrā: A Study in Medieval Town Planning," in ibid., 119–56, has brilliantly discussed the consequences of the separation of caliphal palaces from the city. For a recent discussion of the three stages in Islamic urbanism, see Jere L. Bacharach, "Administrative Complexes, Palaces, Citadels: Changes in the Loci of Muslim Rule," in *The Ottoman City and Its Parts*, ed. I. A. Bierman, R. Abou-El-Haj, and D. Preziosi (New Rochelle, N.Y.: A. D. Caratzas, 1991), 111–28.

10. This was certainly the case in Baṣra, Kūfa, Fusṭāṭ,

and Qayrawān. See, for example, Saleh Ahmad El-Ali, "The Foundation of Baghdad," in *The Islamic City*, ed. A. H. Hourani and S. M. Stern (Oxford: Bruno Cassirer, 1969), 88–91. See also Nezar Alsayyad, *Cities and Caliphs: On the Genesis of Arab Muslim Urbanism* (Westport, Conn.: Greenwood, 1991), 45–76. A recent panel at the 22d annual conference of the Middle East Studies Association questioned the idealized concept of the amṣār and introduced a number of nonconforming examples, such as 'Anjar and Aqaba. But it still seems that the general rule for early Islamic foundations remains that of the Basra-Kufa model.

which were built adjacent to each other or at most separated by a narrow street. In either case, direct passage was provided from the palace to the mosque through a gate, a tunnel,[11] or, as in the case of the Great Mosque of Cordoba, an elevated vaulted passage.[12] The two institutions, the Great Mosque and the *Dār al-Imāra*, therefore, stood at the core of early Islamic cities, integrating the religious, administrative, financial, and legal functions of the early Muslim community. Whether or not these early civic centers reflected the centralized authority and egalitarian values of the first Islamic state is open to question. But at the very least they projected an image that could suggest these possibilities.

The authority of this image was in fact powerful enough to be perpetuated in the Round City of Baghdad (begun in 762), at a time when the integrating values of early Islam had already been challenged by several major schisms and rebellions, including the Abbasid revolution itself. Regardless of its far greater degree of formality and monumentality and the iconographic associations of its circular form, the core of the Round City was here also dominated by two enormous and closely related structures, the Great Mosque and the palace of Caliph al-Manṣūr.[13] The image of the caliph as the ultimate authority in secular and religious matters radiated outward from this central point to the city and the Islamic world at large. But the strain between ideal image and urban reality soon led to the decline of the Round City, as the caliph himself abandoned it for a number of nearby palaces and as vast residential quarters developed all around it.

By the time the second Abbasid capital was founded at Sāmarrā in 836, Islamic urbanism had entered a second more complicated phase, primarily characterized by the nearly total isolation of the caliph in one of several gigantic palatial enclosures. None of these palaces could be labeled *Dār al-Imāra* in the earlier sense of the word; in fact, based on their physical separation from the city and their enormous size, they could be called palatial cities. The largest of these, Jawsaq al-Khāqānī, was officially designated *Dār al-Khilāfa* and seems to have inherited some of the functions of the earlier institution. Separated from the Great Mosque of al-Mutawwakil by about two kilometers, it covered an area of 432 acres containing an official palace (200 meters square), a small mosque, a number of harems, gardens with pavilions and pools, stables, and many other utilitarian units. Thus isolated in such an enormous, inaccessible palace, the caliph gradually turned into an insular, semidivine figure whose appearances on Fridays and some feast days were occasions for much pomp and ceremony. Once vigorous and directly involved in the affairs of the community, he evolved into a legendary figure, resplendent in fabulous luxury.

The progressive withdrawal of the caliph behind the gates and gardens of his palace had major implications for the Great Mosque as well as the city itself. Alienated from the court and the administration, the congregational mosque lost much of its earlier vibrant

11. See in particular Creswell, *Early Muslim Architecture*, 1:part 1, fig. 18 for Kūfa and fig. 73 for Wāsiṭ.

12. This passage, variously referred to as *āzāj* and *sābāṭ* or even *al-Sābāṭ*, was built by the caliph ʿAbdullah (888–912) between the palace and an opening in the west side

of the mosque. See Creswell, *Early Muslim Architecture*, 2:140–41.

13. See the detailed studies by Lassner: *Baghdad*, passim; and *The Shaping of ʿAbbāsid Rule* (Princeton: Princeton University Press, 1980), esp. 184–203.

life as the hub of the Muslim community; gradually and irreversibly, it became a religious and pious institution. The *Dār al-Imāra* was now symbolically replaced by a small four-iwan structure, which could have served as little more than a vestiary and resting place for the caliph during his rare visits to the mosque (Fig. 52).[14]

But, as if to compensate for the withdrawal of political authority from mosque and city, it was precisely at this time that much caliphal ceremonial developed; in addition, new architectural forms were introduced and older ones monumentalized. Among these, two are relevant to the present discussion: the mosque tower and the ceremonial gate called *Bāb al-'Āmma*. The mosque tower at Sāmarrā, called *al-Malwiyya* because of its helicoidal form, has been conclusively shown to have served not as a *mi'dhana* but rather as a generalized symbolic form pertaining to the Abbasid dynasty.[15] It is tempting to speculate that such an obviously authoritative form might have been introduced in an attempt to compensate for the actual absence of the palace and the caliph.[16]

The removal of *Dār al-Imāra* from the center of the city to the outlying palaces deprived the community of a very important institution, the *diwān 'āmm*, or public audience, whose most important function was as a court for grievances (*mazālim*). Herzfeld has suggested that this public audience continued in the Sāmarrā period, when it was housed in the *Bāb al-'Āmma* of the Jawsaq al-Khāqānī palace.[17] This suggestion was accepted by most archaeologists and art historians[18] but rejected by Sourdel, who claimed that it was based on a faulty reading of a text by Ya'qūbī. The text in question describes *Bāb al-'Āmma* as the gate leading to the public part of the palace, called *Dār al-'Āmma*, where the caliph sat on Monday and Thursday. Based on the ambiguity of this passage, as well as other references to guests and emissaries traversing several gates and gardens before being allowed into the caliphal presence, Sourdel concluded that no gate ceremony ever took place in Sāmarrā.[19]

There is, however, no real contradiction between the official audience where dignitaries and foreign visitors paid homage to the enthroned caliph and the public audience alluded to by Ya'qūbī, where the caliph established himself at one of the most public and monumental portions of his palace in order to receive the populace.[20] The first describes the official ceremony (*dīwān khāṣṣ*) and the second the public audience (*dīwān 'āmm*), two essential and well-established components of royal ceremonial since early and pre-Islamic times. In fact, a ceremony that takes place regularly on two given days of the week

14. This small structure, uncovered some twenty years ago, is very important as a transitional palace form, and I will return to it in the following chapter.

15. Jonathan Bloom, *Minaret: Symbol of Islam*, Oxford Studies in Islamic Art, no. 7 (Oxford: Oxford University Press, 1989), 66–67 and 84–85.

16. Rogers, "Sāmarrā," 152–53: "And even the helical minarets of the Great Mosque and of the Mosque of Abū Dulaf, although not primarily secular monuments, can be included in this category, for the archaism of their form is sufficient to characterize them as the product of a controlling imagination."

17. Ernst Herzfeld, "Mitteilungen über die Arbeiten der zweiten Kampagne von Samarra," *Der Islam* 5 (1914): 196–204.

18. For example, Grabar, *Formation*, 171; and Rogers, "Sāmarrā," 147.

19. D. Sourdel, "Questions des Cérémonial 'Abbaside," *REI* 28 (1960): 126–27.

20. This view has been recently challenged by Alastair Northedge, "An Interpretation of the Palace of the Caliph at Samarra (Dar al-Khilafa or Jawsaq al-Khaqani), in Neçipoğlu, *Islamic Palaces*, 143–70. Northedge (152–53) believes that the public audience did not take place at the gate but rather in a separate building on the southern edge of the enclosure.

(usually Mondays and Thursdays) can only be a public ceremony, since important guests were probably not expected to time their visits accordingly. Finally, it is precisely these two days, Monday and Thursday, that are dedicated to the public audience during the Zangid and Ayyubid periods, as discussed below.

The third and equally pivotal stage in the transformation of Islamic cities occurred sometime in the middle of the eleventh century, when the Sāmarrā model for royal architecture was gradually supplanted by that of the citadel palace. It has not yet been determined where the model for the citadel palace originated, nor whether it is related to eastern Iranian cities which, according to ninth-century Arab geographers, consisted of *quhanidz* (fort), *shahristān* (walled city and market), and *rabaḍ* (suburb).[21] Since after the twelfth century most central Islamic cities displayed something like this three-part form, it seems plausible that they were ultimately based on the Persian model, perhaps introduced by the Great Seljuqs in the eleventh century. Furthermore, a highly defensible urban form may have been considered desirable at a time of fragmentation and external threats.

In Aleppo, the citadel played only a marginal role in the early Islamic period, a time when the rulers of the city resided in spacious palaces in the outlying suburbs. The Ḥamdānids of the tenth century, for example, seem to have preferred a Sāmarrā-like suburban palace located west of the city on the River Quweiq. In fact, it was the Mirdasids, a local Arab dynasty that controlled Aleppo and parts of the Jazīra between 1025 and 1079, who first inhabited the citadel, making it their official palace and administrative center, thereby, according to Ibn Shaddād, "creating a precedent for the kings who followed them."[22]

The Citadel: Inner Context of Power

Having established the historical and urban context of the Aleppo citadel, we turn next to its interior composition and outward image. Our objective is dual: (1) to reconstruct and analyze the constituent monuments within the citadel and (2) to discuss the iconography of these structures and the kind of imagery they projected to the surrounding city. This line of investigation is hampered by the usual silence of literary sources on questions of function and ceremonial, as well as by the highly problematic archaeology of the site.

With the exception of Herzfeld's early efforts, the entire citadel has never been systematically studied as a unit. Subsequent efforts at survey, excavation, and restoration have been sporadic, shortsighted, and at times downright destructive. It is not even possible to reconstruct the sequence of these later endeavors, much less understand their findings, since almost nothing about them has been published. The little that has appeared in print demonstrates a surprising nonchalance with respect to the archaeological process and a

21. On the organization of Iranian cities, see Richard N. Frye, *The Golden Age of Persia, Arabs in the East*

(London: Weidenfeld and Nicolson, 1988), 108.
22. Ibn Shaddād, A'lāq, 1:24 and 29.

total preoccupation with restoration and rebuilding. Dominated by the desire to present nearly complete monuments at any cost, these efforts have culminated in two major travesties: the first, in 1962, was the roofing of the Mamluk palace with highly intrusive wooden marquetry of Damascene workmanship; the second, in 1984, was the building of a large Roman-style theater in the northeastern quadrant of the citadel.[23] This last act will forever stand in the way of re-creating the organic and functional unity of the Aleppo citadel.

In terms of its chronology, the citadel is an exceedingly complex organism with several building phases: pre-Islamic, Seljuq, Zangid, Ayyubid, and Mamluk. But despite the complex chronology of the pre-Ayyubid phases,[24] they do not seem to have been very considerable architecturally. They were, in any event, subsumed within the far more important Ayyubid rebuilding. This phase began with the reign of the second Ayyubid sultan of Aleppo al-Ẓāhir Ghāzī (1186–1216), who took it upon himself to rebuild the citadel and the entire fortification of Aleppo. Contemporary sources and epigraphic evidence (in the form of five preserved inscriptions inside the citadel) confirm that Ghāzī was responsible for its total refortification, including the building of its impressive entrance block from the Gate of the Serpents to the Gate of the Two Lions in 606/1210, and for the erection and rebuilding of several structures within it, including the palace, the mosque, the arsenal, and the water cisterns.[25] This work was continued after his death by his *atābek* Ṭoghril and largely completed by his son al-'Azīz Muhammad. There is no evidence that either Ḍayfa Khātūn or the last Ayyubid sultan al-Nāṣir Ṣalāḥ al-Dīn added much to the citadel.

By means of this long process of accretion, rebuilding, and restoration, which peaked in the first three decades of the thirteenth century, the citadel gradually became a fortified and largely self-sufficient palatial city (Fig. 12). In addition to a series of palaces and baths, it also boasted a substantial mosque, a shrine dedicated to Abraham, vast water cisterns, granaries, and a variety of military installations, including the arsenal, the training grounds, numerous towers, and the massive entrance block. Thus, for all practical purposes, and with the important exception of the Mamluk palace on top of the two towers of the entrance block, the citadel of Aleppo is an Ayyubid structure.

With these problems in mind, our description of the interior of the citadel must necessarily focus on its best-preserved and best-documented components. We begin at the highest point of the citadel, where in 1214 al-Zāhir Ghāzī built a Friday mosque on a site once occupied by a small Christian martyrium associated with both Abraham and John the Baptist. The direct model for building a mosque within the citadel may have been Damascus, whose citadel received its first mosque during the reign of Nūr al-Dīn in 1160. But antecedents for both mosques can perhaps be found in the palaces of Sāmarrā and especially the Umayyad desert palaces, nearly all of which contained small mosques.[26]

23. A reasonably factual report about the processes of excavation and restoration in the citadel has recently appeared: Shawqi Sha'ath, *Qal'at Ḥalab, dalīl atharī tārīkhī* (Damascus: Ministry of Culture Publications, 1986); esp. 67–71.

24. Herzfeld, *MCIA-Alep*, 1:1–11.

25. Herzfeld, *MCIA-Alep*, 1:85–89 and 130–41.

26. For example, Khirbat al-Mafjar, Mshatta, the two Qasr al-Hayrs.

The Aleppo mosque is appropriately traditional in form, consisting of an open courtyard surrounded by vaulted porticos on three sides and a tripartite prayer hall with a central dome (Figs. 71–74); see Chapter 5 for a fuller description).

The long tradition notwithstanding, there is something triumphant about the location of this particular mosque and especially its lofty minaret. Situated some 50 meters above the city at the highest point of the citadel, with its minaret soaring an additional 21 meters, this towering structure is visible from every corner of the city (Fig. 13). Greatly impressed by its prominence, Gertrude Bell remarked in 1905 that it was "visible several hours away while no vestige of the city appears until the last mile of the road."[27]

Conversely, many parts of the city were at least implicitly visible from the minaret, which, from that lower vantage point, could be seen as a tower of observation and surveillance. Although this function of the minaret is rarely alluded to in contemporary sources or even recent literature, there is at least one other example of a similarly situated minaret that may have served a related function. This is the minaret of the Juyushi mosque of 478/1085, built by Badr al-Jamāli on the Muqattam Mountain in Cairo. In an excellent article, Farīd Shāfi'ī demonstrates that this minaret functioned primarily as a beacon for sending light signals to the city and also as a tower of observation from which "any suspicious gathering of people in any part of the city . . . could be detected . . . and reported immediately to headquarters for action."[28] The minaret of the mosque of al-Ẓāhir very likely fulfilled a similar function as a surveillance tower. That would explain its location at the highest point in the citadel, its great height, and the existence of eight windows in its shaft, in addition to the domed *shurfa* above, facing in the four cardinal directions.

The minaret is also interesting because of its somewhat archaizing square shape. Although minarets with square shafts tend to be identified with Syria and were used in some northern Ayyubid provinces well into the thirteenth century,[29] it is important to note that octagonal and even circular minarets were preferred in later Ayyubid architecture.[30] Indeed, after about 1200 the square-shafted minaret was mainly used in the provinces and in some of the lesser buildings in Aleppo but was no longer the most current form within the capital.

Two related explanations may be proposed for the retardataire appearance of this

27. *The Desert and the Sown* (Boston: Beacon, 1985), 260.

28. Farīd Shāfi'ī, "The Mashhad al-Juyūshī (Archaeological Notes and Studies)," in *Studies in Islamic Art and Architecture in Honour of Professor K. A. C. Creswell* (Cairo: American University in Cairo Press, 1965), 251 and 246–52 passim. Shāfi'ī's view has been partly refuted by Jonathan Bloom, *Minaret*, 140–42, who seems to prefer a pious interpretation of the mosque itself and a symbolic interpretation of the minaret. Bloom's refutation rests mainly on the designation of the building as a *mashhad* and the choice of Qur'ānic inscriptions within it, but he largely ignores its highly unusual form and placement. For these reasons, I find Shāfi'ī's interpreta-

tion far more convincing.

29. Of these, the best known are the square tower at the Great Mosque of Diyarbakr (after 1160) and the five-storied minaret at the Mayyāfāriqīn mosque *extramuros*, begun by Najm al-Dīn Ayyūb (596–607/1199–1210) and completed by his successor Muẓaffar al-Dīn in 609/1212. See Bloom, *Minaret*, 166–67 n. 32.

30. See Robert Hillenbrand, "Eastern Islamic Influences in Syria: Raqqa and Qal'at Ja'bar in the Later 12th Century," in *The Art of Syria and the Jazīra, 1100–1250*, ed. Julian Raby (Oxford: Oxford University Press, 1985), esp. 26–30, for a short discussion of the Ayyubid minaret. Cf. my conclusions in Chapter 7.

minaret in the citadel. The first is that, in view of the great visibility of the minaret to
natives and visitors alike, the traditional square shape was preferred because of its close
identification with northern Syria. It is also possible that this minaret was modeled after
the late eleventh-century minaret of the Great Mosque, whose basic shape and horizontal
divisions it echoes in a simplified manner. A reference to the most venerable monument
of the city might enhance the prestige of the citadel and its patrons while reaffirming the
role of Ayyubids as guardians of the faith.[31]

Nearly midway between the mosque and the palace stood the small but highly signifi-
cant *maqām* Ibrāhīm (Fig. 14). First built by Nūr al-Dīn, this shrine underwent restora-
tions and additions during the reigns of Ghāzī and his son Muhammad. As the patron
saint of Aleppo and the traditionalist figure par excellence, Abraham was venerated by
the Zangids and the Ayyubids as a way to enhance their authority and legitimacy by
deepening their roots in Aleppo and reinforcing their image as the safeguards of Sunni
Islam. This structure also served as a memorial link with the more important shrine for
Abraham south of the city, which, as discussed below, was equally revered by the Seljuqs,
the Zangids, and the Ayyubids (see Chapter 6).

The Outer Context: Creation of a Royal Precinct

One of the most serious ramifications of containing the palace within the citadel must
have been the difficulty of providing it with the necessary links to the city. While
important foreign visitors and local dignitaries would probably have been received inside
the citadel, it is unlikely that the general population was allowed to enter. What provi-
sions, therefore, were made for the centrally important institution of the public audience,
or *majlis ʿāmm*? Where was this institution located, and how was it linked with the
citadel? The answers to these questions lie outside the citadel, in the region generally
known as *taḥt al-qlaʿah*.

Nūr al-Dīn had already shown a great deal of interest in this region, which under him
became especially noted for its *khānqāhs* and other pious institutions.[32] Although the term
taḥt al-qlaʿah is used generically to describe the entire region surrounding the citadel, it
seems clear from the location of the Zangid monuments that the area most affected by the
patronage of Nūr al-Dīn and his associates was west of the citadel in the direction of the
Great Mosque.[33] Al-Ẓāhir Ghāzī, on the other hand, concentrated his efforts on that
portion directly south of the citadel and just east of its entrance block. Within a span of

31. Such visual puns are not so unusual as they may
seem. Archibald Walls, "Two Minarets Flanking the
Church of the Holy Sepulchre," *Levant* 8 (1976): 159–
61, documents a related case in Jerusalem.

32. See Elisséeff, *Nūr ad-Dīn*, 3:766–68.

33. The one remaining monument in this region

from the time of Nūr al-Dīn is the *madrasa* al-Shād-
bakhtiyya, today called Jāmi ʿal-Shaykh Maʿrūf, which
was built by his manumitted slave Shādbakht. The
bazaar in which it is located at present was built in the
late nineteenth century, and the building may have
originally been free-standing.

about fifteen years, this region, which had previously been an amorphous *maydān* bordering the citadel and the eastern city wall, was systematically converted into a zone of official exchange between the Ayyubids and the city.

Two major institutions contributed to the official image of this region, which is located directly opposite the palace. These were the *dār al-ʿadl* (court of grievances or tribunal) and the funerary *madrasa* of al-Ẓāhir (al-Sulṭāniyya). Al-Ẓāhir Ghāzī began the *dār al-ʿadl* in 585/1190; it was completed shortly afterward. He also founded the *madrasa* al-Sulṭāniyya but died in 1216 before its completion.[34] It remained unfinished for six years, until his *atābek* Ṭoghril completed it in 620/1223. Ghāzī's mausoleum, which was ready to receive him shortly after his death, stands at the southeastern corner of the building (Fig. 19).

The location of the *dār al-ʿadl* in Aleppo has occasioned some controversy. Several writers have placed it southwest of the citadel underneath the National Hospital of c. 1885.[35] Here I will argue that it was originally located *east* of the entrance block, underneath the late nineteenth-century *serail,* or municipality. Both textual and archeological evidence are adduced to confirm this hypothesis.

Ibn Shaddād writes: "He [al-Ẓāhir Ghāzī] built a wall east of the city near *dār al-ʿadl* and opened in it a southern gate and another gate on the northeast at the edge of the moat, called Bāb al-Ṣaghīr." More specifically, he adds: "He built *dār al-ʿadl* for his general audience between the two walls: the new one which he rebuilt to the side of the *maydān* and the old wall which has in it Bāb al-Ṣaghīr. Building commenced in the year 585."[36] A third reference further confirms the location of the *dār al-ʿadl* and its intimate link with the Ayyubid palace. In discussing Ghāzī's many building acts in the citadel, Ibn Shaddād writes: "He cut in the wall of the citadel a gate which is called Bāb al-Jabal, east of the citadel's [main] gate, and he made for it a vaulted vestibule (*durgāh*) which is only opened for him when he descends to *dār al-ʿadl.* This gate and all the preceding were finished in the year 611" (25).

The *dār al-ʿadl* was therefore built due south of the citadel (Fig. 15). Surrounded by walls on three sides, with its northern side facing the moat of the citadel, it was accessed by means of three gates: Bāb al-Jabal, the secret gate connecting it with the citadel, and two others mentioned by Ibn Shaddād: Bāb Dār al-ʿAdl facing south, for the procession of

34. This would make it the only extant two-*madhhab madrasa* in Aleppo, a type that was in any case quite rare in Syria. Ḥanafīs and Shāfiʿīs were by far the two most important Sunni sects in Aleppo, a fact that is clearly reflected in the large number of *madrasas* (22 for Ḥanafīs and 21 for Shāfiʿīs) that were built for them during the Ayyubid period and the negligible number dedicated to the other two sects. See the statistical tables in K. A. C. Creswell, "The Origin of the Cruciform Plan of Cairene Madrasas," *BIFAO* 21 (1922): 1–54; updated in idem, *Muslim Architecture of Egypt,* 2:122–23. See also J. Lauffray, "Une madrasa Ayyoubide de la Syrie du Nord. La Soultaniya d'Alep," *Les Annales archéologiques arabes Syriennes* 3 (1953): 49–66.

35. Ghazzi, *Nahr al-Dhahab,* 2. In *Alep,* pl. LVIII, Sauvaget clearly placed the "palais de justice" west of the entrance block. This is curious because in an earlier and little-known publication entitled "L'enceinte primitif de la ville d'Alep," *Mélanges de l'Institut Français de Damas* 1 (1929): 148–49, Sauvaget quite accurately places the *dār al-ʿadl* east of the entrance block, within the gates created for it by al-Ẓāhir Ghāzī. Dominique Sourdel, "Esquisse topographique d'Alep intra-muros a l'époque Ayyoubide," *AAS* 2 (1952): fig. 2, repeats Sauvaget's later error by placing the *dār al-ʿadl* to the west of the entrance block.

36. Ibn Shaddād, *Aʿlāq,* 1:17 and 21.

al-Ẓāhir Ghāzī, and the two gates called Bāb al-Ṣaghīr to the northeast on the edge of the
moat, one in the old wall and one in the new. We know nothing about its form except
that it most likely contained one or more iwans for the public audience of the judges and
the sultan.

The location and function of the secret gate and tunnel linking the *dār al-ʿadl* with the
Ayyubid palace merit further investigation. The tunnel has largely disappeared, but its
location may be determined by postulating a vaulted passage leading from the palace to the
present *serai*, which was built over the *dār al-ʿadl*. The best place to look for the beginning of
this passage seems to be at the end of the vaulted corridor separating the bath from the
arsenal (Fig. 28). But this corridor actually stops short of piercing the exterior wall of
the citadel and turns 90 degrees to the right through a staircase that ascends to the level of
the lower ramparts. From the top landing of these stairs the view ahead and slightly to the
right reveals an opening at the base of the outer curtain wall (Fig. 16). Through this
opening the modern *serai* can be glimpsed directly ahead and, leading in its direction,
remains of stairs. With a little reconstruction, then, it is possible to posit that the stairs
leaving the palace area would have led to a vaulted passage that pierced the outer wall of the
citadel through the extant arched opening. This opening would have descended to the *dār
al-ʿadl* through a vaulted, though not entirely subterranean, passage. With a vault esti-
mated at two meters high and a glacis about half a meter thick, the course of the passage
would have remained visible. This is problematic, and one wonders why a deeper tunnel
was not made.

As an institution, the *dār al-ʿadl* is intimately connected with the addressing of griev-
ances (*al-naẓar fi'l-maẓālim*), perhaps one of the most central concepts in Islamic gover-
nance. In his highly important treatise, the *Siyāsatnāma*, Niẓām al-Mulk expatiated on
the concept of justice that he saw as the foundation of stately power and the primary
attribute of correct government:

> It is absolutely necessary that on two days in the week the king should sit for the
> redress of wrongs, to extract recompense from the oppressor, to give justice and to
> listen to the words of his subjects with his own ears, without any intermediary. It is
> fitting that some written petitions should be submitted if they are comparatively
> important, and he should give a ruling on each one. For when the report spreads
> throughout the kingdom that on two days in the week The Master of the World
> summons complainants and petitioners before him and listens to their words, all
> oppressors will be afraid and curb their activities, and no one will dare to practice
> injustice or extortion for fear of punishment.[37]

A decade later Ibn al-Balkhī, who wrote during the reign of the Great Seljuq Muhammad
b. Malik-Shāh, expressed a similar view: "Those possessed of learning have said: 'When a
king is adorned by religion and his rule is stable because of justice, kingship will not

37. *The Book of Government or Rules for Kings: The
Siyāsat-nāma or Siyar al-Mulk of Niẓām al-Mulk*, trans. Hubert Drake (New Haven: Yale University Press,
1960), 14.

disappear from his house unless, God forbid, some disorder appears in religion or he commits a tyranny.' "[38]

The *dār al-ʿadl* was a direct outgrowth of such formulations, which were themselves based on earlier conceptions of Islamic sovereignty. But curiously, the chroniclers of Nūr al-Dīn Maḥmūd ibn Zangi, who was the first to build this institution in Damascus, invoke much more specific circumstances to explain his action. According to Abū Shāma and others, Nūr al-Dīn created the *dār al-ʿadl* in order to deal with grievances resulting from the newly systematized *iqṭāʾ*, specifically the grievances of some farmers against the Ayyubid Shirkūh, the greatest feudal lord of the time.[39] Generalized, this instance suggests that Nūr al-Dīn conceived this institution in an attempt to undercut the authority of those feudal lords (*muqṭaʿs*) whose land-based wealth and power had become a threat to his own.

Although it is tempting to accept this rare instance of cause and effect as the sole explanation for the *dār al-ʿadl*, I think that the tradition on which it draws and what little is known about its biweekly ceremonies suggest a broader urban function. At the very least, the slightly later *dār al-ʿadl* in Cairo, which was ultimately based on the courts of Aleppo and Damascus, was primarily concerned with cases of an economic nature, such as charity, taxation, price control, and inheritance.[40] Such cases suggest that the *dār al-ʿadl*, particularly under the first Mamluks, was also intended as a mechanism for controlling the urban patricians (including the judges themselves) by pitting against them members of a lower class.[41]

Despite its physical independence and relative importance during the twelfth and thirteenth centuries, the *dār al-ʿadl* was by no means an autonomous institution subject to its own charter and body of laws. It was in every sense of the word an appendage of royal power: it received its ultimate authority neither from the city elders, as was the case in the communal courts of medieval Europe,[42] nor from the chief justice (*qāḍī al-quḍāt*) but from the physical or implied presence of the sultan, who alone embodied the state and directed its affairs in accordance with the *shariʿah*.

38. A. K. S. Lambton, "The Internal Structure of the Saljuq Empire," in *The Cambridge History of Iran*, vol. 5, *The Saljuq and Mongol Empires*, ed. J. A. Boyle (Cambridge: Cambridge University Press, 1968), 205, quoting *Fars-Nāma*, ed. G. Le Strange and R. A. Nicholson, n.s., 1 (London: Gibb Memorial Series, 1921): 34.

39. *Mufarrij al-Kurūb*, 1:110. See also Elisséeff, *Nūr ad-Dīn*, 3:843–47, which also discusses the specific allusions to justice in the titulature of Nūr al-Dīn, *al-Malik al-ʿĀdil*.

40. Maqrīzī, *Khiṭaṭ*, 3:124–25, mentions several cases that were presented to Sultan al-Ẓāhir Baybars. Only the first involves a grievance resulting from a rural *waqf*. The others concern: (1) the high price of wheat; (2) alleviation of urban poverty through various acts of charity; (3) a case of inheritance involving an orphan child; and (4) several cases involving the

distribution of the great estates of some urban notables. Interestingly, the judgment passed in some of these individual cases is then used as a precedent for wider measures of legislation.

41. In a recent paper dealing with the phenomenon of *dār al-ʿadl* and the three institutions in Damascus, Aleppo, and Cairo, Nasser Rabbat concludes that this institution was created as a rhetorical instrument, intended primarily to convey an ideal image of the ruler as *ʿādil* and *mujāhid*. This is of course contradicted by the literary sources, which invariably stress more mundane issues. But Rabbat's formulation is probably valid on the far more general level of *mentalité*, since the image of the just ruler still enjoyed tremendous resonance in this period.

42. Georges Duby, ed., *A History of Private Life*, vol. 2, *Revelations of the Medieval World* (Cambridge: Harvard University Press, 1988), 300–302.

The physical relationship between the palace and the tribunal closely parallels the political one. The palace, symbol of absolute authority, literally presides over the *dār al-ʿadl* and, more tellingly, is directly linked with it through a secret passage. Such underground passages are commonplace in Islamic citadels—most often for escape in time of danger or to reach provisions[43]—but this link between palace and tribunal is unusual and seems to have more serious implications. Overtly, this connection underlines the essential link between authority (*mulk*) and justice (*ʿadl*) and of course facilitates the sultan's movement between palace and tribunal during his routine biweekly audience. But the invisibility of this connection suggests some covert implications: the sultan could presumably observe proceedings at the *dār al-ʿadl* anytime he wished without being seen and could even interrupt them if he heard something not to his liking. The secrecy of the ruler's movements through this passage would make it more a vehicle for monitoring and observation than for a detached interest in the progress of justice.[44] This capacity for surveillance was an important mechanism of control and coercion, in this case directed at curtailing the authority and independence of the judges.

The one major component that remains of al-Ẓāhir Ghāzī's works under the citadel is his funerary *madrasa*, generally called al-Sulṭāniyya since he was the sultan of Aleppo par excellence (Fig. 17). Created according to its *waqf* for both Ḥanafīs and Shāfiʿis, the *madrasa* was not finished in Ghāzī's lifetime but was, like most of his pious works, completed by the *atābek* Ṭoghril (see Chapter 2 for the patronage of Ṭoghril). Its minaret-topped portal faces the entrance block of the citadel, while Ghāzī's mausoleum at its southeastern corner would originally have faced the *dār al-ʿadl* across the street leading to Bāb al-Maqām (Fig. 18). The mausoleum projects slightly into the urban space and has windows on three sides that are intended to encourage various acts of piety by the passing population (Fig. 19).

The location of this *madrasa* is significant for two reasons. First, the siting of Ghāzī's mausoleum and its three grilled windows confirms the existence of a street bordering it from the east. This street would originally have run parallel to the first wall, which, after the expansion by al-Ẓāhir Ghāzī, had become an internal wall enclosing the *dār al-ʿadl*. The street can be thus located because, with virtually no exception, the mausoleums of funerary *madrasas* in Syria and Egypt always have street frontage, a tradition already apparent in the first extant specimen, the *madrasa* al-Nūriyya of 1172. Second, the specific orientation of this two-sect *madrasa* in relation to the citadel seems deliberate, undoubtedly intended to affirm the traditionalist orientation of the Ayyubids and to reinforce their links with the *ʿulamāʾ*. In fact, the location of this *madrasa* may have inspired the grander but similarly situated *madrasa* complex of Sultan Hassan in Cairo.[45]

43. For example, there is at least one other secret passage in the Aleppo citadel itself, located near its northern wall. This seems to have led to a place near the ancient Bāb al-Arbaʿīn.

44. A related, though not identical, clandestine means of surveillance is reported by several chroniclers for the *madrasa* al-Mustanṣiriyya in Baghdad. There, it took the form of an elevated window (*shubbāk*) directly

overlooking one of the main iwans of the school; see Chapter 7.

45. This is not so far-fetched as might otherwise seem. Disregarding the overall larger scale of building in Cairo, there are a number of parallels between the two citadels and their vicinities. In both cases, a royal citadel faces a *maydān* containing, among other buildings, the *dār al-ʿadl* and an important *madrasa*.

Palace and Ceremonial

The literary evidence available for Fatimid and Mamluk court ceremonial is relatively rich, but precious little is written on the ceremonies of Ayyubid Aleppo.[46] With the exception of the ceremony associated with the *dār al-'adl*, the sources are nearly silent about official functions. For example, although it seems likely that the sultan led the Friday prayer and other feast prayers, no sources refer to this act or to the ceremonial associated with it. They are equally silent on another likely axis of ceremonial movement—that connecting the citadel with the important shrine of Abraham and the many Ayyubid monuments south of the city.

Although the absence of textual evidence is a serious obstacle, it need not completely derail an investigation of ceremonial, whose existence can sometimes be inferred from physical evidence. We therefore turn our attention to the road connecting the citadel with the *maqām* Ibrāhīm and to some of the monuments lining it, all of which offer tantalizing suggestions about ceremonial. The street between the *madrasa* al-Sulṭāniyya and the *dār al-'adl* once continued south and then southwest, leaving the city through Bāb al-Maqām (Fig. 15). From there it went through the Ayyubid *madrasas* quarter, ending at the shrine of Abraham.

Did this road serve a ceremonial function, perhaps as a conduit between the secular and religious domains of the Ayyubids? Here, it is fruitless to look for help from the chronicles or for a few lines of poetry describing an imperial procession. Fortunately, an important clue may be provided by Bāb al-Maqām itself, which was completed by al-'Azīz Muhammad around 1230 on the road connecting the *Maqāmāt* with the city and the citadel. It stands today, greatly altered over the ages, as a wide arch flanked by two slightly projecting towers. Remains of a smaller entrance on its right (eastern) side are still preserved, and traces of a similar opening on its left side can easily be discerned from the disjuncture between the Ayyubid masonry of the jamb and the later masonry that was used to block this opening. Furthermore, according to Herzfeld's reconstruction, the central bay was emphasized by a dome resting on the vestibule behind it (Fig. 6). Although no supports for such a dome have survived, it seems plausible from an aesthetic standpoint that it once existed to fill the gap between the two salients and give substance to the rather two-dimensional appearance of the central arch.

The Bāb al-Maqām, as built around 1230 by al-'Azīz Muhammad, was therefore a tripartite gate with a wide central arch capped by a dome and flanked by two narrower side arches. This gate differs from nearly all other medieval Syrian gates in three very important respects: it has no defensive towers; it has a straight instead of a bent axis; and it has three openings instead of one. From the middle of the twelfth century onward,

46. Fatimid court ceremonial has been studied by Marius Canard, "Le cérémonial fatimide et le cérémoniale byzantin; essai de comparison," *Byzantion* 21 (1951): 355–420; and more recently by Paula Sanders, "From Court Ceremony to Urban Language: Ceremonial in Farimid Cairo and Fustāṭ," in *The Islamic World*

from Classical to Modern Times: Essays in Honour of Bernard Lewis, ed. C. E. Bosworth, et al. (Princeton, N.J.: Darwin, 1989): 311–21. For the Mamluk period, see Ḥayāt al-Ḥajji, *Aḥwāl al-'ammah fī ḥukm al-mamālīk* (Kuwait: Kadhima, 1984): esp. 291–95.

nearly all new gates in the enclosures of Damascus and Aleppo conformed to a new, highly defensive form, consisting of two massive towers, one of which was pierced by a single bent entrance. As far as I know, no other tripartite gate was built in the Ayyubid, or even Mamluk, period. Indeed, the tripartite gates of the Roman period were considered so undesirable from a military perspective that some, such as the Bāb Sharqī (Eastern Gate) in Damascus, were partially blocked up, and the remaining single opening was converted into a bent entrance, or *bāshūra*.[47] Thus, it seems that in Bāb al-Maqām utility was entirely sacrificed for monumentality.

Why was such a deliberately archaizing gate built in this specific location, and what does that reveal about the gate and the road over which it presides? Was the Bāb al-Maqām an essentially ceremonial, even triumphal entrance? Although triumphal arches and ceremonial gates are rare in medieval Islamic architecture, they do exist. One of the earliest may have been a tripartite gate called Bāb al-Maydān built by Aḥmad ibn Ṭūlūn across a wide ceremonial road that led to his palace north of Fusṭāṭ. According to al-Balawī and Maqrīzī after him, on festive occasions Ibn Ṭūlūn, mounted on horseback and leading a large procession, would enter alone by the middle arch while the soldiers marched through the side ones.[48] A somewhat more contemporary example is the brick arch that in today's Afghanistan stands alone in the middle of what was once a square at the foothill of Qalʿat-i Bust. This single-entrance gate has recently been convincingly interpreted as a ceremonial gate or even a commemorative structure erected across the important processional road leading from the eastern city gate to the citadel.[49] A third example is the Gate of Wine at the Alhambra palace, which also has been interpreted as a triumphal arch commemorating Muhammad V's recent military successes.[50]

The availability of these precedents, the highly unusual form of the Bāb al-Maqām, and its location on an important road argue for the existence of a ceremonial procession between the citadel and the *Maqāmāt*. In effect, this ceremonial procession would have served to connect the secular and religious domains of the Ayyubids while at the same time paying homage to Abraham, the "patron saint" of the city. Such a ceremony would

47. Bāb Sharqi was rebuilt in this manner during the reign of Nūr al-Dīn, when a minaret was also added on top of it. See Yasser Tabbaa, "Monuments with a Message: Propagation of Jihād under Nūr al-Dīn," in *The Meeting of Two Worlds: Cultural Exchange between East and West during the Period of the Crusades*, ed. Vladimir P. Goss and Christine V. Bornstein (Kalamazoo: Medieval Institute Publications, Western Michigan University, 1986), 235–36 and fig. 28.

48. Abū Muḥammad ʿAbdullah al-Balawī, *Sīrat Aḥmad Ibn Ṭūlūn*, ed. Muhammad Kurd ʿAli (Damascus: al-Maktabah al-ʿArabiyyah, 1339/1921): 54–55; and Maqrīzī, *Khiṭaṭ*, 2:94. For a full description of the palace and hippodrome, see Creswell, EMA, 2:328.

49. Terry Allen, "Notes on Bust," *Iran* 26 (1988): 60 and nn. 17–19. Allen also reports the existence of another "countryside arch" in Dū Baradār, Khurāsān. This has been published in William M. Clevenger, "Some

Minor Monuments in Khurāsān," *Iran* 6 (1968): 57–67, where it is identified as a ceremonial arch. Allen also refers to written descriptions of temporary processional arches in Timurid Herat; in fact, such arches were also occasionally erected in Aleppo, Damascus, and Cairo during the Ayyubbid and Mamluk periods. His suggestion that these ceremonial or commemorative arches may represent "a more solid version of a form familiar from temporary construction" does not necessarily follow, since it is equally possible that these arches were based on ancient models or even the memory of such models.

50. Oleg Grabar, *The Alhambra* (Cambridge: Harvard University Press, 1978), 152–53. To this list can be added the Qasṭal al-Shuʿaybiyya of 1150 in Aleppo, which though not a gate seems to have been built primarily as a triumphal monument celebrating Nūr al-Dīn's victories against the Crusaders. See my "Monuments with a Message," 223–40.

also have countered the popular Shiʻi ceremonies and pilgrimages at the two shrines west of the city (see Chapter 6).

This chapter has examined the origin of the citadel palace type and the implications of its widespread adoption for the relationship between the ruler and the ruled. It has also demonstrated that in Aleppo the Ayyubid palace and citadel formed an organic unit that was linked to the city and the southern suburb on a number of levels: physically through the tunnel and the southern road; ceremonially and politically through *dār al-ʻadl* and Bāb al-Maqām; pietistically through the Abrahamic connection; and religiously by means of the double *madrasas* of al-Ẓāhir Ghāzī, one facing the citadel and the other near the *maqām* Ibrāhīm.

This intricate construct, unprecedented in the history of Aleppo and quite uncommon in other medieval Islamic cities, was in its essentials, if not in its entire execution, the vision of one man, al-Ẓāhir Ghāzī. In some respects, this structure looks back to a mythical golden age and, on a greatly diminished scale, attempts to imitate some of the forms and ceremonies associated with the Abbasid caliphate. In other more important ways, however, it grapples directly with the new reality of a shrunken state, which though linked to the Ayyubid confederacy and contained within a larger Islamic state, was in most respects an independent city-state.

4

The Palace:
Forms and Meanings

Sources and Description

The relations of the palace and citadel with the surrounding city, explored in Chapter 3, provide a context in which to study the Ayyubid palace itself. Through archaeological reconstruction the first section of the present chapter offers a chronology of the palace and a full description of its existing remains. Subsequent sections compare the most significant components of the palace—such as plan and portal—to a number of unpublished or little-known contemporary palaces in the vicinity of Aleppo. These comparisons help establish the palatial group to which this palace belonged and permit a broader comparison of the entire group with the classical Islamic palaces of the Abbasids and Ghaznavids.

Several important passages in Ibn Shaddād illuminate a discussion of the archaeological aspects of the palace and its defending entrance block. Beginning with the exterior, the thirteenth-century historian of Aleppo writes:[1]

1. Ibn Shaddād, A'lāq, 1:24–25,

When al-Malik al-Ẓāhir Ghāzī ascended to reign, he fortified it [the citadel], embellished it, and built within it a large cistern of water and stores for provisions. He tore down the fortified gate (bāshūrah) that used to be in it, graded the hill of the citadel, and rebuilt it with Herculean stones, raising its gate to its present level. . . . Al-Malik al-Ẓāhir made for this gate a bridge extending from it to the town and built for it two towers, the like of which had not before been built. He also fashioned for the citadel five vaulted passages with bent axes, and made for them three iron gates, each with a keeper (isphahsilār) and a defender (naqīb). And he built in it places for soldiers and commanders in which the machines of warfare were hung. And he opened in the wall of the citadel a gate called Bāb al-Jabal, east of the gate of the citadel, and made for it a vaulted passage which was only opened for him when he descended to dār al-ʿadl. This gate and the preceding were completed in the year 611/1213.

The thoroughness and lucidity of this passage make it abundantly clear that al-Ẓāhir Ghāzī rebuilt the entire entrance block and the bridge connecting it with the city, replacing earlier defensive structures in the process. Despite the straightforwardness of the literary evidence, however, it would be unwise to conclude from it that the existing entrance block corresponds in its entirety to the one mentioned by Ibn Shaddād. Further confirmation must be sought in the archaeological and epigraphic record.

The bridge leading to the entrance block presents only minor problems of chronology: it belongs to the period of Ghāzī, except that the gate at its head is much later, as confirmed by the inscribed date on this gate (913/1507)[2] and by the small size of its stones compared to the gigantic ones of the bridge (Fig. 20). The entrance block is far more complicated since Ibn Shaddād and later Mamluk sources indicate that it was subject to several restorations and additions—most importantly in 809/1415, when the Mamluk sultan al-Faraj ibn Barqūq authorized his governor Sayf al-Dīn Jakam to rebuild the citadel after its devastation by Timur in 1410. The centerpiece of this building activity was a large palace built above the two entrance towers of al-Ẓāhir Ghāzī. This palace still retains its original appearance, although its roof was rebuilt in the early sixteenth century and again in 1954.[3] Despite its excellent workmanship and the architect's attempts to blend it in with the earlier structure, it can be easily distinguished from the Ayyubid substructure, whose twin towers terminate in massive machicoulation typical of Ayyubid military architecture. When this palace is removed from the entrance block (as Herzfeld has done in an excellent reconstruction drawing), what remains are two massive towers—the right one containing the actual entrance (Figs. 21 and 22).

Curiously, the ample epigraphic evidence, instead of confirming the fairly straightforward archaeology, seems to obfuscate or even contradict it. A number of long and highly

2. Herzfeld, Alep, 1:103–4.
3. These domes gradually decayed throughout the Ottoman period so that only their supporting arches remained by the beginning of this century. In the 1950s these arches were removed and the hall was covered once again by a flat wooden roof with excessive ornamentation in the style of late Damascene rooms.

important inscriptions are still preserved at the Gate of the Serpents, the Gate of the Lions, and across the entire entrance block. Only the inscription in the tympanum of the Gate of the Lions belongs to the period of al-Ẓāhir Ghāzī. One of his longest and most detailed inscriptions, it consists of seven lines in large clear *thuluth*; six lines are within the tympanum, while the seventh is inscribed on the lintel below (Fig. 28).

(1) بسم الله الرحمن الرحيم أمر (2) بعمله مولانا السلطان الملك الظاهر العالم (3) العادل المجاهد المرابط المظفَّر المنصور غياث الدنيا (والدين) (4) ملك الإسلام والمسلمين سيّد الملوك والسلاطين قامع الكفرة والمشركين (5) قاهر الخوارج والمتمرّدين أبو المظفَّر الغازي إبن الملك الناصر صلاح الدين (6) يوسف بن أيُّوب ناصر أمير المؤمنين أعزَّ الله أنصاره بتوليّ بدر الدين أيدمر الملكي الظاهري (7) وذلك في سنة ستّ وستُّمائة

(Bismillāh . . . Has ordered its making our master the sultan, al-Malik al-Ẓāhir, the just, the champion of the faith, the vigilant, the aided [to victory; my addition], the victorious, the succour of the world [and of the religion], the prince of Islam and the Muslims, the ruler of princes and sultans, the suppressor of infidels and polytheists, the vanquisher of rebels and heretics, Abu'l-Muẓaffar Ghāzī son of al-Malik al-Nāṣir Ṣalāḥ al-Dīn Yūsuf, son of Ayyūb, the defender of the Commander of the Faithful, may God glorify his victories. Under the supervision of Badr al-Dīn Aidemir, the official of al-Malik al-Ẓāhir; and this [was completed] in the year 606 [1209–10].)[4]

Herzfeld concluded from the dominant position of this inscription that "toute l'oeuvre de la grande entrée, y compris les voutes des passages et celles de la porte extérieure aux serpents, appartient a l'époque de Ẓāhir Ghāzī, en accord parfait avec les sources littéraires" (86). Although not based on a thorough examination of the masonry, this seems to be a reasonable deduction, which is further confirmed by two other short inscriptions from the time of al-Ẓāhir Ghāzī. Both are located on reinforced wooden doors; their letters are made of wrought iron, each filling ten of the squares that decorate the surfaces of the two double doors. The first of these remains in situ beneath Ghāzī's long inscription:

أمر ــ بعمله ــ مولانا ــ الملك ــ الظاهر ــ
غازي ــ يوسف ــ في سنة ــ ستّ ــ وستُّمائة

(Has ordered its making our master, al-Malik al-Ẓāhir Ghāzī [son of] Yūsuf, in the year 606 [1209–10].)

4. Reading and translation are based on Herzfeld, *Alep*, 1:85.

The second inscription, which once belonged to an earlier gate at the head of the bridge, was reused by Qānṣuh al-Ghūrī in the sixteenth-century rebuilding of this gate. It is identical to the previous one except that it gives the date as 608/1211.

The problematic inscriptions are the two located in the tympanum of the Gate of the Serpents and especially those on the entrance block. Of the two inscriptions located in the tympanum, the lower one need not concern us: it dates to the year 786/1384 and speaks of certain restorations in the citadel during the reign of the Mamluk sultan Barqūq, prompted by its advanced state of ruin. But the upper inscription in the tympanum and the gigantic inscription on the entrance block leave plenty of room for speculation. Both date from the same period; in fact, the one in the tympanum simply abbreviates the longer inscription on the entrance block (Fig. 24). We therefore begin with the latter, which runs across the two great salients of the entrance block below the machicoulis for a total length of 70 meters. The script is in the kind of heroic *thuluth* style first introduced by the Mamluk sultan al-Manṣūr Qala'ūn in his funerary complex in Cairo. The length of this inscription, the great size of its letters (50 cm), and its splendid calligraphy conspire to make it one of the most important medieval Islamic inscriptions.

(East salient) (E) بسم اللّٰه الرحمن الرحيم إعلموا أن اللّٰه يحيى الأرض بعد موتها
قد بيّنّا لكم الآيات لعلكم تعقلون (S) أمر بعمارتها بعد دثورها مولانا السلطان الأعظم
الملك الأشرف العالم العادل الغازي المجاهد المرابط المثاغر المؤيّد المظفّر المنصور (W) صلاح
الدنيا والدين أوحد الملوك ناصر الاسلام والمسلمين عماد الدولة ركن الملّة مجير الأمّة ظهير
(West salient) جي الخلا (curtain wall) فة نصير الامامة سيّد الملوك والسلاطين سلطان
(E) وش الموحدين ناصر الحق بالبراهين محيى العدل في العالمين [مبيد] الخوارج قامع
المتمردّين قاتل الكفرة والملحدين قاهر(S) الطغاة والمارقين قامع عبدة الصلبان اسكندر
الزمان فاتح الأمصار هازم جيوش الفرنج والأرمن والتتار هادم عكّا والبلاد السا(W)حلّية
محيى الدولة الشريفة العبّاسيّة ناصر الملّة المحمّديّة خليل بن السلطان الملك المنصور
أعزّ اللّٰه أنصاره وذلك في سنة أحد [وتسعين] وسبُّمائة

("Bismillāh . . . Know that God makes alive the earth after its death. We have made clear our revelations to you, that you may understand." [Qur'ān, LVII, 17] Has ordered its rebuilding after its dilapidation our lord the supreme sultan, al-Malik al-Ashraf, the learned, the just, the invader, the champion of the faith, the vigilant, the guardian of the frontiers, the aided [to victory; my addition], the victorious, the vanquisher, Ṣalāḥ al-Dunyā wa'l-Dīn, the unique among the princes, the defender of Islam and the Muslims, the pillar of the nation, the supporter of the community, the protector of the nation, the succor of the caliphate, the aid of the imamate, the master of princes and sultans, the sultan of the armies of the unitarians, the defender of right by means of proofs, the reviver of justice in the worlds, the exterminator of recalcitrants, the suppressor of rebels, the

killer of infidels and polytheists, the vanquisher of tyrants and heretics, the suppressor of the worshippers of the cross, the Alexander of the time, the conqueror of territories, the defeater of the armies of the Franks, the Armenians and the Tartars, the destroyer of Acre and the litoral countries, the reviver of the honored state of the Abbasids, the protecter of the Muhammaden community, Khalīl, son of the sultan al-Malik al-Manṣūr Qala'ūn, may God glorify his victories. And this [was completed] in the year 691 [1290]. With the high council of our lord, the great amir, Shams al-Dīn Qarāsunqur, may God glorify his victories.)

Surrounding the entrance block on three sides and apparently part of the original masonry, this outstanding inscription suggests that the structure on which it is inscribed had fallen into total disrepair after the first Mongol destruction and was completely rebuilt by Qarāsunqur, al-Ashraf Khalīl's governor in Aleppo. But several factors, all proposed by Herzfeld, seem to counter this possibility and confirm the Ayyubid date of the entrance block. The first is the above-mentioned inscription of al-Ẓāhir Ghāzī on the Gate of the Lions, which verifies at least that the inner structure of the great entry is Ayyubid. The second factor is that despite the uncommon length of the Mamluk inscription, it does not mention whether the object of reconstruction was the entrance or the citadel as a whole. On the basis of the feminine pronouns used in the first sentence (*amara bi-'imāratihā ba'da duthūrihā*), Herzfeld proposes that the building act refers not to the masculine *bāb* but to the feminine *qal'ah*. He thus concludes that the first Mamluk restorations did not deal with the entrance block, which was as well preserved then as it is now. Rather, he suggests that the inscription, which was carved directly onto the existing masonry, referred to acts of restoration inside the citadel.[5]

Thus, despite the ambiguity of the inscription, Herzfeld maintains that it was not intended to mislead, for its feminine pronouns would have clearly pointed to works within the citadel. But that can hardly be the case, since the inscription—its feminine gender notwithstanding—is the longest, largest, and most legible in the entire citadel, affixing a Mamluk label to the citadel and the entrance block. Furthermore, since no other inscriptions in the names of Qarāsunqur or al-Ashraf Khalīl have been found inside the citadel, their architectural works within the citadel may not have been especially important. All this suggests that the inscription on the entrance was little more than a blatant Mamluk *prise de possession* of a totally Ayyubid structure.[6]

The entrance block, "one of the most remarkable products of Arab military architecture,"[7] was therefore built in its entirety during the reign of al-Ẓāhir Ghāzī. It rises like a great monolith from a superb stone glacis, which was once partly submerged in the water of the moat. It is connected with the city by means of a ramp supported by seven arches resting on an equal number of massive stone piers. Its great height, excellent masonry,

5. Herzfeld, *Alep*, 1:89–92.

6. The use of inscriptions for laying false claims to earlier buildings is far too common in Islamic architecture to detail all its instances here. It is known in the earliest Islamic monument, the Dome of the Rock in Jerusalem, but becomes especially prevalent in the Mamluk period.

7. Max van Berchem, *Voyage en Syrie*, 211.

numerous arrow slits, and imposing machicoulated brattices create an image of power with few equals in medieval Islamic architecture (Fig. 22).

It is also a very real image of power: the citadel of Aleppo was legendary for its impregnability. It is known to have withstood sustained sieges that would certainly have brought down lesser citadels. This impenetrability can be ascribed in part to its location but also to the colossal entrance block, with its many gates and tunnels (Fig. 23). An imagined army would first have to pass through the gate at the head of the bridge and ascend a bridge with large steps, being exposed to arrows from right and left. Reaching the entrance block, the army would have to turn right and attempt to break through the first Gate of the Serpents, while standing under the hot liquids being poured from the machicoulated brattices above. Having succeeded in taking the gate, the attackers would then have to turn left into a large hall (about 17 by 6 meters) whose single access to the citadel is blocked by another iron door. Breaking through the second door, the soldiers would find themselves in a vast U-shaped hall in which they must once again change their direction three times. At the end of this hall, and on the same axis as the external ramp, stands the third and last defended gate, that of the lions, with its many gates and tunnels. In all, the attackers would need to penetrate three iron doors and change their direction of attack six times, all the while being exposed to projectiles from the defenders and hot liquids poured from openings in the vaults above them. After finally succeeding in just this endeavor, Ṣalāḥ al-Dīn is supposed to have said: "I was never more pleased in conquering a citadel than the citadel of Aleppo."[8] One understands why.

The figural sculpture on the two monumental gates at each end of the entrance block, the Gate of the Serpents and the Gate of the Two Lions, may also contribute to this imagery of power. The first gate has inscribed in the voussoir of its arch a relief sculpture in the form of two knotted and intertwined dragons (Figs. 25 and 26). Each of these serpentine dragons has two heads, one at the springing of the arch and two adorsed at its apex. A few other twelfth- and thirteenth-century examples of dragons used in a similar context have been documented. Most notably, the now-destroyed Talisman Gate in Baghdad once depicted a seated figure (presumably the caliph al-Nāṣir) grabbing in each hand the tongue of a rather ferocious dragon whose serpentine body fills the rest of the archivolt.[9] Another example has been documented by Herzfeld on the gate of a *khān* in Sinjar. Dating from the reign of Badr al-Dīn Lu'lu' (619–57/1219–59), it depicts on each half of the archivolt a nimbed and bearded man attacking a knotted dragon with a spear.[10] A third specimen, consisting of deeply engraved interlaced dragons, decorates the spandrel of the entry iwan of the Karatay *khān* (638/1240) on the Kayseri-Malatya road.[11] A fourth, fragmentary example that once decorated a portal in the Konya citadel shows a

8. Ibn Wāṣil, *Mufarrij*, 2.

9. Discussed in some detail in Sarre and Herzfeld, *Reise*, 2:153–56.

10. Ibid., 1:13–15. This may represent the Arabic Christian saint al-Khiḍr, who is based on Saint George. The church of Mar Bahnām in Mosul has several stone reliefs and one large plaster relief depicting the saint

Bahnām (also a variant of Saint George) lancing a dragon or a devil form underneath his horse.

11. Aslanapa, *Turkish Art and Architecture*, 154. See also the recent photograph of this interlace in Ahmet Ertuğ, ed., *The Seljuks* (Istanbul: Ahmet Ertuğ, 1991), fig. 60.

knotted double-headed dragon with a ferociously open mouth at each end of its scaly body.[12] Although smaller than the others, a fifth, also fragmentary example exists in the form of a stone block reused in the late Ottoman rebuilding of the western wall of the Damascus citadel. Its discovery in the context of the citadel may suggest that it also once decorated the archivolt of a small door to the citadel.

In an astrological interpretation, Willy Hartner argues that the dragon in Islamic art is the eclipse monster, related to the demon Rahu, the antagonist of light and life.[13] But this argument, however strong and erudite, is best applied to those dragons used in association with signs of the zodiac and cannot be accepted as a comprehensive interpretation. In other words, the iconography of the dragon apparently varied according to the context and period in which it was employed.[14]

Despite this iconographic ambiguity, the use of the intertwined dragon motif in medieval Islamic architecture is quite consistent: all documented examples exist in gates and portals.[15] Rather than a specific astrological symbol, intertwined dragons should perhaps be viewed as components in the imagery of power, impregnability, or even good fortune of the structure they decorated. Thus, the fantastic and ferocious aspects of the dragons would have enhanced the imagery of power, while their mysterious knotting would have contributed a magical apotropaic symbolism.[16]

Evidently serving a similar iconographic function, paired recumbent lions flank the third and last gate of the entrance block, jutting out like consoles from the masonry of the door jambs (Figs. 27 and 28). Their schematic features typify other sculptural representations of lions in medieval Islamic art, such as those in the Fountain of the Lions at the Alhambra palace. These creatures, usually in pairs, have a long history in Ancient Near Eastern and Islamic art, one of the earliest examples being the two terra-cotta lions flanking the entrance to the Kassite palace at Tell Ḥarmal.[17] Paired lions supporting a throne or a dais are commonly represented in Sassanian silver,[18] and this iconography was bequeathed to early Islamic art, where it appears in at least two Umayyad palaces.[19] Later,

12. Gönül Öney, *Anadolu Selçeku Mimarisinde Süsleme ve el Sanatlari* (Ankara: Turk Matbaacilik Sanayii, 1978), 46, fig. 32.

13. Willy Hartner, "The Pseudoplanetary Nodes of the Moon's Orbit in Hindu and Islamic Iconographies," *AI* 5 (1938): 113–54.

14. It would be absurd, for example, to suggest that the various dragons depicted in the illustrations of the *Shāhnāma* were eclipse monsters and not simply ferocious creatures or forces of darkness.

15. Interestingly, even in contemporary eastern Christian art, best exemplified by Mar Bahnām monastery, the intertwined dragon is invariably employed above or around important portals. Sarre and Herzfeld, *Reise*, 2:285–90. Even the two well-known bronze door knockers in the form of two confronted dragons with bird heads as tails are also related to the concept of entry, or better, to the protection of an entrance. Once attached to the doors of the Great Mosque at Cizre (a small town in the southeastern corner of Turkey), these

door knockers are now divided between the David Museum in Copenhagen and Museum für Islamische Kunst in Berlin. See *The Arts of Islam: Hayward Gallery, 8 April–4 July 1976* (London: Arts Council of Great Britain, 1976), 178.

16. Cf. Herzfeld, *Alep*, 1:137 and 236–39, which suggests a similar symbolism for any of the many knotted forms common in this period.

17. Pierre Amiet, *Art of the Ancient Near East* (New York: Abrams, 1980), fig. 446.

18. See, for example, Oleg Grabar, *Sasanian Silver* (Ann Arbor: University of Michigan Museum of Art, 1967), figs. 12 and 14.

19. At Qusayr 'Amra, the fresco in the back of the throne niche depicts an enthroned ruler supported by two adorsed lions. In the portal to the bath hall of Khirbat al-Mafjar two adorsed lions in high relief support the standing caliph above them; see Grabar, *Formation*, fig. 81.

with the limited twelfth- and thirteenth-century revival in public figural sculpture, paired lions once again occur in royal or military contexts.[20] Although in the Mamluk period the lion often became an attribute of a particular sovereign (al-Ẓāhir Baybars, for example), its use in the Ayyubid period seems more generalized as an emblem of royal power. A similar symbolic function may be assigned to the paired lions in the Aleppo citadel, based on their close proximity to the royal palace.

The palace complex itself is located in the southern part of the citadel, to the right of the ascending ramp that begins at the entrance block and ends at the mosque of al-Ẓāhir above. According to Ibn Shaddād, the palace built by al-Ẓāhir Ghāzī, called *Dār al-ʿIzz* (House of Glory), was erected over the remains of several earlier residences, including the palace of Nūr al-Dīn, the so-called *Dār al-Dhahab* (House of Gold), a residence called *Dār al-ʿAwāmīd* (House of Columns), and a third residence belonging to the Seljuq prince Riḍwān.[21] It is also possible that these successive palaces were not all built on the same spot but occupied different portions of the citadel mound. Unfortunately, this is very difficult to determine since archaeologists working in this part of the citadel have neither distinguished levels nor determined the relations among walls.

Ibn Shaddād has summarized the works of al-Ẓāhir Ghāzī and his son Muhammad in the palace area:[22]

He [Ghāzī] built several apartments and rooms, baths, and facing the iwan of this palace a garden with trees and flowers. In front of the entrance he set up covered porticos which lead to the aforementioned vaulted passages (*dūrgāhs*). And he built at its gate places for civil and military secretaries.

When in 609/1212 [al-Ẓāhir] was to wed Ḍayfa Khātūn, the daughter of his uncle al-Malik al-ʿĀdil . . . a fire began after the wedding and consumed the palace, including its furniture, jewelry, vessels, and other things, and also the *zaradkhāna* (arsenal). The fire took place in 11 Jumādā I, 609 (October 1212). He thereupon restored the palace and called it *Dār al-Shukhūs* (House of Images), because of the abundance of these things in its ornamentation (*zakhārif*). It covered 40 by 40 cubits. . . .

In 628 (1231), al-ʿAzīz Muhammad built, to the side of the arsenal, a palace too beautiful to describe, on a surface of 30 by 30 cubits.[23] When in 9 Rabiʿ I 658 (23 February 1260), the Tartars took over the citadel, they proceeded to demolish its wall and to burn what was in it of ammunition and war machinery, including

20. For Anatolian examples, see Tamara Talbot Rice, *The Seljuks in Asia Minor* (New York: Praeger, 1961), figs. 49 and 50, which show three-dimensional stone sculptures of seated lions from the citadels of Divriği and Konya, respectively. See also the recent discussion of Anatolian palaces by Scott Redford, "Thirteenth-Century Rum Seljuq Palaces and Palace Imagery," in *Pre-Modern Islamic Palaces*, ed. Gülru Neçipoğlu, in *Ars Orientalis* 23 (1994): 219–36. For Aleppo, see Herzfeld, MCIA-Alep, pls. VIII and IX.

21. Ibn Shaddād, *Ḥalab*, 25

22. Ibn Shaddād, *Ḥalab*, 25–26. A biography of this remarkable prince is sorely needed. Recently, Farid Juha, "Qalʿat Ḥalab," *ʿĀdiyyat Halab* 2 (1976): 105–9, has presented a summary of al-Ẓāhir Ghāzī's works in the citadel.

23. These are curiously small dimensions since the existing palace alone measures approximately 30 by 30 meters and closer to 40 by 45 meters with the bath included.

the mangenoles. . . . They returned a second time after having killed al-Malik al-
Muẓaffar . . . and wreaked terrible destruction in the citadel and all its residences
and treasuries, leaving no place in it for habitation. This took place in Muḥarram
659 (December 1260): And now the wall of the ancient citadel is described as
"lock on a ruin."

The citadel remained in this state for thirty-three years, after which, as mentioned
above, it was restored during the reign of al-Ashraf Khalīl ibn Qala'ūn in 691/1292. But
not until the late Mamluk period, after the second Mongol devastation of Timur in 1410,
was any large-scale work done on the military and civil structures of the citadel. In 809/
1415, the Mamluk sultan al-Faraj ibn Barqūq appointed the prince Sayf al-Dīn Jakam as
governor of Aleppo, authorizing him to rebuild the citadel. His most important building
act was a large new Mamluk palace, which rose above the two entrance towers of al-Ẓāhir
Ghāzī. During the reign of Mu'ayyad Shaykh (1412–21) this new palace was covered by a
flat wooden roof, which was replaced by nine domes during the reign of the last Mamluk
sultan Qānṣūh al-Ghawrī (1501–17). In short, the literary evidence indicates that the
Ayyubid palace was largely abandoned in the Mamluk period, when it was replaced by
another palace of an entirely different type.

Given this chronology, the existing ruins—a palace, a bath, and an arsenal—should
belong exclusively to the period of al-'Azīz Muhammad, with some remains from the
palace of his father al-Ẓāhir Ghāzī. The epigraphic evidence is not so helpful as one would
wish. No in situ inscription from the time of al-Ẓāhir Ghāzī has been discovered in or
anywhere near the palace. But Herzfeld, citing Bischoff, reports the existence of an
inscription from the time of Ghāzī that had been reemployed in a later building near the
palace. Despite the unreliability of Bischoff's reading, the inscription at the very least
corroborates the literary evidence with regard to Ghāzī's works in the palace area.

أمر بعمارته مولانا السلطان الملك الظاهر العالم العادل المجاهد المرابط المنصور المظفّر
الغازي غياث الدنيا والدين أبو المظفّر بن يوسف بن أيُّوب ناصر أمير المؤمنين

(Has ordered its construction our lord the sultan al-Malik al-Ẓāhir, the learned,
the just, the fighter for the faith, the keeper of the outposts, the victorious, the
aided to victory, al-Ghāzī Ghiyāth al-Dunya w'al-Dīn, Abu'l-Muẓaffar ibn Yūsuf,
the helper of the Commander of the Faithful.)[24]

Fortunately, this problematic inscription is corroborated by an extant, though hitherto
unpublished, inscription, preserved today among the architectural fragments near the
upper mosque of the citadel (Fig. 29).

24. Herzfeld, Alep, 1:136. 'Imād should be replaced
by ghiyāth; the reading is faulty in several places and
possibly incomplete.

(1) [بسم اللّه الرحمن الرحيم] أمر بعمله مولانا الملك (2) الظاهر العالم العادل
المجاهد المؤيَّد المظفَّر (3) المنصور غياث الدنيا والدين أبو المظفَّر الغازي
(4) إبن الملك الناصر يوسف بن أيُّوب في سنة خمس وتسعينٌ وخمسمائة

([Bismillāh] Has ordered its making our lord al-Malik al-Ẓāhir, the learned, the
just, the fighter for the faith, the supported, the aided to victory, the victorious,
Ghiyāth al-Dunya w'al-Dīn, Abu'l-Muẓaffar al-Ghāzī son of al-Malik al-Nāṣir
Yūsuf b. Ayyūb, in the year 595/1198.)

This, like the previous inscription, does not refer to a specific building act. But these
two inscriptions and the others in the entry block and the upper mosque provide ample
evidence for Ghāzī's early and continuous interest in the rebuilding of the citadel and its
various components.

There are equally two inscriptions from the time of al-ʿAzīz Muhammad, the first of
which is still in situ on a wall near the arsenal. It is dated 625/1228 and refers to the
arsenal:

(1) بسم اللّه الرحمن الرحيم أمر بعمارة مذه الزردخانه المباركه
مولا [نا السلطان] الملك (2) العزيز [] محمد أعزَّ اللّه
انصاره (3) [] طغرل في شهور سنة خمس وعشرين وسُّمائه

(Bismillāh . . . Has ordered the building of this blessed arsenal our lord the sultan
al-Malik al-ʿAzīz [] Muhammad—May God glorify his victories—[] Ṭoghril,
during the year 625/1228.)[25]

The second, dated 631/1234, does not refer to any specific works (Fig. 30). Preserved
now in a temporary museum in the Egyptian barrack on the northern end of the citadel, it
was originally found at its southern end near the palace, suggesting that it might refer to
al-ʿAzīz Muhammad's rebuilding of the palace.[26]

(1) بسم اللّه الرحمن الرحيم ممَّا أمر بعمله مولانا (2) السلطان الملك العزيز محمد غياث
الدنيا والدين ركن الإسلام (3) والمسلمين سيِّد الملوك والسلاطين خلَّد اللّه (4) ملكه بتوليَّ
العبد الفقير الى رحمة اللّه سيف الدين بكتاش الملكي العزيزي (5) سنة احد وثلاثين وسُّمائه

(Bismillāh . . . This is what has ordered its making our lord the sultan al-Malik
al-ʿAzīz Muhammad Ghiyāth al-Dunyā w'al-Dīn, the pillar of Islam and the

25. Ibid., 136–37. 26. Ibid., 139, and *Répertoire*, no. 4067.

Muslims, the master of kings and sultans, may God make his reign immortal. Under the supervision of the needy of God's mercy, Sayf al-Dīn Bektāsh, the associate of al-Malik al-'Azīz, in the year 631/1234.)

Curiously, the facade of the palace itself bears no Ayyubid inscriptions whatsoever. In fact, its only inscription is a Mamluk one located just above the lintel of the portal, in the middle of the *muqarnas* cell. But despite its prominent position, this inscription, dated to the governership of Manglibogha in 769/1367, refers only to the restoration of water service to the palace or, according to Herzfeld, to the entire citadel.[27] Manglibogha's works do not seem to have affected the fabric of the palace, which, with the exception of much later crude additions, seems to belong to one phase or two closely related phases.

The Ayyubid Palace in Aleppo and Its Contemporaries

The rectangular palace complex, approximately 45 meters north-south and 40 meters east-west, is bordered to the west and north by access roads (Fig. 31). Three fairly distinct functions are contained within this complex: the palace proper in the northern two-thirds; a bath in the southeastern corner; and what appear to be guard rooms and arsenals in the southern third. Parts of the arsenal have been rather unscientifically excavated in recent years, so they remain the poorest known in this complex. Little of the vaulting and none of the second story of the palace have survived, whereas the vaulting of the bath and the arsenal is nearly intact (Fig. 32).[28] The following descriptive and comparative analysis deals exclusively with the palace proper, primarily discussing its portal, its plan, its courtyard elevations, and the fountain in its northern iwan.

The Muqarnas Portal

The palace is entered from the west through a monumental portal, which is situated before a spacious area that may have served a ceremonial function (Fig. 33). Though traditional in form, the portal is striking in its richness and complexity, combining as it does striped masonry, joggled voussoirs, geometric ornament, and plaited ornament within the standard format of the *muqarnas* entry. It consists of a recessed door whose jambs and lintel are made of joggled voussoirs overlaid by a network of geometric orna-ment (Figs. 34–35). A superb *muqarnas* vault of the "Iranian" type,[29] with three zones of

27. Herzfeld, *Alep*, 1:138.
28. This is very often the case in medieval palaces, as for example Qal'at Ṣahyūn, where the palace proper has also lost all its vaults whereas the arsenal is remarkably well preserved. This primarily reflects the far greater stability and solidity of cross-vaulting. The preservation of the vaulting of baths, on the other

hand, is greatly enhanced by the lightness of the domes (which always include glass) and especially their very low-slung profile.
29. See Herzfeld, "Damascus-III," 12–15, for his classification of *muqarnas* vaults into "Mediterranean" and "Iranian"; and Chapter 7 for a more complete discussion of the *muqarnas* portal in Syrian *madrasas*.

cells and a scalloped half-dome, rises above the lintel and is crowned by a panel of black and white stone marquetry. Two rectangular windows topped by a braided motif are symmetrically placed on either side of the portal.

Although typologically related to the portals of contemporary pious buildings, this entry also differs from them: it has no dedicatory inscription and is far more elaborate. The absence of the usual inscription providing some information about the founder, the building act, and the date is baffling at first. To be sure, pious buildings are often uninscribed in medieval Syria, denoting that their patrons died before their completion. But nearly all of these buildings have some provision for an inscription, usually a framed plaque, which at times bears the posterior inscription of an act of restoration. No such plaque exists in the lintel of this portal.

Only one other nearly contemporary Islamic palace known to me has a standing portal. This is the Ayyubid palace at Qal'at Ṣahyūn, which in addition to its overall formal similarities to the Aleppo portal, is also anepigraphic (Fig. 38).[30] Although two examples hardly permit firm conclusions, it seems possible that the royal palace needed no further identification since its identity was already clear from numerous other inscriptions in the citadel. Or perhaps the inscription plaque was sacrificed for aesthetic reasons, since it would have interrupted the rich and complex ornament of the portals.

The portal is also grander and more elaborate than the portals of most contemporary pious buildings, engaging the most up-to-date decorative motifs and stereotomic techniques of northern Syria. Beginning with the frame around the door, it combines striped masonry, joggled voussoirs, and geometric ornament—all elements with a long history in north Syrian architecture—in a totally original manner (Fig. 36). The joggled voussoirs, here used as both a flat arch and a framing element, are overlaid with a net of carved geometric ornament that conforms precisely to the cut edges of the blocks.[31] Despite its apparent simplicity, this technique is actually quite astounding in its complexity and precision. As with stone *muqarnas*, each stone block had to fulfill a structural, geometric, and aesthetic function. It had to be cut to fit properly in the structure while contributing to the overall geometry of the lintel. The desired effect of a solid but highly articulated passage of masonry is achieved by cutting the stones with such care as to make the joints nearly invisible.

Herzfeld suggests that such geometric patterns were carved onto standing structures,

30. The only study so far published on this curious palace (wrongly called *ḥammām* locally) is Maurice Écochard, "Notes d'archéologie musulmane, I, Stéréotomie de deux portails du XIIe siècle," BEO 7–8 (1937–38): 98–112. Although undated, this palace is undoubtedly Ayyubid and possibly contemporary with that of the Aleppo citadel. Ṣahyūn (Crusader Soane) was taken in 584/1186 by Ṣalāḥ al-Dīn, who gave it as *iqṭā'* to Amir Nāṣir al-Dīn Mankūras ibn Khumārtekin and his descendants, who ruled it until 671. Since Ṣalāḥ al-Dīn is not otherwise known as its builder, the

palace was probably built during the reign of his son Ghāzī, who was greatly concerned with fortifying his borders. In view of the complexity of the portal, a date in the latter part of Ghāzī's reign, c. 1200–1215, seems most likely.

31. Other examples of the joggled voussoir can be seen at Qasṭal al-Shu'aybiyya in Aleppo (1150) and in the late eleventh-century gates of Cairo, which are known to have been built by Syrian craftsmen. See Creswell, MAE, 1:170ff., for a discussion of some early examples of this motif in Cairo.

whether doorways or *miḥrābs*.[32] This is very unlikely—in fact, no more likely than that *muqarnas* cells were chiseled out after a smooth vault had first been assembled. On the contrary, it seems abundantly clear that the overall geometric design had been conceived in its entirety *before* the voussoirs were cut; or conversely, that the contours of the stone blocks were carved to comply with the overall geometric pattern and coincide precisely with the incised pattern. The harmonized elements of structure, color, and geometric ornament give this portal its special character. This demanding technique also characterizes the portal of the Ayyubid palace at Qal'at Ṣahyūn, where it is limited to a wide band above a lintel of joggled voussoirs.[33]

The lintel of the Aleppo palace is deceiving: it is not immediately clear how it is supported, considering the size of its blocks and their shallow engagement into one another. Closer inspection reveals the secret of this "unsupported" flat arch: it is actually supported from beneath by a hefty iron bar firmly lodged into the masonry. Although now visible due to the damaged condition of the stonework, the iron bar was originally totally concealed by the projecting ends of the stone blocks it supports. Here is another example of those "special effects" for which medieval Islamic masons were noted—effects that were intended to mystify the structural logic of the building craft.[34] Similar effects are used in the portal vault of the Ayyubid palace at Ṣahyūn (Figs. 38–41), described in Chapter 7.

The *muqarnas* vault is a particularly complex and accomplished specimen that closely resembles vaults at the *madrasa* al-Kāmiliyya or al-Ẓāhiriyya. It differs from these examples in having four instead of the usual three zones of cells and in its somewhat fuller scalloped half dome (Fig. 37). It is topped by a vigorous geometric interlace, of which only meager traces remained by the time of Herzfeld's study. In his otherwise excellent and accurate drawing, Herzfeld reconstructed it nearly twice the height of the existing reconstruction. Although more monumental in effect, this reconstruction does not seem archaeologically or aesthetically justified. Two rectangular windows with missing grilles, most likely intended for surveillance, flank the portal. They are topped by a braided masonry motif typical of the period.[35]

The portal leads to a rectangular vestibule that reorients traffic 90 degrees to the left, where a smaller door is located. Beyond this door the entry to the small court lies to the right; straight ahead a marble-paved corridor turns around the small court to enter the large court from its northwestern corner (Fig. 42). This corridor is also accessed from its northwestern corner by a small door most likely intended for members of the household.

32. "Damascus-II," 65 and n. 76.

33. Écochard, "Notes d'archéologie musulmane, I, Stéréotomie," 108, fig. 6, which outlines the ingenious ways that the stone blocks have been cut and the way they were fitted together to produce a nearly seamless effect.

34. Other devices are foliate arches, pendant arches, arches with broken profiles, and all the varieties of *muqarnas* vaulting.

35. Examples of this motif abound in Aleppo: plaque on exterior wall of masjid al-Iskāfi (541/1147); portal of *mashhad* al-Ḥusayn (596/1199); portal of the *madrasa* al-Sharafiyya (1220–40). Indeed, the motif is closely related to the polychrome interlaced masonry.

The Cruciform Four-Iwan Plan

The palace proper consists of two cruciform units of unequal size surrounding open courtyards (Fig. 31). The smaller unit surrounds a square court (4.55 meters per side), whose floor is paved with bichrome stone marquetry (Fig. 43). The design consists of an eight-pointed star inscribed within a square, with circles filling the four corner spaces. The court is surrounded by three raised iwans, a large one on the north and two smaller iwans on east and west, and on the south by a tripartite arch that screens the courtyard from the adjacent corridor. The size and location of the northern iwan seem to indicate its privileged position as the seat of the sovereign. A narrow corridor paralleling the movement of the outer one leads to an enclosed space, which may have been a latrine.

As with most Islamic palaces or luxurious residences, the smaller of the two courts was used for public receptions while the larger housed private audiences as well as family life. This is confirmed by the greater accessibility and relative isolation of the smaller court, as well as by the direct accessibility of the larger court to the bath area.

The larger unit surrounds a squarish court (9.49 by 9.72 meters) with an elaborate octagonal fountain in its center (Fig. 44). Although its marble and basalt paving has largely disappeared, enough remains to reconstruct the design as identical to that of the small unit. The courtyard is surrounded by three raised iwans of nearly equal size on its north, east, and west and a much larger one on the south. The southern iwan is flanked by two rooms of unequal size: a spacious one to the west and a narrow one to the east. The direct connection between this iwan and the arsenal just behind it suggests it may have been used by the private guard of the Ayyubid sultan. The sleeping quarters must have been on the second floor above the northern part of the residence, as indicated by two partly preserved staircases to the right and left of the northern iwan.

It is immediately clear that both courtyards are of the cruciform four-iwan type, here roughly symmetrical along a north-south axis. The origin of the four-iwan plan, particularly in relation to the history of the *madrasa* and the Persian mosque, was one of the most hotly debated issues in the formative period of Islamic architectural studies (approximately 1920–60).[36] But despite the length of this debate and the great erudition of its participants, it has left several important questions unanswered and a number of opposing views unreconciled.

At a remove of several decades, it seems that at least two major factors complicated the controversy and contributed to its obfuscation. The first is the nationalist factor. To put it most simply, researchers working in Iran—at the time the majority—favored an Iranian origin for the four-iwan plan, while those working in Egypt, a minority led by Creswell, argued for an Egyptian origin of the four-iwan *madrasa*. Second, and far more elusively, scholars in both camps were simultaneously arguing the origin of the four-iwan plan as a form *and* the origin of the Iranian *madrasa*, which was presumed to have used this form

36. This controversy is summarized and given new focus in Oleg Grabar, "The Visual Arts," in *The Cambridge History of Iran*, vol. 5, *The Saljuq and Mongol Periods*, ed. J. A. Boyle (Cambridge: Cambridge University Press, 1968), 631–37. See also André Godard, "L'Origine de la madrasah, de la mosquée, et du caravansérails à quatre iwans," *AI* 15–16 (1951): 1–9.

from the very beginning. In other words, the origin of the form and its application to an emerging institution were so often conflated in the literature that it could be difficult to determine which point was being argued.

The first factor need not detain us long; it primarily concerns the strategies of a developing field and the rather limited pool of available information. In fact, when Herzfeld and Sauvaget expanded their research to Syria and Albert Gabriel to Anatolia, the earlier dogmatic opinions had to be adapted or even rejected in order to accommodate the new data. No easy solution is available for the second problem, which conflates the formal origins of cruciform plans and the institutional development of the *madrasa*, since to argue against such a multidisciplinary approach goes against the direction of most modern scholarship, including this work. Still, it seems logical at least momentarily to separate the two components of the argument and deal with the origin of the four-iwan plan independently from the origin of the *madrasa*. This is the scheme followed below, but I shall return to this question in Chapter 7, where I deal with the *madrasa*.

Although the cruciform four-iwan plan was used in some *madrasas* and is embroiled in the history of that institution, it should be stressed that the plan had a very long and largely ignored history in palatial architecture. Indeed, what is missing in all the various four-iwan hypotheses[37] is any mention of palatial architecture as a possible prototype. This omission is especially striking given the relatively large number of palaces preserved from the pre-Islamic and early Islamic periods and the fairly continuous history of the four-iwan and other quadripartite forms in their plans.[38] Such quadripartite division is first seen in some first-century Parthian and Sassanian palaces, such as the Parthian palace at Assur (first–third century A.D.; Fig. 45). The type becomes especially common in early Islamic palaces, including the seventh-century *Dār al-Imāra* at Kūfa (Fig. 46), the Umayyad palace at the Amman citadel (Fig. 47), the palace of Abu Muslim at Merv from 750 to 755 (Fig. 48), and the recently excavated so-called Victory Monument of Hārūn al-Rashīd at Hiraqla from c. 795 (Fig. 49).

While the Kūfa palace remains close to the more common four-iwan plan with a large open court, the three succeeding examples show the emergence of a new variant in which the four iwans converge onto a domed court. The recent reconstruction of the Amman palace posits a central dome, and Abu Muslim's palace, which is reconstructed from literary descriptions, would have consisted of a raised platform supporting four orthogonal iwans converging onto a central dome.[39] Closely related to the palace at Merv is the "Victory Monument" of Hārūn al-Rashīd at Hiraqla.[40] It is also erected above a raised square platform, and in the middle of each side four long iwans converge onto a central dome.

Both variants are known at Sāmarrā, whose palaces (833–92) display a bewildering array of innovations and original combinations, nearly all based on the principle of

37. Since these pertain primarily to the history of the *madrasa*, they are discussed in Chapter 7.

38. The one exception is Godard, "L'Origine de la madrasah," 6, who actually cites the spectacular example of the cruciform Umayyad palace at the Amman citadel

but only to argue for an Iranian origin of the plan.

39. See Creswell's reconstruction in *Early Muslim Architecture*, 2:fig. 1.

40. Kassem Toueir, "Natā'ij al-tanqīb fī Hiraqlah," in *AAS* 33, no. 1 (1983): 99–112.

cruciform design. In all five primary palaces—Jawsaq al-Khāqānī (Dār al-Khilāfa) (833–42), Qaṣr al-Jiṣṣ (833–42), Qaṣr al-Hārūnī (842–47), Qaṣr Balkuwāra (847–61), and Qaṣr al-ʿĀshiq (870–92)—a cruciform design occupies the center formed by a domed throne hall with four axial iwans.[41] The design seems hesitant in the earliest of these palaces, the Jawsaq al-Khāqānī, where the cruciform core is lost in an otherwise labyrinthine plan, but becomes more assured in the Balkuwāra (Fig. 50), whose cruciform audience hall is perfectly integrated with the geometry of the palace. In the smaller palaces, in particular al-Jiṣṣ and al-ʿĀshiq (Fig. 51), the cruciform design dominates the entire palace.

Whereas none of these palaces has the traditional four-iwan plan with an open court, such a plan nevertheless exists in the official architecture of the period, as a recently excavated example demonstrates. This is the so-called Rest House of the caliph al-Mutawakkil, located adjacent to the *qibla* wall of the mosque of Abu Dulaf (847–61) (Fig. 52). It is a rectangular building (42 by 33 meters) with two courtyards, the larger and clearly more official of which has a perfect four-iwan plan. I have suggested above that this building served as a kind of small-scale substitute for the *Dār al-Imāra*, which might explain its cruciform plan.

It is clear from this brief look at early Islamic palatial architecture that cruciform plans play a dominant role in their design, occupying the most privileged part of the palace and imparting a sense of order and monumentality to the courtyard. What functional or symbolic values lie behind this formal order? And how did these ordered forms in turn contribute to the iconography of power? Without stretching the question of origin too far, it should nevertheless be noted that the concept of fourfold division as a symbol of universal power is deeply rooted in the Ancient Near East, where it can be traced back to the time of the Akkadian sovereign Naramsin, c. 2250 B.C., who called himself "The King of the Four Quarters of the World."[42]

This particular attribute of royal glory does not seem to occur in the titulature of early or medieval Islamic caliphs and sultans, nor is it referred to directly in the few remaining treatises on kingship and royalty. But the concept of the "Master of the World," which occurs frequently in the *Siyāsat-nāma* of Niẓām al-Mulk[43] and in such titles as *sulṭān al-arḍ thāt al-ṭūl w'al-ʿarḍ* (sultan of the long and wide earth) and *malik umarā' al-mashriq w'al-maghreb* (king of the princes of the East and the West)[44] suggests some continuity with the original attribute of universal rule. Although not identical to the concept of "The King of

41. These plans are illustrated in Alastair Northedge, "Creswell, Herzfeld, and Samarra," *Muqarnas* 8 (1991): 74–93.

42. See, for example, Henri Frankfort, *The Art and Architecture of the Ancient Orient* (London: Penguin, 1970), 84; and Pierre Amiet, *Art of the Ancient Near East* (New York: Abrams, 1980), 104. Although no work of art from the time of Naramsin represents this conception of kingship in an emblematic fashion, Frankfort suggests that it was nevertheless "expressed" in some of his works. Indeed, apparently the closest approximation to a symbolic representation of this

concept is the depiction of Assyrian camps as a circle or an oval divided into four quadrants. See Amiet, *Ancient Near East*, fig. 599.

43. *Siyāsat-nama*, esp. 9–13.

44. These titles occur first in the titulature of the Great Seljuq sultan Malikshāh as *sulṭān arḍ Allah* and later in the titulature of the Mamluk sultan Qalawūn and some of his successors. See Herzfeld, *Alep*, 1:112–13 and 155. Herzfeld demonstrates a direct continuity between the latter title and several Achaemenid inscriptions, which are themselves based on Babylonian titles.

the Four Quarters of the World," these epithets share with it the idea of defining kingship in geographical terms; that is, the king is imagined as a central figure whose power and emanations reach out and control portions of the world.

An even fuller manifestation of this concept, I believe, was put to practice in the ceremonial of Abbasid caliphs and their successors and emulators the Ghaznavid kings. Cursory references in Hilāl al-Ṣābi'[45] and somewhat more detailed ones in Baihaqī[46] portray a formalized court ceremonial in which the caliph is described as surrounded in the four directions by contingents of honor guards (ghulāms). Within the fourfold composition of the throne hall, contingents of ghulāms, whose distinctive clothing and headdress referred specifically to different parts of the Islamic world, defended the right, left, front, and rear of the sovereign.[47]

It seems fairly certain, therefore, that the cruciform divisions of the courtyards and throne halls at Lashkar-ī Bāzār (Fig. 53) and earlier at Sāmarrā played an important role in organizing the form of the ceremonial and in codifying the roles of its participants. The sovereign stood at the center of this ceremony, and the fourfold arrangement of his honor guards symbolized the strength of his empire and his personal aura. His image as "The King of the Four Quarters of the World" was embodied in the very architecture that surrounded him and emphasized by the complex ceremonial. The ceremony therefore recharges and sharpens the meaning of the ancient symbol, converting it from a static emblem of royalty into a dynamic attribute of authority, which is ultimately based on military power.[48]

Given the royal and authoritarian associations of the four-iwan plan, its use in the palace at the Aleppo citadel and in several other medieval Islamic palaces comes as no surprise. The precise genealogy of this transmission is impossible to ascertain since very few palaces are known in the central Islamic world between the tenth and the first half of

45. *Rusūm Dār al-Khilāfa*, ed. Mikhā'il 'Awwād (Baghdad, 1964), 91.

46. Abu'l-Faẓl al-Bayhaqī, *Ta'rīkh-ī Mas'ūdī*, ed. A. A. Fayyāḍ (Mashhad: Mashhad University Press, 1971), 539–41. These passages are quoted at length by C. E. Bosworth, *The Ghaznavids*, 2d ed. (Beirut: Librarie du Liban, 1973), 135–38. See also ibid., 104, where Bosworth concludes that "the literary descriptions . . . of these levées have in recent years received striking confirmation from the researches of the French Archaeological delegation in Afghanistan in 1949–51 at the Ghaznavid palace of Lashkar-ī Bāzār at Bust."

47. Baihaqī, as translated by Bosworth, *The Ghaznavids*, 136, states: "All around the hall, standing against the panels, were the household ghulāms (ghulāmān-i khāṣṣagī) with robes of Saqlaṭūn, Baghdādī and Iṣfāhānī cloth, two-pointed caps, gold-mounted waist sashes, pendents and golden maces in their hands. On the dais itself, to both left and right of the throne, were ten ghulāms, with four-sectioned caps on their heads, heavy, bejewelled waist sashes and bejewelled sword belts. In the middle of the hall [serai] were two lines of ghulāms; one

line was standing against the wall, wearing four-sectioned caps. In their hands they held arrows and swords, and they had quivers and bow-cases. There was another line, possibly down the centre of the hall, with two-pointed caps, heavy, silver-mounted waist sashes, pendents and silver maces in their hands. The gulāms of both these lines all wore cloaks of Shushtarī brocade." This ceremony was immediately followed by a feast for all soldiers and gentry and terminated by a smaller *majlis* lasting until the evening prayer.

48. The metaphor of military formations indeed underlies another well-known palace plan, namely, the Ḥīrī type. This T-shaped iwan plan is said to have been based on the image of battles (*'alā ṣūrat al-ḥarb*), such that the king would be in the center flanked by armies on his right and left. See al-Mas'ūdī, *Murūj al-dhahab wa-ma'ādin al-jawhar*, 4 vols. (Beirut: Dar al-Andalus, 1973), 4:4–5. See also John Onians, *Bearers of Meaning, The Classical Orders in Antiquity, the Middle Ages, and the Renaissance* (Princeton: Princeton University Press, 1988), 8ff., for an intepretation that links the Greek temple to a military phalanx.

the twelfth century and since palaces from this period in North Africa adopt a very different typology.[49] The gap may be partly filled by referring to the eleventh- and twelfth-century Ghaznavid palaces at Ghazna and especially Lashkār-ī Bāzār, which are known to have been modeled after the Sāmarrā palaces[50] but which are even more closely based on cruciform design. Still, a significant gap exists, particularly in northern Syria: the last pre-Seljuq palace built there was the tenth-century palace of Sayf al-Dawla, also known to have been modeled after the palaces of Sāmarrā.[51]

Two possible modes for the transmission of cruciform design from the tenth to the twelfth century may be proposed. The first posits that a series of no longer extant quadripartite palaces was built in Aleppo between the Ḥamdānids and the Ayyubids, making cruciform palatial design a continuous process. Alternatively, there may indeed have been a hiatus of nearly two centuries, but cruciform plans, in view of their association with the Abbasid caliphate and their established iconography of power, may have become the standard type for palatial architecture. The second model seems more plausible since it explains not just the palace in Aleppo but the use of quadripartite plans in a number of other related palaces in Syria and the Jazīra.

Nine existing palaces, dating from the third quarter of the twelfth century to the Mongol invasion, utilize the four-iwan plan. In approximate chronological order these are: the so-called Qaṣr al-Banāt at Raqqa, the Ayyubid palace at Qal‘at Ṣahyūn in the ‘Alawite Mountains, the Ayyubid palace at Qal‘at Najm on the Euphrates, the Artuqid palace in the Diyarbakr citadel,[52] the so-called Maṭbakh al-‘Ajamī palace in Aleppo, the Ayyubid palace (serai) in the Bosra citadel, the Ayyubid palaces at the Karak and Shawbak citadels in Jordan, and the late Ayyubid palace at the Roda Island in Cairo. Nearly all these palaces are located in Syria and the Jazīra, and all, except the palace at Diyarbakr, were built by Ayyubid princes.[53] The following discussion focuses on four of these nine: Qaṣr al-Banāt, since it is the earliest; the palaces at Qal‘at Ṣahyūn and Qal‘at Najm, which were built under royal Ayyubid supervision; and Maṭbakh al-‘Ajamī, in view

49. At the tenth-century Madīnat al-Zahrā’, for example, most of the pavilions are rectangular buildings that overlook a pool or a garden through an arcaded porch. A similar plan is used at the eleventh-century Qal‘ah of Banī Ḥammād, although here the pool is surrounded by the architecture. Quadripartite courtyard gardens do exist in North Africa but perhaps not until the twelfth century.

50. Bosworth, The Ghaznavids, 133–34.

51. Jean Sauvaget, "Alep au temps de Sayf al-Dawla," Mémoires de l'Institut Français de Damas (Beirut, 1936).

52. See Oktay Aslanapa, "Erster Bericht über die Ausgrabungen des Palastes von Diyarbakir," Istanbuler Mitteilungen 12 (1962): 115–28; and Ara Altun, Anadolu'da Artukulu devri Türk Mimarisi'nin Gelişmesi (Istanbul, 1978), 215–28.

53. This raises questions about the little-known typology of palaces in contemporary Iran and Iraq and

the totally different typology extant in Seljuq Anatolia. Only two medieval palaces have been documented in Iraq, one in Baghdad and the other in Mosul. The first, so-called Abbasid palace has a courtyard plan but with only a single northern iwan, the other sides possibly being occupied by a mosque on the south and muqarnas-covered galleries leading to individual chambers on the east and west. It has been suggested by Naji Ma‘rūf in Al-madāris al-sharābiyya, 2d ed. (Baghdad, 1976), 173–217 passim, that this building is not a palace but a madrasa built by the late Abbasid vizier Sharaf al-Dīn al-Sharābī in 628/1230. Ma‘rūf's detailed argument is convincing in some respects, but it does not take into account the formal appearance of the main portal, which differs from all known madrasa portals yet resembles the portal of palaces (including the one in the Aleppo citadel) in its vestibule connected to a bent-axis corridor.

of its close proximity to the Aleppo citadel. The Artuqid palace at Diyarbakir (Fig. 61) and the Ayyubid palaces at Boṣra (Fig. 65), Karak, Shawbak, and the Roda Island (Fig. 66), which are quite distant from Aleppo and very little known, are referred to only in passing.

Although a thorough analysis of these four palaces is outside the scope of this book, a brief look at their plans, courtyard elevations, and some unusual features helps to situate the Aleppo palace within its family. The Qaṣr al-Banāt in Raqqa was recently excavated[54] and even more recently convincingly dated to the time of Nūr al-Dīn's rebuilding of the city's Great Mosque and fortifications around 1168 (Figs. 54 and 55).[55] The core of this palace is a square courtyard (9.95 by 9.15 meters) with four coaxial iwans. Of these, the eastern and the western iwans are identical in size, the southern is a little deeper, and the northern combines the form of the iwan with a tripartite basilical hall that ends in a smaller iwan with a rectangular chamber behind it. This building is closely related to the Umayyad *Dār al-Imāra* at Kūfa in its building material, its square courtyard with four iwans, and especially in the design of its northern basilical iwan (cf. Fig. 46). In fact, these two basilical throne halls so closely resemble each other in design that it would be tempting to suggest a much earlier date for the Raqqa palace, were it not for the existence of certain features, such as the *muqarnas* squinches in one of its ancillary chambers, that cannot be earlier than the twelfth century.[56]

Since no intermediaries link these temporally disparate structures, the cruciform palatial plan was perhaps not directly transmitted from Abbasid Iraq to Ayyubid Syria but rather adopted as a design that had long since entered the repertory of royal iconography. While this might explain the overall plan of Qaṣr al-Banāt, it cannot account for its close resemblance to the Kūfa palace, especially its use of a basilical throne hall. Since Qaṣr al-Banāt is unlikely to have been copied directly from the Kūfa palace, we may postulate an Abbasid palace at Raqqa that was itself based on the Kūfa prototype and may have provided the model for the later palace. Whatever the case might be, the plan of Qaṣr al-Banāt is not exactly repeated in any of the succeeding palaces, all of which have a standard cruciform plan without a basilical throne hall.

The Ayyubid palace at Qal'at Ṣahyūn was built in the late twelfth or early thirteenth century by Nāṣir al-Dīn Mankūras, a Kurdish prince to whom Ṣalah al-Din gave the fortress as a fief after its conquest in 1188 (Figs. 56–57).[57] It is entered through an elaborate portal (Figs. 38–41) that leads to a domed cruciform vestibule, which in turn leads to a courtyard through a bent-axis corridor. The courtyard (6.65 by 6.73 meters) is surrounded by four iwans, three of which have a tripartite composition while the larger fourth one fills the entire western side. Instead of the usual pool, the actual bedrock was

54. Kassem Toueir, "Der Qaṣr al-Banāt in ar-Raqqa. Ausgrabungen, Rekonstruktion und Wiederaufbau (1977–1982)," *DM* 2 (1985): 297–319.

55. Robert Hillenbrand, "Eastern Islamic Influences in Syria: Raqqa and Qal'at Ja'bar in the Later 12th Century," in *The Art of Syria and the Jazīra, 1100–1250*, ed. Julian Raby (Oxford: Oxford University Press, 1985), 37–39.

56. To these one might add the decorative brickwork on some of the columns and the octagonal pool in the middle of the courtyard.

57. Malcolm Cameron Lyons and D. E. P. Jackson, *Saladin: The Politics of the Holy War* (Cambridge: Cambridge University Press, 1982), 288–91.

excavated to form a shallow ring-shaped pool fed by two water channels emanating from the two niches flanking the northern iwan and drained by two more channels that leave the courtyard through the two niches flanking the southern iwan.[58]

Much closer to the Aleppo palace in form and in patronage is the palace at Qal'at Najm. This spectacular fortress, which dominates a strategic crossing of the Euphrates, has a long pre-Ayyubid history, but like the Aleppo citadel, it seems to have been extensively rebuilt during the reign of al-Ẓāhir Ghāzī.[59] This is confirmed by three inscriptions—the only ones discovered in the citadel—in his name: one above the portal and another at the entrance to the upper-level mosque, both dated 612/1215.[60] The third, which has only recently been uncovered, comprises inscribed stone blocks of gigantic size, comparable only to the Mamluk inscriptions on the towers of the Aleppo citadel. These blocks may have formed a large inscriptional frieze just below the level of the rampart.[61]

The cruciform palace is located to the right of the main vaulted passageway of the fortress (Fig. 58). A bath, guard rooms, and what has been identified as a bakery are annexed to it. The four iwans of the palace are disposed around a perfectly square courtyard (7.05 meters per side), with an elaborate octagonal pool in its center (Fig. 59). The plan, which resembes that of the Ayyubid palace at the Aleppo citadel to a remarkable degree, consists of two identical tripartite iwans on its eastern and western courtyard facades and two larger iwans on its principal north-south axis. The northern iwan fills up the entire facade, and its archivolt is embellished with a double molding that stands out in the context of the austere architecture (Fig. 60). It contains two openings on its eastern and western walls: the eastern leads to a small chamber; the western seems once to have connected with a wind shaft, the same arrangement as in the Aleppo royal palace. The southern iwan is only a representational iwan, serving as a tripartite entry to a spacious rectangular room, which in turn leads to other ancillary spaces. The central pond is identical to the one at the Aleppo citadel and to several other ponds built during the reign of Ghāzī and later, including the *madrasas* al-Kāmiliyya and al-Firdaws and *khānqāh* al-Farāfra.

Finally, the so-called *Maṭbakh* al-'Ajami, located not more than two hundred meters west of the citadel, is the only surviving nonroyal palatial residence from medieval Aleppo, if not from all Syria. Although not corroborated by inscription or direct textual reference, its ascription to the Ayyubid period has been accepted by most researchers on the basis of its current name and architectural features. Its current designation as *maṭbakh* (kitchen) undoubtedly postdates by several centuries its original usage as a residence,[62] but its attribu-

58. I have commented elsewhere on the cruciform created by these four channels and the overall link of the design with courtyard gardens in the western Islamic world; see Tabbaa, "Use of Water," 208.

59. Dominique Sourdel, "Ḳal'at Nadjm," *EI²*, 4:487. There is a considerable amount of source material on this fortress, and its excavation by 'Ali Simmaqiya has been especially fruitful. But to date no site reports or analytical articles have been written about it.

60. *Répertoire*, nos. 3776 (portal) and 3777 (mosque).

61. This was the suggestion made by the archaeologist and restorer of the fortress, Ali Simmāqiya.

62. The name may indicate the subsequent endowment of the palace as a kitchen for the poor. Unfortunately, this obvious deduction and the undeniable palatial nature of the structure have been ignored in the current rebuilding of the palace and its conversion into a restaurant.

tion to al-'Ajamī believably connects it with Banu al-'Ajamī, an illustrious family through-out the medieval history of Aleppo.[63] Several palaces belonging to this family are men-tioned by Ibn Shaddād; at least one would fit the general location of this structure.[64]

The 'Ajamī palace suffered greatly in the widening of Khan al-Wazīr Street in 1965, when its entire southern third was demolished (Fig. 62). It is entered today through a long vaulted passage with a bent axis that leads from the street to the northeastern corner of the main courtyard. This spacious courtyard (9.70 by 9.90 meters) is surrounded by four iwans and covered by a dome on *muqarnas* pendentives, possibly the largest preserved Ayyubid dome. All four iwans are flanked by narrow arched openings, forming the tripartite facade composition typical of Ayyubid palaces. The eastern and western facades are nearly identical in form and size: they are fronted by narrow triangular arches and contain modest-sized rectangular rooms behind them (Fig. 63). The southern iwan was once a spacious, nearly square hall with a raised alcove at its southern end. It opened through doors in the middle of its eastern and western walls to large, nearly isolated *qā'as*. The northern iwan, which is framed by an elaborate arch with pendant voussoirs, seems to have been more official (Fig. 64). I shall turn to it below.

In addition to their cruciform four-iwan plans, nearly all eight palaces mentioned above share two other related features. First, their courtyards are either perfect squares (Ṣahyūn and Najm) or close approximations of a square. Boṣra, with a rectangular courtyard covered by a cross-vault, is the only exception in this group (Fig. 65). Second, the dimensions of these courtyards generally fall within a fairly restricted range, between 6.35 meters and 9.70 meters per side, or between approximately 50 and 90 square meters in area. The two exceptions are the palace at the citadel of Diyarbakir (Fig. 61),[65] which has a miniscule courtyard (3.50 by 3.80 meters), and the Roda palace, whose dimensions cannot be determined with any accuracy (Fig. 66).[66] These dimensions are small, even in comparison with those of the courtyards of some contemporary *madrasas*. While these palaces may have had second stories and other appendages, such as baths or storerooms, the modest dimensions of their courtyards seem to indicate their overall modest size. I shall return to this point later.

Another question raised by the modest size of the courtyards and their overall squarish plan is whether some of them were originally domed. Two facts strengthen this possibility: al-'Ajamī palace is covered by a dome that appears to be original to the Ayyubid structure, and the palace at the Boṣra citadel is covered by a cross-vault, undoubtedly because of its rectangular courtyard. But arguing against the existence of a courtyard dome for the Aleppo citadel palace and some of the other palaces is the dearth of archaeological evidence. As far as we know, none of these palaces, even those

63. See Chapter 2 for the patronage of the Banu al-'Ajamī. They seem to have inhabited the privileged region between the Great Mosque and the citadel, where their two extant monuments—*madrasa* al-Sharafiyya and *matbakh* al-'Ajamī—are located.

64. Ibn Shaddād, *A'lāq*, 1:133 and 136.

65. Oktay Aslanapa, "Erster Bericht."

66. A rough measuring of the plan reproduced by Creswell from the original in *Description de l'Egypte* yields a courtyard of 6.50 meters by 5.50 meters. This is small enough to have been domed, and the triple columns at each corner of the courtyard seem to support this possibility; Creswell, *MAE*, 2:86.

that have been properly excavated and restored, show any traces of a dome, such as fragments of *muqarnas* or masses of specially cut stone. This is equally true for the Aleppo citadel palace, where the Shādirwān fountain, the plants said to have flowered in its courtyard, and the second floor covering some of its portions further diminish the possibility of a dome.

The Tripartite Court Facade

The partly restored northern courtyard facade consists of an iwan flanked by two narrow doors surmounted by arched windows (Fig. 67). This tripartite composition is found in the eastern and western facades of the small court and in nearly all the twelfth- and thirteenth-century palaces of Syria and the Jazīra (Figs. 64 and 68). The form is also used in pious buildings, including *madrasas* and *bimāristāns*, beginning with their very earliest examples in Syria: the *madrasa* of Gümüshtekin in Bosra (1136) and the *bimāristān* al-Nūrī in Aleppo, datable to c. 1150.

Tripartite courtyard facades have a long history in Middle Eastern architecture; the composition is first seen in Parthian temples and palaces, such as the Sun Temple at Hatra and the Parthian palace at Assur.[67] Possibly originating in Roman gates and triumphal arches, this composition is combined in Parthian and Sassanian architecture with the iwan form. Subsequently, tripartite iwan compositions are documented at a number of early Islamic palaces, including Kūfa, Ukhaidir, Sāmarrā, and Lashkār-ī Bāzār, which is known to have been modeled after Samarran prototypes. Samarran and East Persian palaces crucially influenced the overall development of the medieval Islamic palace, whose tripartite facade may thus owe its origin to classical Islamic prototypes.

But a closer and somewhat more concrete prototype is provided by the Early Christian churches of northern Syria, several of which exhibit this composition in their facades and, especially, in some of their interior divisions.[68] The medieval specimens closely resemble their late antique predecessors in the quality of their stonework and the use of lintels but differ from them in the use of the iwan for the central space. Thus, the tripartite facade composition as known in medieval Syria and the Jazīra was perhaps ultimately based on the fusion of the eastern tripartite iwan composition with the local architectural tradition of northern Syria.

To what extent can we attribute any specific meaning to this highly ubiquitous form? Although the Parthian palace at Assur arguably still retained some of the specific meanings associated with the triumphal arch, the medieval examples are too chronologically and culturally removed to allow for any such associations. At this point the most we can say is that by the middle of the twelfth century this form had become one of the necessary

67. Roman Ghirshman, *Persian Art: The Parthian and Sassanian Dynasties, 249 B.C.-A.D. 651* (New York: Golden, 1962), 32. At Hatra, another important Parthian site, the tripartite form is also used as a gate and in the exterior facades of temples; idem, 35–36.

68. Some of these are illustrated in Georges Tchalenko, *Villages antiques de la Syrie du nord*, 3 vols. (Paris: Librarie Orientaliste Paul Geuthner, 1953).

elements of a royal palace or aristocratic residence, perhaps even an important component of palatial iconography.

Also part of this aristocratic iconography may have been the elaboration of the arch framing the main iwan and its vault. Although neither vault nor arch has survived in the Aleppo citadel palace, we are fortunate in possessing a single outstanding example of these forms in the palace of al-'Ajamī in Aleppo. The northern iwan of this palatial residence is distinguished from the other three by its highly elaborate arch, which is composed of a double row of alternatingly pendant and recessed voussoirs (Fig. 69). The trefoil-shaped pendants of the inner and outer arches are staggered in such a way that the pendants of the rear arch can be seen between the pendants of the front arch, creating a luxurious effect.

The iwan behind this arch seems at first surprisingly small and inconsequential, an incongruity that is perhaps attributable to the special demands made by the spectacular vault covering it. The vault, measuring approximately 2 by 4 meters, is a supreme example of north Syrian stereotomy (Fig. 70). It is actually made up of two identical square *muqarnas* vaults that are suspended without a central supporting arch. Each half of the vault surrounds a little octagonal cupola with an inscribed eight-pointed star. The complex design unfolds from these central octagons, which are encircled by eight clustered pendants ending in four-pointed stars that resemble a starry halo. The two octagons enclose between them a hexagon surrounded by a six-pointed star, located at the exact center of the vault. All eight corners of the two half-vaults are embellished by five-pointed stars, and each pair of these stars except the four in the middle contains three tiny three-pointed stars between them. By means of an ingenious composition and excellent craftsmanship, the mason was able to display stars with three, four, five, six, and eight points, all within a traditional *muqarnas* vault. The master of the house would have sat underneath a starry canopy fronted by an elaborate arch with pendant voussoirs, all arranged so as to minimize their bulk and deny their crushing weight.[69] It is quite possible that the vault of the northern iwan of the palace in the citadel was made in a similar manner.

Imagery of Water

Although poorly preserved, the northern iwan of the citadel palace stands out because in its rear wall is a *muqarnas* vault beneath which a *shādirwān* fountain once flowed (Fig. 71). Only traces of this fountain exist, but it is quite vividly described by Sibṭ Ibn al-'Ajamī, who visited the palace (already in ruins) sometime in the early second half of the fifteenth century.

69. Although unique in other respects, such suspended vaults are not uncommon in Syria, especially Damascus, where they can be seen in at least three portals of Zangid and Ayyubid *madrasas*: al-Nūriyya al-Kubra (1172), al-'Ādiliyya al-Kubra (c. 1220), and al-Qillījiyya (1256) All are illustrated in Herzfeld, "Damascus-II" and "Damascus-III." One of the most spectacular vaults of this kind, consisting of three suspended vaults, has already been seen in the portal of the Ayyubid palace at Qal'at Ṣahyūn.

The floor of this courtyard is reveted in solidly assembled colored marble. There is in it a fountain, fed by the sweet *sāturah*,[70] that flows down a *maqlab*[71] which is located in its own small iwan, solidly constructed of colored marble. . . . Below this *maqlab* the water plunges under the floor, later to burst out in a water jet in the middle of the courtyard.[72]

Assuming that the sovereign would have sat on a kind of a dais throne near the rear middle part of the iwan, he would have had a miniature waterfall rippling behind his back, a stream of water flowing beneath his feet, and a *muqarnas* vault above his head.

Two possible sources for this powerful image can be suggested, the first originating in the pictorial representation of royal figures and the second in the actual use of water in Islamic palatial architecture. In one of its earliest depictions in Islamic art, this image occurs in a well-known fresco located in the apse of the central hall at Qusayr 'Amra, datable to c. 720.[73] The fresco portrays an enthroned and haloed figure "shown in the manner of the Byzantine Cosmokrator" with an aquatic scene beneath his throne and the blue sky above it.[74] Although this representation is the only one of its kind, the basic theme of a royal personage enthroned between a body of water and a luminous sky is not entirely lost in the succeeding centuries but is perpetuated in the decorative arts, where it occurs on some examples of twelfth- and thirteenth-century Persian pottery and metalwork.[75]

The antecedents of this image in architectural iconography are equally deep and complex, given the ubiquity of water in pre-Islamic and early Islamic palatial architecture.[76] Among its many other uses in palaces and gardens, water, often in the form of single or intersecting courses, seems to be closely associated with the throne of the sovereign, therefore with the concept and iconography of royalty. Already present in some of the Sāmarrā palaces, this association is further elaborated at the Ghaznavid palace of Lashkar-ī Bāzār and at some Zīrid and Ḥammādid palaces in North Africa, which also produce the first documented use of the *shādirwān*.[77] By the twelfth and beginning of the thirteenth century this fountain type becomes quite common in medieval Islamic palaces, including the Norman La Ziza palace near Palermo (1166–85) and

70. This is the name of the main water cistern of the citadel.

71. Perhaps a local name for the Persian word *shādir-wān*. The adjectival noun is derived from the Arabic root *qlb*, among whose many meanings is that of turning over or upside down. In this context *maqlab* refers to the action applied to the flowing water by the carved surface of the inclined marble slab.

72. *Trésors d'ors*, 165.

73. Quite a large bibliography exists on the frescos of Qusayr 'Amra, compiled until 1965 in Creswell, *EMA*, 1, no. 2:414–15. More recent work has been done by Grabar in *Formation*, 45–48, and "La Place de Qusayr Amrah dans l'art profane du Haut Moyen Age," *Cahiers Archéologiques* 36 (1988): 75–83.

74. Richard Ettinghausen, *Arab Painting* (New York: Rizzoli, 1977), 30.

75. A luster plate, dated 616/1219–20, at the Teheran Archeological Museum, and a luster bowl, dated 624/1227, formerly at the Kelekian Collection, both depict a seated figure and a body of water with swimming fish beneath him. See Richard Ettinghausen and Grace Guest, "The Iconography of a Kashan Luster Plate," AO 4 (1961): figs. 4 and 6.

76. See Tabbaa, "Use of Water"; and idem, "Typology and Hydraulics in the Medieval Islamic Garden," in *Garden and Landscape History: Issues, Approaches, Methods*, ed. John Dixon Hunt (Washington, D.C.: Dumbarton Oaks Publications, 1992), 303–29.

77. Idem, "Use of Water," 201 and fig. 3.

the palaces at the citadels of Ṣahyūn, Najm, and Diyarbakr (Fig. 58).[78] Although paradisiac associations were sometimes implied in the use of water in gardens, its use in such a highly charged secular setting must also reflect the power and sophistication of the patron. In the specific case of Ghāzī, this fountain also celebrates his major efforts at expanding the underground water network in the city and especially the citadel; he was responsible for bringing water to its moat and enlarging a vast underground cistern in its eastern half. In fact, Ibn Shaddād specifically states that only after Ghāzī's extensive works did it become customary for Aleppine houses to have pools in their courtyards.[79]

The Medieval Islamic Palace in the Shadow of Classical Islamic Palaces

As should be clear from this discussion, these five components of the palace—sculptural ornament, *muqarnas* portal, four-iwan plan, tripartite courtyard facade, and *salsabīl* fountain—all belonged to the repertory of significant forms in medieval Islamic palaces, and, except for the *muqarnas* portal, they all echoed well-established formal typologies in early Islamic palaces.[80] Indeed, the correspondences between the two kinds of palaces are at times so striking that they almost eclipse the crucial difference of scale. This essential difference can best be understood by comparing the courtyard dimensions of some early and medieval Islamic palaces (see Appendix, Table 1).

The average courtyard of a medieval palace measures approximately 7.57 by 7.25 meters; that of an early Islamic palace measures a gigantic 62.17 by 42.50 meters. The ratio of the average linear dimensions of the two groups is approximately 1 to 8 (8.21) for the longer (usually north-south) dimension and 1 to 6 (5.85) for the shorter one. In effect, this means that the surface area of the courtyards in early Islamic palaces is on the average forty-eight times that of medieval ones, a striking disparity that clearly underlines the basic differences between the two groups of palaces and hence between the two periods in which they were built.

This difference in scale is so startling as to demand a reevaluation of all the implied similarities and the overall relationship between the two classes of palace. Clearly, this is not a relationship of equals but rather one of petty dynasties invoking a distant golden age—ninth-century Sāmarrā or tenth-century Baghdad—which they are unable to supersede and yet unwilling to ignore.[81] The palaces they built were not just miniature versions

78. See George Marçais, "Salsabīl et Šādirvan," in *Mélanges d'Histoire et d'Archéologie de l'Occident Musulman*, vol. 1 (Algiers, 1957).

79. *Alep*, 149.

80. Although no trace remains of any painted decoration in the Ayyubid palace, such decoration may have once existed. A short passage in Ibn Shaddād, *Ḥalab*, 26, describes an earlier palace on the same site called *dār al-shukhūṣ* (house of images) because of the many images decorating it.

81. The Ayyubids were tradition-bound in many other respects, including the adoption of classical poetic genres (see, for example, A. F. Ḥayb, *Al-Ḥarakah al-shiʿriyyah zaman al-ayyūbiyyīn fī Ḥalab al-shahbā'* [Kuwait: Muʿalla, 1987], 167ff.] and the use of proper names with historical associations (e.g., Muḥammad, Abū Bakr, Yūsuf, and ʿIsa).

of classical Islamic prototypes but an essentially new palace type, some of whose most important forms and images were derived from the past. These palaces were original not so much because they were smaller as because this down-scaling seems to have led to the sharpening of the appropriated images and the enhancement of their iconography. This is readily observed in the precision of the plans, the complexity of portals, the dramatic use of water, and the variety of such architectural devices as *muqarnas* and pendant arches— all calculated to induce wonder and amazement in the viewer.

I have attempted in this chapter and the preceding one to place the Ayyubid palace in the Aleppo citadel within a complex matrix of relationships that include its urban context, its typological parentage, the symbolic associations of its significant forms, and its links with contemporary and classical Islamic palaces. What distinguished this palace from all its cognates is not so much its formal qualities but its contextual relations, both inside and outside the citadel. Its overall significance derived equally from its formal and typological associations and from its multiple links with Aleppo, its history, its 'ulamā' and patricians, and its general population.

Viewed from this multifaceted perspective, the citadel appears less impregnable and isolated and more firmly linked with the city. Through overt and subtle means, it broadcast political and religious messages that were heard throughout the city. Conversely, the soft and luxurious image of the palace and even its smallish size were partly modified by the apotropaic and authoritative symbolism of its gates and the princely associations of its plan and forms.

To some extent, however, the contradictions between the image and intent of citadel and palace remain unresolved. And this may reflect the special situation of the Ayyubid dynasty of Aleppo—an alien dynasty that, perhaps more than any other, attempted to integrate its authority with that of the city.[82] Painfully aware of their arriviste status and of the limitations of brute force, the Ayyubids of Aleppo seem to have left no stone unturned and no venue unexplored in their attempts to establish the foundations of their rule while effectively and justly dealing with an urban population. The measure of power and dominion that they attained was not simply handed to them through their noble lineage and links with the Abbasid court but was actively constructed through historical, social, pietistic, and symbolic means. The resiliency of this construction ensured a century of prosperity and relative stability for Aleppo, but its inherent weakness could not withstand the onslaught of the Mongols and the far more centralized rule of the Mamluks.

82. The acculturation of the Ayyubids to local Arab culture stands in sharp contrast to the exclusionary policies of other alien dynasties, including the Rum Seljuqs and especially the Mamluks. Alone among these dynasties, the Ayyubids adopted Arabic names as well as conversing and writing in Arabic. A number of princes even became quite proficient in poetry and theology. By contrast, there is very little likelihood that the Rum Seljuqs ever learned Kurdish or Armenian, the main languages in Anatolia until recently. While a few Mamluks were given Arabic names, the majority were not. In any case, their well-known exclusionary policies stood firmly in the way of their integration within Egyptian society.

PART 3

CONSTRUCTIONS
OF
PIETY

5

The Mosque:
Diminishing Importance

The patrons of Ayyubid architecture were not primarily concerned with building congregational mosques. This is not so surprising as it may sound, since by the time of the Ayyubids Syria had existed under Islam for five centuries and had thus already accumulated a significant number of such mosques.[1] Syria and the Jazīra had also benefited in the middle decades of the twelfth century from Nūr al-Dīn's enormous program of architectural patronage, which was divided about evenly between congregational mosques and other institutions. In addition to founding new Friday mosques in Hama and Mosul, he was responsible for major additions and rebuildings at the Great Mosques of Aleppo, Ba'albak, Damascus, Raqqa, and possibly Ḥarrān.[2] His addition to the Great Mosque of Aleppo greatly increased its size,[3] perhaps eliminating any need for the Ayyubids to work on it further.

1. The situation is markedly different in the newly Islamicized regions of Anatolia, where numerous new congregational mosques were built, including those at Dunaysir, Mayyafāriqīn, Mardin, and elsewhere. See, for example, Tom Sinclair, "Early Artuqid Mosque Architecture," in The Art of Syria and the Jazīra, 1100–1250, ed. Julian Raby (Oxford: Oxford University Press, 1985), 49–68.

2. Nikita Elisséeff, "Les monuments de Nūr ad-Dīn," BEO 13 (1951): 14, 17, 22, 32, 34, 37; and Tabbaa, "Nūr al-Dīn," passim.

3. Terry Allen, "Some Pre-Mamluk Portions of the Courtyard Façades of the Great Mosque of Aleppo," BEO 35 (1983): 7–12.

A less obvious reason for the dearth of Friday mosques among Ayyubid buildings is that expressions of official and popular piety since about the twelfth century had taken a decisive turn toward smaller and more specialized institutions—especially *madrasas*, *khānqāhs*, and mausoleums—that fostered the Sunni policies of the Ayyubids and other post-Seljuq dynasties. Indeed, these institutions, with their more exteriorized form, wider basis of patronage, and directed agendas, may have been at odds with the far more traditional institution of the congregational mosque.[4]

Most of the congregational mosques that the Ayyubids did build were located in relatively marginal areas. A few were built in the Ayyubid-controlled parts of the Jazīra, including Manbij, Bālis (Maskana), and Mayāfāriqīn.[5] Others were erected within urban citadels, including Aleppo and Damascus, and remote fortresses, such as al-Muḍīq, Najm, Ṣahyūn, and Ḥārim.[6] Finally, some were constructed in the newly established suburbs of major cities, such as Ṣāliḥiyya in Damascus and Maqāmāt in Aleppo.[7] If there is any pattern in the location of these mosques, it is that they were built where they were needed, except in fortresses, where their building also had a symbolic dimension.

Both the topographies and the architectural remains confirm that the Ayyubids built a very small number of mosques in Aleppo. In addition to the Great Mosque, Ibn Shaddād mentions only four other congregational mosques for the entire city and its suburbs: the mosque in the citadel; the mosque of Sayf al-Dīn in al-Ḥāḍir, also known as the *madrasa* al-Sayfiyya;[8] a mosque in al-Ramāda, a southeastern suburb, called al-Bakhtī; and a mosque in Bānqūsa, a northeastern suburb, founded by 'Īsā al-Kurdī al-Hakkārī.[9] This list suggests that in the Ayyubid period congregational mosques were built in regions that were conceived as independent entities, usually by virtue of their extramural location. The citadel, of course, was always considered an independent entity.

The archaeological evidence is problematic and only partly supports the evidence from the topographies. The first problem is that two of the four mosques mentioned by Ibn Shaddād (at al-Ramāda and Bānqūsa) have totally vanished; the one in al-Ḥāḍir is fragmentary; and the fourth in the citadel is an entirely special case. The second problem is that the remains of two other mosques attributed to the Ayyubid period—al-Shaybānī and al-Dabbāgha al-'Atīqa—have survived but are not mentioned in Ibn Shaddād. This unusual omission requires further discussion.

4. There is only indirect evidence for this mosque-*madrasa* dichotomy. Humphreys, *From Saladin to the Mongols*, 210–12, notes that al-Ashraf Mūsā (1229–37), the most orthodox of the Ayyubids of Damascus, built only mosques.

5. None of these mosques has been adequately published. The mosque at Manbij has a square minaret with an inscription of al-Ẓāhir Ghāzī, dated 598/1202 (*Répértoire*, no. 3543). Only a minaret remains from the Bālis mosque, with an inscription of al-Malik al-'Ādil, datable to c. 600/1204. This minaret was recently discussed in Hillenbrand, "Eastern Islamic Influences," 21–48. The Mayāfāriqīn mosque is only partly Ayyubid; see Sinclair, "Artuqid Mosque Architec-

ture," 50–54.

6. Little is known about the archaeology of these fortresses, all of which have been subjected to considerable restoration in recent years. Their Ayyubid inscriptions are discussed in Wiet, "Une inscription d'al-Malik al-Ẓāhir": al-Muḍīq (602/1206); Najm (612/1215); Ṣahyūn (early thirteenth century).

7. The main congregational mosque in Ṣāliḥiyya was al-Muẓaffarī or al-Ḥanābila, built by Muẓaffar al-Dīn Gokburi in 604/1207. See Ernst Herzfeld, "Damascus: Studies in Architecture—IV," *AI* 13–14 (1948): 120–23.

8. Ibn Shaddād, *A'lāq*, 1:38, 118, and 149–50.

9. Ibid., 38.

The first of these omitted mosques is the so-called Jāmiʿ al-Shaybānī, located in Jallūm al-Ṣughra southwest of the Great Mosque. Its remains have been documented by Herzfeld as a small nondescript portal with an inscriptional plaque. The inscription, written in excellent Ayyubid *thuluth*, gives the name of the founder al-Malik al-ʿĀdil Abu Bakr, the name of the supervisor, and the date of the building.[10]

(١) بسم الله الرحمن الرحيم أمر بعمارته مولانا الملك العادل سيف الدنيا (٢) والدين ركن الإسلام والمسلمين أبو بكر محمّد بن أيُّوب خليل أمير المؤمنين (٣) أدام الله أيَّامه بتوليِّ الفقير أحمد بن عبد الله القصري في سنة إحدى وثمانين وخمس مائة

(Bismillāh . . . Has ordered this construction our master al-Malik al-ʿĀdil Sayf al-Dunyā w'al-Dīn, the pillar of Islam and Muslims, Abu Bakr Muhammad son of Ayyūb, the friend of the Commander of the Believers—may God perpetuate his days—at the hands of the humble Aḥmad son of ʿAbdullah al-Qaṣrī, in the year 581/1185).

The building, which is not identified in the inscription as a congregational mosque, was therefore built by al-Malik al-ʿĀdil during his short reign over Aleppo before the city was returned to al-Ẓāhir Ghāzī.[11] Herzfeld identifies Aḥmad b. ʿAbdullah al-Qaṣrī, the supervisor, as Fāris al-Dīn Maimūn al-Qaṣrī, an ex-official of the Fatimid court, who had moved to Aleppo with al-Malik al-ʿĀdil, where he died in 1213.[12] Judging from its inconsequential portal, the absence of a minaret, and its omission from the sources, this building was very probably not constructed as a congregational mosque but rather as a *masjid*. At a later time, possibly as late as the Mamluk period, it may have been restored by a member of the Shaybānī family, who owned a nearby *khān*, and converted into a congregational mosque.[13]

The so-called Jāmiʿ al-Dabbāgha al-ʿAtīqa (the old tannery) exists today primarily as a tall, solitary, anepigraphic minaret located about 200 meters due north from the Great Mosque (Fig. 72). Its associated mosque had almost completely disappeared by the time of Herzfeld's first visit in the 1920s, and its archaeological context has been totally destroyed in recent years. Herzfeld has dated it on stylistic grounds to the Ayyubid period, citing primarily its square shape, the cuspidated molding framing its four windows, and the *muqarnas* cornices defining its three levels.[14] None of these indicators, however, is definitive enough for a secure Ayyubid dating. Although the square shape is generally associated with pre-Mamluk Syrian minarets, most of the Ayyubid minarets in Aleppo were

10. Herzfeld, *MCIA-Alep*, 2:32.
11. See Chapter 2 for a brief discussion of this problematic succession.
12. Herzfeld, *MCIA-Alep*, 2:251–53.
13. There is no mention of this family in Ibn Shad-

dād or other Ayyubid sources. However, they are mentioned a number of times in the Mamluk source, Ibn al-Shiḥna, *Durr*, 189–92.
14. Herzfeld, *MCIA-Alep*, 1:249–50; and idem, "Damascus—III," 39–40.

short octagonal towers built over the main portal or in one corner of the building.[15] Conversely, although most Mamluk minarets are octagonal or even cylindrical, at least one is square: the minaret of the mosque and mausoleum of Qarāsunqur in the Maqāmāt, dated 709/1309.[16] On purely stylistic grounds, this square and totally unadorned minaret would be datable to the late eleventh or early twelfth century. Its secure early fourteenth-century date, therefore, suggests that it was deliberately archaizing, perhaps recalling or paying homage to the Ayyubid monuments that surround it. The same might be true of the minaret of al-Dabbāgha al-'Atīqa.

The two main stylistic features in the minaret of al-Dabbāgh al-'Atiqa—the cuspidated molding and the *muqarnas* cornices—also present problems for an Ayyubid dating (Fig. 73). The cuspidated molding, the name given to a molding in which chevrons and cusps alternate, is known in Aleppo in a handful of examples, including the door frame of the *bīmāristān* of Nūr al-Dīn (1150–54) and the inscription of al-Ẓāhir Ghāzī at *maqām* Ibrāhīm (594/1198) (Fig. 80). There are no known examples after this date, again suggesting that its use in the minaret of al-Dabbāgha al-'Atīqa was a form of archaism. Indeed, compared to earlier cuspidated moldings, it appears overlinear and decorative, having lost all its antique organic quality in the process of copying. The *muqarnas* cornices, on the other hand, appear perfectly Mamluk: their cells are too small and their composition too rigid to be Ayyubid.

Thus, the minaret of al-Dabbāgha al-'Atīqa was probably not Ayyubid but perhaps early Mamluk in date. Its archaistic shape and decoration were meant to evoke an earlier era, or more specifically, to refer to the minaret of the Great Mosque, which is just 200 meters due south of it. Furthermore, although Ibn Shaddād fails to mention it, the later topographer Sibṭ Ibn al-'Ajamī (d. 1479) lists it among Mamluk mosques, further suggesting that it was a Mamluk structure.[17]

Eliminating al-Shaybānī and al-Dabbāgha al-'Atīqa from the list of Ayyubid congregational mosques leaves only the mosque of the citadel, also called the upper *maqām* of Ibrāhīm.[18] It is located at the uppermost level of the citadel, at the end of the staircase leading from the entry block to the northern ramparts (Fig. 74).[19] Built completely of stone, the mosque and its 25-meter minaret tower over the citadel. Externally, the mosque is a perfect square, 26.75 meters per side, with a square minaret attached to its northeastern corner. Its single plain portal just south of the minaret bears a foundation inscription in the name of al-Ẓāhir Ghāzī (Fig. 75) (see above).

15. See below, Chapter 7, for a fuller discussion of this problem.

16. Herzfeld, MCIA-Alep, 3:pl. CXL a.

17. Sibṭ Ibn al-'Ajamī, 52–53. The author relates an anecdote that might shed some light on the significance of this mosque. A certain Mūsa al-Ṣarrāf (the money changer) is said to have converted to Islam (most likely from Judaism) in this very mosque. Could it be that this insignificant mosque with a huge minaret, located midway between the Christian and Jewish quarters, was primarily symbolic, intended to assert the presence of Islam even in traditionally non-Muslim quarters?

18. MCIA, Alep, 1:132–34.

19. Placing the mosque at the highest point of the citadel seems to have been customary in the medieval Islamic world. It is also seen at Qal'at Ja'bar, Qal'at Najm (where the mosque even has a view of the Euphrates), Mārdin, and Cairo.

(1) بسم الله الرحمن الرحيم أمر بعمله مولانا السلطان الملك الظاهر (2) العالم العادل المجاهد المؤيَّد المظفَّر المنصور غياث الدنيا والدين أبو المظفَّر (3) الغازي ابن الملك الناصر صلاح الدين يوسف بن أيُّوب خلَّد الله ملكه سنة عشر وستمائة

(Bismillāh . . . has ordered its construction our lord the sultan al-Malik al-Ẓāhir, the learned, the just, the champion of the faith, the supported, the aided [to victory; my addition], the victorious, the succor of the world and of the religion, Abu'l-Muẓaffar Ghāzī son of al-Malik al-Nāṣir Ṣalāḥ al-Dīn Yūsuf, son of Ayyūb, may God immortalize his sovereignty, in the year 610 [1213].)

Internally, the mosque consists of a porticoed courtyard, 13.30 by 12.35 meters, and an oblong sanctuary, 23.95 by 5 meters (Fig. 76). A continuous barrel-vaulted corridor, now intercepted by a number of later walls, once ran behind the massive piers of the arcade. On the northern side this *riwāq* leads to four small rooms built within the massive exterior wall of the citadel. Although primarily intended as retreats for study, these chambers must have doubled as posterns, since three of them end in arrow slits. The sanctuary closely resembles the tripartite sanctuaries found in most Ayyubid *madrasas*, but this one has one extra bay at either end. All these bays are cross-vaulted, except the center one, which is covered by a dome resting on bipartite triangular pendentives.

The mosque, which has been rather harshly restored in recent years, is plain even by Ayyubid standards. The *miḥrāb* is much simpler than most contemporary *miḥrābs*, lacking their flanking columns and various moldings and interlaced masonry (Fig. 77). It is totally undecorated except for the use of bichromy in its hood and incised geometric ornament on the voussoir and soffit of its arch. The simplicity of the mosque might be attributed to the haste of its building after the fire that consumed the citadel during the wedding of Ghāzī and Ḍayfa Khātūn.[20]

The limited interest in mosque building during the Ayyubid period and the highly conservative nature of the congregational mosque seem to have greatly circumscribed the formal development of this institution. Whereas the Ayyubid *madrasa* drew on a variety of monumental types, vaulting techniques, and stereotomic motifs, the Ayyubid mosque, whether in Aleppo or Damascus, steered close to simple and unchanging formulas. With virtually no exception, the mosques built in Damascus during the Ayyubid period were based on the plan of the Great Mosque of Damascus (Fig. 78),[21] and those built in Aleppo were derived from the tripartite plans of the *masjids* within *madrasas*.

In the Mamluk period, by contrast, official patronage shifted dramatically from *madrasas* to congregational mosques. This transformation was even noted by the late Mamluk topographer Ibn al-Shiḥna, who after listing the small number of Ayyubid mosques, went on to say that "since that time more than twenty mosques in which the *khuṭba* is delivered have been built."[22] Mostly erected by Mamluk governors in the

20. Ibn Shaddād, *A'lāq*, 1:26.
21. The most complete study to date of this phenom-

enon is still Herzfeld, "Damascus—IV," 118–38.
22. Ibn al-Shiḥna, 66–67.

fourteenth and fifteenth centuries, these mosques, unlike their Ayyubid counterparts, were large and very richly decorated. Furthermore, whereas the Ayyubids only built congregational mosques in parts of the city deemed independent from it, the Mamluks built mosques everywhere, within and outside of the walled city.

These differing Ayyubid and Mamluk practices may have had a theological basis: as Kurds, the Ayyubids were Shāfiʿīs, whereas, as Turks, the Mamluks were Ḥanafīs. According to Pedersen, "the Shāfiʿīs . . . permit the Friday service in only one mosque in each town," but the Ḥanafīs were more flexible in this regard.[23] This important difference, Pedersen adds, was clearly at work in Egypt during the Ayyubid and Mamluk succession. When Saladin took control of Egypt in 1173, he apparently restricted the Friday service to the al-Ḥākim mosque, which was the largest in the city. But in 1266, al-Ẓāhir Baybars, through the intervention of his Ḥanafī theologians, abandoned this rule and allowed the building of many Friday mosques.[24] The same mechanism was also clearly at work in Aleppo.

23. J. Pedersen, "Masdjid," *EI²*, 6:656. 24. Ibid.

6

The Shrine and Popular Piety

Although the act of foundation of a *madrasa*, a *khānqāh*, or even a mosque can often be pinpointed, shrines elude this type of analysis. As spots commemorating a sanctified event, celebrating a vision, or protecting a holy relic, they have a kind of transcendent existence that predates the building act, which in a sense is only intended to give substance to the memory and embellish the sacred presence. This ontological presence gave shrines in the Islamic world a continuity and a pan-religious appeal that other institutions lacked, with the possible exception of the first congregational mosques.[1] The persistence and continuity of these shrines from Christianity (and sometimes Judaism) to Islam, as well as from Shi'ism to Sunnism, also reflected their status as institutions of popular piety standing somewhat outside the legalistic divisions of high religion.

But this continuity was not entirely free from tension; indeed, it might be described as a continuity that could accommodate a variety of changing religious and sectarian controversies. In an ancient city like Aleppo, which in the Ayyubid period contained an

1. Indeed, even these mosques may owe part of their continued importance and appeal to the presence of shrines within them. This is certainly true of the Great Mosque of Aleppo, which contains a shrine for Yaḥyā ibn Zakariyya (Saint John the Baptist); and the Great Mosque of Damascus, which contains a shrine for the same saint as well as another for al-Ḥusayn.

unprecedented variety of shrines—pre-Christian, Christian, Sunni, and Shi'i—these tensions were often close to the surface. Rarely resulting in total effacement or destruction, such strains could lead to assimilation, transformation, appropriation, or sectarian competition. The following discussion first outlines the history of shrines in Aleppo, then analyzes its remaining Sunni and Shi'i shrines as well as the sectarian rivalry that evidently contributed to their size and importance and may even have informed their design.

Commemorative shrines for prophets of the Old Testament had been known in Syria and the Jazīra since the early days of Christianity. The Aramaic and Arab Christians of Syria took no great interest in the Christianity of the Gospel, which they regarded as a kind of class religion. Instead, they adapted their own pagan cults and heroes to the new religion by incorporating the attributes of some Old Testament prophets. Trimingham wrote: "Certain Old Testament heroes they regarded as universal figures. Those upon which the Arabs placed the most stress, Abraham and Ishmael, Amos and Job, were actually pastoral nomads."[2]

Islam inherited the cults of the Old Testament prophets, first through the Qur'ān and later through *Qiṣaṣ al-Anbiyā'* (stories of the prophets).[3] Assimilated into Islamic popular religion, these cults formed what might be called the traditionalist or even Sunni branch of saint worship. For Shi'i Islam, the veneration of saints focused from the start on the martyrs of Shi'ism, for whom commemorative monuments were erected and whose birth and martyrdom were celebrated in elaborate ceremonials. Indeed, some of the earliest Sunni commemorative shrines were probably built in direct rivalry with the Shi'is, as was the case in tenth-century Khurāsān.[4]

The Cult and Shrines of Abraham in Aleppo

The most important commemorative shrines in Aleppo were those dedicated to Abraham, all of which had a pre-Islamic history. There were shrines for Abraham in the village of Nawā'il, east of Aleppo; at the Ṣāliḥīn cemetery; and two within the citadel. This unusual interest in Abraham was motivated by a number of factors. First, Muslims considered Abraham the first true monotheist (*ḥanīf*), since his monotheism was uninfluenced by either Judaism or Christianity. His religion is said to have been a direct precursor of Islam, a claim that gave the new religion precedence over Judaism and Christianity.[5] Second, Abraham and Aleppo were linked by the widely accepted legend that the city's ancient Semitic name, Ḥalab, alluded to Abraham milking his goats near the citadel (*ḥalaba Ibrāhīm*).[6]

2. J. S. Trimingham, *Christianity among the Arabs in Pre-Islamic Times* (London: Longman, 1979), 240.

3. There are several compendiums of this extremely widespread genre of pious literature. See T. Nagel, "Ḳiṣaṣ al-Anbiyā'," *EI²*, 4:180–81. Among the more popular of these compendiums are: al-Tha'ālibī, *'Arā'is al-majālis fī ḳiṣaṣ al-anbiyā'* (Cairo, 1898) and al-Kisā'ī,

Ḳiṣaṣ al-anbiyā', ed. I. Eisenberg (Leiden: E. J. Brill, 1922).

4. Makdisi, "Sunni Revival," 156, after Ibn al-Jawzī, *al-Muntaẓam*, 4:205–6.

5. Trimingham, *Christianity among the Arabs*, 262.

6. Herzfeld, *MCIA-Alep*, 1:2–4.

Third, the veneration of Abraham and other ancient prophets was also apparently driven by the traditionalist trends that began to prevail in the twelfth century. Specifically, the Sunnis adopted the cult of Abraham in part because two of the three greatest and most sacred shrines in Islam, the Haram of Makka and the Dome of the Rock in Jerusalem, were at some level commemorative monuments for the great patriarch. Creating other monuments in his memory served the dual purpose of establishing a spiritual link with these great monuments while also responding to the far more engrossing tradition of Shi'i hagiography.

Finally, there was a political aspect to the veneration of Abraham and other Old Testament prophets. Since the tradition of these figures was deeply rooted in the Arab Islamic world, their commemoration by the foreign dynasties of the medieval period would have helped deepen their roots in their newly conquered lands. By appropriating the memory and cult places of these prophets, the foreign dynasties hoped to create for themselves a kind of spiritual genealogy that would enhance their own very short and non-Arabic genealogies. The fact that many of these rulers could trace their origins no more than two or three generations back would pale in comparison with their spiritual connection to Abraham and the first prophets.

These forces therefore motivated successive foreign dynasties in Aleppo—Seljuqs, Zangids, and Ayyubids—to maintain and improve the ancient Abrahamic shrines, of which three survive today. These are the two shrines in the citadel, one of which was converted into a mosque discussed in the preceding chapter. The second (Figs. 14 and 79) was totally rebuilt by Nūr al-Dīn in 563/1168 and subsequently restored or endowed by his young son Ismā'īl (575/1179) and his *atābek* Shādbakht (undated), as well as by al-Zāhir Ghāzī (undated), al-'Azīz Muhammad by the authority of Toghril (616/1219), Zayn al-Dīn Ibn al-Shihna (811/1408), and a few others.[7] The Ayyubid works, obliterated by the theft of all the revetment and furnishings of the shrine in the 1920s, seem to have been restricted to the splendid woodwork that once encircled the Nūrid *mihrāb* and the frames and shutters of the windows facing the courtyard.[8]

Despite the importance of this shrine, its location within the citadel would necessarily have restricted its access to those inhabiting the citadel and the select few visiting it. Far more important as a pilgrimage and burial site was the *maqām* Ibrāhīm at the Sālihīn cemetery—one of the first sites that the Great Seljuq sultan Malikshāh chose to visit when in 1086 he came to inspect Aleppo and see its "marvels" (*'ajā'ib*). He and his son—the crown prince 'Adud al-Dawla Ahmad, then nine years of age—were reportedly taken there by the minister of the court, Tāj al-Mulūk Abu'l-Ghanā'im. In commemoration of the visit, the young crown prince decided to build a small shrine, of which only a Kufic inscription, dated 479/1086, remains, located in the tympanum of the door leading to the sanctuary. In Rajab 505/January 1112, a certain *khwaja* Muwaffaq, client of the vizier Mu'ayyad al-Mulk, gave a stone *mihrāb* to the *maqām*. It is now the oldest preserved *mihrāb* in the city.[9]

7. Ibid., 119–32.
8. Ibid.,122–28. This wooden marquetry once contained two Ayyubid inscriptions: the first, undated, in the name of al-Zāhir Ghāzī; and the second, dated to 616 (1219) in the name of the *atābek* Toghril.
9. Ibid., 176–79.

The only Ayyubid inscription in this shrine belongs to al-Ẓāhir Ghāzī (Fig. 80). Its three short lines, dated 594/1198, are framed by a typically Zangid-Ayyubid "cuspidated" molding. It does not describe the nature of the work done, but its location in the northern wall of the courtyard suggests that the commission may have involved that part of the sanctuary. This possibility is borne out by the large-scale masonry of the northern wall and by the octagonal minaret above the portal (Fig. 81), a feature found in three other Ayyubid monuments: the *madrasa* al-Sulṭāniyya, the shrine of Nabī Yūshaʿ in Maʿarrat al-Nuʿmān, and the mosque al-Tawba in Damascus. Indeed, this minaret resembles other Ayyubid minarets in its squat octagonal form, which is further embellished here by a heavy *muqarnas* cornice supporting a circular balcony. The sophisticated treatment of the *muqarnas* zone is closely related to other Ayyubid *muqarnas* and need not argue for a fourteenth-century date, as Sauvaget has suggested.[10]

The one name that recurs in all three shrines for Abraham in Aleppo is al-Ẓāhir Ghāzī: he totally rebuilt the upper shrine in the citadel as a mosque; contributed some furnishings to the lower *maqām*; and rebuilt the extramural shrine, adding an attractive minaret to its northern part. Clearly, the Abrahamic tradition so actively encouraged by Nūr al-Dīn and princes before him was perpetuated by the most important ruler of the Aleppo Ayyubids. The veneration of this shrine continues today, and the cemetery around it is still considered "among the most noble of the Aleppo cemeteries."[11]

Shiʿi Shrines in Aleppo

A large number of small Shiʿi shrines once existed in Aleppo, including two *mashhads* for ʿAlī, *masjid* Sīdī Ghawth, *masjid* al-Nūr, and *mashhad* Qaranbiya.[12] Almost nothing has survived of these shrines, which in any case could not have been much larger than a single domed chamber with a small funerary garden.[13] Fortunately, however, two very important Aleppine Shiʿi monuments did survive: the *mashhad* al-Dikka (or Imam Muḥassin) and the *mashhad* al-Ḥusayn, located near each other at the foothill of Jabal Jawshan, about two kilometers west of Bāb Anṭākiya. They differ from other Shiʿi shrines in the city in terms of their size, complexity, and long history of patronage.

10. Sauvaget in "Notes sur quelques monuments musulmans," 224, disputes the Ayyubid date given to this minaret (and several others), suggesting that it cannot be any earlier than the fourteenth century. In addition to the art-historical arguments, presented elsewhere in this book, for an Ayyubid dating of other minarets (al-Sulṭāniyya and al-Firdaws), the main objection to Sauvaget's post-Ayyubid dating of the minaret is that it is not supported by epigraphic evidence. There are no fourteenth-century inscriptions in the building, and the inscription of al-Ẓāhir Ghāzī appears to be bonded with the masonry of the minaret.

11. Ghazzī, *Nahr*, 2:289.

12. Ibn Shaddād, *Alep*, 42–50.

13. Fragments from *masjid* Sidi Ghawth have been documented by Herzfeld, MCIA-Alep, 2:271–73. See also Janine Sourdel-Thomine, "Une inscription inédite de la madrasa as-Sultaniya à Alep," AAS 3 (1953): 67–70, which demonstrates that this shrine was converted into a *zāwiya* for Sufis from western Islam (*al-fuqarā' al-maghāribah*). But this shrine, like so many other historical buildings surrounding the citadel, was destroyed during the building of the *Serail* and the National Hospital in the first decades of this century.

Mashhad al-Dikka

First built in 351/962 by Sayf al-Dawla, the Ḥamdānid ruler of Aleppo, the *mashhad* al-Dikka was the earliest known Shi'i shrine in Aleppo. According to Ibn Shaddād:

> Sayf al-Dawla 'Alī b. Ḥamdān was sitting in a belvedere in his palace outside the city when he saw light descend repeatedly on the location of the *mashhad*. In the morning he rode alone to that place and dug in it. He found a stone inscribed with: "This is the grave of al-Muḥassin b. al-Ḥusayn b. 'Alī b. Abī Ṭālib." He thereupon gathered the 'Alawites in the city and asked them whether al-Ḥusayn had a son called al-Muḥassin. Some said: "We are not aware of that, but what we did hear is that Fāṭima was pregnant and the Prophet told her 'In your belly is Muḥassin.' When the day of the *bay'ah* came, they attacked her in her house to take 'Alī to the *bay'ah*, so that she aborted." Others said: "It is possible that the enslaved wives of al-Ḥusayn buried the aborted fetus in this location."[14]

Despite this highly dubious account and the silence of all Shi'i sources about this alleged son of al-Ḥusayn, the vision of Sayf al-Dawla, the most important Shi'i prince in the history of Aleppo, was apparently sufficient to justify the building of this shrine.[15]

This monument is located today in a western suburb of Aleppo on the slope of a barren hill, commonly known as Jabal Jawshan (Figs. 82–83). From the time of its foundation in 962 to the end of the twelfth century, this was the foremost Shi'i shrine in Aleppo. It was restored and expanded by Shi'i and Sunni rulers alike: the Mirdāsids in the second half of the eleventh century; the governor of Aleppo, Aqsunqur in 482/1089; *atābek* Zangī in 537/1143; Nūr al-Dīn in 541/1146; al-Ẓāhir Ghāzī in 585/1189 and 609/1212; and an unknown patron (but during al-'Azīz Muhammad) in 632/1234.[16] The Sunni patronage of Shi'i monuments is typical of the Ayyubid period in Aleppo; it recurs in the *mashhad* al-Ḥusayn, as discussed below.

The present jumbled appearance of *mashhad* al-Dikka testifies to its great age and numerous building phases. Its earliest extant part, dating back to Zangī, is the double-domed mausoleum in the southeastern corner, which contains a wooden cenotaph of possible twelfth-century date.[17] The projecting cubical mass at the northeastern corner constitutes the water facilities added by Nūr al-Dīn in 541/1146, his only contribution to a Shi'i monument. The rest of the building is Ayyubid. The main entrance, a massive stone *muqarnas* portal, bears an inscription in the name of Ṭāriq b. Ṭarīra b. Yaḥyā, dated by Ibn Shaddād to 585/1189 (Fig. 84).[18]

14. This tale is reported in full by Moritz Sobernheim, "Das Heiligtum Schaikh Muhassin in Aleppo," *Mélanges H. Derenbourg* (Paris, 1909), 370–90; and Jean Sauvaget, "Deux sanctuaires chiites d'Alep," *Syria* 9 (1928): 224–37 and 320–27.

15. See also Shaykh Ibrahim Naṣrallah, *Ḥalab w'al-tashayyu'* (Beirut: Mu'assasat al-Wafā', 1983), esp. 27–33, for a more traditionalist account.

16. Herzfeld, *MCIA-Alep*, 193–201.

17. Covered by thick layers of cheap carpets, this rarely seen cenotaph is an exquisite piece of medieval woodwork. It is carved and painted in series of niches with lamps, a motif also seen in the cenotaph of Khālid b. al-Walīd at the Damascus National Museum.

18. Herzfeld, *MCIA-Alep*, 1:193–201.

(١) بسم الله الرحمن الرحيم جدَّد عمارته في دولة مولانا الملك (٢) الظاهر
غياث الدنيا والدين غازي بن الملك الناصر يوسف بن أيُّوب (٣) الفقير الى
رحمة الله تعالى طارق بن طريرة بن يحيى

(Bismillāh . . . Has rebuilt this during the regin of our lord al-Malik al-Ẓāhir, the
succour of the world and of the religion, Ghāzī, son of al-Malik al-Nāṣir Yūsuf,
son of Ayyūb, the needy to God's mercy, Ṭāriq b. Ṭarīra b. Yaḥyā.)

This in effect would make it the earliest extant stone *muqarnas* portal in Aleppo, predat-
ing the one at the *madrasa* al-Shādbakhtiyya by four years. It is of the western type:
muqarnas pendentives support two tiers of complete *muqarnas* cells, which in turn support
a smooth hemispherical vault. This produces an incomplete and incongruous effect,
which, so far as I can tell, is unique among *muqarnas* portals.

The southern tripartite sanctuary was rebuilt, according to inscription, as a direct
commission of al-Ẓāhir Ghāzī in 609/1212.

(١) بسم الله الرحمن الرحيم أمر بعمارة (٢) هذا الموضع المبارك مولانا
السلطان (٣) الملك الظاهر غياث الدنيا والدين أبو المظفَّر (٤) الغازي
بن يوسف خلَّد الله ملكه في سنة تسع وستُّمائة

(Bismillāh . . . Has ordered the reconstruction of this blessed place our lord the
sultan al-Malik al-Ẓāhir Ghiyāth al-dunyā w'al-dīn abu'l-muẓaffar al-Ghāzī son of
Yūsuf, may God perpetuate his reign, in the year 609/1212.)

The sanctuary consists of three domes: the flanking ones rest on bipartite triangular
pendentives, while the center dome is raised above *muqarnas* pendentives (Fig. 85). The
interior is totally plain and covered with modern paint, although the *miḥrāb* may have
once been revetted in wooden marquetry. The northern portico, rebuilt under al-ʿAzīz
Muhammad in 632/1234, also consists of three domed bays, although these domes rest on
squinches instead of pendentives. The bays bear no detail or decoration whatsoever.

Mashhad al-Ḥusayn

The *mashhad* al-Ḥusayn is the most important medieval Shiʿi structure in all of Syria. It is
also the largest, most complex, and most enigmatic religious monument in Ayyubid
Aleppo, comparable in all these respects to the *madrasa* al-Firdaws. Although it appears
nearly intact today, it is actually a reconstructed building. The original structure was badly
damaged by a massive explosion in 1918[19] and remained in ruins for about forty years.

19. The shrine had been used to store ammunition accidental explosion, see Ghazzī, *Nahr*, 212–13.
since the end of World War I. For the details of this

Minor works of restoration in the 1950s were followed in the 1970s by a long process of conservation and restoration, funded by the local Shi'i community and directed by 'Ali Summāqiya of the Directorate General of Antiquities and Museums. The restoration, which took more than ten years to complete, is admirable for its methodical and scientific approach and for adhering as closely as possible to the original appearance of the monument. But it is not without some faults. The first is that a few building details were incorrectly restored, and I shall point those out in my description. The second and far more serious fault is that at some point the restoration took on the (unstated) purpose of rebuilding the monument for use as a Shi'i sanctuary. In recent years, long after the retirement of Mr. Summāqiya from the project, the process of "rehabilitation" of the monument has become highly damaging, with a steel-frame canopy erected over the courtyard and a gaudy "shrine" inserted between the main iwan and the chamber north of it.[20]

Unlike the *mashhad* al-Dikka, whose history of patronage goes back to the Ḥamdānids in the tenth century, the *mashhad* al-Ḥusayn is a totally Ayyubid building. According to Ibn Shaddād, who quotes the Shi'i historian Ibn abī Ṭayyi', this *mashhad* was built after a dream that a certain shepherd had while taking an afternoon nap at the foothill of Jawshan Mount. In his dream the shepherd was approached by a holy man who directed him to have the people of Aleppo build a shrine for al-Ḥusayn at the spot where one of the shepherd's goats had sunk into the solid rock. When he awoke, he pulled the goat from the rock and a spring of water gushed forth. This event was deemed sufficient proof of the sanctity of the location, and the shrine was begun shortly afterward.[21]

This peculiar tale notwithstanding, it is perhaps not coincidental that the shrine was begun shortly after the death in 569/1174 of Nūr al-Dīn, the sworn antagonist of Shi'ism in all its forms. It seems likely that the Shi'is of Aleppo took advantage of his passing and the succession of his eleven-year-old son Ismā'īl to assert once again their spiritual authority and rootedness in the land. The first phase of construction, begun during the short reign of al-Ṣāliḥ Ismā'īl (569/1174–577/1182), was a truly collaborative effort: the patricians of the community provided some of the capital; the artisans dedicated one workday per week to the shrine; and the shopkeepers in the bazaar also set aside some of their weekly profits for the purchase of materials and tools. According to Ibn Shaddād, the first part to be built was the prayer hall (*al-qibliyya*), which was first erected low and then increased in height to comply with the wishes of the historian's grandfather, who agreed to increase its funding.[22]

20. In January 1991, I notified Mr. Waḥīd Khayyāṭa, the director of Antiquities and Museums in Aleppo, of these violations while they were being committed. In June of the same year, I revisited the monument and was surprised to discover that the work had progressed to an irreversible degree: the courtyard was now completely covered with a heavy canopy supported by a massive steel framework. The once-bright courtyard was thus considerably dimmed, and the interior spaces were very dark. A monument so lovingly restored by Mr. Summaqiya was rendered an aesthetic ruin.

21. Dreams and visions were often used as pretexts for the creation of Shi'i shrines. Ibn Shaddād (*Alep*, 42–50) mentions no fewer than seven instances of this interesting phenomenon, which apparently has no parallel in Sunni piety. In five of these shrines—*mashhad* 'Alī, *masjid* Ghawth, *masjid* al-Nūr, *mashhad* Qaranbiya, and *mashhad* 'Alī *e.m.*—the vision was of 'Alī. In the *mashhad* al-Dikka it was a flash of light, and in *mashhad* al-Ḥusayn it was a miraculous occurrence.

22. Ibn Shaddād, *A'lāq*, 1:51.

According to Ibn Shaddād, the main iwan was built next. "The iwan in the middle [*fī ṣadrihi*] was built by the Hajj Abu'l Ghanā'im b. Shaqwīq out of his own private funds. The portal [to the shrine] was torn down, as it was too low, by Ṣafiyy al-Dīn Ṭāriq b. 'Alī al-Bālisī, the *ra'īs* of Aleppo. He raised it higher than before, and that was in the year 585/1189. And in this year its [?] construction was terminated" (51). Ibn Shaddād continues that both Ṣalāḥ al-Dīn and his son al-Ẓāhir Ghāzī took great interest in the shrine, dedicating considerable funds to its endowment. "When his son al-Malik al-'Azīz acceded to rule, Bahā' al-Dīn [Ibn al-Khashshāb] asked his permission to build next to the shrine an enclosure with residential units [*buyūt*] for the use of those who wished to withdraw in the shrine. He was granted permission, and construction began immediately. But the Tartars took over Aleppo before it was completed." After the Mongol destruction, the shrine was restored a final time by al-Ẓāhir Baybars (52).

This fairly detailed account is somewhat difficult to reconcile with the epigraphic and archaeological evidence. The earliest inscription in the shrine was previously located above the two niches in the main iwan (Fig. 97). Its three short lines specified that the iwan was built by a certain silk merchant (*bazzāz*) named Abu'l-Ghanā'im b. Abi'l-Faḍl Yaḥyā (or 'Īsa).[23]

(1) بسم الله الرحمن الرحيم أمرّ بعمارة هذا الأيوان المبارك

(2) العبد الفقير إلى رحمة ربّه أبو الغنائم بن أبي الفضل يحيى

البزّاز (3) الحلبي غفر له وذلك في سنة تسع وسبعين وخمسمائة

(Bismillāh . . . has ordred the building of this blessed iwan, the slave, the needy to his Lord's grace, Abu'l-Ghanā'im, son of Abi'l-Faḍl Yaḥyā al-Bazzāz al-Ḥalabi, may he be forgiven, and that was in 579 [1183].)

Herzfeld has disputed Ghazzī's dating of this disappeared inscription, instead proposing 569/1174. But this earlier date is quite unlikely since it predates by four years the vision of the shepherd, which allegedly took place at the end of 573/1178 and since it occurs just before the death of Nūr al-Dīn. The year 1183 is therefore the most likely date for the termination of the mosque and the iwan, whose peculiar funding arrangements must have made its progress very slow. The proposed date falls just outside the short reign of Ismā'īl (1174–82), but that in no way contradicts the literary evidence.

The next historical inscription comes from the main portal to the shrine, located in the middle of its eastern side (Fig. 93).

23. Herzfeld, *MCIA-Alep*, 1:228 and *Répertoire*, no. 3027.

(1) بسم الله الرحمن الرحيم (2) عمّر مشهد مولانا الحسين بن علي بن أبي
طالب عليهما السلام في أيّام دولة مولانا الملك الظاهر العالم العادل سلطان الإسلام
(3) والمسلمين سيّد الملوك والسلاطين أبي المظفّر الغازي بن الملك الناصر يوسف
بن أيّوب (4) ناصر أمير المؤمنين في شهور سنة إثنين وتسعين وخمسمائة (5)

(Bismillāh . . . was built the shrine of our master al-Ḥusayn son of ʿAlī son of Abī
Ṭālib, on them peace, during the reign of our lord al-Malik al-Ẓāhir, the learned,
the just, sultan of Islam and Muslims, master of kings and sultans, Abu'l-Muẓaffar
al-Ghāzī b. al-Malik al-Nāṣir Yūsuf b. Ayyūb, the defender of the Commander of
the Believers, during the year 592/1196.)[24]

This inscription contradicts Ibn Shaddād's chronology, which gives the termination date
for the portal as 585/1189, seven years earlier than the date given in the inscription. Here
also, we are obliged to accept the epigraphic evidence, which suggests that the progress of
construction was extremely slow. Epigraphic and archaeological evidence, therefore,
demonstrates that despite the slowness of construction—from prayer hall to iwan to
portal—the work continued uninterrupted between 1183 and 1196, a thirteen-year pe-
riod that thus represents a single building phase.[25] The inscription is also accurate in
distancing Ghāzī from the *mashhad*: he did not order its construction; rather, the shrine
was constructed during his reign.

The second building phase is not dated by any inscriptions, but it was presumably
begun and perhaps terminated during the reign of al-ʿAzīz Muhammad (1216–37). Herz-
feld attributes to this phase the two domed chambers and the public facilities adjoining
the shrine to the north and the entire eastern enclosure, whose residential units (*buyūt*)
were never completed. This attribution conforms perfectly with literary sources and
archaeological evidence.[26] The monument also contains four other texts—three pious
inscriptions and an artisan signature—whose reading does not affect the chronology of
the shrine. I return to these inscriptions below.

The entire shrine, including the unfinished enclosure, measures on the outside approxi-
mately 66.90 by 39.60 meters, which is longer but a little narrower than the *madrasa* al-
Firdaws. Photographs taken before the explosion show a massive and typically un-
ornamented stone structure, whose three main units are terraced over the gentle slope of
Mount Jawshan (Fig. 85). The uppermost terrace is occupied by the double domed
structure of phase two, the middle terrace encompassed by the central shrine, and the

24. *Répertoire*, no. 3483, and Ghazzī, *Nahr*, 2:213, give the date as 592. Herzfeld (*MCIA-Alep*, 1:238), on the other hand, proposed 596/1200. Unfortunately, that portion of the inscription is today too abraded to read with total certainty. I have, therefore, cautiously accepted the earlier readng.

25. Herzfeld, *MCIA-Alep*, 1:239.

26. Recent restoration work in the two northwest-ern domes has demonstrated that this section was built against but not bonded with the original shrine. I saw a number of walls in this wing whose southern ends revealed a clear break in bondage with the perfectly dressed masonry against which they were built.

lowermost terrace enclosed by the walls of the residential enclosure.[27] As with the *madrasa* al-Firdaws, the sobriety of the exterior is partly alleviated by the numerous domes whose profile juts slightly above the flat roofs. The *mashhad* al-Husayn has more domes—a total of thirteen—than any other pre-Ottoman building in Aleppo (Fig. 86).

The shrine is entered through a barrel-vaulted portal near the eastern end of the residential enclosure (Fig. 87). This leads to a vast walled enclosure, visibly unfinished until recently. The floor had not yet been leveled, and only a few of the cells near the portal had been built. The only noteworthy feature in this enclosure is a *mihrāb* in its southern wall, which suggests that part of it was intended as a *musallā*, or a place for outdoor prayer. In fact, the existence of another *mihrāb* in the exterior wall, about fifteen meters to the right of the portal, also intimates that overflow congregants would have been accommodated in an external *musallā*. The shrine was well equipped to handle the large numbers of pilgrims it apparently received.[28]

The main shrine is entered from the east through an elaborate *muqarnas* portal with a number of unique features (Fig. 88). Accessed from the lower terrace by four steps, the portal appears taller and narrower than other contemporary portals (Figs. 90–91). This false impression—2.70 by 7.75 meters is entirely within the norm—is enhanced by the depth of the portal, its unusual *muqarnas* vault, and the radiating pattern that crowns it. The builder contrived to make the portal as deep as it is wide by extending the *muqarnas* vault beyond the usual hemispherical design and framing it with a wide arch, which in turn supports the radiating stonework. The foundation text above the portal is not inscribed on a plain lintel, as is usually the case, but is framed within a splendid braided design, one of the hallmarks of Ayyubid stereotomy. Above this braid extends a frieze of tiny lamps suspended within a continuous arcade whose arches terminate in the three points of a star. The springing of the vault is marked by a tiny but richly ornamented molding, in which a pearled undulating filet is crossed by a scroll of grape vine (Figs. 92–93).[29]

The *muqarnas* vault is a unique variant of the eastern type. Creswell, who generally refrained from aesthetic judgments, was impressed by its "crispness and beauty" and by the uniqueness of its style.[30] It comprises four courses of cells, alternatingly large and small, that terminate in a little scalloped shell. In the first tier, seven large cells alternate with four massive brackets to form among them two star-shaped squinches. The lowermost cells are large enough to bear inscriptions (discussed below), and the squinches contain in their apexes little globular pendants carved with a floral pattern. The squinches and the edges of the brackets provide a highly corbeled zone on which the rest of the tiers are arranged in the usual manner.

The arch crowning the upper part of the vault is made up of seven massive trapezoidal ashlars, alternatingly black and white, whose joints form a radiating pattern with eight

27. Early photographs also show what appears to be a later residential structure, consisting of a dome and an iwan, built on top of the eastern end of the prayer hall. This structure has not been rebuilt.

28. The popularity of the shrine may be surmised from Ibn Shaddād's detailed description (*A'lāq*, 1:52) of the numerous gifts and votive objects that the Mongols looted from the shrine: "It was something that

cannot be counted nor contained within limits."

29. Herzfeld, *MCIA-Alep*, 1:239, believes the reappearance of these floral ornaments, which continue in Syria and Egypt until the Bahri Mamluk period, indicate the abandonment of the asceticism prevalent during the period of Nūr al-Dīn.

30. *MAE*, 2:146.

spokes. These voussoirs can credibly appear to be composed of a series of star-shaped arches framed by a large polylobed arch. In reality, the load-bearing voussoirs apparently had their upper portions cut away, leaving a lower chevron-shaped strip that would become part of the first star-shaped arch and serve as a footing for the other "arches" above it. In order to make this first arch appear truly star-shaped and totally independent of the voussoir, the front edges of each voussoir were given triangular notches that parallel the lines of the chevron above. The large recess thus produced between the cut-away surfaces and the dressed masonry of the flanking wall was then filled with a succession of brick-shaped stones in two different colors: yellow limestone and black marble. The star-shaped arches thus formed were then framed by two polylobed arches also made by slotting circular sections into the recessed space. The entire arch was set off by a dentillated molding, which also helps to hide the joints of the recessed voussoirs.

This complex process produces two fairly independent effects, the first general and the second iconographically specific. The general effect—also seen in *muqarnas* vaulting, pendant keystones, and interlaced masonry—is that of an unsupported structure whose oddly shaped arches do not seem arranged in the usual manner. In fact, the radiating bichrome arches seem to produce a floating effect that defies the static nature of architecture. Iconographically, the superposed voussoirs may be read as a radiant sun, whose disc is none other than the hood of the *muqarnas* vault. Indeed, this reading of the abstract composition is reinforced by the more figural reference to light, in the form of the frieze of tiny lamps. These references to light are especially appropriate in a shrine dedicated to al-Ḥusayn, who in Shiʻi hagiographic literature is often compared to a miraculous light.[31]

The signature of the artisan, located in a cartouche within the uppermost arch, has become obscured with time. The same artisan was probably responsible for the ceiling of the vestibule on the other side of the door. This monolith (2.70 by 1.75 meters) has been carved to imitate a richly ornamented wooden ceiling. Eight fluted beams set within a frame of deep niches "support" a ceiling inset with decorative cartouches. No examples of wooden ceilings are preserved from this period in Syria, but this unique specimen in stone conveys some idea of their appearance.[32] This monolith must have suffered considerable damage in the explosion; today only a small portion of it remains, while the rest has been rebuilt in concrete.

The portal bears one historical inscription, discussed above, and two religious inscriptions, whose content sheds some light on the situation of Shiʻism in Aleppo. The first of these is carved on both lateral faces of the portal bay, 4.40 meters above the floor level (Fig. 94).

(١) بسم الله الرحمن الرحيم اللهمَّ صلِّ على محمد النبي وعليّ الوصيّ والحسن الأمين المسموم والحسين الشهيد المظلوم وعلي زين العابدين ومحمد الباقر علم الدين وجعفر الصادق الآمر وموسى الكاظم الوفيّ وعلي الطاهر الرضى ومحمد البرّ التقيّ وعلي الهادي النقيّ والحسن العسكري وصاحب الزمان الحجّة المهديّ واغفر لمن سعى في هذا المشهد بنفسه ورأيه وماله

31. See Caroline Williams, "The Cult of ʻAlid Saints in the Fatimid Monuments of Cairo. Part I: The Mosque of al-Aqmar," *Muqarnas* 1 (1983): 37–52; and L. Veccia Valgieri, "Al-Ḥysayn b. ʻAlī b. abī Ṭālib,"

EI², 3:613, which recounts a tale about "the miraculous light emanating from [al-Ḥysayn's head]."
32. Herzfeld, *MCIA-Alep*, 1:241.

(Bismillāh . . . O God! Give your blessing to Muhammad the prophet; 'Alī the mandator; al-Ḥasan the trustworthy, the poisoned; al-Ḥusayn the martyr, the oppressed; 'Alī Zayn al-'Ābidīn; Muhammad al-Bāqir, the standard of religion; Ja'far al-Ṣādiq, the commander; Mūsā al-Kāẓim, the loyal; 'Alī the pure, the contented; Muhammad the reverent, the pious; 'Alī al-Hādī the pure; al-Ḥasan al-'Askarī; and the Master of Time, the Authority, al-Mahdī; and pardon whoever has worked for this shrine with his person, his opinion, and his fortune.)[33]

The last supplication in the inscription was intended for the favor of those members of the Shi'i community who had endeavored to build the shrine. The second inscription is carved on the three middle cells of the first tier of the *muqarnas* vault. Each cell is inscribed with three short lines (Figs. 95–96).

(A) (1) اللهمّ (2) صلّي على سيّدنا محمد (3) وعلى آل محمد وسلّم

(B) (1) ورضي اللّه (2) عن أبا بكر وعمر (3) وعثمان وعلي

(C) (1) ورضي اللّه (2) عن أصحاب (3) رسول اللّه أجمعين

(Oh God! Give your blessing to our master Muhammad and to the family of Muhammad and offer them peace. May God be pleased with Abu Bakr, and 'Umar, and 'Uthmān, and 'Alī. May God be pleased with all the Companions of God's Prophet.)[34]

Herzfeld shrewdly observes that this Sunni litany of the family of the Prophet neutralizes the Shi'i devotional formula inscribed just beneath it. This is quite correct; in fact, the same Sunni formula had been used for several centuries on tombstones[35] and inscriptions from the time of Nūr al-Dīn.[36] By the early Ayyubid period, this form of Sunni *taṣliya* seems to have become a necessary feature of the Friday sermon, as indicated by Ibn Jubayr's descriptions of the sermons at al-Azhar mosque in Cairo and at the Ḥaram of Makka.[37] In all these instances, the main purpose of the formula, which often also included al-Ḥasan, al-Ḥusayn, and Fāṭima, was not to gloat over the victory of Sunnism but rather to present a compromise that moderate Shi'is might accept.[38]

33. This is based on a direct reading of the inscription. Cf. Herzfeld's reading (MCIA-Alep, 1, 244), which omits the names of three of the Twelve Imams and the last two words of the inscription. It also gives the attribute of Ja'far al-Ṣādiq as al-Āmir instead of al-Amīn, which is the correct reading. The end of the inscription clearly refers to the community effort that led to the creation of this shrine.

34. Herzfeld also misread part of this very straightforward inscription. Instead of *rasūl Allah*, which makes perfect sense after *aṣḥāb*, he read *w'arḥam li'l-muslimīn*, which makes absolutely no sense in this context.

35. For example, the two tombstones (datable to the late eleventh century) published in Sarre and Herzfeld,

Reise, 2:figs. 272 and 27.

36. All the inscriptions of Nūr al-Dīn that have this Sunni formula are in the Great Mosque of Damascus. They are datable to the year 554/1159, when Nūr al-Dīn carried out important restorations in the Umayyad Mosque. See Creswell, EMA, 1:350–61, figs. 41–42; and Tabbaa, "Nūr al-Dīn," 179–81.

37. Ibn Jubayr, *Riḥlat*, 24–25 and 73.

38. This is clearly stated in Ibn Hubayra, *Kitāb al-Ifṣāḥ*, one of the most influential theological tracts of the twelfth century. The author repeatedly attempts to encompass within his views not just the four Sunni *madhhabs* but also the Imāmī or Twelver Shi'i who are not *ghulāt*.

The main iwan in the squarish courtyard makes clear the Shi'i nature of the shrine. A large calligraphic panel (7.75 by 1.25 meters, including the frame) sitting above the iwan forms the focus of the entire courtyard (Fig. 100). It gives the devotion to the Twelve Imams in large and clear *thuluth* script.

(1) بسم اللّه الرحمن الرحيم اللهمّ صلِّ على محمد المصطفى وعليّ المرتضى وفاطمة الزهراء والحسن المجتبى والحسين الشهيد وعلي زين العابدين ومحمد الباقر (2) وجعفر الصادق وموسى الكاظم وعلي الرضى ومحمد الجواد وعلي الهادي والحسن العسكري ومولانا محمد بن الحسن القائم بأمر اللّه تعالى

(Bismillāh . . . O God! Give your blessing to Muhammad the chosen, 'Alī the satisfactory, Fāṭima the brilliant, al-Ḥasan the chosen, al-Ḥusayn the martyr, 'Alī Zayn al-'Ābidīn, Muhammad al-Bāqir, Ja'far al-Ṣādiq, Mūsā al-Kāẓim, 'Alī the agreeable, Muhammad the generous, 'Alī al-Hādī, al-Ḥasan al-'Askarī, and our master Muhammad ibn al-Ḥasan al-Qā'im bi-amri Allah.)[39]

The central part of the shrine is disposed around a squarish courtyard (16.09 by 16.72 meters), which once contained an off-center small square pool (Fig. 97). The western side is dominated by an iwan raised on four steps and flanked by two smaller arches, an arrangement paralleled on a smaller scale in the eastern facade. As in contemporary *madrasas*, the southern sector is occupied by a prayer hall, consisting here of five domed bays. These domes are balanced on the northern side by three connected domed bays, a fourth dome in the northwestern corner, and an impluvium-vaulted square chamber in the northeastern corner. Also contributing to the balanced and unified appearance of the courtyard is a dentillated cornice raised on brackets that surrounds the courtyard on all sides except the iwan, which has a higher roof line.[40]

Overall, the plan (Fig. 88) is closely related to that of *mashhad* al-Dikka, particularly in the location of its portal and in the use of the domed bay to define space in the sanctuary and the northern portico. The main differences are the large iwan, which may or may not have existed at the *mashhad* al-Dikka, and the curious absence of a well-defined shrine at the *mashhad* al-Ḥusayn. Interestingly, the cooking and sanitary facilities that form an incongruously projecting block at the *mashhad* al-Dikka have been duplicated as a smaller and better integrated chamber in the northwestern corner of the first phase of *mashhad* al-Ḥusayn. This does not seem to have sufficed, and larger facilities were added in the second phase, as mentioned below.

The spacious iwan (5 meters wide, 7.85 meters tall, and 8.41 meters deep) forms the centerpiece for the entire courtyard (Figs. 89b and 97). With its flanking arches, its interlaced spandrel, and its crowing inscription, it constitutes a unified and unique

39. *MCIA-Alep*, 1:240.

40. Although not especially common in Syria, bracketed cornices or eaves are known in two closely related *madrasas* in Diyarbakr, al-Mas'ūdiya and al-Zinjiriya. These *madrasas* were both built by Syrian craftsmen.

composition that resembles a triumphal arch. The iwan itself (Fig. 99) is flanked by free-standing but recessed columns, a unique feature that also heightens the sense of its monumentality. The columns carry *muqarnas* capitals topped by impost blocks, from which spring the arch of the iwan. It is a typically pointed arch made up of very large voussoirs, whose surfaces have been carved with two moldings that follow the outline of the arch and constitute the starting points of a large knotted pattern that fills up both spandrels.

This interlaced motif, one of the most complex and engaging aspects of Aleppine masonry, has not been adequately analyzed (Fig. 98). Indeed, it is difficult enough to describe this ornament or even find a concise term for it. Creswell suggested calling it "interlacing rectangular strapwork,"[41] while Herzfeld proposed a number of related names, including "spandrels in marble maquetry with entrelacs" and "interlaced spandrel ornament."[42] Creswell's term seems redundant, Herzfeld's somewhat indefinite; neither mentions color, which, in all cases but one, is essential. I would suggest using "interlaced polychrome masonry" as a term that captures material, coloristic effect, and geometric quality.

Their interlaced appearance notwithstanding, these spandrels, like any stretch of masonry, have presumably first been laid out in regular courses. At the *mashhad* al-Ḥusayn, these regular courses are still readily visible in the less complex parts of the pattern, but they begin to lose their simplicity and acquire a knotted quality toward the middle part of the design. What is difficult to determine—that is, without dismantling the entire spandrel—is which part of the interlaced design is structural and which part has been inlaid into specially prepared slots. It seems probable here and in other examples that although some inlay was used judiciously, most of the masonry is structural while also forming part of the overall pattern. Both structural and decorative, this masonry epitomizes the main principle of north Syrian stereotomy, namely the skillful cutting of stones into an invisible portion that forms part of a structural body and a visible portion that constitutes part of a decorative pattern. The basic stereotomic technique is closely related to *muqarnas*; in both, the structural and decorative aspects of the masonry are closely related. But interlaced masonry lacks the corbeled, three-dimensional aspect of *muqarnas* while introducing a coloristic effect.

Herzfeld suggests that this interlaced masonry and the large Shiʿi inscription above it postdate the original building of the iwan in 579/1183. The only evidence he presents for this hypothesis is his view that such interlaced masonry first appeared in Aleppo in the *miḥrāb* at the *madrasa* al-Shādbakhtiyya, dated 589/1193 (Fig. 171). But in the absence of any literary, epigraphic, or archaeological evidence to support this claim, the decorative masonry and the inscription should be assigned to the first phase of construction—making the interlaced motif above the iwan the earliest of its kind in Aleppo and the first of a long series. This conclusion is not at all far-fetched. After all, the portal, which belongs to the end of phase one, displays astonishing stonework, as shown above; and the *miḥrāb*, which belongs to the beginning of phase 1, already shows interlaced masonry.

The iwan originally contained two tall niches in its rear wall. These have been blocked

41. Creswell, MAE, 2:170–71. 42. Herzfeld, "Damascus—II," 61–62.

up and replaced with windows at a higher level. The iwan also has a *miḥrāb* carved into its southern wall, one of four in this part of the shrine alone. This *miḥrāb* is today completely obscured by a large, shiny brass object, referred to as *Ḥusayniyya*, that seems to have a devotional function in contemporary Shiʻi ritual. To the right of the iwan there was originally a pair of square domed rooms, since reconstructed as rectangular cross-vaulted rooms. And to its left is a complex chamber consisting of a square cross-vaulted bay and a smaller barrel-vaulted bay. With its own *miḥrāb* and numerous storage niches and nooks, this room may have served for private devotion.

The prayer hall consists of five domed bays: four of these are raised on bipartite triangular pendentives, while the *miḥrāb* dome rests on a zone of *muqarnas* pendentives of the western type (Fig. 101). Large corner brackets support above them two cells each. The apexes of these cells support four sides of a cymated octagonal molding, on which are arranged two rows of staggered *muqarnas* cells (Fig. 104). A smooth dome of concentric courses rests above these cells.

The *miḥrāb*, which must date to the earliest years of the first construction campaign, appears at first glance to be totally plain (Fig. 102). With the exception of two marble columns that have lost their capitals,[43] it is made from the same yellowish limestone as the rest of the sanctuary. Unlike other Ayyubid *miḥrābs*, it is not lined with polychrome marble, nor is it likely that it once had such revetment since the masonry of the concavity and the hood is perfectly smooth. But what it lacks in precious materials, it makes up by the skillful and ingenious design of its interlaced masonry. Here, in the earliest recorded example of this form, the artisan could not rely on coloristic effects to produce the knotted and suspended impression seen in later interlaces. Rather, he had to produce the desired effect in monochrome, relying on the precise cutting and subtle detailing of the stone surfaces.

In fact, two artisans seem to have collaborated on this *miḥrāb* and perhaps much of the first building project. Their names are signed in a medallion just above the *miḥrāb* (Fig. 103).

(1) الله (2) صنعة أبي عبد (3) الله وأبي الرجا (4) إبني يحيى [الرستاني] (5) رحمهما

(The work of Abī ʻAbdullah and Abī al-Rijā, the sons of Yaḥyā [al-Rastānī], may God have mercy on them.)[44]

The reading of the father's *nisba* has proved troublesome for most writers. Herzfeld read it as al-Khatrānī, which is simply untenable.[45] Ghazzī read it as al-Kinānī, hoping to connect it with the famous tribal name of Kināna.[46] This is equally unlikely, since the word contains the following succession of letters: *alif*, *lām*, illegible character, *sīn*, *tā'*, *fā'* or *nūn*, and *yā'*. Al-Kistāfī, al-Rustāfī, and al-Rastānī seem to be the most likely readings.

43. These capitals were still in situ during Herzfeld's visit (Figs. 79 and 80). They were salvaged Romanesque capitals from Frankish territory.

44. The same two brothers also signed the *miḥrāb* of

the *madrasa* al-Shādbakhtiyya, dated 595/1198; see Chapter 7.

45. *MCIA-Alep*, 1:241–42.

46. *Nahr*, 2:213.

But the first two are problematic since they are not derivable from any toponyms. The one possible exception is al-Rastānī, which might be associated with the town al-Rastan, just south of Hama.

Phase 2 of the shrine, datable to 1216–37, consists of two independent units connected by a wide arch and accessed through separate entrances cut into the northern wall of the original shrine. The two units are further distinguished from each other by their relative height: the western unit is built up on a higher terrace, while the eastern unit is on the same level as the main courtyard (Fig. 105). The western unit is accessed through a short flight of steps that leads into one of two domed chambers. The westernmost of these is a spacious room (8.65 by 6.05 meters) equipped with seven storage niches. It is covered by a dome that rises above a magnificent squinch zone, the most perfect example of a rare type in Aleppo (Fig. 106).[47] Four large squinches fill the corners, their arches supported by pairs of colonnettes that rest on a projecting console. They contain among them four other niches that are built into the thickness of the dome's drum. The size and solidity of these niches permitted the builder to bypass the usual octagonal zone and directly build a sixteen-sided drum on which rests a smooth dome set off by a heavy molding. The body of the dome itself is pierced by four windows located midway between the squinches. The eight niches, all with radiating conches, create a solid but rhythmical effect that greatly contributes to the spatial quality of this chamber.[48]

The second chamber consists of a central domed square (approximately 5.10 meters per side) surrounded by iwans on its southern, eastern, and northern sides and by the arch of the adjacent chamber on its western side (Fig. 107). This gives it a cruciform appearance, which is further emphasized by the tripartite arrangement of the southern iwan. One of the smaller arches of this tripartite composition is the actual entrance to this wing, while the other leads to a corridor that revolves around the main eastern iwan and leads to a latrine with a very tall ventilation shaft.

The dome rests on a double tier of muqarnas cells, the upper one forming a complete circle beneath the springing point (Fig. 108). The muqarnas zone is of the eastern type except that its corner cells rest on brackets that resemble small pendentives. The dome is pierced by three windows and once terminated in an oculus that provided much-needed illumination to this wing. It has been rebuilt as a smooth dome without an oculus.

The exact function of these two chambers is difficult to determine with any certainty. The size of the northwestern chamber and the presence in it of seven niches (usually intended for the storage of books) suggest that it was used for study and meditation. The adjoining chamber has a pronounced residential character, evident primarily in its cruciform plan and especially in its tripartite southern iwan (Fig. 107), which is a characteristic feature of all preserved palaces in Ayyubid Syria (see above). Indeed, this chamber differs from contemporary palaces only in its reduced scale and in the dome over its central space

47. Herzfeld, MCIA-Alep, 1:247, compares this dome to domes from a number of early Byzantine structures, including the church of Alahan Manastiri in Cilicia and the Basilica at Rusafa. See Sarre and Herzfeld, Reise, 4:pl. cxxii. The treatment of the squinch zone is indeed nearly identical, although none of these domes had the eight-niche arrangement of the dome of mashhad al-Ḥusayn.

48. This dome has been cited as an influence on some domes in Sicily, southern France, and Egypt.

(or courtyard). Its residential character is further emphasized by its nearby latrine. In short, this space may have been the "private" quarters of the *shaykh* of the *mashhad*.

The southeastern part of phase 2 also consists of two adjoining chambers (Fig. 89a). The larger of these, generally identified as the kitchen, is today an open space with a well in its northern end and a staircase built against its western wall. This may have led originally to a timber-built mezzanine for the storage of grains and other perishables. Unlike the kitchen at *mashhad* al-Dikka, this one does not have a fireplace, or at least none has survived. The chamber is covered by an impluvium vault whose opening is set off by an architrave consisting of a cymated frieze and a cornice on brackets. The adjoining chamber is a rectangular space with seven isolated latrines.

Built between the last decades of the twelfth century and the beginning decades of the thirteenth, the *mashhad* al-Ḥusayn represents Ayyubid architecture at its peak of development and innovation. Rejecting strict symmetry as an organizational principle, the building instead presents an "equilibrium of functional parts, carefully weighed . . . with enough contrast not to become monotonous."[49] This equilibrium is achieved less by confronted iwans than by picturesquely arranged domes, whose volumetric aspect softens the otherwise linear architecture and contributes a rhythmic quality to the monument. One iwan instead of four dominates the plan; it is balanced across the courtyard by a smaller iwan that provides only a gesture of symmetry.

The vaulting and ornament at the *mashhad* al-Ḥusayn encompass the entire repertory of Ayyubid architecture and introduce some new features. In addition to such standard features as the *muqarnas* portal vault and dome, this shrine also has an extraordinary stone dome on squinches and a monolithic flat vault that imitates a wooden ceiling. Their stereotomic ingenuity aside, these vaults define the space beneath them and imbue it with a sense of serenity. In terms of ornament, this building introduces three main features: the frieze of lamps and the radiating voussoirs at the portal and the interlaced polychrome masonry in the spandrel of the main iwan. The first two, probably related iconographically to al-Ḥusayn, do not appear in other monuments. The third, possibly because of its less specific meaning, becomes quite common in Aleppo and elsewhere in the Islamic world.

The brilliance of the *mashhad* al-Ḥusayn and its less illustrious neighbor, the *mashhad* al-Dikka, must have easily eclipsed the *maqām* Ibrāhīm and posed a challenge to the Sunni Ayyubids. The challenge, it seems, was met in one of two ways. The first and most obvious was through direct acts of patronage to these shrines. Ayyubid rulers contributed to both *mashhads* and had their names inscribed on them, hoping to ingratiate themselves to the Shi'i population while also stressing their own authority. Less directly, the challenge was met by developing the vicinity of the *maqam* Ibrāhīm into a region of Sunni piety and pilgrimage. Although the sources are silent on this matter, there is little question that the flurry of *madrasa* building activity near the *maqam* Ibrāhīm was at least in part a response to the challenge posed by *mashhad* al-Ḥusayn. These *madrasas*, as explained below, were larger and more elaborate than any previously attempted, and they contained some features first seen at the two Shi'i shrines.

49. Herzfeld, "Damascus—III," 37.

7

Propaganda and Education
in the Ayyubid *Madrasa*

Scholars have virtually ignored a curious disjuncture between the peak of Islamic learning and the development of specifically educational institutions. This disjuncture is temporal: the high period of Islamic intellectual culture in the ninth and tenth centuries predates by two or three centuries the peak of activity in the construction of educational institutions, in particular of *madrasas*. It is also geographical: whereas the most illustrious centers of learning were generally located in Iraq and eastern Iran, *madrasas* and other institutions of learning were most highly concentrated in Syria, Anatolia, and somewhat later in Egypt. Both aspects of this disjuncture are closely related to the overall emphasis of Islamic learning, which in the earlier period was dominated by philosophy and the ancient sciences, in the later by jurisprudence and Qur'ānic sciences.

Despite the considerable attention that different facets of this major cultural shift have received, the problem in its totality and especially the central role of the *madrasa* remain largely neglected. Indeed, the very complexity of the problem seems to have fallen victim to the increasing specialization of twentieth-century Orientalist scholarship. As a subject that straddles the fields of Islamic intellectual history, institutional history, and architec-

tural history, the *madrasa* has thereby been fragmented into at least three different areas of research that do not always inform one another.[1]

This was not always the case. The illustrious scholar Max van Berchem addressed both the institutional and the architectural aspects of the *madrasa*.[2] Although based on inadequate archaeological information and an incomplete understanding of the processes of Islamic higher education, van Berchem's attempt to synthesize the literary and archaeological evidence is methodologically sound and, in my view, has not been entirely superseded by other more specialized approaches. This is not in any way to diminish the importance of later scholarship, whether by archaeologists like Creswell or intellectual historians like Makdisi, whose contributions in fact greatly inform the following discussion. It is rather to suggest that an integrated approach drawing on these recent findings is once again needed to present a coherent picture of the *madrasa* as form and as institution.[3]

Following van Berchem's example, therefore, this chapter treats both institutional and architectural aspects of the *madrasa* in Syria, particularly in Ayyubid Aleppo. As background, I summarize the origins of the *madrasa* in eastern Iran and Iraq and its overall message during the Sunni transformation of the twelfth century. I next examine the progressive westward shift of the *madrasa* from Iran to Syria and the role played by Nūr al-Dīn in its institutional development. The formal development and variation of the Ayyubid *madrasa* is handled in three long sections: the first treats its interesting connections with contemporary palace architecture; the second discusses its religious components, in particular the chapel mosque and the mausoleum; and the third analyzes the way specific functional requirements, such as housing and water supply, were accommodated within its structure.

The Madrasa: Institutional and Functional Development

Almost exactly a century ago, van Berchem argued for the first time that the *madrasa*, which had been generally associated with the Great Seljuqs and with the person of Niẓām al-Mulk in particular, originated much earlier and in much humbler surroundings.[4] These early *madrasas* existed in large numbers in eastern Iranian and Central Asian cities—such as Amul, Nishapur, Merv, and Bukhara—where they were located in small *masjids* or the private residences of professors.[5] In a subsequent but closely related development, some of

1. Cf. George Makdisi, *The Rise of Colleges: Institutions of Learning in Islam and the West* (Edinburgh: Edinburgh University Press, 1981): "Thus political history, religious history, as well as institutional history are all involved and must be unscrambled before one can hope to understand the significance of the madrasa and its place in history."

2. Max van Berchem, "Origine de la madrasah," *MMAF* 19, no. 2 (1894): 254–69.

3. It is interesting in this regard that the recent article by Robert Hillenbrand, "Madrasa, III. Architecture," *EI²*, 5 (1986), esp. 1136–38, by and large follows the outline provided by van Berchem and in fact contradicts the views expressed by George Makdisi just a few pages above in the same article.

4. Van Berchem, "Origine de la madrasah," 254–69.

5. Some numerical information is provided in Hillenbrand, "Madrasa," 1136. See also Nājī Ma'rūf, *'Ulamā' al-niẓāmiyyāt wa-madāris al-mashriq al-islāmī* (Baghdad: Matba'at al-Irshad, 1973), 4–9.

these professors either endowed their own house as a *waqf* to be used as a *madrasa* in perpetuity after their death or built a small structure as a *madrasa*, using their own funds and contributions from the community. Van Berchem therefore concluded that the first *madrasas* were "of a private character; whereas the official courses were generally held in the mosque, the original madrasas were due to the professors themselves, and the teaching they dispensed in them was independent and personal."[6]

In the mid-eleventh century important changes in patronage rather abruptly transformed the overall character, and quite possibly the form, of the *madrasa*. In 459/1066 Niẓām al-Mulk, a man of great learning and solid convictions who was vizier to three successive Seljuq sultans, founded the great Niẓāmiyya *madrasa* in Baghdad and, shortly thereafter, other *madrasas* bearing his name in different parts of the Seljuq empire. Due largely to his patronage and overall Sunni policy, the *madrasa* was transformed from an independent religious fellowship to "une institution politique sous le contrôle officiel de l'Etat,"[7] or, in the words of a recent writer, a "state-sponsored and largely state-financed" institution.[8]

Much has been written about Niẓām al-Mulk and the *madrasa*; the recent trend has been to downplay his singular importance in favor of a more gradual process that involved other patrons and other institutions of learning. Makdisi in particular has insisted that there was nothing new in the building of the Baghdad Niẓāmiyya, proposing that "it had been done before by men of means, who were neither viziers nor finance ministers" and concluding therefore that it "was not an official institution."[9]

While Makdisi's premises cannot be denied, his conclusions are especially problematic for architectural historians, for whom the vernacular origins can differ decidedly from the monumental form of a given institution and who put considerable stock in the very process of monumentalization. In this respect, what Niẓām al-Mulk did to the *madrasa* between 1066 and his death in 1092 can only be compared in extent and magnitude to what the Umayyad caliph al-Walīd accomplished for the congregational mosque. Both pulled an important religious institution out of its vernacular beginnings, re-created it in an imperial image and in the capital city, and duplicated it in the major cities of the realm. Furthermore, it is no more possible that Niẓām al-Mulk used only private funds for creating this vast network of *madrasas* than it is that al-Walīd or other great patrons of architecture would have. Indeed, there is every reason to believe that the Seljuq sultan supported, coordinated, and even funded this great endeavor in which so much, after all, was at stake.[10] From this perspective, the *madrasas* founded by Niẓām al-Mulk and other high officials and sultans after him were, if not state institutions, then institutions for the state.[11]

6. Van Berchem, "Origine de la Madrasah, 260; translation by Makdisi, *Rise of Colleges*, 297.

7. Ibid., 260.

8. Hillenbrand, "Madrasa," 1136.

9. George Makdisi, "The Sunnī Revival," in *Islamic Civilization, 950–1150*, ed. D. S. Richards (Oxford: B. Cassirer, 1973), 158.

10. The overall policy of Niẓām al-Mulk and his patronage of *madrasas* are neatly summed up in Richard Bulliett, *The Patricians of Nishapur: A Study in Medieval Islamic Social History* (Cambridge: Harvard University Press, 1972), 72–75. Bulliett (73) specifically stresses the role of the Niẓāmiyya *madrasas* in "control[ling] the patriciate by making it dependent upon the state."

11. Yet Makdisi is right that these *madrasas* did not just teach Ashʿarī theology but were more broadly based in the various *madhhabs* of Islamic jursiprudence. In Baghdad, particularly in the person of the caliph, Ḥanbalism was especially strong. See ibid., 159–64.

Madrasas were from the beginning associated with the resurgence of Islamic traditional-ism (*salafiyya*), a reaction prompted at least in part by the dominance of Muʻtazilī rationalist thought in the ninth and tenth centuries. Although this so-called Sunni revival was not dominated by a single *madhhab* or a uniform theological orientation, it was, despite internal controversy, at least arguably united by its opposition to Shiʻi doctrines, which at the time were variously influenced by rationalism. On a more official level, these early *madrasas* also represented incipient efforts to counter Fatimid institu-tions of Shiʻi propaganda, including the al-Azhar mosque founded by the caliph al-Muʻizz in 359/970, the *Dār al-Ḥikma* of the caliph al-Ḥākim, founded in 395/1005, and espe-cially the various *Dār al-Daʻwas* that were established throughout the Islamic world, including Syria and Iran.[12]

The *madrasa* perfectly suited the political agenda of the Seljuqs and their vizier Niẓām al-Mulk, who saw in it the ideal means for providing the new empire with a moral framework while countering the power and influence of the Fatimid caliphate. According to Bosworth, "Niẓām al-Mulk desired to speed up the provision of educational institutions within the eastern Sunni world and to make them comparable with those still flourishing in Umayyad Spain and Fāṭimid Egypt."[13] In addition to their anti-Shiʻi charter, the Niẓāmiyyas served an equally important if somewhat more mundane function, namely the training of a loyal body of state officials, including notaries, judges, and other *madrasa* professors. Such systemization of education seems perfectly congruent with Niẓām al-Mulk's political ideas as explicated in his treatise, the *Siyāsat-nāma*, whose central theme is the use of trained individuals to maintain order and enforce control and power.[14]

While accepting the *madrasa*'s normative function as a college of law, Makdisi has per-sistently rejected its role in Seljuq political propaganda, stressing that "it had no special mission to serve against Shiʻism or Muʻtazilism."[15] This view of the *madrasa* as an indepen-dent and nonpolitical institution may have been valid for the earliest *madrasas* in Khurasan or Baghdad (on which Makdisi's work tends to focus) but loses credence when extended to the post-Niẓām period.[16] Ample direct and indirect evidence, especially from the twelfth and thirteenth centuries, demonstrates that the *madrasa* was perceived as anti-Shiʻi in character and was a crucial institution for the newly emerging post-Seljuq succes-sor states.[17]

12. C. E. Bosworth, "The Political and Dynastic History of the Iranian World (A.D. 1000–1217)," in *The Cambridge History of Iran*, vol. 5, *The Saljuq and Mongol Periods*, ed. J. A. Boyle (Cambridge University Press, 1968), 71.

13. Ibid.

14. It is interesting, however, that from early on this institutionalization of learning was viewed skeptically by the *ʻulamā*ʼ of Transoxiana, who, according to Hajjī Khalīfa in *Kashf al-Ẓunūn*, 1:53: "were quite distressed when they were told about the erection of *madrasas* in Baghdad. They staged a mock funeral for learning, say-ing that *ʻilm* was once practiced by those of high moral character and pure spirit . . . but once a salary could

be derived from it, the lowly and the lazy would encroach upon it."

15. Makdisi, *Rise of Colleges*, 300.

16. The narrow foundation for Makdisi's argument has already been noted by R. Stephen Humphreys, *Islamic History* (Princeton: Princeton University Press, 1991), 210: "Makdisi's conception of his topic is very much rooted in that time and place [eleventh-century Baghdad], and even though *The Rise of Colleges* includes much materials from Ayyubid and Mamluk Cairo and Damascus, he is not quite at home there."

17. Indeed, nearly all writers on the *madrasa* (other than Makdisi) have stressed these two tenets, including Bosworth, Sourdel-Thomine, and quite recently Ḥas-

The different receptions of the *madrasa* in Damascus and Aleppo strongly suggest that it was generally perceived as an aid to Sunnism and a threat to Shi'ism. The Damascenes, historically known for their traditionalism and adherence to orthodoxy, wholeheartedly accepted this new institution for learning: even before Nūr al-Dīn began his own *madrasa* building program in 1154, the city boasted no fewer than eleven *madrasas*.[18] In Aleppo, on the other hand, the founding of the *madrasa* al-Zajjājiyya, the first one in the city, was vehemently opposed by patrician Shi'i families, who sent their hooligans to tear down at night what been built during the day, thus delaying its completion by six years, until the year 510/1116.[19] This antagonistic reaction to *madrasas* seems to have continued well into the twelfth century when, during a serious illness of Nūr al-Dīn in 1157, the Shi'is of Aleppo went on a rampage and destroyed several *madrasas* and *khānqāhs*.[20] These incidents are sufficient, I believe, to illustrate that the Shi'is considered the *madrasa* a threat to their sect.

The stamp of state authority was also impressed on *madrasas* during their foundation ceremonies and other important events held in them, including receptions for diplomatic visitors. The most detailed account of such events comes not from Ayyubid Syria but from the roughly contemporary (1233) description of the opening ceremonies for the *madrasa* al-Mustanṣiriyya in Baghdad.

> On Thursday the fifth of Rajab Naṣīr al-Dīn, the vice minister, and all the *wālis*, *ḥājibs*, *qāḍis*, professors, and jurists; and the *shaykhs* of *ribāṭs* and sufis, preachers, Qur'ān readers, poets, and a group of the select among the merchants and the foreigners were present at the *madrasa*. He selected for each *madhhab* in the *madrasa* sixty-two students, and appointed for it two professors and two assistant professors. . . . Each professor was presented with a black cloak, a dark blue robe, and a fully caparisoned mule. As for the assistants . . . each was offered a white coat and a silver-threaded turban. . . . A dinner was then spread in the entire courtyard of the *madrasa*.

The dinner was followed by poetic recitals praising the *madrasa* and its founder, after which each of the professors and assistant professors discussed their curriculum. The *madrasa* was then divided into four unequal quarters; the Ḥanafīs and Shāfi'īs got the larger sections on either side of the mosque and the Ḥanbalīs and Mālikīs the smaller quarters to the right and left of the entrance.[21] The anonymous chronicler adds that "on

san Shmaysāni, in *Madāris Dimashq fi al-'aṣr al-Ayyūbi* (Beirut: Dar al-Afaq al-Jadida, 1983), 266ff. See, on the other hand, Gary Leiser, "The *Madrasa* and the Islamization of the Middle East, the Case of Egypt," *JARCE* 22 (1985): 29–47. Leiser's well-reasoned argument probably applies best to Egypt, where Christianity seems to have been a viable force as late as the twelfth century.

18. Tabbaa, "Nūr al-Dīn," 184.

19. Ibn al-'Adīm, *Zudbat* , 2:210, and Ibn Shaddād, *A'lāq*, 1:96–97.

20. Elisséeff, *Nūr ad-Dīn*, 2:517–19.

21. Anon., *Al-ḥawādith al-jāmi'ah w'al-tajārib al-nāfi'ah fi'l-mi'ah al-sābi'ah* (Baghdad: al-Maktaba al-'Arabiyyah, 1931), 55–57. This chronicle is sometimes attributed to al-Fuwaṭī al-Baghdādī, but that is not a secure attribution.

that day the caliph was seated in his *shubbāk* [elevated window] in the rear wall of the iwan, observing all that had taken place."[22]

Subsequently, al-Mustanṣiriyya apparently often housed receptions and banquets for distinguished visitors, including the son of Badr al-Dīn Lu'lu', lord of Mosul;[23] and al-Malik al-Nāṣir Dāwūd, the Ayyubid prince of Kerak. According to the same anonymous chronicler, this prince "sat at the front edge of its northern iwan while his mamluks and guards stood in the quarters of the Mālikīs and Ḥanafīs."[24]

Despite the dearth of such detailed accounts for Ayyubid *madrasas*, formal receptions probably also took place in them. Ibn Shaddād mentions that al-Ẓāhir Ghāzī came to the opening ceremony of the Aleppine *madrasa* al-Ẓāhiriyya specifically to hear the teaching of its first jurist, Ḍiyā' al-Dīn ibn al-'Ajamī; he subsequently hosted a great banquet that was attended by other jurists.[25] Receptions were also held to commemorate the burial of a sultan or prince in his own *madrasa*. Such a ceremony, according to Abū Shāma, followed the interment of al-Malik al-'Ādil in his mausoleum at the *madrasa* al-'Ādiliyya of Damascus.[26]

> Sultan al-Malik al-Mu'aẓẓam 'Isā b. al-'Ādil was in attendance, and he presented a lesson to the congregation. The meeting took place in the iwan of the *madrasa*. Seated to the sultan's right was the *shaykh* of the Ḥanafīs, Jamāl al-Dīn al-Ḥuṣayrī, and next to him the *shaykh* of the Shāfi'īs, our *shaykh*, Fakhr al-Dīn ibn 'Asākir. . . . Seated to the sultan's left was the professor (*mudarris*) of the *madrasa*, chief justice, Jamāl al-Dīn al-Miṣrī, and next to him our *shaykh* Sayf al-Dīn al-Āmidī. . . . The patricians behind them filled the entire iwan . . . and it was an honorable *majlis*, without equal except for the year 623.

In at least one late Ayyubid *madrasa* (al-Firdaws), discussed below, such official presences seem to have been accommodated in special annexes and gardens that are otherwise superfluous for a *madrasa*.

Thus, the combined evidence of the contentious early history of the *madrasa* in Aleppo, its programmatic use by Nūr al-Dīn as the chief institution of the Sunni revival, and its use for official receptions and banquets all speak to its developing role as an official institution and its increasing links with state authority. The interpenetration of official authority with the *madrasa*'s role as a religious and educational institution was also echoed in its formal aspects, and in Syria more than any place else. Indeed, it is only by looking closely and comparatively at the *madrasa* as a work of architecture that we can fully appreciate the various influences on its development as an institution.

22. Ibid., 58. The same elevated window is mentioned in Ibn Wāṣil, *Mufarrij*, 5:317, who calls it a *manẓara*: "The caliph has a *manẓara* that overlooks the *madrasa*. From it he can see the jurists and hear their disputations without being seen."

23. Ibid., 79–80.
24. Ibid., 77–78.
25. Ibn Shaddād, A'lāq, 1:107.
26. *Dhayl al-rawḍatayn*, ed. Izzat al-Husayni (Cairo, 1974), 132–33.

The Ayyubid Madrasa in Aleppo: Formal Development

Madrasa and Palace: Interchange of Form and Meaning

The confluence between the official status of the *madrasa* and its role as a pious and educational institution is confirmed by its architectural form, which seems to draw equally on palatial and religious architecture, with some modifications necessitated by specific functional requirements. This section thus begins by exploring the intriguing connections between *madrasa* and palace architecture, connections that influenced some of the most significant forms in the *madrasa*, including its portal, plan, courtyard design, and use of water. Although this discussion ultimately focuses on a group of closely related Ayyubid *madrasas* in Aleppo, it also takes up other Syrian *madrasas* as well as contemporary *madrasas* in Iraq and Anatolia.

The four-iwan plan and its variations

Chapter 4 emphasizes the essentially palatial origin and authoritative significance of the cruciform four-iwan plan, departing in this respect from previous scholarship that sought its origin in vernacular architecture and its subsequent development in the institution of the *madrasa*. In this section I examine the process through which the cruciform four-iwan plan was applied to the *madrasa* and the factors that might have led to the pan-Islamic assimilation of the cruciform *madrasa*. Next, I discuss the plans of the main Ayyubid *madrasas* in Aleppo in relation to the cruciform four-iwan plan.

In the best-documented, though perhaps most misguided, of all attempts to discover the origin of the four-iwan *madrasa*, Creswell advanced two arguments. He first demonstrated the strict correspondence between the four Sunni rites represented in some *madrasas* and their four-iwan plans. He then proposed that the cruciform *madrasa* originated in Cairo. On the basis of material collected in Syria and his own ongoing research in Cairo, he contended that "although the four-rite *madrasa* is found at Baghdad, the first *madrasa* of cruciform plan is found in Cairo. . . . the cruciform plan was Egyptian in origin and practically unknown outside Egypt."[27]

Critics of this hypothesis, including Godard, Herzfeld, and Ettinghausen, instead stress the Persian ancestry of this plan, which they identify in numerous Iranian monuments several centuries before the earliest Egyptian example. The main stumbling block to this argument is the absence of any well-preserved Seljuq *madrasa* in Iran.[28] This lacuna led Godard to the caravanserai (several Seljuq and pre-Seljuq examples are known) and to a

27. K. A. C. Creswell, "The Origin of the Cruciform Plan of Cairene Madrasas," *BIFAO* 21 (1922): 1–54; updated in idem, *MAE*, 2:104–33.

28. This problem is concisely discussed by Hillenbrand, "Madrasa," 1137–38, who wistfully concludes,

"it is regrettable that the undoubtedly seminal role of Iran in the early development of the *madrasa* is so unjustly obscured by the lack of early surviving specimens whose claims to be *madrasas* are not disputed."

type of east Iranian house with a four-iwan plan. On the basis of these typological comparisons, he concluded that the four-iwan plan, indigenous in Iranian residential architecture, was passed on to the early *madrasas* and from them to mosques and caravanserails.[29] Herzfeld,[30] Ettinghausen,[31] and others accepted this conclusion with minor qualifications, and this view is still current.

While accepting Godard's hypothesis, Ettinghausen went one crucial step further, attempting to explain the widespread appeal of the four-iwan plan *madrasa* in different parts of the Islamic world:

> What is surprising is the fact that this purely regional, restricted, type of architecture was quickly accepted everywhere in the enormously extensive Islamic world, in nearby Iraq as well as in distant Morocco. . . . While the ready acceptance of the hypostyle mosque . . . may be explained by the overwhelming pressure of an "imperial" power and its official religion, the adoption of the madrasa well beyond the realm of the Seljuqs, who had first fostered it, indicates a close, all-Muslim cohesion and interrelationship which influenced each region and created an integrated civilization with only local variations.[32]

Despite the inadequacy of his explanation, Ettinghausen succeeded in displacing the problem from the search for origins to the process of monumentalizing and dispersing the *madrasa* throughout the Islamic world.

The process of monumentalization, according to Godard and Ettinghausen, progressed through a typological transmission from vernacular to monumental architecture and from informal to official status. Although such a scheme corresponds to the well-known grassroots development of the first *madrasas*, it still seems problematic in two main respects. First, the suggested prototype bears no date, and although a degree of timelessness is generally assumed in vernacular architecture, there is no reason to suppose that it was impervious to change and immune to external influences. Thus, the four-iwan houses that Godard and others found early in this century cannot be confidently traced to the tenth or eleventh century. It is entirely possible, even highly probable, that sometime in the later medieval period the house form in eastern Iran gradually assimilated the cruciform iwan plan from an external source, such as the palace.[33] The second problem is that the proposed model contravenes the far more common trend whereby lesser buildings

29. Godard, "Origine de la madrasah," 1–9.

30. Ibid., 28.

31. Richard Ettinghausen, "Originality and Conformity in Islamic Art," in *Individualism and Conformity in Classical Islam*, ed. Amin Banani and Speros Vryonis Jr. (Wiesbaden: Otto Harrassowitz, 1977), 95–103; and idem, "Muslim Cities," 297–98.

32. Ettinghausen, "Originality and Conformity," 95–96.

33. To my knowledge, the one author to question the vernacular origin of the cruciform Seljuq *madrasa* and to suggest instead an origin in palatial architecture has been Janine Sourdel-Thomine in her two excellent articles: "La mosquée et la madrasa," *Cahiers du monde médiévale* (1970): 114–15; and "Renouvellement et tradition dans l'architecture saljūqide," in *Islamic Civilisation, 950–1150*, ed. D. S. Richards (Oxford: Cassirer, 1973), 256–62.

imitate the monumentality of great buildings. Indeed, even if at an early unconscious stage the house form was transmitted to the *madrasa*—just as residences in the early Christian period were converted to *domus ecclesiae*—nevertheless a secondary phase nearly always involves monumentalization through the adoption of grander forms.[34] Finally, why would Niẓām al-Mulk or Nūr al-Dīn, for whom the *madrasa* was nothing less than the cornerstone of Sunnism and the foundation of state authority, look to village architecture for a model?

It seems reasonable, therefore, to suggest that the cruciform four-iwan plan, which had already enjoyed a long history in palatial architecture, was at some point appropriated for the specific purpose of recasting the *madrasa* as a state institution. Historically speaking, the most likely time for this process of monumentalization would have been the period of Niẓām al-Mulk, who would have had the funds, the motives, and the vision for effecting this decisive transformation in the form of the *madrasa*, much as he was able to transform it institutionally. His *madrasas* in Baghdad and elsewhere are known to have become models for later *madrasas*, and there is every reason to assume that this process of emulation also involved the formal aspects of his structures. Indeed, short of appealing to such unsubstantiated concepts as "integrated civilization" or "pan-Islamic unity," only an act as significant as that of Niẓām al-Mulk can explain the widespread dispersion of the *madrasa* as an institution with a characteristic form.

But despite this central link, even early *madrasas* in different parts of the Islamic world exhibit considerable variation, not just in materials and building techniques but also in plan. Generally speaking, Anatolian *madrasas* follow the cruciform four-iwan formula most closely and are characterized in addition by a degree of axial symmetry, although even here variants based on the domed courtyard are also known.[35] Later Iranian *madrasas* are nearly always pristine examples of the four-iwan plan, and it is not unlikely that those from earlier periods would have been equally formulaic. Syrian *madrasas*, examined in detail below, vary greatly in plan and design, often abandoning the formula altogether.

These regional differences led Sourdel-Thomine to suggest that each geographic region produced distinct types that had "nothing to do with an earlier Seljuq invention," adding that "the history of the different types of *madrasa* should be written first for each region."[36] But this view contradicts the well-documented existence of cruciform *madrasas* in nearly all regions of the Islamic world. Instead, I posit a type—perhaps even a prototype—with several local variations.

Syrian *madrasas* show the greatest degree of variation among all pre-Mongol *madrasas*. Curiously, earlier examples tend to steer close to the cruciform four-iwan formula, while later ones display substantial latitude. The earliest surviving *madrasa* in Syria—indeed the earliest surviving *madrasa* anywhere—is the *madrasa* of Gümüshtekin in Boṣra, dated

34. The example is not simply restricted to Constantine's use of the basilica but can also be seen in the origins of the mosque, where forms ranging from Persepolis to a late Roman palatial facade were used.

35. Some of the earliest Anatolian *madrasas* (at Tokat, 1151–57, and at Niksat, 1158) were domed,

and the type seems to continue alongside the far more common open courtyard. Two later domed courtyard *madrasas* are known in Konya: Karatay *madrasa* (1251) and Ince Minareli *madrasa* (1260–65). See Aslanapa, *Turkish Art and Architecture*, 123–27.

36. "Renouvellement et tradition," 257.

530/1136 (Fig. 109). Built of black basalt, this small building (20 by 17 meters externally) is entered by two narrow doors on the east and west sides, which open into small vestibules. These lead to a narrow hall, which opens by a triple arch into a square courtyard measuring around 6 meters per side, small enough to have been covered by a dome.[37] To the right and left are iwans, while the southern side is occupied by a deep prayer hall entered through a triple arch. The height and width of the central arches on the northern and southern sides create the representational effect of an iwan and define an axis that intersects the east-west axis to give the building a measure of cruciform unity.[38] Thus, despite its domed courtyard—absent in most Syrian madrasas—and other peculiarities, this early madrasa represents the confluence of the Seljuq concept of cruciform design with a provincial architecture employing local and largely non-transferrable materials and techniques.

Later Syrian madrasas do not follow the model of Bosra but rather present their own characteristic melding of Seljuq prototype, local tradition, and the specific requirements of the patron. In Damascus, this synthesis is exemplified by the madrasa al-Nūriyya al-Kubra, finished in 567/1172, whose plan is adapted from that of the cruciform bīmāristān al-Nūrī of 1154 (Fig. 110). Arrayed around a courtyard with a large central pool, the Nūriyya is a modified four-iwan building whose southern side was converted into a timber-roofed prayer hall and whose western iwan once contained a shādirwān fountain. Its greatest innovation is including the mausoleum of its founder Nūr al-Dīn, thereby initiating the funerary madrasa, a monumental type that became extremely popular in Syria and Egypt.

Despite this auspicious beginning and the close imitation of the madrasa al-Nūriyya by a number of twelfth-century Syrian madrasas, including al-Rayḥāniyya,[39] al-Muqaddamiyya,[40] and al-'Ādiliyya (begun under Nūr al-Dīn but not completed until 618/1222),[41] Damascene madrasas of the Ayyubid period do not follow a standard canon but show a disconcerting variety in plan, design, and quality. Only one other extant Ayyubid madrasa, al-Ṣāḥiba of c. 1230 (Fig. 111), shows any affinity with cruciform planning. The rest tend to be simply planned courtyard structures; a few consist of little more than a mausoleum and a small chapel mosque (e.g., al-Rukniyya of 621/1224, al-Takrītiyya before 640/1243, and al-Murshidiyya of 650/1253). Slightly more elaborate examples (e.g., al-Shāmiyya of 582/1186 and al-Māridāniyya of 610/1214) contain in addition to mosque and mausoleum one or more rooms, all disposed around a courtyard. The most curious madrasas, however, are those consisting only of mausoleums (e.g., al-Frarrūkhshāhiyya of 579/1182–83 and 628/1230 and al-Jahārkasiyya of 608/1211).[42] It is inconceivable that any kind of formal educa-

37. Traces of this dome existed until the beginning of the nineteenth century, when the Wahhābis of Arabia apparently destroyed it. See Creswell, MAE, 2:107–8.

38. This rather obvious feature has escaped the notice of Creswell and most other writers, who have never discussed this madrasa as an example of cruciform design.

39. Sauvaget, Monuments ayyoubides, 2:51–56.

40. I saw this building in 1980 just before it was destroyed in order to make room for the great expansion of the shrine of Sittī Ruqayya, just inside of Bāb al-Farādīs. At the time two spacious iwans and a large rectangular pond with corner niches were still visible.

41. Herzfeld, "Damascus-III," 1–3.

42. All these madrasas are discussed in Herzfeld, "Damascus-III," passim.

tion took place within these confined spaces: they were probably intended for the simple recitation of the Qur'ān to benefit the deceased.

The tremendous diversity in Damascene structures identified as *madrasas* raises questions about the nature of the institution there and elsewhere in Syria. Is it fair to conclude from this evidence that "the term [*madrasa*] did not connote one single type of building" and consequently that Syrian architects exhibited "a basic uncertainty about the ideal form such buildings should take," as Hillenbrand suggests?[43] Only partly, since the larger and earlier *madrasas* in Damascus do conform to our concept of what the institution should look like. Furthermore, many of the larger intramural *madrasas* in Damascus have disappeared as a result of the expansion of the market area in the late nineteenth century, the great fire of 1925,[44] and more recent acts of willful destruction (see note 40).

The situation in Aleppo is somewhat more straightforward, lacking the extreme variation in *madrasa* plans evident in Damascus. While not one surviving *madrasa* has a cruciform four-iwan plan, there are by the same token no mausoleums posing as *madrasas*. Rather, most *madrasas* in Aleppo follow a kind of flexible canon that calls for a tripartite prayer hall, a single iwan, and rooms for study and residence on two floors, all disposed around a central courtyard with a pool in its center.

The dearth of mausoleums standing in for *madrasas* is easy to explain: Aleppo had not yet developed the tradition of independent mausoleums so prevalent in Ayyubid Damascus. But the absence of the four-iwan plan is more puzzling, since Aleppine *madrasas* tend to be somewhat larger and better built than their Damascene counterparts, employing cut stone for both exterior and interior and for most of their vaulting. Herzfeld explains this lacuna by appealing to geographical, sociological, and aesthetic factors. Geographically, he notes that Syria's ancient stone-built towns, particularly Aleppo, have remained on the same location for thousands of years: "the narrow space inside their walls is crowded to the utmost."[45] The open expanses available for building in Iran were unknown here; architects therefore had to adapt the pristine Iranian formula to the limitations of the site. Sociologically, he emphasizes, again in contradistinction to Iran, the wider basis of architectural patronage in Syria, where *madrasas* were founded not just by kings and princes but also by members of the nobility. Finally, he suggests that the Iranian penchant for symmetry had no resonance for Syrian aesthetics, "whose aim was solid masonry, good proportions instead of decoration, an equilibrium of functional parts, carefully weighed, emphasizing the important, subordinating the accessory . . . but no strict symmetry, simple, double, or quadruple" (36).

Herzfeld's broad-stroke picture of medieval Syrian architecture is generally correct, but it fails to take into account some important facts. The first is that many (perhaps even most) of the Ayyubid *madrasas* in Aleppo were conceived as free-standing structures whose plans could develop without any site restriction. This is certainly true for all the

43. Hillenbrand, "Madrasa," 1139. These views are restated almost verbatim in Robert Hillenbrand, *Islamic Architecture, Form, Function and Meaning* (New York: Columbia University Press, 1994): 186–90.
44. This fire resulted from the French bombing of

the city in 1925. The entire western quadrant of the walled city, which was especially rich in historical structures, was burnt down. Today it is appropriately called al-Ḥarīqah; see also note 40.
45. "Damascus-III," 36.

extramural *madrasas* and even some of the intramural ones, such al-Sulṭāniyya and al-Shādbakhtiyya, which was later enclosed within a nineteenth-century expansion of the bazaar. The sociological argument is closer to the mark, but Herzfeld fails to follow it to its logical conclusion by relating patronage to the formal qualities of the *madrasas*. Specifically, were monuments built by patrician families different in size and plan from those built by princely and royal patrons? Information from nine Ayyubid *madrasas* (seven in Aleppo and two in Damascus) indicates that *madrasas* built by royal patrons do tend to be larger than those erected by court officials and the patrician class (see Appendix, Table 2). Second, although none of the Ayyubid *madrasas* in Aleppo utilizes the four-iwan plan, those built by royal patrons tend to be somewhat more regular and to have axial entrances on line with the *miḥrāb*. *Madrasas* built by officials and patricians are usually entered through bent entrances or portals located on the long side of the building.

Indeed, the location of the portal seems to be a major determinant of the plan of the Ayyubid *madrasas* in Aleppo, and that is why I have chosen it as a basis for a preliminary typology: (a) *madrasas* with a bent entrance (Shādbakhtiyya and Kāmiliyya); (b) *madrasas* entered from the long side (Sharafiyya and ʿAdīmiyya); and (c) *madrasas* with an axial entrance (Ẓāhiriyya and Sulṭāniyya). Interestingly, each subtype is represented by one intramural and one extramural *madrasa*. The *madrasa* al-Firdaws represents a unique hybrid and merits independent treatment.[46]

Madrasa al-Shādbakhtiyya

The earliest preserved Ayyubid *madrasa* is al-Shādbakhtiyya, founded by the freed slave of Nūr al-Dīn, Jamāl al-Dīn Shādbakht,[47] commonly known as *masjid* Shaykh Maʿrūf (Fig. 112).[48] It is located about two hundred meters west of the citadel on a nineteenth-century extension of the vaulted bazaar whose shops surround it on three sides and encroach on its plan. As a result, its exterior limits are uneven and much of its western wing has disappeared. The details of the foundation of this *madrasa* are written on an inscription plaque on its portal (Fig. 113):

(1) بسم اللّه الرحمن الرحيم وقف هذه المدرسة على أصحاب الإمام (2) الأعظم سراج الأُمَّة أبي حنيفة رضي اللّه عنه في أيّام (3) الملك الظاهر غازي بن يوسف عزّ نصره العبد الفقير إلى رحمة (4) ربّه شاذبخت عتيق الملك العادل محمود بن زنكي في سنة تسع وثمانين وخمسمائة

46. This *madrasa* typology could also include the two Shiʿite shrine-colleges (al-Dikka and al-Ḥusayn). Like group C the portals of these two buildings are located in the middle of the short side. But they differ from this group in that the portal is not axial but cross-axial with respect to the prayer hall. Instead, the portal

of the *mashhad* al-Ḥusayn faces a large iwan, as may also have been the case at the *mashhad* al-Dikka.

47. See Chapter 2 for a brief biography of the founder Jamāl al-Dīn Shādbakht.

48. Herzfeld, *MCIA-Alep*, 2:255–60.

(Bismillāh . . . Has constituted the *waqf* of this college in favor of the followers of the supreme imām, the lantern of the community, Abū Ḥanīfa—may God be pleased with him—during the reign of al-Malik al-Ẓāhir Ghāzī son of Yūsuf—may his victories be glorious—the slave, the needy to his Lord's mercy—Shādbakht, the manumitted slave of al-Malik al-ʿĀdil Maḥmūd son of Zangī, in the year 589 [1193].)[49]

A circular medallion just below this plaque contains the mason's signature:

<div dir="rtl">(1) اللَّه (2) صنعة قاسم (3) بن سعيد الفقير (4) إلى رحمة</div>

(The work of Qāsim son of Saʿīd the needy to God's mercy.)[50]

A third fragmentary inscription was carved on the brass door knocker once attached to the door. This simply reiterated that the building was erected during the reign of al-Malik al-Ẓāhir:

<div dir="rtl">". . . في أيَّام الملك الظاهر . . ."</div>

A *muqarnas* portal leads through a domed vestibule to what might originally have been an arcade that opens onto a rectangular court. The court is enclosed by a tripartite prayer hall to the south, a large iwan to the north, and a series of cells on one floor to the east. The northeastern corner of the building is occupied by another tripartite hall—this one arranged north-south—that today contains the shrine of Shaykh Maʿrūf, after whom the building has been renamed. Despite the disappearance of the western arcade and the ponderous layout of the rooms on the eastern portion, the central core of the *madrasa* is quite regular. The prayer hall, consisting of a dome flanked by two rectangular sail vaults, stands on axis with the northern iwan, creating a sense of balance without monotony. This composition is repeated at the *madrasas* al-Kāmiliyya and al-Firdaws and at *khānqāh* al-Farāfra. A medallion on top of the elaborate *miḥrāb* contains another mason's signature:

<div dir="rtl">(1) عمل أبي الرجا وأبي عبد اللَّه (2) إبني يحيى رحمهما اللَّه</div>

(The work of Abi'l-Rajā and Abi ʿAbdullāh, the sons of Yaḥyā, may God forgive them.)[51]

The same two brothers also signed a slightly earlier *miḥrāb* at the *mashshad* al-Ḥusayn (see Chapter 6).

49. *Répertoire*, no. 3467.
50. *Répertoire*, no. 3468.
51. *Répertoire*, no. 3469.

Madrasa al-Kāmilyya

The plan of the Shādbakhtiyya is imitated by the extramural *madrasa* al-Kāmiliyya, located some three hundred meters south of Bāb al-Maqām at the beginning of Maqāmāt (Fig. 114). Though anepigraphic, it has been convincingly matched with one of two *madrasas* known to have been built by Fāṭima Khātūn, daughter of al-Malik al-Kāmil (hence the name) and wife of al-ʿAzīz Muhammad, between 627–634/1230–37.[52] The two *madrasas* share a *muqarnas* portal in the northwestern corner leading to the court through a vaulted vestibule; a tripartite prayer hall facing a large northern iwan; and a variety of rooms and cells on the eastern and western sides opening onto the court through arcaded piers (Fig. 115).

But the *madrasa* al-Kāmilyya shows significant developments over its prototype, not the least of which are its increased size and improved craftsmanship. In terms of plan, the main difference is that the mausoleums are here placed at the southeastern and southwestern ends of the building, on either side of the prayer hall. The various implications of the placement of mausoleums in Ayyubid *madrasas* are discussed below, but, strictly in formal terms, locating the mausoleum at the rear rather than the front of the building creates a more balanced design in which all the domes are located at the southern end of the structure. The two *madrasas* also differ in that the Kāmilyya has a second floor containing cells for a small number of students, a provision that seems to be absent at the Shādbakhtiyya.

Madrasa al-Sharafiyya

The second subtype, with a straight entrance piercing the building on its long side, is represented by the *madrasas* al-Sharafiyya and al-ʿAdīmiyya. The *madrasa* al-Sharafiyya, located no more than fifty meters northeast of the Great Mosque of Aleppo, occupies a corner lot created by the intersection of a narrow bazaar and the thoroughfare connecting the Great Mosque with the citadel. The building is anepigraphic and undated, but a detailed account of its construction by Sibṭ ibn al-ʿAjamī securely attributes its foundation to Shams al-Dīn ʿAbd al-Raḥīm ibn al-ʿAjamī and his son Sharaf al-Dīn ʿAbd al-Raḥmān, who taught in it until his death in 658/1260. The *madrasa* was very long in building but seems to have been effectively completed by 640/1242, when a *waqf* was instituted for it.[53]

Already fragmentary in the fourteenth century, the *madrasa* al-Sharafiyya was recently damaged further by the Awqāf ministry; today only its portal and the vaulting of its prayer hall remain from the original structure. Creswell has reconstructed its plan as a rectangular building entered through an elaborate portal located in the middle of its western side

52. Herzfeld, *MCIA-Alep*, 2:305–6. This identification is based on the location of the *madrasa* and on its fully developed Ayyubid qualities, which seem to argue for a late Ayyubid date. This identification has been accepted by Fāʾiz al-Ḥumṣī, *Ḥalab al-Qadīmah* (Damas-cus: Publication of Directorate General of Antiquities, 1983), 37.

53. Sibṭ, *Kunūz al-dhahab*, 76–77; Ṭalass, *al-Athār al-Islāmiyya*, 90–91.

(Fig. 116). The portal is mirrored on the courtyard side by a vestibule in the form of a shallow iwan containing remains of *muqarnas* vaulting. This small iwan faces a much larger one in the middle of the eastern court facade, an arrangement that gives the spacious courtyard (13.16 by 18.47 meters) a degree of axiality.[54] A cross-axis is provided by the triple arches on the southern and northern ends of the courtyard, the southern opening to a tripartite prayer hall and the northern originally leading to student cells on three stories.[55] The *madrasa* is also known to have had a mausoleum intended for its second patron, which Creswell tentatively placed at the northwestern corner of the building, facing the main street.

Madrasa al-Kamāliyya al-'Adīmiyya

The *madrasa* al-Kamāliyya al-'Adīmiyya, known today as Jāmi' al-Ṭurunṭā'iyya, is located in an impoverished suburb, about half a kilometer east of Bāb al-Nayrab. It stands today in an excellent state of preservation on a small hill north of a modern thoroughfare that has totally devastated the surrounding context. Although anepigraphic and often ascribed to a later patron,[56] it has been attributed to the famous historian of Aleppo, Kamāl al-Dīn ibn al-'Adīm.[57] This identification is ultimately based on a short passage in Ibn Shaddād:[58]

> Al-madrasa al-Kamāliyya al-'Adīmiyya: It was founded by *al-ṣāḥib* Kamāl al-Dīn 'Umar . . . known as Ibn al'Adīm, east of Aleppo. He built near it a mausoleum, a *jawsaq*, and a garden. Its construction began in 639 (1241) and was completed in 649 (1251). No one taught in it because the Nāṣirid [i.e. Ayyubid] nation was terminated before the founder was able to fulfill his objectives.

Despite its nonroyal patronage, the *madrasa* 'Adīmiyya compares well with royal *madrasas* in terms of size and exceeds most in terms of complexity (Figs. 117a–b). This complexity lies primarily in the residential unit[59] annexed to the *madrasa* proper; each unit is entered through its own *muqarnas* portal, a unique configuration among all Syrian *madrasas*. The main portal leads through a cross-vaulted vestibule to the southwestern corner of the courtyard (10.80 by 14.50 meters). Arcades consisting of four granite columns supporting five pointed arches define the eastern and western boundaries of the courtyard and lead to equal-sized cells behind them. The northern end of the court, today subdivided vertically and horizontally into a number of residential units, was originally a

54. This arrangement also resembles the *mashhad* al-Ḥusayn, except there the entry is on the short side.

55. Sibṭ, 75.

56. Ghazzī, *Nahr al-Dhahab*, 2:274: "The *madrasa* is attributed to al-amīr Ṭuruntāy Sayf al-Dīn, but he is merely the one who restored it and increased its endowment. It was actually 'Afīf al-Dīn b. Muḥammad Sahms al-Dīn who founded it in the year 785."

57. Sauvaget, *Inventaire*, 94. In the text, Sauvaget refers to it as "an unknown *madrasa*, whose name and

date in 1392 are unsupported claims of its *shaykh*." In a footnote he adds: "after having written this report, my research has led me to assert that this is the *madrasa* al-Kamāliyya al-'Adīmiyya which the historian of Aleppo Ibn al-'Adīm began in 1241 (639) and finished in 1251 (649)."

58. *A'lāq*, 121.

59. See below, where I argue that this unit should be considered a residence rather than a mausoleum, as Sauvaget suggested.

vast iwan (approximately 8 meters wide by 9.80 meters deep) provided with seven wall niches intended for the storage of books. The southern end of the courtyard has a shallow iwan that serves as a vestibule for directing traffic to the prayer hall and to the flanking chambers (Fig. 118). The prayer hall is entered through a triple arcade whose tall, narrow middle arch (now made much lower) gives the courtyard a sense of axiality. This axiality is reinforced by the absolute regularity and perfect balance of the eastern and western porticos. Flanking the prayer hall are two domed rooms with antechambers that may have served as mausoleums.[60] Certainly, one of them (the southwestern one) is a funerary chamber, although the cenotaph within it is undated.[61]

The madrasa has twenty-four cells for students, disposed regularly around the courtyard: ten on the first floor and fourteen on the second. A latrine with four cubicles occupies the northeastern corner of the building. The second exterior portal of the madrasa leads to a domed courtyard with surrounding chambers, possibly serving as the residence of the chief professor.

Madrasa al-Sulṭāniyya

The third type, with a straight entrance axially oriented with respect to the miḥrāb, is represented by two madrasas, al-Sulṭāniyya (or al-Ẓāhiriyya al-Juwwāniyya) and al-Ẓāhiriyya, both built by Sultan al-Ẓāhir Ghāzī. The Sulṭāniyya, though not completed until 620/1223 by the atābek Ṭoghril, was probably begun by al-Ẓāhir around the same time that he conducted works on the citadel and dār al-ʿadl. At the very least, the mausoleum must have been completed by the year 613/1216, when al-Ẓāhir died and was buried in it.[62]

The building is especially rich in inscriptions, all apparently added by Ṭoghril. The three windows of the mausoleum carry an identical inscription on their respective lintels (Fig. 120):

(1) هذه تربة السلطان الملك الظاهر غازي بن الملك الناصر صلاح (2) الدين منقذ بيت المقدس من أيدي الكافرين قدّس الله روحهما ورحمهما ورحم من ترحّم عليهما

(This is the mausoleum of the sultan al-Malik al-Ẓāhir Ghāzī son of al-Malik al-Nāṣir Ṣalāḥ al-Dīn, the savior of Jerusalem from the hands of the infidels, may God bless their souls, have mercy on them, and have mercy on all those who pray for them.)

60. In his plan, Sauvaget refers to them as "salles de cours," a designation that seems related to his identification of the independent cruciform unit as a mausoleum.

61. A mausoleum and a "reading room" are not so incompatible in medieval Islam as they might seem. Some reading, whether from the Qurʾān or from books of duʿāʾ, certainly took place in most mausoleums. A more striking example of this combined usage existed until recently in the mausoleum of al-Ẓāhir Baybars in Damascus, which was used as a reading room by members of the Arab Academy.

62. Al-Ẓāhir was first interred in a chamber near his palace in the citadel. Shortly afterward, his remains were moved to the mausoleum at the madrasa al-Sulṭāniyya.

The *madrasa* is entered through a portal that carries a short inscription on a cyma molding serving as a cornice and a long inscription just below the springing of the vault. The first inscription reads:

(1) أنشأها لقراءة القرآن وعلوم الشريعة في دولة السلطان الملك العزيز محمّد عزّ الله نصره مشتملة على تربة والده الملك الظاهر غازي(2) قدَّس الله روحه بتولِّي العبد الفقير إلى رحمة الله طغرل غفر الله له وذلك في تاريخ سنة عشرين وستّمائة ورحم الله من ترحَّم على ساكنها واستغفر لمنشئها

(Has founded it for reciting the Qur'ān and the legal sciences during the reign of the sultan al-Malik al-ʿAzīz Muhammad, may his victories be glorious, consisting of the mausoleum of his father al-Malik al-Ẓāhir Ghāzī, may God bless his soul, under the supervision of the slave, the needy to God's mercy, Ṭoghril, may God forgive him, and this was in 620 [1225]. And may God have mercy on whoever prays for its dweller and seeks forgiveness for its founder.)

The longer inscription is a greatly expanded version of the short one, with some additional information about the conditions of its endowment.[63] Its length and bureaucratic language, as well as the precise details of its endowment, can probably be ascribed to the building's long-delayed completion by a slave of the first founder. It further indicates the correctness and thoroughness of Shihāb al-Dīn Ṭoghril (see Chapter 2).

(1) بسم الله الرحمن الرحيم إنّما يعمر مساجد الله من آمن بالله واليوم الآخر وأقام الصلوة واتى الزكوة ولم يخش إلا الله فعسى أولئك أن يكونوا من المهتدين هذه مدرسة تقدّم بعمارتها وانشائها في أيّام السلطان الملك العزيز غياث الدنيا والدين محمد بن السلطان الملك الظاهر غازي بن السلطان الملك الناصر صلاح الدنيا والدين منقذ بيت الله المقدَّس من أيدي الكافرين أسكنهما الله (2) محال رضوانه وفسائح جنانه وخلّد سلطان الملك العزيز وألهمه العدل والإنصاف وانشأها أتابك وولِيّ أمره وكافل دولته القائم بقوانين حفظه العبد الفقير إلى رحمة ربّه الجليل شهاب الدين أبو سعيد طغريل (sic) بن عبد الله الملكي الظاهري تقبّل الله منه تربته وأجزل على ما تقرّب به عطيّة وعظّم جزاءه ومثوبته مدرسة للفريقين ومقرًّا للمشتركين بعلوم الشريعة من الطائفتين (3) الشافعية والحنفية والمجتهدين في الإشتغال السالكين طريقة الأخيار الأمثال الذين يعيّنهم المدرّس بها من الفريقين مشتملة على مسجد لله تعالى ومشهد فيه مدفن السلطان الملك الظاهر قدّس الله روحه ونوّر ضريحه لينال ثواب قراءة العلم ودراسة وبركة القرآن وتلاوته فجزاه

63. Herzfeld, *Alep*, 2:279–80. *Répertoire*, no. 3895.
This reading is based on both versions but contains some corrections.

اللَّه أفضل جزاء على الوفاء بعهد صحبته وقضاء حقّ أسدّ أنعمته (4) وشرط فيها أثابه
اللَّه أن يكون المدّرس شافعي المذهب والإمام للصلاة في مسجدها شافعي المذهب وكذلك
المؤذّن ويرتّب بها قارئاً يتصدَّر لإقراء القرآن العظيم ويلقنها لهم على الوجه المرضي
لله وقد استوفيت الشروط في كتاب الوقف المبارك [1 word] كل مولي وناظر وسلطان
وذلك أن يقرّر قواعدها على ما شرطه الواقف أثابه اللَّه تعالى ويمضى على وجه ابتغاء
لمرضاة (5) اللَّه ورجاءً لجزيل ثوابه فمن بدّله بعد ماسمعه فإن إثمه على الذين
يبدلونه إنَّ اللَّه سميع عليم وكان انتهاء عمارتها في شهور سنة عشرين وستّمائه

(Qur'ān IX: 18 This is a *madrasa* whose foundation and construction was begun during the reign of the sultan al-Malik al-ʿAzīz Ghiyāth al-Dunyā w'al-Dīn Muhammad, son of the sultan al-Malik al-Ẓāhir Ghāzī, son of sultan al-Malik al-Nāṣir Ṣalāḥ al-Dunyā w'al-Dīn, the savior of the Sacred House of God from the hands of the infidels, may God make them inhabit the abodes of His satisfaction and the spaciousness of His Paradise, may he eternize the reign of al-Malik al-ʿAzīz, and inspire in him justice and impartiality! It was founded by his atābek, the trustee of his authority, the guarantor of his empire, the upholder of the laws of his preservation, the slave needy for his Illustrious God, Shihāb al-Dīn Abū Saʿīd Ṭoghrīl, son of ʿAbdullāh, the servant of al-Malik al-Ẓāhir, may God accept his offering, and recompense him abundantly for what he has offered, and increase his reward and compensation. This is a *madrasa* for the two rites, a center for those who are involved in the study of sacred law of the two rites, Shāfiʿī and Ḥanafī, for those engaged in this work, who travel in the road of the select and the exemplary, who are assigned by the professor among the two rites. It consists of a mosque for God, and a shrine that contains the tomb of the sultan al-Malik al-Ẓāhir, may God bless his soul and illuminate his tomb—so that he may benefit from the reading and study of the Qur'ān and from the benediction attached to its recitation. May God accord him the greatest reward for having remained faithful to the pact of his alliance and for having completely satisfied the acknowledgment of His favors. He has stipulated, may God recompense him, that the professor be of the Shāfiʿī rite, and the *imām* for prayer in its mosque of the Shāfiʿī rite, as well as the *muʾadhdhin*, and that it should contain a reader for teaching the Great Qur'ān and for inculcating it in a manner satisfactory to God. It has satisfied the conditions in the blessed act of *waqf* [1 word] each master, attendant, and sovereign, such that he should fix its foundations according to what the founder had stipulated, may God recompense him, and proceed in a manner that is satisfactory to God and hopeful for his bountiful reward. [Qur'ān II: 181]. Its construction was completed during the months of 620/1223.)

The portal is vaulted with a corbeled sail vault which is reflected on the courtyard side by a shallow iwan, the only one in the building (Fig. 119). The middle of the rectangular

courtyard (16.80 by 19.70 meters) is occupied by a rectangular pool with four corner niches, similar to those seen in earlier Zangid buildings in Damascus (e.g., the *madrasa* and *bīmāristān* of Nūr al-Dīn) but not in later Ayyubid buildings, which have elaborate octagonal pools. A tripartite arcade, now walled up in the usual manner, leads to a spacious tripartite prayer hall with a deep southern niche in which a splendid *miḥrāb* is set. The *miḥrāb*, the central arch of the prayer hall, the pool, and the portal are perfectly aligned, forming an axis about which the *madrasa* is nearly symmetrical. The main departures from this axial symmetry are in the southeastern corner, which contains the mausoleum of al-Ẓāhir, and the southwestern corner, which is chamfered on the exterior at an unusual and inexplicable angle.[64] The location of the mausoleum in the southeastern corner of the building differs from the more common placement next to the portal in urban funerary *madrasas*. This change allows the mausoleum to benefit from frontage on the important thoroughfare connecting the citadel with Bāb al-Maqām (see Chapter 3). The *madrasa* has two double rows of student cells on its eastern and western side, and these were originally surmounted by a second story.

Madrasa al-Ẓāhiriyya

Ibn Shaddād provided scant but important information about this anepigraphic *madrasa*:

> It was built by the sultan al-Malik al-Ẓāhir Ghiyāth al-Dīn Ghāzī. . . . It was finished in the year 610. He built next to it [?] a *turba* which he designated for whoever dies from among the kings or princes. . . . The first to teach in it was Dhiyā' al-Dīn Abu'l-Ma'ālī Muhammad. . . . Ibn al-'Ajamī. The sultan al-Malik al-Ẓāhir himself attended his [first] day of teaching and made a great banquet that was attended by the jurists.

The *madrasa* al-Ẓāhiriyya is located in al-Maqāmāt, about five hundred meters south of Bāb al-Maqām, between the *madrasas* al-Kāmiliyya and al-Firdaws. Although anepigraphic, it was undoubtedly built by al-Ẓāhir Ghāzī as a *madrasa* and as a mausoleum intended for "whoever dies from among the kings or princes."[65] Its exact date, specifically whether it was completed during Ghāzī's lifetime, is problematic, since Ibn Shaddād dates it to 610/1213 and Ibn al-Shiḥnah to 616/1219.[66] Ibn Shaddād's closeness to the events would give priority to his opinion, but the building's lack of inscription suggests that it remained unfinished at the time of Ghāzī's death in 613/1216.

The *madrasa* is entered axially through a portal that is reflected on the interior as a shallow iwan (Fig. 121). This opens to an oblong courtyard that is surrounded on its

64. Sauvaget, *Alep*, 276, suggests that "son contour est irrégulier, parce que l'immeube était compris entre des ruelles irrégulieres." This is indeed the usual explanation for the irregularity of religious buildings, but in this case it rings false since this was not a densely populated part of the city.

65. Ibn Shaddād, *A'lāq*, 1:107. At least one known prince was buried in it: al Malik al-Mu'ayyad, brother of al-Ẓāhir Ghāzī, who had died in 606/1209 at Rās al-'Ayn. See Ibn Wāṣil, *Mufarrij*, 3:198.

66. Ibn Shaddād, *A'lāq*, 1:107; and Ibn al-Shiḥnah, *Durr*, 115.

northern and southern ends by a triple arcade resting on two granite columns, on the east by a deep iwan, and on the west by small rooms on two levels (Fig. 122). Three tall pointed arches lead to a tripartite mosque whose three square bays are covered by domes resting on bipartite triangular pendentives. The southeastern corner is occupied by a mausoleum whose dome is pierced by a *malqaf* (wind catcher), a rare sight in Aleppo. The southern half of the western side consists of three domed bays, the middle one rising above *muqarnas* pendentives. Their purpose is not known, but they may have served as study halls during the winter months. The northwestern part of the *madrasa* is entirely residential. It has two identical rows of little rooms with a connecting corridor on the first and second floors.

Madrasa al-Firdaws

The *madrasa* al-Firdaws, fully discussed in Chapter 8 as a *khānqāh-madrasa*, combines the bent entrance approach seen in the first subtype, the geometric rigor observed at al-Ẓāhiriyya, and original features in its northern extension not seen elsewhere (Figs. 192–93). On its exterior, the Firdaws is a large rectangle (43.5 by 55 meters) with a total area of about 2,400 square meters, more than twice that of al-Zāhiriyya, which is already large by Syrian standards. The plan is dominated by a rectangular courtyard with a peristyle (*riwāq*) on its eastern, southern, and western sides. The peristyle expands the open rectangle into a precise square with a spacious, elevated iwan on its northern side. A typically Ayyubid octagonal pool with polylobed edges and an inscribed eight-pointed star stands in the center of the rectangle.

I have dealt elsewhere with the geometrical aspects of this *madrasa*, suggesting that it was one of a handful of medieval Syrian buildings whose plans were based on precise geometric principles.[67] It suffices to reiterate here that this one-iwan *madrasa* is actually based on an underlying four-iwan plan or at least the principle of cross symmetry. The fact that only one side of the courtyard contains an iwan and the three others are covered by domes has more to do with the functional requirements of the *madrasa* than with its underlying design.[68]

External Appearance

Perhaps the most striking feature of Ayyubid *madrasas* is their sober, even dour exterior, often totally unornamented except for a *muqarnas* portal, a band of inscription, and a few grilled windows. Some of these *madrasas*, especially those that have remained free-standing, appear like massive blocks of hewn stone, their severity partly softened by one or more domes and by grilled windows inserted in their unadorned walls (Figs. 123–27).

67. Yasser Tabbaa, "Geometry and Memory in the Design of the Madrasat al-Firdaws in Aleppo," in *Theories and Principles of Design in the Architecture of Islamic Societies*, ed. Margaret Ševčenko (Cambridge, Mass.: Aga Khan Program for Islamic Architecture, 1988), 23–34.

68. Cf. Herzfeld, "Damascus-III," 35–38.

Scholars have offered various explanations for this tendency toward simplicity and severity. Herzfeld ("Damascus-III") explained it partly as an atavistic tendency among Syrian architects who shared a "magnificent tradition of craftsmanship . . . complemented by dislike of the unnecessary, of mere decoration" (37). Further, however, he proposed a theological explanation, suggesting that it was "the Sunnite reaction that produced these changes, and it was Nūr al-Dīn who impressed that spirit into the people of his time" (38). Sauvaget attributed this sobriety, which he admired, to "le fait que la Syrie gardé plus résolument qu'aucun autre pays d'Islam ses *traditions hellénistiques*."[69] Finally, Arab authors, including Rīḥāwī[70] and 'Abbo,[71] saw in these *madrasas*, which they often compared to fortresses, a reflection of the "austere and militaristic spirit of the age."

There is perhaps a little truth in all these assertions, which range from the imperatives of architectural tradition to the influence of a single dynast to the *zeitgeist*, which itself is defined variously as the Sunni revival or the counter-Crusade. At the same time, they are nearly all too general, applying equally to the exterior and interior of *madrasas* and even to some of their component parts. Indeed, the only concrete explanation, often mentioned in passing, compares the Ayyubid *madrasas* of Aleppo to fortresses. In fact, the Ayyubid *madrasa* generally resembles an imaginary fortress (though not any specific standing fortress) in its solid stone construction, single entrance, and minimal fenestration. But the two building types are otherwise so different, particularly in degree of defensibility, as to make fortresses highly unlikely models for the exteriors of medieval Syrian *madrasas*.

Two more probable models are the caravanserai and the palace. Caravanserais, known in Iran and Central Asia since Achaemenid times and in Syria since at least the Umayyad period, are, like Ayyubid *madrasas*, solidly built free-standing structures with a single entrance that leads to a courtyard. These similarities can in fact be extended to the interior design of the courtyards, which after the tenth century acquire the characteristic four-iwan plan.[72] But it is difficult to prove any direct influence of the Central Asian caravanserail on the Iranian *madrasa* since no early Central Asian or Iranian *madrasas* remain extant. Furthermore, early Iranian *madrasas* would probably not have resembled Syrian *madrasas*, at least not in their exteriors.

Palatial architecture might be deemed a more suitable object of appropriation and would explain the increasing monumentalization of the *madrasa* after the eleventh century. Formally speaking, however, this is also a difficult case to make since nearly all contemporary palaces are located inside citadels and survive in a highly fragmentary condition. Only two of these palaces, at the citadel of Aleppo and at Qal'at Ṣahyūn,

69. J. Sauvaget, "L'Architecture musulman en Syrie," *Revue des arts asiatiques* 8 (1933–34): 19–51; emphasis in original.

70. 'Abd al-Qādir al-Rīḥāwī, *Al-'imāra al-'arabiyya al-islāmiyya, khaṣā'iṣuhā wa-āthāruhā fī Sūriya* (Damascus: Wizarat al-Thaqafa, 1979).

71. 'Ādil Najm 'Abbo, "Al-Madrasa fī al-'imāra al-ayyūbiyya fī Sūriyya," *AAS* 24 (1974): 75–99.

72. See, most recently, Burchard Brentjes, "Kara-

wanserail und Ribat in Mittelasien," *AMI* 21 (1988): figs. 4–12. Brentjes further distinguishes the "pure" cruciform four-iwan type from other types that use this basic unit in combination with (a) "*bayts*" in the four corners, (b) another four-iwan unit, or (c) a domed unit. These seem to me to be subtypes of the cruciform four-iwan type, which should be distinguished primarily from non-iwan types, such as figs. 14–19 in Brentjes.

still retain part of their facades, which are in both cases dominated by a highly elaborate portal (see above). While this does resemble the exterior form of *madrasas*, the multiplicity of functions in these palaces and their interconnectedness with the citadel are quite different.

Indeed, austerity or the absence of any exterior treatment (except for the portal) is what links together all these different institutional types. Rather than a stylistic choice, the absence of any facade treatment in early Syrian *madrasas* is perhaps best explained by the relative newness of the *madrasa* as a monumental type and the fact that even earlier *madrasas* had been housed in typical courtyard residences with minimal street frontage. This building type, therefore, had been literally pulled out of its urban fabric and built as an independent structure without any real idea of how to treat its facade. Ayyubid *madrasas* retain this ambiguity of location nearly to the very end of the period: although they by and large tend to be free-standing buildings, their dour exteriors and single narrow entries betray an origin within a dense urban fabric. Only in Cairo and somewhat less so in Anatolia does the *madrasa* acquire its first exterior adornments, and these changes are ultimately echoed back in Mamluk Syria.

The *muqarnas* entrance

Unlike Friday mosques, which always have multiple entrances, the vast majority of *madrasas* are entered through a single portal. While a few *madrasas*, such as al-ʿAdīmiyya and al-Firdaws in Aleppo, have more than one portal[73] and some small mosques have only one portal, the distinction between the two institutions generally holds true. It might be argued that this difference simply results from the size of the two institutions, since *madrasas* are normally much smaller than congregational mosques. But this assertion cannot be sustained: even enormous *madrasas*, like that of Sultan Ḥassan in Egypt, have only one portal, and relatively small Ayyubid mosques, such as Jāmiʿ al-Ḥanābila in Damascus,[74] have several. More likely, functional and typological differences between the two institutions explain this distinction. Functionally, the congregational mosque was intended for all Muslims and, as such, needed to be literally open to the entire community. The *madrasa*, on the other hand, was restricted to a select group whose access to its premises needed to be monitored.

The majority of the Zangid and Ayyubid *madrasas* of Aleppo, and many of those in Damascus, have stone *muqarnas* portals. In Aleppo, thirteen *madrasas*, one *khānqāh*, two Shiʿite shrine-colleges, and one hospital still retain portals built during the Zangid-Ayyubid period (see Appendix, Table 3). Of these, thirteen have *muqarnas* portals, three have portals with cloister vaults, and one has a trilobed cross vault. Of the four non-*muqarnas* portals, three belong to the Zangid period—*madrasas* al-Ḥallāwiyya (544/

73. These two *madrasas* have multiple entrances because they contain annexed residential units that, for the sake of privacy, needed their own entries. See below.

74. Herzfeld, "Damascus-IV," 120–23.

1149) and al-Muqaddamiyya (563/1168) (Fig. 127) and *bīmāristān* al-Nūrī (c. 545/ 1150)—suggesting that up to the third quarter of the twelfth century the stone *muqarnas* portal had not yet been developed in Aleppo, or at least, had not yet been used in *madrasas*. The third non-*muqarnas* portal is more problematic since it belongs to the *madrasa* al-Sulṭāniyya, which was begun by al-Ẓāhir Ghāzī (d. 613/1216) and completed by his *atābek* Ṭoghril in 620/1223 (Fig. 138). Although the portal belongs to the first period of construction, it still looks strangely retardataire and unimposing, especially in view of its royal patronage. Indeed, the only explanation for this simple vault seems to be structural: a cloister vault may have been deemed preferable to a *muqarnas* vault for supporting the heavy minaret above it. In fact, three other examples show exactly the same disposition: the *maqām* Ibrāhīm at Ṣāliḥīn and the shrine of Nabī Yūshaʿ at Maʿarrat al-Nuʿmān, both built by al-Ẓāhir Ghāzī; and *jāmiʿ* al-Maqāmāt, built by the Mamluk governor Aqsunqur.

The earliest stone *muqarnas* portal in Aleppo, dating to 1189, forms part of al-Ẓāhir Ghāzī's rebuilding of the *mashhad* al-Dikka (Fig. 84).[75] Indeed, this is to my knowledge the earliest stone *muqarnas* portal vault in Syria and perhaps in the entire Islamic world.[76] Curiously, however, the plaster *muqarnas* vault at the *bīmāristān* al-Nūrī in Damascus is considerably earlier (549/1154),[77] and could arguably have provided a model for the Aleppine stone *muqarnas* portal vault. But there are several problems with this suggestion. First, the two types of vault are unrelated in terms of their material, technique, or overall design. Second, the suspended stucco *muqarnas* vaults of the *bīmāristān* are intrusive in Damascus, having perhaps originated in Baghdad,[78] and they seem not to have gained much favor with local craftsmen. Finally, these vaults apparently failed to inspire any stone imitation in Damascus, which did not have stone *muqarnas* portal vaults until the second decade of the thirteenth century. These compelling considerations strongly suggest that the stone *muqarnas* portal vault was indigenous to Aleppo and in no way modeled after the stucco *muqarnas* vaults in Damascus.[79]

One remaining possibility is that stone *muqarnas* portal vaults were based on a brick prototype, possibly originating in Iran. Although the existence of *muqarnas* forms in Iran from the late eleventh century supports this kind of transmission, the absence of early *muqarnas* portal vaults in Iran makes it difficult to verify details.[80] In Baghdad, *muqarnas* portals are strangely missing until the Ilkhanid period,[81] and that seems to describe the

75. See above. Cf. Creswell, *MAE*, 2:146–47, who lists al-Shādbakhtiyya as the earliest *muqarnas* portal.

76. Cf. Creswell, ibid., 146–47, who also concludes that "the stalactite portal is a feature which appears to have come down through Syria from the north."

77. Herzfeld, "Damascus-I," 2ff.

78. Tabbaa, "The Muqarnas Dome," passim.

79. One surviving stone *muqarnas* vault in La Zisa outside Palermo closely resembles the portal vault of the *bīmāristān* al-Nūrī of Damascus and other stucco vaults in North Africa. Unlike Syrian *muqarnas* vaults, it was not assembled from previously cut stone blocks. Rather, its various cells and pendants seem to have been carved directly on an already standing vault. See Maurice Ecochard, *Filiation de monuments grecs, byzantin et islamiques: Une question de géométrie* (Paris: Librarie Orientaliste Paul Geuthner, 1977), 76, fig. 11.

80. See, for example, Ulrich Harb, *Ilkhanidnische Stalaktitengewölbe: Beitrage zu Entwurf und Bautechnik* (Berlin: Reimer, 1978); and my article, "Muqarnas," *Dictionary of Art* (London: Macmillan, 1998).

81. For example, this feature is even lacking in the *madrasa* al-Mustanṣiriyya of 1242, which instead has a rather heavy arch framing a flat tympanum with a long inscription.

situation in Iran as well.[82] This implies two possibilities for the origin of the stone *muqarnas* vault: either it was based on a brick prototype that has only survived in later examples, or it was an independent creation based on imported geometric principles and local stone masonry.

Syrian stone *muqarnas* has not been studied so thoroughly as Iranian *muqarnas*.[83] As a result little is known about the typological and stereotomic aspects of the portal vaults and transition zones that constitute one of the greatest accomplishments of Syrian architecture in the Ayyubid and early Mamluk periods. Herzfeld is, in fact, nearly alone in providing even a preliminary typology of Syrian *muqarnas* vaults. On the basis of what transition zone they employed, he classifies these vaults into what he terms a "Mediterranean" or "western" and an "Iranian" or "eastern" type (Figs. 132 a–b). In the Mediterranean type, the vault is gradually developed from a *muqarnas* pendentive (Fig. 130), whereas in the Iranian type the vault begins abruptly from corner squinches, which are themselves made of *muqarnas* elements (Fig. 134).[84] Beyond the transition zone, the two types are nearly identical and generally consist of three zones of staggered *muqarnas* cells and brackets that support a scalloped half dome.[85] Visually, however, this seemingly minor distinction makes a big difference: the western vault type can be read as a logical system of corbeling that unfolds smoothly from the corners, whereas the eastern vault type, which springs directly from a horizontal line, resembles a suspended canopy.

The extant specimens suggest that the Mediterranean type predated the Iranian type by about ten years, which comports with the greater complexity of the Iranian type. But the short time span separating the two types and their essential difference do not point to a linear development. Rather, the two types may have developed simultaneously through the application of the principles of *qarnaṣa* to the pendentive and the squinch, two well-known means of dome transition. Herzfeld finds "no distinction, local or temporal, between the two,"[86] which is only partly true. In fact, the two types were used simultaneously for only two or three decades before the Iranian type became predominant (Figs. 133–42).

Despite its overall soundness, Herzfeld's analysis of the *muqarnas* is problematic in some respects and incomplete in others. First, it does not sufficiently distinguish among stucco, brick, and stone *muqarnas* vaults and domes. Second, it does not adequately address the stereotomic and geometric aspects of stone *muqarnas*. And third, it does not grapple with the question of the origin and significance of the stone *muqarnas* vault—specifically whether it originated in palatial or religious architecture and consequently whether it was intended as a generalized symbol of luxury, a sign of royal patronage, or an allegory of some religious concept.

82. See Creswell, "Bāb," *EI*², 2:830. Harb, *Stalaktitengewölbe*, also does not mention any pre-Mongol *muqarnas* portal vaults.

83. For example: Harb, *Stalaktitengewölbe*, passim; or Lisa Golombek and Donald Wilber, *The Timurid Architecture of Iran and Turan* (Princeton: Princeton University Press, 1988), 164–69.

84. "Damascus-III," 12–15.

85. There are a few exceptions to this rule: the *khānqāh* al-Farāfra, which only has two zones of *muqarnas* and a large unscalloped dome; the *madrasas* al-Sharafiyya and al-Karīmiyya, which actually have smooth half-domical vaults resting on *muqarnas* squinches.

86. "Damascus-III," 15.

Addressing the first two of these problems, Michel Ecochard proposes that the stone *muqarnas* required a command over the stone that at the time was only available in Syria and Anatolia and a level of geometric precision that was only possible through measured drawings.[87] The special quality of Syrian stereotomy is illustrated by the vault of *madrasa* al-Muqaddamiyya (1168) in Aleppo, which is not *muqarnas* but a trilobed cross vault (Figs. 127–28). Here nearly every stone block has two distinct parts: an external facing that is cut in accordance with the design of the trilobed arch and a much larger body that is deeply embedded within the masonry of the vault. This is most clearly apparent in the stone blocks at the exact edges of the lobe, which on the surface seem curiously unsupported, but which in reality are securely engaged within the flanking blocks.

The same basic stereotomic principle applies to stone *muqarnas* vaults, although greatly complicated by the three-dimensionality of these vaults and the variety of the stone blocks involved. The vault of the Ṣahyūn palace is the only *muqarnas* vault whose stereotomy has been analyzed, which is why I include it in this discussion of *madrasa* portals (Figs. 38–41). The portal is 7.20 meters high, 4.25 meters wide, and only 1 meter deep. It is covered by three small scalloped half domes with two pendant keystones, all resting on two tiers of *muqarnas* cells. Despite these departures from the standard *muqarnas* vault, the stereotomy of this vault conforms with the stereotomy of *muqarnas* vaults in general. Ecochard's investigation of this vault reveals that the visible portion of the stone blocks has been volumetrically cut into a number of discrete shapes, including simple Y-shaped brackets, two brackets flanking a triangular cell, and two cells flanking a bracket, and into even more complex shapes, such as blocks that contain a section of the voussoir and a portion of the adjacent dome and, most complex of all, two blocks that have been cut into a pendant keystone, two sections of the flanking scalloped dome, and a bracket with five facets. After being cut on the ground, these blocks were placed with their hidden masses superimposed, as with normal ashlar masonry, while their carved faces fitted together like a large three-dimensional jigsaw puzzle.

Obviously, such an exacting procedure called for the best limestone and the best masons. But beyond that, sketches of the overall design would have been necessary to determine materials and cost and also to convey design information to the stone masons. The total absence of any contemporary sketches for the stone *muqarnas* has led Ecochard and others to propose various schemes by which it could have been generated. Most commonly, these schemes rely on the rotation of polygons within a circle inscribed in the square created by duplicating the half square of the vault. The rotation of these polygons resulted in a complex web of intersecting lines and star patterns, all ultimately emanating from the center of this imaginary circle, or in reality from the center of the scalloped dome that usually caps Syrian *muqarnas* vaults.

This limited analysis of stone *muqarnas* vaulting in Ayyubid Syria[88] demonstrates that it was an exacting process demanding the collaboration of an architect or a master mason

87. *Filiation*, 86–87. See also idem, "Stéréotomie de deux portails," 98–108.

88. Actually, a number of researchers are actively involved in exploring the problems of *muqarnas* vaulting, including Richard Brotheron, Mamoun Sakkal, and Muhammad Asad. But to my knowledge, their work has yet to be published.

and a small group of highly skilled craftsmen. It was also a costly process because of the need to use only marble or the finest limestone and the high probability of waste. It follows then that stone *muqarnas* vaulting was an important technical achievement and a fine luxury product, thus ranking among the greatest accomplishments of Syrian architecture in the middle period. Its use in the facade of a monument was a mark of distinction and a statement of status that sometimes hid quite ordinary structures.[89]

Was the *muqarnas* portal only a symbol of luxury and an attribute of aristocratic patronage, or did it embody some religious meaning? Its early use in both palatial and pious architecture seems to indicate an overlapping significance; at the very least, the form may have originated in one domain and been quickly assimilated by the other. At this point in our knowledge, the argument for origin can go either way. An origin in religious architecture is favored by the sheer quantity of available evidence: numerous medieval *madrasas* and other pious institutions in Syria and Anatolia have *muqarnas* portal vaults, the earliest dating from the last decades of the twelfth century (Figs. 129–41). Such an origin is also supported by the fact that *muqarnas* domes of the Mesopotamian variety were almost always used in mausoleums, a practice that was eventually transferred to Damascus and North Africa.[90]

An origin in palatial architecture, on the other hand, is supported by the use of *muqarnas* vaults in the portals of two preserved Ayyubid palaces and in a few medieval Christian palaces, including La Zisa in Palermo[91] and the so-called Mouchroutas, a large structure built in the twelfth century adjacent to the principal throne room of the Imperial Palace at Constantinople.[92] None of these Christian monuments appears to have utilized *muqarnas* vaulting in their portals; its use was seemingly restricted to the ceilings of throne rooms and garden pavilions and the shallow decorative vaults built above some *shādirwān* fountains in Sicily.[93]

But a purely secular interpretation of *muqarnas* vaulting in portals and domes is vexed by two important problems. The first is that *muqarnas* vaulting is also used in Christian buildings of a strictly religious nature. The most outstanding example is the *muqarnas* vault covering the central aisle of the Cappella Palatina in Palermo, specifically described in a contemporary sermon as having heavenly associations.[94] *Muqarnas* vaulting is also often used in Armenian churches of the twelfth century and later, where it nearly always covers the *gavit* or *jamatūn*, a large squarish space used for public gathering.[95]

89. Such "facadism" is rare in the Ayyubid monuments of Aleppo but is quite prevalent in contemporary Damascus, particularly in the Ṣālhiyya suburb. See Herzfeld, "Damascus, III," 48–52.

90. Tabbaa, "Muqarnas Dome," passim.

91. Giuseppe Bellafiore, *La Zisa di Palermo* (Palermo: S. I. Floccovio, 1978). La Cuba, La Favara, and other rustic Norman palaces seem to have utilized the *muqarnas* in different guises.

92. Cyril Mango, *The Art of the Byzantine Empire, 312–1453: Sources and Documents* (Englewood Cliffs, N.J.: Prentice-Hall, 1972), 228–29. The text by Nikolaos Mesarites is also discussed by Jean Ebersolt, *Le Grand Palais de Constantinople et le Livre des Cérémonies* (Paris: E. Leroux, 1910), 149–50; and August Heisenburg, *Die Palastrevolution des Johannes Komnenos* (Wurzburg: Universitäts–Druckerei von H. Sturtz, 1907), 44ff.

93. Tabbaa, "Use of Water," 202–5.

94. This sermon was delivered in the building as part of its dedication ceremonies. See J.-P. Migne, *Patrologie Graecae*, vol. 132 (Paris, 1864), cols. 953/954b.

95. Several examples are illustrated in O. Kh. Khalpakhchian, *Architectural Ensembles of Armenia* (Moscow: Iskusstvo, 1980), e.g., figs. 23, 12, 13, 15.

The second problem in assigning purely secular values to a particular form or motif just because it is used in a palatial setting is that royal iconography, whether in medieval Islam or the Christian world, often incorporated religious themes for its own purposes. This is not to suggest that there is no separation between the two realms and that forms used in both contexts have the same meaning. It is rather to emphasize that these two systems of artistic production were often involved in a process of dynamic exchange: forms initially created in one realm were shortly thereafter appropriated by the other realm, where they would gradually acquire new associations. Indeed, traces of this process of appropriation are still visible in the mixed metaphors often used by writers and poets to describe buildings. For example, in his otherwise unabashedly secular description of the Mouchroutas, the twelfth-century Byzantine historian Mesarites mentions "the heaven-like ceiling."[96] And in describing the *muqarnas* forms of the *minbar* at the Great Mosque of Aleppo, Ibn Jubayr compares it to "a great crown."[97] Given the permeability of the two systems of representation, it seems best not to insist on an exclusively religious or exclusively palatial interpretation of the *muqarnas* vault but rather to see it as a form capable of sustaining a variety of meanings according to context.

What are, then, the most salient architectural and decorative properties of *muqarnas* vaulting, and how can they inform an understanding of its various meanings? The attributes that immediately come to mind are fragmentation, unsupported projection, and, of course, beauty. Indeed, the sense of beauty or aesthetic fulfillment is closely related to the skillful cutting of the stone according to precise geometric principles that are intended to produce the desired fragmentation of the mass of the vault and its seemingly unsupported projection. These fundamental aesthetic qualities underlie the widespread appeal of *muqarnas* vaulting in both palatial and religious architecture.

In palaces, *muqarnas* vaulting was most likely understood as an exotic form, whose excessive detail and ingenious construction were intended to produce awe and amazement in the viewer. These are precisely the sentiments expressed by Mesarites when describing the Mouchroutas: "There is insatiable enjoyment here—not hidden, but on the surface. Not only those who direct their gaze to these things for the first time, but those who have often done so are struck with wonder and astonishment."[98] *Muqarnas* vaulting would therefore belong to the same class of wonderous devices (*'ajā'ib*) as unusual fountains, water clocks, and automata.[99] In addition to producing the desired effect of awe and surprise in the viewer, all these exotic devices identified their owners as members of the aristocracy, which is another important reason for their wide cross-cultural circulation.

A religious interpretation of *muqarnas* vaulting would seek a different understanding of the same fundamental qualities mentioned above. Thus, the unsupported projection of these vaults would be understood as an allusion to the dome of heaven, which is unsup-

96. Mango, *Byzantine Sources*, 229.

97. *The Travels of Ibn Jubayr*, 227. This is the *minbar* built by Nūr al-Dīn in 1168 for the mosque al-Aqsa in Jerusalem.

98. Mango, *Byzantine Sources*, 229.

99. There is a considerable literature on these mechanical devices. For bibliography, see Donald R. Hill, *Kitāb al-Ḥiyal: The Book of Ingenious Devices of Banu Mūsā b. Shākir* (Boston: D. Reidel, 1979) and Ahmad Yahya al-Hassan and Donald R. Hill, *Islamic Technology: An Illustrated History* (Cambridge: Cambridge University Press, 1986).

ported except by the power of God, who "has created heaven without pillars." This allusion is especially apparent in later *muqarnas* vaults, such as those at the Alhambra palace and the *madrasa* of Sultan Ḥassan, but it can already be seen in some later Ayyubid and early Mamluk *madrasas*, such as al-Kāmiliyya in Aleppo (Fig. 134) and al-Ẓāhiriyya in Damascus, whose portal vaults employ a variety of star patterns.[100]

The courtyard and its facades

Although Ayyubid *madrasas* were perhaps the first building type in Islam to use the *muqarnas* portal consistently, their exterior facades remained poorly developed to the very end of the period. Instead, the architects seem to have concentrated their efforts on the porticos and facades of the courtyard, attempting to provide them with a sense of monumentality and a semblance of overall unity. In the strictly cruciform buildings, these requirements were addressed by giving identical tripartite compositions to all four facades. But somewhat more innovative solutions had to be devised as soon as the original formula was modified and adapted to new functional requirements.

In the earliest medieval monuments in Syria, such as the *madrasa* of Gümüshtekin in Bosra (1136) and the *bīmāristān* al-Nūrī in Damascus (1154) (Fig. 143), the courtyard facades tend to conform almost precisely to the composition described above for contemporary palatial architecture.[101] They are tripartite, consisting of a wide, tall central iwan flanked by two small arched doors with lintels. In Aleppo other variations are adopted for the irregular plans of some *madrasas*, but the tripartite composition remains the most common for the facades of prayer halls. It is found at the Shādbakhtiyya, the Kāmiliyya (Fig. 144) (with extra flanking doors), the Sharafiyya, the ʿAdīmiyya (Fig. 145) (completely blocked up), the Sulṭāniyya (Fig. 146), and *khānqāh* al-Farāfra, which has the only example with wooden tie beams (Fig. 147). An early variation on this composition, with three arches of equal width and height, survives at the *madrasa* al-Muqaddamiyya of 1168, but it occurs again only at the *madrasas* al-Ẓāhiriyya and al-Firdaws, where it is preceded by an arcaded portico, and at the mosque in the citadel.

The main iwan of Ayyubid *madrasas* is most commonly located in the northern facade, except for the *madrasas* al-Ẓāhiriyya and al-Sharafiyya, where it is placed in the eastern facade, and at the *mashhad* al-Ḥusayn, where it is located in the western facade. Whenever possible, the main iwan is flanked by two smaller doors leading to small rooms or a corridor, creating a tripartite composition similar to that of the southern facade (Figs. 149–51). In smaller spans, where the iwan occupies the entire facade, windows or blind niches are introduced as a way of achieving balance and enhancing the monumentality of the central feature (Fig. 148).

100. See Ecochard, *Filiation*, figs. 45–47, for a geometric analysis of these vaults.

101. See Chapter 4. Other early monuments with tripartite courtyard facades include the *bīmāristān* al-Nūrī in Aleppo (c. 1150), the *dār al-ḥadīth* of Nūr al-Dīn in Damascus (1154–68), the *madrasa* al-Rayḥāniyya (1170), and the *madrasa* al-Nūriyya. All are discussed in Tabbaa, "Nūr al-Dīn," 103–50, passim.

This tripartite composition is closely related to palatial architecture, characterizing, as mentioned in Chapter 4, nearly all the medieval palaces of Syria and Anatolia (Figs. 64, 67–68). These palaces also tend to have their most elaborate and often their largest iwan in the northern facade. But the iwans of palaces are more elaborate than those of *madrasas*, a difference that also applies to their respective portals. Specifically, no Aleppine *madrasas* have iwans as lavishly complex as those in the palace of Banū al-ʿAjamī, with its pendant voussoirs, or even the Ayyubid palace in the citadel, with its *muqarnas* and *shādirwān* fountain. Curiously, however, the two surviving Artuqid *madrasas* at Diyrabakir, al-Zinciriyya (1198) (Fig. 151) and al-Masʿūdiyya (1198–1223), both have arches with foliate and pendant voussoirs that resemble the one at the ʿAjami palace (Fig. 69). Although considerably cruder than the one remaining example in Aleppo, the design and stereotomy of these iwans point to an Aleppine influence and further emphasize the connection between palaces and *madrasas*.

The other two facades (generally eastern and western) exhibit considerable variation and an overall lack of consistency, reflecting no doubt the absence of a centralizing feature such as a prayer hall or iwan behind them. In most cases, these facades consist of little more than a series of equally spaced doors leading to cells behind them. These are arranged on a single floor (e.g., Shādbakhtiyya); double floors (Sulṭāniyya, Ẓāhiriyya, and ʿAdīmiyya); and rather exceptionally on triple floors, as at the Sharafiyya. At the Kāmiliyya, where rooms of different sizes occupy the eastern and western flanks, an attempt was made to organize their respective facades into alternating narrow and wide doors.

But the most significant development in the design of the courtyards of Ayyubid *madrasas* is the introduction of porticos. These are used first at the *madrasa* al-Ẓāhiriyya, which has triple-arcaded porticos at its northern and southern ends (Fig. 152). In addition to enhancing the axiality of the *madrasa*, the southern portico in particular heightens the monumentality of the mosque by giving its three domes a sense of scale. The same function is performed by the three porticos of the *madrasa* al-Firdaws, each of which is visually surmounted by its own dome (Figs. 153 and 197). At the same time, the eleven arches surrounding the courtyard on three sides provide it with a sense of rhythm and unity that makes up for the absence of four iwans. The latest Ayyubid portico at the *madrasa* al-ʿAdīmiyya is also the most logical and functional. Stretching along the eastern and western facades, it unifies the northern and southern units of the *madrasa* while supporting a second story of cells above it (Figs. 154–56).

The use of water

The last feature that *madrasas* share with palatial architecture is the decorative use of water. Interestingly, the earliest *madrasa* in Damascus, al-Nūriyya of 1172, exhibits the most elaborate fountain, a *shādirwān* whose water originates beneath a small *muqarnas* vault in the western iwan, crosses the court in a channel, and empties into a large rectangular pool. This fountain type was most likely palatial in origin, its use in that

context dating back to the eleventh century if not before. It is, however, used in various pious structures in Syria, Anatolia, and Egypt throughout the later medieval period.[102]

Elaborate fountains were generally abandoned in Ayyubid pious architecture, although pools remained, and some of these may have contained a water jet. These pools are either rectangular or octagonal. The rectangular type typically consists of a heavily built rectangular pool whose corners are cut away into semicircular niches. These niches do not extend to the bottom of the pool but rather rest on shelves that span the corner. This type is first seen at the *bīmāristān* al-Nūrī (1154) and in a number of Zangid and Ayyubid monuments in Damascus, where it may have originated. It is much less common in Aleppo, where it appears only in the two *madrasas* of al-Ẓāhir Ghāzī (Fig. 157) and in a handful of Mamluk examples.[103]

Far more prevalent in Aleppo and northern Syria was the octagonal type, usually made up of a heavily built octagonal pool composed of three superimposed stone courses (Fig. 158). The lowermost course is arranged in the form of an octagon. The second course is shaped like an eight-pointed star inscribed around the octagon below it. This in turn supports a third course whose exterior is a perfect octagon but whose interior is carved into eight recesses, each composed of two small semicircular niches whose inner edges form a right angle and outer edges a kind of arrow that points to the middle. This pool type is represented in three Ayyubid pious structures: the *madrasas* al-Kāmiliyya (Fig. 159) and al-Firdaws (Fig. 197) (which also has one in each of its two residential units) and the *khānqāh* al-Farāfra (Fig. 158). It is also known in two palaces, the Aleppo citadel and Qalʿat Najm (Figs. 44 and 60), both dating from the period of al-Ẓāhir Ghāzī. Given this close chronology, it is impossible to say in which domain this particular pool type originated. It suffices to say that sometime in the late Ayyubid period lobate octagonal pools became a characteristic feature in the courtyards of many *madrasas* and palaces. This pool type is not known outside the province of Aleppo.

I have demonstrated in this section that the Ayyubid *madrasa* and the medieval Islamic palace share in varying degrees the following formal characteristics: a plain exterior form pierced by a *muqarnas* portal, an overall preference for regular plans with one or more iwans, courtyard facades with triple arches, and courtyards centered on an elaborate pool of water. These formal links further substantiate my contention that *madrasas* in this period were increasingly becoming appendages of the state, whether or not they were directly founded by royalty or state officials. Indeed, the adoption of these forms, with their well-established authoritative associations, for *madrasas*, *bīmāristāns*, and other institutions in the twelfth and thirteenth centuries reflects the professionalization of learning and its gradual infiltration by the pervasive juridical attitude of the later Islamic Middle Ages.[104] The utilization

102. See Tabbaa, "Use of Water," passim.

103. It seems that the *madrasa* al-Sharafiyya also had this kind of pool as can be noted in Hillenbrand, *Islamic Architecture*, fig. 136.

104. See in particular Joan Gilbert, "Institutionalization of Muslim Scholarship and Professionalization of the 'Ulamāʾ in Medieval Damascus," *SI* 52 (1980): 90–135. In this important article the author argues persuasively that the Ayyubids "institutionalized inter-national scholarship and professionalized the 'ulamāʾ in Damascus and sought to bureaucratize, hierarchize, and further dominate the 'ulamāʾ by making areas once in the hands of scholars dependent on government." "The *madrasa* system that the rulers supported, expanded and produced the personnel necessary to provide authoritative and expeditious guidance for the mass of the Muslim community."

of plans and forms hitherto associated with royalty and state authority confirm and re-
inforce this fundamental transformation.

Madrasa, Religious Practice, and Popular Piety

Despite its well-established links with the secular domain, the madrasa remained closely
connected to religious practice and popular piety. Its religious status was made explicit by
the inclusion of a mosque and at times even a minaret within its structure. Its links with
popular piety were reinforced by the incorporation of one or more mausoleums within its
plan.

"Classes [in madrasas] began with a prayer and ended with a prayer."[105] Indeed, this
central Islamic ritual was often mandated in the waqf deed of the madrasa. For example,
the waqf of the madrasa al-Ṣāliḥiyya in Jerusalem stated that "the five daily prayers were to
be performed congregationally (jamāʿa), except for those who had a legally valid ex-
cuse."[106] It is not surprising, therefore, that every madrasa, khānqāh, and mashhad in
Aleppo and Damascus included a mosque.[107] Indeed, in some of the tiny madrasas of
Damascus, a mosque, usually combined with a mausoleum, was all there was.

In Aleppine madrasas these chapel mosques are nearly always tripartite in plan, with a
central square bay in front of the mihrāb flanked on either side by square or rectangular bays.
While the plan remains constant for nearly all Zangid and Ayyubid madrasas, the vaulting
of the bays shows considerable variety. The most common arrangement in the Ayyubid
period is a dome flanked by barrel or cross-vaults (Shādbakhtiyya, Kāmiliyya [Fig. 161],
Sulṭāniyya, Farāfra [Fig. 189], Sharafiyya, and ʿAdīmiyya). The two most elaborate ma-
drasas (Ẓāhiriyya [Fig. 160] and Firdaws) have three domes, as does the mashhad al-Dikka.
The mashhad al-Ḥusayn has a longer prayer hall with a total of five domed bays (Fig. 101).

The most common means of transition for these domes is the bipartite triangular (or
pyramidal) pendentive, which is used in nearly every structure discussed in this book.
More elaborate transition zones—employing variations of the muqarnas pendentive or
squinch—are generally used for the central dome above the mihrāb (e.g., mashhads al-
Dikka [Fig. 85] and al-Ḥusayn [Fig. 104] and madrasas al-Kāmiliyya [Fig. 162] and al-
Firdaws [Fig. 199]). The madrasa al-Sharafiyya retains an older dome type whose interior
composition resembles the stucco muqarnas domes seen in the bīmāristān and madrasa of
Nūr al-Dīn in Damascus and in numerous examples in Iraq (Fig. 163).[108] No other dome
in Aleppo has the same design; perhaps it was used in the Sharafiyya because its founder
had spent some time in Baghdad during his youth (see Chapter 2). The madrasa al-
Ẓāhiriyya is also unusual in that its mihrāb dome rests on pyramidal pendentives, whereas
the middle dome on its western side rests on an elaborate muqarnas zone (Figs. 164–65)—
a striking but inexplicable discrepancy.

105. Makdisi, Rise of Colleges, 93.
106. Ibid., 94.
107. According to Creswell, MAE, 2:127, the exis-
tence of a specially designated mosque was one of the

main features distinguishing Syrian from Egyptian
madrasas. In the latter, "the līwān qiblī served as masgid
when the time came for prayer."
108. See Tabbaa, "The Muqarnas Dome," passim.

Other than their vaulting, these prayer halls are today bare of all decoration except for their outstanding *mihrābs*,[109] which in the twelfth and thirteenth centuries could be made of wooden marquetry or revetted with polychrome marble panels. The wooden marquetry *mihrābs* were somewhat more popular during the period of Nūr al-Dīn, although one excellent specimen was made late in the Ayyubid period: the *mihrāb* erected in the ancillary iwan of the *madrasa* al-Ḥallāwiyya during the reign of al-Nāṣir Ṣalāḥ al-Dīn Yūsuf II in 643/1245.[110]

The marble-paneled *mihrābs* (Figs. 166–72) themselves fall into type A, with plain or lightly ornamented voussoirs and spandrels, and type B, with polychrome interlaced voussoirs and spandrels. These differences are restricted to the upper part (the hood) of the *mihrāb*. The lower part (the niche) is nearly identical in both types, consisting of a fairly deep concavity flanked by inset colonnettes and framed on all four sides by a heavy continuous molding. The concavity itself is usually sheathed by alternating panels of light and dark marble, most commonly veined white marble and green diorite. These panels are treated in one of three ways: they are left plain (al-Muqaddamiyya and al-Shādbakhtiyya [Figs. 166 and 171]); the darker panels are topped by a little refoil arch that gives them the appearance of small niches (al-Kāmiliyya, al-Ẓāhiriyya, al-Sulṭāniyya, and al-Firdaws [Figs. 168, 170, 172, and 200); and in one case (al-Farāfra [Fig. 190]) the dark panels have a columnar appearance. The flanking columns, mostly salvaged from Byzantine or Crusader monuments, display capitals characteristic of their place of origin.[111]

Type A is represented by one pre-Ayyubid and two Ayyubid *mihrābs*: the *madrasa* al-Muqaddamiyya (1163) (Figs. 166–67); the *madrasa* al-Kāmiliyya (c. 1230) (Figs. 168–69), and the *khānqāh* al-Farafra (1236) (Fig. 190). In all three the upper rectangular portion is framed by a continuous molding that touches the voussoir of the arch at its points of springing and at its apex. This leaves two triangular zones in the spandrel, decorated in all three *mihrābs* by a simple knot whose center is inlaid with stone mosaic in the form of a geometric pattern. In addition, inlaid mosaics in the keystones of the two Ayyubid *mihrābs* take the form of an eight-pointed star in the *madrasa* al-Kāmiliyya and a six-pointed star within a hexagon at the *khānqāh* al-Farāfra. The hood itself is plain in the first two *mihrābs*, but at al-Farafra it is inlaid with radiating greenish marble panels that conform precisely to those in the lower niche.

Type B is represented by the *mashhad* al-Ḥusayn (before 1183) (Fig. 102) and the *madrasas* al-Shādbakhtiyya (1193) (Fig. 171), al-Sulṭāniyya (c. 1200) (Fig. 172), and al-Firdaws (1234) (Fig. 200). Of these four *mihrābs* only the earliest is monochrome and has an unelaborated voussoir; in the three later examples two or three colors of stone are used,

109. This disconcerting barrenness is partly due to the disappearance (through decay or theft) of the wooden marquetry on the windows and doors and the rugs on the floor.

110. Despite the beauty of this *mihrāb* and its outstanding calligraphy, I have chosen not to discuss it here because it belongs in a study of woodwork more than in a book on architecture. See Herzfeld, *MCIA-Alep*, 1:217–20, for a discussion of this splendid *mihrāb*

and its long inscription.

111. Herzfeld, "Damascus-II," 46–47. Herzfeld rejects the notion that the use of these columns and other fragments from Crusader buildings was motivated by necessity, since the stonecraft was at its peak in the first half of the thirteenth century. Rather, he sees these acts as symbolic appropriations or subjugations of the enemy.

and the voussoirs display a characteristic polylobed and interlaced appearance. The earliest of these is the *miḥrāb* of the *madrasa* al-Shādhbakhtiyya (Fig. 171), made by the two brothers Abi al-Rajā and Abi ʿAbdullah, sons of Yaḥyā, who had built the *miḥrāb* at the *mashhad* al-Ḥusayn. The complexity and density of its design, the delicacy of its carved ornament, and the appropriateness of its columns make it the most accomplished of the series. The *miḥrāb* of the *madrasa* al-Sulṭāniyya (Fig. 172) is simpler but also displays a characteristically firm design with a totally unified appearance. The *miḥrāb* of the *madrasa* al-Firdaws, the last of this series before the Mongol invasion, is also the largest and most elaborate (Figs. 200–201). Its special distinction rests in its use of four instead of three different colors of stone and in its unique crowning element, which carries the height of the *miḥrāb* to just below the rim of the dome.

Since these mosques were not intended for the Friday prayer, they did not include a *minbar*. Curiously, however, four *madrasas* in Aleppo—al-Sulṭāniyya, al-Firdaws, al-ʿAdīmiyya, and al-Sayfiyya—were equipped with minarets. Although they were not a regular feature of Syrian or even Aleppine *madrasas*, there is no reason—archaeological or epigraphic—to assume that these minarets were not part of the original structure.[112] On the contrary, their excellent, nearly unadorned masonry and their squatness are very much in keeping with Ayyubid architecture but totally different from the sculptural and attenuated minarets of the succeeding Mamluk period.

The minarets do not conform to one specific type, although all four depart from the square shape characteristic in early Syria.[113] Those at the *madrasas* al-Sulṭāniyya (Fig. 173), al-ʿAdīmiyya (Fig. 174), and al-Sayfiyya have an octagonal shaft with a single balcony, supported on a zone of *muqarnas* in the former and brackets in the latter. Similar octagonal minarets from the Ayyubid period, both placed above the portal, are also known at the *maqām* Ibrāhīm at Ṣāliḥīn (Fig. 81) and at *maqām* Nabī Yūshaʿ.[114] At least three other octagonal minarets exist elsewhere in Syria: the minaret at Bālis (Meskené) on the Euphrates, built in 607/1210–11 by al-Malik al-ʿĀdil Abu Bakr; the minaret of the mosque al-Tawba in Damascus, built in 632/1234 by al-Malik al-Ashraf Mūsā; and the minaret of the Friday mosque northeast of Salkhad in southern Syria, built in 630/1232–33 by al-Malik al-Muʿaẓẓam ʿĪsā.[115]

Of the nine octagonal minarets from the Ayyubid period, then, six (all in the Aleppo region) are attached to *madrasas* or shrines and three belong to congregational mosques elsewhere in Syria. The popularity of the octagonal minaret in thirteenth-century Syria would suggest it was developed locally, were it not for the existence of earlier octagonal minarets in Egypt, Iraq, and Iran. In Egypt and Iraq the type is represented by a single example each: respectively, the northwestern minaret of the mosque al-Ḥākim in Cairo, dated 393/1003, and the solitary brick minaret at ʿĀnah, datable to the late eleventh century.[116] In Iran the type, never very popular, appears in two early specimens: the

112. Creswell, *MAE*, 2:127–28.

113. See Hillenbrand, "Eastern Islamic Influences in Syria," 26–30, for a short discussion of the Ayyubid minaret.

114. Herzfeld, "Damascus-III," fig. 5.

115. Hillenbrand, "Eastern Influences," figs. 6 and 8.

116. See, for example, Bloom, *Minaret*, figs. 77 and 101.

minaret of the Great Mosque at Nayin from the tenth century and the solitary minaret at Kirat, datable to c.1100.[117] These precedents, however, seem formally unlikely to have provided the model for the Ayyubid octagonal minaret, although it is possible that all of them reflect a common source. This source may be a new minaret form developed in Baghdad or, as Bloom has suggested for the minarets of al-Ḥākim, the early tenth-century Abbasid minarets at the Ḥaram of Mecca.[118] Alternatively, the Ayyubid octagonal minaret could simply be a local development.

The minaret at the *madrasa* al-Firdaws rests on an octagonal base, but its visible part is a short cylindrical shaft with a single balcony (Fig. 175). The decagonal balcony rests on ten brackets, while the shaft tapers to a little dome. The wooden framework that once surrounded the upper shaft has completely disappeared. The cylindrical shape of this minaret is not shared by any Ayyubid or Mamluk minaret in Aleppo. Even the well-known Ottoman cylindrical minarets are totally different in their overall character.

Most, perhaps even all, the Ayyubid *madrasas* in Aleppo were associated with funerary structures. This practice was as old as it was popular: the earliest known combination of a *madrasa* and a mausoleum in Aleppo dates to 522/1127, when Zangi interred the remains of his father Aqsunqur in a special mausoleum in the *madrasa* al-Zajjājiyya.[119] By the Ayyubid period, this practice was firmly established in both Damascus and Aleppo, where it took one of two forms. The first and more traditional type was a single mausoleum dedicated to the founder of the *madrasa* and usually consisting of a single dome (Fig. 110). The second was the group mausoleum, in which two or more members of the founder's family were buried, as, apparently, in several extramural *madrasas*, including al-Ẓāhiriyya and al-Firdaws.[120]

For a number of reasons the identification of mausoleums within these *madrasas* remains at times conjectural. Some mausoleums (e.g., al-Ẓāhiriyya and al-Kāmiliyya) were not used for their original purpose and remain today without any indications of burial. Others were used at later dates for the burial of religious or saintly figures after whom the *madrasa* was sometimes renamed. Thus, al-Shādbakhtiyya came to be called *masjid* al-Shaykh Maʿrūf, and al-ʿAdīmiyya is today known as al-Ṭuruntāʾiyya. In still others, portions of the building not originally intended for burial were later used for that purpose. This was certainly the case in the *madrasa* al-Firdaws, where, prior to the recent restoration, the entire eastern and western wings were "filled with graves of people with unknown genealogies."[121]

The single mausoleum form is represented in Ayyubid Aleppo by the *madrasas* al-Shādbakhtiyya, al-Sulṭāniyya, and al-Sharafiyya. The desirability of street frontage for mausoleums seems to have determined the location of all three. At the Shādbakhtiyya (Fig.

117. Anthony Hutt and Leonard Harow, *Iran 1* (London: Scorpion, 1977), 63 and 92–93.

118. Jonathan Bloom, "The Mosque of al-Hakim in Cairo," *Muqarnas* 1 (1983): 15–36; and Bloom, *Minaret*, 146–47. Hillenbrand, "Eastern Influences," 26–27 and 41–42, has argued that this form is alien to Syria and must be attributed to an Iranian influence. But this

connection is quite problematic since very few octagonal brick minarets have been published.

119. Ibn Shaddād, *Aʿlāq*, 1:97.

120. See Chapter 2 for other examples of *madrasas* with group mausoleums, often founded by women.

121. Ghazzī, *Nahr al-dhahab*, 2:218.

112) the mausoleum occupies the northeastern corner of the building, communicating with the street through a grilled window. At the Sulṭāniyya (Fig. 119) the mausoleum projects from the southeastern corner of the madrasa, presenting three windows to the important street connecting the citadel with Bāb al-Maqām. The mausoleum at the Sharafiyya has disappeared, but it originally existed on the northeastern corner of the building, facing the street connecting the Great Mosque with the citadel (Fig. 116). In terms of their location, these madrasas, like the funerary madrasas of Ayyubid Damascus and Mamluk Cairo, were placed for maximum street frontage. But they differ, especially from Mamluk madrasas, in that mausoleum and portal are not both aligned with the street facade.

The multiple mausoleum type is represented by the madrasas al-Kāmiliyya (Fig. 114), al-Ẓāhiriyya (Fig. 121), al-Firdaws (Fig. 192), and al-ʿAḍīmiyya (Fig. 117). This type of mausoleum, which already had a long history in Syria, was generally intended for the immediate family of the founder, as with the madrasa al-Ẓāhiriyya, in which al-Ẓāhir Ghāzī "founded a mausoleum intended for the burial of departed kings and princes."[122] The madrasa al-Firdaws was probably intended for the same purpose since at least one brother of Ḍayfa Khātūn—Arslānshāh, prince of ʿAzāz fortress—was buried in it.[123] We have no information about burials in al-Kāmiliyya and al-ʿAḍīmiyya.

Although the exact identification of these mausoleums remains problematic, a shift in their overall location from the front to the rear of the building seems quite evident. Instead of being located near the portal or at least in the northern part of the building, mausoleums, in fact all domed spaces, were moved to its southern part, where they flank the prayer hall. At al-Ẓāhiriyya, the mausoleum is located to the east of the prayer hall, although one or more of the domes to the west of the sanctuary were conceivably also intended for burial. A similar situation obtains at al-Kāmiliyya and al-ʿAḍīmiyya, where one or both of the domes flanking the mosque would have served as mausoleums.[124] At the madrasa al-Firdaws the situation is complicated by its multiplicity of domes. Although the two flanking the sanctuary were probably intended as mausoleums, it is impossible to determine whether any of the domes on the eastern and western wings of the courtyard was also funerary in purpose.[125]

The removal of mausoleums from the entrance side of the madrasa to its sanctuary side seems to have been motivated by two factors.[126] The first has to do with location: since many Ayyubid madrasas were located outside of the city proper and away from any regular street network, there was no incentive for placing the mausoleum on the front of the

122. Ibn Shaddād, Aʿlāq, 1:107.

123. Ibn al-ʿAdīm, Zubdat, 3:263.

124. In the case of the madrasa al-ʿAḍīmiyya, the identification of the domes flanking the mosque as mausoleums contradicts Sauvaget's identification of them as study rooms and his suggestion that the mausoleum was located in the independent northwestern wing. While a mausoleum can always also serve as a study area, I shall demonstrate below why the northwestern wing was residential, not sepulchral.

125. Curiously, the southwestern dome today contains two shrines, one of which is claimed to belong to

Imām ʿAlī. This is a blatant fabrication, probably of recent date.

126. This phenomenon is not seen in Damascus nor in Egypt, where a mausoleum facing the street on either side of the main portal remained the rule until the end of the Mamluk period. One interesting Cairene exception is the zāwiya of Shaykh Zayn al-Dīn Yūsuf (1298–1325). Its mausoleum is located away from the street to the west of the mosque. Interestingly, this building displays other Aleppine features, primarily the austerity of its stone work and its use of the first muqarnas in Cairo. Creswell, MAE, 2:229–33.

building. The second factor may have been aesthetic: placing all the domed spaces in the southern half of the building eliminated the fragmented impression inevitably produced when the domes of the mausoleum and the *miḥrāb* bay were separate; it also created a unified and rhythmic design with a more prominent exterior profile. This is indeed the impression produced by most Ayyubid *madrasas* and the *mashhad* al-Ḥusayn.

Removing the mausoleum from the street facade to the rear of the building must also have entailed some adjustments to the use of the building. Mausoleums with street frontage were intended to attract the pious devotions of the passerby while making a visible statement of dynastic continuity.[127] No one needed to enter the building to see the shrine, since most had a grilled window with access to the street level. On the other hand, it would have been necessary to enter the structure to visit mausoleums placed in the far corner. We have no information on how that rite would have been accommodated within the normal functioning of a *madrasa*.

Madrasa and Functional Requirements

The *madrasa* differed from the mosque and from all other medieval pious institutions (except the *khānqāh*) in that it was required to provide long-term housing for its professors and students. In view of the modest size of most *madrasas* in Aleppo, and in Syria generally, these functional requirements developed in a somewhat more rudimentary fashion than they eventually did in Mamluk Egypt. They included rooms or cells for students and staff, larger residences for professors, water facilities, and in some cases kitchens.

For a number of reasons it is difficult to count the student cells in most Syrian *madrasas*. First, while it is easy enough to designate a domed space as a mausoleum and an iwan as a lecture hall, it is often difficult to identify which of the many other spaces in a given *madrasa* were intended for student residence. For the sake of convenience, I have ascribed this function to featureless chambers whose dimensions did not exceed two by three meters. This leaves a few other middle-sized spaces, which I have generally designated as study areas but which in truth may have been residential. Second, the residential parts of medieval *madrasas* were almost always the first to be lost, whether to natural decay or to willful encroachment and destruction. Indeed, in several *madrasas* discussed in this chapter, only the mosque and some of the mausoleum spaces survived relatively unscathed to the present century, whereas the residential spaces had long since turned into heaps of rubble. Some of these were later restored, while others were totally replaced by modern structures.

These caveats notwithstanding, it is possible to estimate the number of residential cells in each of the seven *madrasas* under study. Al-Shādbakhtiyya, which is partly ruined, has

127. A prime example of this kind of royal mausoleum is that of Nūr al-Dīn in Damascus. Its closeness to the street and the later inclusion of a drinking fountain next to its grilled window have helped perpetuate the memory of its founder until today.

about ten cells on a single floor. Al-Sulṭāniyya, one of the most populous, has around fifty cells disposed on two floors on the eastern and western sides of the courtyard. Al-Ẓāhiriyya, which is actually a little larger than al-Sulṭāniyya, has only about twenty-five rooms—also arranged on two floors on either side of the courtyard (Fig. 176)—because a large iwan and a series of domes consume considerable portions of its eastern and western flanks. Al-Kāmiliyya, one of the more unusual Ayyubid *madrasas*, seems to have fewer than ten rooms disposed on two levels. Al-Sharafiyya must have originally had a spectacular array of student cells, probably more than fifty, arranged on three floors. Al-ʿAdīmiyya, on the other hand, still retains all twenty-four of its residential cells, arranged pristinely on two levels.[128] Most curious of all is the *madrasa* al-Firdaws, which has no student cells whatsoever, although it had residential annexes, which are discussed next.

Residential annexes exist in three Ayyubid pious buildings: the *mashhad* al-Ḥusayn (already discussed) and the *madrasas* al-Firdaws and al-ʿAdīmiyya. At al-Firdaws, two residential units occupy the northeastern and northwestern corners of the building on either side of the exterior iwan (Fig. 177a–b). They are almost completely independent from the main courtyard, from which they are accessed only by means of two long corridors that flank the exterior iwan. These units remain imperfectly known because of their ruinous condition and their enclosure within later residences that completely block their northern facades and obscure their exterior limits. Their plans as presented here are tentative but a little more accurate than those suggested by Herzfeld.

The northwestern unit is the larger and better preserved of the two. It is disposed around a squarish courtyard (6.65 by 6.50 meters) with a central octagonal pool (Fig. 178). This courtyard is surrounded by two iwans and two rectangular chambers with arched openings. The southern iwan is flanked by two square rooms while the northern iwan has the tripartite appearance typical of all palatial residences of the period. The octagonal pools with polylobed centers in this and the northeastern courtyard are exact miniatures of the pool in the courtyard of the *madrasa*.

The northeastern unit is smaller and more ruinous: its exterior borders are impossible to determine accurately, and its rather bizarre eastern extension may in fact be a later addition (Fig. 171a). The core plan is, however, certain; it consists of a squarish courtyard (6.00 by 5.75 meters) with a central pool surrounded by two axial iwans on east and west and two chambers with arched openings on north and south, exactly the opposite orientation as the northwestern unit. The tripartite eastern iwan (Figs. 179–80) is nearly identical to the one in the other courtyard and the two are closely related to the two tripartite iwans at Qalʿat Najm, with which they share many dimensions in plan and in elevation. The eastern extension from this unit contains a staircase within it and seems to end in latrines.

Once the function of these two units has been determined as residential, it is not difficult to identify the northwestern wing of the *madrasa* al-Kamāliyya al-ʿAdīmiyya as a

128. These numbers totally contradict the recent assertion made by Hillenbrand, *Islamic Architecture*, 188, where he claims that sixteen cells was "the most generous housing capacity to be found in surviving contemporary Syrian *madrasas*."

residence too (Fig. 117a). Indeed, Sauvaget's identification of this structure as "tombeau du fondateur,"[129] which has never been questioned, makes little sense. First, the building seems already to be equipped with two mausoleums, located in the traditional manner on both sides of the prayer hall. Second, this wing has its own *muqarnas* portal, which, in addition, leads to a vestibule that prevents any direct view of the interior. These are features associated with entries in residential architecture. Third, the so-called mauso-leum does not have the simple domed square plan typical of contemporary mausoleums. It is rather a cruciform structure with a domed courtyard, a plan closely related to most contemporary palatial structures. Indeed, the plan is especially close to that of the Ayyubid palace at the Bosra citadel, which also has a vaulted center. In all likelihood, therefore, this wing was the residence of the professor of the *madrasa*.

Although both Shi'i shrines in Aleppo seem to have had kitchens equipped with ovens, none of the *madrasas* display any identifiable cooking areas. All, however, were fed with running water, and most had latrines. These water facilities are found in the *madrasas* al-Shādbakhtiyya, al-Sulṭāniyya, al-Ẓāhiriyya, al-Firdaws, al-'Adimiyya, and in the two Shi'ite *mashhads*. Without exception they are located on the northern part of the building, as far away as possible from the prayer hall. The northeastern corner, apparently the preferred location for latrines, is used for that purpose in all these buildings except the *madrasas* al-Shādbakhtiyya and al-Sulṭāniyya, which use the northwestern corner. In most cases the latrines consist of an isolated but ventilated space with two to six stalls surrounded by low walls.

This chapter has investigated in some detail the institutional, formal, and iconographic aspects of the Ayyubid *madrasa*. Having made a case from the start for the polemic and authoritative nature of the *madrasa* in the post-Niẓām al-Mulk period, I have endeavored to demonstrate what factors impinged on the development of the *madrasa* in Aleppo and how these factors permeated its architectural development. I discussed three main coordinates that seem to have contributed to the formation and monumentalization of the *madrasa* in Aleppo: the authority of the state as exemplified by palace architecture; the impact of religious practice and popular piety as manifest in the mosque and the mausoleum; and the imperatives of function as revealed in the use of student cells and various facilities.

Palatial architecture played a definitive role in the creation of a monumental form for early *madrasas*. Thus, the cruciform four-iwan plan, the *muqarnas* portal, the tripartite court facade, and such exotic features as *shādirwān* fountains and foliate and pendant arches—design elements with a long history in palace architecture—were adopted nearly unadulterated in some early Syrian *madrasas*. By the Ayyubid period, however, and especially in Aleppo, these pristine concepts had been modified and amended to reflect the impact of the religious sphere and the increasing institutional development of the *madrasa*. The rigid plans common in early *madrasas* gave way to a highly adaptable system that accommodated the pious and functional components of a more mature institution.

129. Jean Sauvaget, *Alep*, pl. LVII.

The symmetrical arrangement of iwans, which continued unchanged in Iran, was supplanted in northern Syria by a more flexible design and a subtler sense of monumentality.

The religious nature of the *madrasa* absolutely required the inclusion of a mosque, and its intimate links with the founder's sense of piety made the mausoleum a highly desirable feature. Indeed, the mausoleum and the mosque, with its array of domes and splendid *miḥrāb*, increasingly became the most important architectural features of the Aleppine *madrasa*. Reading and lecturing areas were not specifically delineated as such, and they were certainly not restricted to the iwan. Rather, at this early stage in the development of the *madrasa* nearly any space in the southern half of the building (including the mosque and the mausoleum) evidently sufficed for those purposes.

Since the Ayyubid *madrasas* of Aleppo are among the earliest preserved in the Islamic world, it is difficult to assign them their place within the developmental scheme of this institution. In addition to their manifold adaptations of the cruciform four-iwan plan, their other lasting contributions were in the area of masonry dome construction and stereotomy, best exemplified by the *muqarnas* portal and polychrome interlaced masonry. The skillful integration of these flexible plans with innovative domes, *muqarnas* portals, and subtle coloristic effects resulted in highly original *madrasas* that reflected their indebtedness to the original Iranian-Iraqi model and their rootedness in the architectural tradition of northern Syria.

8

The Impact of Mysticism

Aleppo has never occupied a significant place in the annals of Islamic mysticism. If anything, its links with Sufism are generally considered negative, due to its infamous association with the murder of the great mystic Suhrawardī. Indeed, the city projects through its Ayyubid monuments an image of rigidity and uncompromising orthodoxy, much at odds with the ecstasy and transcendentalism of Islamic mysticism. It therefore comes as a surprise that some of the longest and most elaborate mystical inscriptions in all Islamic architecture are found on the Aleppine *madrasa* al-Firdaws. Completed in 1235, about forty years after the execution of Suhrawardī, the *madrasa* and its inscriptions indicate a renewed interest in mysticism, now harnessed within the context of Sunnism. Before dealing with the *madrasa* al-Firdaws and its inscriptions, the centerpiece of this chapter, I shall survey the situation of Sufism in Aleppo during the Ayyubid period and the role of the Ayyubid house, both men and women, in this mystical revival.

Ibn Jubayr, who visited Damascus during the early Ayyubid period, vividly described its *khānqāhs* and Sufis:[1]

1. *Ibn Jubayr*, 297.

As for the *ribāts*, called here *khānqāhs*, they are many. They are meant for the Sufis, and are decorated palaces in which water runs in the most agreeable manner.

These Sufis are the kings of the land, for God has spared them the trouble of getting provisions and cleared their minds for His worship instead of worrying about the means of living. He has placed them in palaces that remind them of the palaces of Paradise, so that the fortunate and the blessed among them have received through God's bounty the comforts of this world and the afterworld. They follow an honorable path (*tarīqa*) and an unusual code of behavior. The way they abide by their ranks of servitude is wonderful and their habits of meeting for chants (*samā'*) are beautiful. Some of the more excitable and tenacious among them may even transcend this world with delicacy and longing/ardor. In general, their conditions are all wonderful, and they wish for a peaceful and comfortable life.

This description was written around 1185, when the Sufis and *khānqāhs* seem to have attained considerable prestige, due in no small measure to their active patronage by Nūr al-Dīn, who was known for his personal interest in asceticism.[2] Before this time the *khānqāh* had followed a developmental path similar to the *madrasa*: originating as a private and autonomous foundation in eastern Iran, it was subsequently subsumed within the political ideology of the Great Seljuq, who converted it into a state institution. Also like the *madrasa*, the earliest preserved *khānqāhs* are not from Seljuq Iran but from Ayyubid Syria and Seljuq Anatolia.

A total of nine *khānqāhs* were built in Aleppo during the reign of Nūr al-Dīn, three by him personally[3] and six others by his princes and associates. All three *khānqāhs* built by Nūr al-Dīn and four of the remaining six were located at the foothill of the citadel, according to Elisséeff in order to be close to their protector.[4] Only one of these, the *khānqāh* al-Qadīm of 1148, survived long enough to be described by Ṭabbākh in the first decades of this century. His description, although short and general, depicts a substantial building disposed around a courtyard with a central pool. It had a prayer hall to the south, a large iwan (possibly to the west), a series of chambers on the eastern side that also contained stairs leading to another pool of water, and a northern monumental entrance. The description also mentions, but does not locate, a dome for the ascetics (*qubbah li'l-fuqarā'*).

The *Khānqāh* al-Farāfra

This description is remarkably close to the *khānqāh*[5] al-Farāfra, the only *khānqāh* to have survived in Aleppo, if not in all of Syria. It is located in the prosperous Farāfra quarter

2. Nūr al-Dīn was the first ruler to use the epithet *al-Zāhid* (the ascetic) in his inscriptions, where it occurs six times. See Elisséeff, "Titulature," 171.

3. These were:

 1. *Khānqāh* al-Qadīm (543/1148) by the moat, adjacent to *dād al-'adl*;
 2. *Khānqāh* al-Qaṣr (553/1158), near the later

 madrasa al-Sulṭaniyya;
 3. *Khānqāh* for women (553/1158), near the later *madrasa* al-Shādbakhtiyya.

4. *Nūr ad-Dīn*, 3:767.

5. For the etymology and historical usage of the term *khānqāh*, see Herzfeld, *MCIA-Alep*, 2:302 ; and more recently J. Chabbi, "Khānḳāh," *EI²*, 4:65–66.

about one hundred meters north of the citadel, on a narrow road that runs east-west. The building is entered through a stone *muqarnas* portal sited in the middle of a stone wall, some of whose blocks date back to the Ayyubid period while others, smaller in size, postdate it. The portal is traditional in form but differs slightly from its contemporaries in having two instead of three zones of *muqarnas* and a smooth hemispherical, instead of the usual sexpartite, hood (Figs. 181–82). The hood consists of true voussoirs, whose joints follow the complex geometric design.[6] It is decorated with an incised geometric pattern that resembles the design on the two known wooden *miḥrābs* in Aleppo, at the *maqam* Ibrahim in the citadel and at the *madrasa* al-Ḥallāwiyya.

A plaque above the lintel contains a cursive, densely carved inscription of six lines (Fig. 183):

(1) بسم الله الرحمن الرحيم قالوا الحمد لله الَّذي أذهب عنَّا الحزن إنَّ ربَّنا

(2) لغفور شكور الذي أحلَّنا دار المقامة من فضله لا يمسُّنا فيها نصب و لا يمسُّنا

فيها لغوب (3) أنشئ هذا الرباط المبارك في أيَّام مولانا السلطان (4) الملك الناصر

صلاح الدنيا والدين يوسف بن الملك العزيز محمَّد بن الملك الظاهر غازي (5)

بن يوسف بن أيُّوب ناصر أمير المؤمنين في شهور سنة خمس وثلاثين وستِّمائه

Bismillāh . . . "And they shall say, Praise belongs to God who has put away all sorrow from us. Surely our Lord is all-forgiving, all-thankful, who of His bounty has made us to dwell in the abode of everlasting life wherein no weariness assails us neither fatigue." [Qur'ān: xxxv, 34–35] This blessed *ribāṭ* was built during the days of the sultan al-Malik al-Naṣir Ṣalāḥ al-Dunyā w'al-Dīn Yūsuf ibn al-Malik al-'Azīz Muhammad ibn al-Malik al-Ẓāhir Ghāzī ibn Yūsuf ibn Ayyūb, the defender of the Commander of the Believers, in the months of the year 635 [1237–38].)

The inscription does not name the founder but simply states that the *ribāṭ* was built during the reign of Ṣalāḥ al-Dīn II in 635, the second year of the regency of Ḍayfa Khātūn, who ruled Aleppo in the name of her young grandson from 634/1237 until her death in 640/1244. Further evidence for Ḍayfa Khātūn's patronage of this building is provided by Ibn Shaddād, who included a structure built by her inside Bāb al-Arba'īn in his list of *khānqāhs* founded for women.[7] This gate has long since disappeared, but its original location would have been just north of the midpoint of the citadel, which accords perfectly with the location of this *khānqāh*.

Although accounts of this remarkable queen are sketchy, nearly all contemporary chroniclers commented on her justice, charity, and especially her inclination to learning and Sufism. Ibn Wāṣil wrote: "And she was just to her subjects, very charitable and loving towards them. She removed various taxes in all the regions of Aleppo. She favored jurists, ascetics, scholars and people of religion, and extended to them many charities."[8] This

6. Herzfeld, *MCIA-Alep*, 2:305. This interesting feature is also found in the portal to the Ayyubid palace at the citadel.

7. Ibn Shaddād, *A'lāq*, 1:95.
8. Ibn Wāṣil, *Mufarrij*, 5:313.

testimony is bolstered by Dayfa Khātūn's architectural patronage, which, as outlined above, focused on *khānqāhs* and mausoleums (Chapter 2).

Herzfeld notes the appropriateness of the Qur'ānic verses in the inscription, suggesting they leave no doubt that this building should be designated a *khānqāh*.[9] While this is generally correct, the verses, which are quite rare in monumental inscriptions,[10] specifically evoke God's merciful and forgiving nature and the reward of eternal and blissful life in paradise. Furthermore, they are immediately followed in the Qur'ān by severe admonitions to unbelievers, but these are not included in the selection, which maintains a benevolent tone. In all these respects, these verses are closely related to the Qur'ānic inscriptions at the *madrasa* al-Firdaws, discussed below.

The entrance leads to a vaulted, bent-axis vestibule that enters the courtyard from its northeastern side (Fig. 184). The squarish courtyard (9.82 by 11.05 meters) is centered on an octagonal pool with a polylobed interior, typical of the Ayyubid period. A tripartite prayer hall (Figs. 185–86) with a central dome occupies the southern side, and a spacious iwan faces it on the northern side (Fig. 187). The shorter eastern and western sides are taken up by uniform chambers extending the entire length of the building (Fig. 188). A portal near the middle of the western side leads through a bent corridor to a smaller square courtyard (approximately 4 by 4 meters) covered by an impluvium vault. On the eastern side of this courtyard a raised iwan is flanked by two rectangular chambers, and on its western side three chambers adorse those facing the larger courtyard.

The building still has a well-preserved, though quite inaccessible, second floor, consisting primarily of residential cells built on top of those in the larger courtyard. It is reached by means of a stone staircase built into the wall of the corridor connecting the two courtyards. If each first-story chamber had another one on top of it, there were a total of thirty-four chambers—somewhat more than the average number of cells for an Ayyubid pious institution.

The tripartite prayer hall is focused on a marble *miḥrāb*, here enclosed within a slightly pointed relieving arch (Fig. 189). This is a true voussoir arch with springing points resting directly on the masonry of the wall flanking the *miḥrāb*. The space between the arch and the *miḥrāb* is filled with cut stone of identical appearance to that of the wall. On the basis of this unusual feature, Herzfeld argues that the prayer hall once had a deep recess where the *miḥrāb* is now located and that it would have conformed entirely to the T-shaped plans of Samarra houses. He thus concludes that this space was originally intended as an audience hall and that the entire building was first built as an aristocratic residence, then later converted into a *khānqāh*.[11]

This bizarre conclusion is contradicted by textual, epigraphic, and architectural evidence. None of the contemporary texts mentions that this structure was once a residence,

9. *MCIA-Alep*, 2:303.

10. The indexes of Erica Cruikshank Dodd and Shereen Khairallah, *The Image of the Word: A Study of Quranic Verses in Islamic Architecture* (Beirut: American University of Beirut, 1981), 2:101–2, mention only six

monuments (*Khānqāh* al-Farāfra is listed twice, also as Ribāt Nāṣiri). Three of these structures are mausoleums (which seems appropriate); one is a Mamluk *madrasa*; and one is a mosque, the Great Mosque of Cordoba.

11. *MCIA-Alep*, 2:304–5.

although, as Herzfeld notes, they do so for several other *khānqāhs* in Aleppo.[12] The foundation inscription, the only epigraphic document in the building, gives a perfectly clear date (the months of the year 635), precluding the possibility that the building was begun "around 600" and turned into a *khānqāh* "before 635," as Herzfeld proposes. Furthermore, the absence of the name of the founder, Ḍayfa Khātūn, in no way indicates the residential origin of the structure but may instead be a sign of modesty in view of the nature of the building.

Architecturally, the building does not work as a palace and does not resemble any of the eight known palaces of the period. First, its tripartite prayer hall, even with a deepened niche, differs completely from the iwan-based audience halls of these palaces, nearly always located on the northern side of the courtyard. Second, even had there been a deep niche where the *miḥrāb* is now, it would not have been wide enough for a throne apse. Indeed, it functions merely as a relieving arch for the *miḥrāb*, a feature also present in the *madrasa* al-Kāmiliyya (Fig. 168). Third, the large number of chambers disposed on two floors would stand out in a palatial context but accords perfectly with the requirements of a *khānqāh*. Finally, the partly vaulted smaller courtyard, which might be read as the private courtyard of a palatial structure, is known in one other pious institution, the *madrasa* al-'Adīmiyya, which may also have functioned as a *khānqāh*. If anything, this courtyard is the most residential aspect of the *khānqāh*; it may have served as the private wing of the Sufi *shaykh*.

The *miḥrāb* belongs to the simpler of two types that were common throughout the Zangid-Ayyubid period (Fig. 190). Built entirely of marble and other hard stones, it is framed by a heavy continuous molding that divides it into two unequal parts: the lower concavity and the upper hood with its spandrels. The lower concavity is sheathed by alternating panels of veined white marble and veined greenish marble. The five darker marble panels have a columnar appearance, which is further emphasized by their capitals and bases. They are flanked by real greenish marble colonnettes, whose Romanesque acanthus capitals suggest Crusader work. These colonnettes "support" a marble arch with a prominent keystone, which is decorated with a roundel of geometric patterns. The space between the arch and the framing molding is filled with two knot motifs with inlaid geometric patterns in their centers. The hood is inlaid with greenish marble panels that conform precisely to those in the lower niche. Like all the *miḥrāb*s of Ayyubid Aleppo, this one is a masterpiece of design and stereotomy.

As one of the first preserved *khānqāh* in the Islamic world and the only one of its kind in Syria, al-Farāfra presents us with a nearly unique survival of this important institution at an early stage in its development. Although it closely resembles contemporary *madrasas* in its overall design, it differs from them by its additional courtyard and its relatively large number of living units. In these respects it resembles some of the later *khānqāhs* built in Mamluk Egypt, including the *khānqāh* of Amīr Shaykhū (1355) and the *khānqāh* of Sultan Faraj ibn Barqūq.[13] Curiously, the *madrasa* al-Firdaws—also built by Ḍayfa Khātūn, at

12. Ibid., 304.

13. Behrens-Abouseif, *Islamic Architecture*, 118 and 137.

least partly as a *khānqāh*—completely lacks living units. In many respects, it was a unique monument.

The *Madrasa* al-Firdaws

Description

Seen from a nearby modern minaret, the *madrasa* al-Firdaws looks like a massive block of hewn stone, whose severity is only partly relieved by the undulating profile of its eleven hemispherical domes (Fig. 191). Its extramural location, about five hundred meters southwest of Bāb al-Māqām, permitted its development as an entirely free-standing building, although today it suffers from encroachments on its eastern and southern sides. The *madrasa* is entered today by a single entrance on its eastern side; of its three other secondary entrances, currently blocked up, two flank the exterior iwan and a third lies exactly opposite the main entrance on the western side (Fig. 192). The main portal is a typical Ayyubid entrance: tall and narrow, with a superb triple-tiered *muqarnas* vault of the Iranian type, according to Herzfeld's classification (Figs. 195–96).[14] The scalloped half-dome on top is framed by radiating voussoirs, whose four middle ashlars extend beyond the roof line of the structure, thereby enhancing the monumentality of the portal. Contrary to common practice, the portal does not bear a foundation inscription on its lintel, which is a totally plain monolith. Rather, a long inscriptional frieze (discussed below) cuts right across the entire eastern facade of the *madrasa*, just below the springing of the *muqarnas* vault.

This portal leads to a vaulted corridor, which turns left to enter the courtyard at its northeastern corner. The nonaxiality of the portal differs from most large Ayyubid *madrasas* (e.g., the al-Zāhiriyya and al-Sulṭāniyya) but resembles Ḍayfa Khātūn's other extant building, *khānqāh* al-Farāfra (cf. Fig. 184). The side portal was necessary because the northern axis was to be occupied by the adorsed iwans, the one facing the courtyard and the other a now-vanished external garden (Figs. 194 and 202–3).

The building is disposed around a rectangular courtyard surrounded by a colonnaded peristyle (*riwāq*) on its eastern, southern, and western sides and by a large iwan on its northern side (Fig. 197). The peristyle consists of eight plain columns and two composite ones at the corners, surrounding the courtyard on three sides. All but one support exquisite *muqarnas* capitals, which are among the earliest of their kind.[15] Typically Ayyubid pointed arches spring from these capitals, four on the two long sides and three on

14. Herzfeld "Damascus-III," 12–15.

15. The earliest in Aleppo seem to be the capitals of the two columns flanking the *miḥrāb* of the *dār al-ḥadīth* of Ibn Shaddād (618/1221). This feature is repeated in a number of later *miḥrābs*, such as the mosque of Ṭaghrībardī. In courtyards, *muqarnas* capitals occur at least one more time in the *bīmāristān* of Arghūn al-Kāmilī, a Mamluk building whose main courtyard may be late Ayyubid.

the short side. Although other Ayyubid buildings, such as the *madrasas* al-Ẓāhiriyya and al-ʿAdīmiyya, contain arcaded porticos in their courtyards, this is the only one in Aleppo with a peristyle on three sides, a design feature that may reflect the rich Roman and Byzantine heritage of the region.

The peristyle leads through three doors on each side into three long chambers, each consisting of three domed bays (Fig. 198). The eastern and western chambers are quite plain; the southern serves as a mosque. Two more domes cover the corner bays flanking the mosque, for a total of eleven domes, a number unmatched by any other *madrasa* in Aleppo.[16] All these stone domes except the one over the *miḥrāb* spring from a dodecagonal base resting on bipartite triangular pendentives. The *miḥrāb* dome springs from a complex *muqarnas* zone of four tiers, with squinches of three tiers in each corner (Fig. 199). The fourth tier forms a ring of *muqarnas* cells encircling the dodecagonal transition zone. The dome itself is pierced at its springing by twelve small windows.[17]

This mosque contains a splendid *miḥrāb* made of a veined white marble, red porphyry, and green diorite. The niche of the *miḥrāb* is supported by granite columns with *muqarnas* capitals (Fig. 200). A rabbetted continuous molding frames the columns and cuts across the cavity of the *miḥrāb*, dividing it into two distinct parts. In the lower part arched panels of colored and white marble alternate. The hood of the niche is rather plain, but the voussoirs of its arch intertwine to form a complex interlace of polychrome masonry. The apex of this interlace is inscribed with the name of the artisan: "The work of Ḥasāh (?) ibn ʿAnān."[18] On this interlace is superimposed a semicircular tympanum framed by a cursive inscription and filled with a geometric pattern (Fig. 201).

The *miḥrāb* features a polychrome interlaced spandrel, the latest in the series before the Mongol invasion as well as the largest and most splendid.[19] It is distinguished by its use of four instead of three different colored stones and by its unique semicircular crowning element, which extends the *miḥrāb* to just below the rim of the dome. It is also the only *miḥrāb* in this group to bear a Qurʾānic inscription, which surrounds the semicircular strapwork.

Facing the prayer hall across the courtyard is a large iwan raised on two steps and covered with a cloister vault (Fig. 202). Its walls, like most others in this *madrasa*, each contain three regularly spaced niches, probably for the storage of books. Above these niches a long cursive inscription begins a little to the right of the iwan and encircles the courtyard on three sides, terminating over the mosque. Another inscription, at the same level, extends along the eastern wall of the courtyard.

The interior iwan is backed by another larger iwan, which faces north and is currently

16. The use of multiple domes becomes quite prevalent in the Ayyubid architecture of Aleppo:

Mashhad al-Muḥassin	9 domes (different periods)
Mashhad al-Ḥusayn	13 domes
Madrasa al-Kāmiliyya	3 domes
Madrasa al-Ẓāhiriyya	7 domes
Madrasa al-Sulṭāniyya	2 domes
Madrasa al-Firdaws	11 domes

17. *MCIA-Alep*,1, no. 2:302.

18. Herzfeld, *MCIA-Alep*, 1, no. 2:303, proposes reading the first name as Ḥasanāh, but there is no indication of a *nūn* in the inscription. Nothing more is known about this artisan.

19. See Chapter 6 for a discussion of this motif.

blocked up by a wall (Fig. 203). Two vaulted corridors flank these adorsed iwans, connecting the exterior to the courtyard and providing access to the exterior iwan through two small openings cut into the rear side walls of the iwan. The northeastern and northwestern corners contained between these corridors and the rest of the building are occupied by residential units, discussed above. According to Sibṭ ibn al-'Ajamī (d. 1479), the northern iwan faced a walled garden with a pool, whose waters were piped into the madrasa.[20] This brief information and the present situation of the building suggest that the northern part was a large iwan flanked by two smaller iwan entrances and two two-storied residential units, all facing a walled garden with a large pool.

To my knowledge, only one madrasa, the nearly contemporary al-Mustanṣiriyya of Baghdad, has an external iwan adorsing the internal one.[21] Some parallels, however, may be found in contemporary secular architecture, of which more examples are preserved than is currently believed. The above reconstruction in fact greatly resembles a little-known building in Mardin called al-Firdaws. I have suggested elsewhere that this was the sole survivor of a group of garden pavilions erected by princes of the Artuqid court between 1240 and 1260 on their property east of Mardin.[22] It stands today as a rectangular building with a large central iwan flanked by two smaller iwans and facing a large cistern.

Indeed, this palatial type, consisting of a tripartite iwan facing a pool, has a long history dating back at least to the Sassanian Ṭāq-ī-Bustān.[23] Such external iwans were also used in early Islamic architecture, as in some of the palaces at Sāmarrā and in the eleventh-century Ghaznavid palaces of Lashkārī Bāzār at Bust. Assuming gigantic proportions and usually commanding a view of a river or pond, these iwans were among the most visible signs of luxury and authority in early Islamic palatial architecture.

These comparisons imply that the external iwan and garden at the madrasa al-Firdaws belonged to a long-established palatial type, known in one extant example from the early thirteenth century.[24] Indeed, the two iwans at Aleppo and Mardin are so closely related in form, date, and location that it is tempting to trace their identical name, al-Firdaws, to a hypothetical early Islamic palace. Of course, the main difference between the two iwans is the absence of a large cistern in front of the iwan at the madrasa al-Firdaws. A pool did exist, but because water was scarce in this extramural region of Aleppo, it was much smaller than the one at Mardin.

Inscriptions

Inscriptions occupy a prominent place at the madrasa al-Firdaws: one stretches along the entire length of the eastern facade for approximately forty meters; a second totally

20. Sibṭ, Kunūz al-Dhahab, 80.

21. According to Creswell's plan (MAE, 2:fig. 68), it is not perfectly axial with respect to the internal iwan. This iwan apparently also faced a garden.

22. Tabbaa, "Use of Water," 197–220.

23. Roman Ghirshman, Persian Art: The Parthian and Sassanian Dynasties, 49 B.C.–A.D. 651 (New York:

Golden, 1962), 136–37 and 193ff.

24. Herzfeld, MCIA-Alep, 1, no.2:301 also compares it to Sassanian and Abbasid architecture and suggests that it represented "un élément primitif rudimentaire." Interestingly, Ghazzī (Nahr al-Dhahab, 289) refers to it as "iwānun kisrawiyy," or an iwan whose size matches that of Khusraw.

surrounds the interior of the building, measuring about ninety-two meters; and a third, in much smaller characters, surrounds the tympanum above the *miḥrāb*. In sheer length, these inscriptions stand out in Ayyubid architecture, whose inscriptions rarely exceed a purely functional plaque above the entrance. They are, furthermore, written in a legible and very elegant script: a large, slightly attenuated *thuluth* that represents the zenith of monumental cursive calligraphy. Their legibility is further enhanced by their relatively low placement—a little more than four meters above ground level in the courtyard and about 2.5 meters above ground level around the elevated iwan. These inscriptions were meant to be read.[25]

The external inscription

This inscriptional band begins just to the right of the entrance and ends close to the northeastern edge of the building. It starts with Qur'ānic verses (XLIII, 68–72) and continues with a foundation inscription that mentions the titles, attributes, and royal lineage of Ḍayfa Khātūn (Figs. 204–206). The name of the building's supervisor (*mutawallī*) 'Abd al-Muḥsin and the date of 633/1235–36 appear in a cartouche over a window just below the main inscription (Fig. 206).[26]

بسم الله الرحمن الرحيم يا عبادي لا خوف عليكم ولا أنتم تحزنون الذين آمنوا بآياتنا
وكانوا مسلمين أدخلوا الجنَّة أنتم وأزواجكم تحبرون يطاف عليهم بصحاف من ذهب
وأكواب فيها ماتشتهيه الأنفس وتلذُّ الأعين وأنتم فيها خالدون وتلك الجنة أورثتموها
بما كنتم تعملون هذا ما أمر بإنشائه الستر الرفيع والحجاب المنيع الملكة الرحيمة عصمة
الدُّنيا والدِّين ضيفة خاتون إبنة السلطان الملك العادل سيف الدين أبي بكر بن أيُّوب
تغمدَّهم الله برحمته في أيَّام مولانا السلطان الملك الناصر العالم العادل المجاهد المرابط
المؤيَّد المظفَّر المنصور صلاح الدنيا والدين يوسف بن الملك العزيز محمد بن الملك
الظاهر غازي بن يوسف بن أيُّوب ناصر أمير المؤمنين عزَّ نصره بتوليٍّ العبد الفقير
عبد المحسن العزيزي الناصري رحمه الله وذلك في سنة ثلثة وثلاثين وستمائه

([Qur'ān, XLIII, 68–72] This is what has ordered its construction the elevated curtain and impregnable veil, the Merciful Queen, 'Iṣmat al-Dunyā wa'l-Dīn, Ḍayfa Khātūn, daughter of the sultan al-Malik al-'Ādil Sayf al-Dīn abī Bakr son of Ayyūb, may God envelop them with His mercy, during the reign of our lord the sultan al-Malik al-Nāṣir, the learned, the just, the warrior for the faith, the

25. The origin of these *ṭirāz* inscriptions is not altogether clear. Long, visible inscriptions on the exterior and interior of buildings are first seen in Fatimid architecture, as for example in the mosque of al-Ḥākim (990 and 1013) and especially the later

Fatimid mosques, such as al-Aqmar (1125) and al-Ṣāliḥ Ṭalā'i' (1165), all in Cairo.

26. *Répertoire*, no. 4084. This inscription is not mentioned by Herzfeld.

defender of the outposts, the assisted by God, the victorious, the vanquisher, Ṣalāḥ al-Dunyā wa'l-Dīn Yūsuf son of al-Malik al-ʿAzīz son of al-Malik al-Ẓāhir Ghāzī son of Yūsuf son of Ayyūb, the supporter of the Commander of the Believers, may his victories be glorious, under the supervision of the poor slave ʿAbd al-Muḥsin al-ʿAzīzī al-Nāṣirī, may God have mercy on him, and that was in the year 633/1235–36.)

The Qur'ānic text, which envisions the faithful entering paradise, where they are offered exquisite food on plates of gold, is very rare in Islamic architecture. According to the index by Dodd and Khairallah, it occurs in only one earlier and two later monuments. The two later monuments are, appropriately enough, a prince's mausoleum and a saint's shrine. The one earlier example comes from the third addition to the Great Mosque of Cordoba, dated 241/855. Since an influence so far removed in place and time is unlikely, these Qur'ānic passages, with their clear evocation of an opulent paradise, were probably chosen purposefully for this building, as one part of a multifaceted program intended to underline the paradisiac connotations of this institution.

With respect to titulature, the historical part of the inscription is one of the earliest to present feminine honorific and royal titles. The honorific titles "al-sitr al-rafīʿ w'al-ḥijāb al-manīʿ," literally meaning "the elevated curtain and impregnable veil," were sometimes used to describe fortifications. But figuratively they refer to virtue and chastity and should perhaps be translated, in Herzfeld's phrase, as "the virtuous veil and chaste veiled [lady]." These are followed by al-Malika al-Raḥīma and ʿIṣmat al-dunyā w'al-dīn, feminine sovereign titles that were later adopted by Shajar al-Durr of Cairo.[27]

The Firdaws is dated to 633/1235 by an inscriptional cartouche above a window in the middle of its eastern facade (Fig. 206). This date is problematic since it contradicts the information provided by the two historical texts in the building. Both of these texts mention that Ḍayfa Khātūn founded this building (hādhā mā-ansha'athu) during the reign (fī ayyāmi) of al-Nāṣir Ṣalāḥ al-Dīn II, who came to power in 634/1236 immediately after the death of his father al-ʿAzīz Muḥammad. Herzfeld also notes a discrepancy between the inscribed date of the building (633) and the sovereign titles borne by the foundress, since, in his view, Ḍayfa Khātūn could only have assumed such lofty titles during her regency for al-Nāṣir Yūsuf, which began in the following year, 634. He resolves this inconsistency by proposing that the building was begun in 633 but completed after 634, when Ḍayfa Khātūn reigned on behalf of her infant grandson until her death in 640/1242.[28]

Herzfeld's proposed dating sequence corresponds to Rogers's conclusion that the date of an inscription refers "not to the completion but to the foundation" of a pious structure but that for legal and practical reasons these inscriptional plaques could not be made until the termination of work.[29] In the case of the madrasa al-Firdaws, this suggests that the inscriptional plaque bearing the date 633 refers to the foundation of the building, which was probably finished several years later, when Ḍayfa Khātūn was regent of Aleppo.

27. Herzfeld, MCIA-Alep, 2:298.
28. Ibid., 298–99.

29. Michael Rogers, "Waqf and Patronage in Seljuk Anatolia," AS 26 (1976): 72–73.

The courtyard inscription

The courtyard inscription actually consists of two distinct parts: a historical inscription that runs along the eastern wall and a religious inscription that traverses the three other walls. The historical inscription is an abbreviated version of the historical portion of the exterior inscription. It omits the date and title *al-Malika al-Raḥīma* but adds the unusual though pertinent detail that Ḍayfa Khātūn was the mother (*wālidat*) of the sultan al-Malik al-'Azīz.[30] This information augments the exterior inscription and leaves no doubt that the building was built by a royal figure.

The religious inscription is one of the most outstanding in all Islamic architecture (Figs. 207–12). Herzfeld totally ignores it, perhaps assuming that it was "merely Qur'ānic." Indeed, at first glance it does look Qur'ānic: it begins with a Bismillāh, ends with a mention of the prophet Yūsuf, and has the name of Allāh interspersed throughout. However, a closer in situ reading convinced me that it was not a Qur'ānic inscription but one made specially for the building. It remains effectively unpublished, although recorded more or less verbatim by Sibṭ Ibn al-'Ajamī (d.1474) and much more recently by Ghazzī.[31]

لله درٌّ أقوام إذا جنَّ عليهم الليل سمعت لهم انين الخائف

وإذا اصبحوا رأيت عليهم تغير الوان

إذا ما الليل اقبل كابدوه و يسفر عنهم وهم ركوع

اطار الشوق نومهم فقاموا و أهل الأمن فى الدنيا هجوع

اجسادهم تصبر على التعبد واتدامهم ليلها مقيمه على التهجد لا يرد لهم صوت

و لا دعا تراهم في ليلهم سجداً ركعا قد ناداهم المنادي و أطربهم الشادي

يا رجال الليل جدوا رب صوت لا يرد

ما يقوم الليل إلاَّ من له حزم و جد

لو ارادو في ليلتهم ساعه أن يناموا أقلتهم الشوق إليه فقاموا و جذبهم الوجد

والغرام فهاموا وأنشدهم مريد الحضره و بثهم وحملهم على المناجاه وحثهم

حثوا مطاياكم و جدوا إن كان لكم في القلب وجد

قد آن أن تظهر الخبايا و تنشر الصحف فاستعدوا

الفرش مشتاقه اليهم والوسائد متأسفه عليهم النوم قرم الى عيونهم والراحه

مرتاحه الى جنوبهم الليل عندهم أجل الأوقات في المراتب و مسامرهم عند

تهجدهم يرعى الكواكب

و زارني طيفك حتى إذا اراد أن يمضي علقت به

فليت ليلي لم يزل سرمدا والصبح لم أنظر الى كوكبه

30. *Répertoire*, no. 4081.
31. Sibṭ, *Kunūz al-Dhahab*, 80–82; Ghazzī, *Nahr al-*

Dhahab, 2:219–20. It is curious that neither writer comments on the inscription.

هجروا المنام في الظلام وتلذذوا بطول المقام وناجوا ربهم بأطيب كلام وانسوا
بقرب الملك العلام لو احتجبوا عنه في ليلهم ساعة لذابوا ولو تغيبوا عنه لحظه
لما طابوا يديمون التهجد الى السحر ويتوقعون ثمر اليقظه و السهر بلغنا أنَّ
الله تبارك و تعالى يتجلى للمحبين فيقول لهم من أنا فيقولون أنت اللَّه أنت
مالك رزقنا فيقول انتم أحبتي انتم اهل ولايتي و عنايتي ها وجهي فشاهدوه
ها كلامي فاسمعوه ها كأسي فاشربوه وسقاهم ربهم شرابا طهورا اذا شربوا
طابوا ثم طربوا إذا طربوا قاموا إذا قاموا هاموا إذا هاموا طاشوا إذا طاشوا
عاشوا لما حملت الصبا ريح قميص يوسف لم يفضض ختامه إلا يعقوب ما عرفه
أهل كنعان ومن عندهم خرج ولا يهودا وهو الحامل

The inscription is important and uncommon enough to require a full translation:

Praised be those people who when night falls you hear from them a groan of fear and when morning comes you witness a change of their mood [Fig. 207]:

> When night falls they resist [sleep]
> It leaves them while still prostrate
>
> Longing has dispelled their sleepiness, so they rose
> Whilst the righteous people of the world are asleep

Their bodies withstand worship and their feet support them in their night vigil. Their voices and pleas are not in vain as they pass the night kneeling and prostrating. They are called by the caller and entertained by the cantor:

> O men of the night exert yourselves
> For so many voices are not answered
>
> Only the serious and persevering
> Will stay up the whole night

Even if they wanted to sleep for one hour, they are disturbed by longing for Him [God]; so they arise attracted by love and ardor for Him, and they roam [Fig. 208]. The aspirant of Divine Presence (murīd al-ḥaḍrah) chants for them and sends them off; he impels them to pray lovingly and insists:

> Encourage your mounts and strive
> If you have any passion in your heart
>
> Time has come to bring out the hidden
> And expose the texts: be prepared!

Their beds beckon them and their pillows regret their absence. Sleep is distant from their eyes and rest has departed from their sides [Fig. 209]. Night for them is

the most precious time, and their companion during their night vigil herds the stars.

> I was visited by Your Apparition,
> and when it wanted to depart I held on
> How I wish my night were eternal
> And I never saw the morning star

They shunned sleep during the dark; and were graced by long stay. They spoke to their Lord with the sweetest of words; and forgot their suffering by the proximity of the Knowing King. If they stayed away from Him one hour during the night, they would dissolve; and if they departed from Him one instant, they would not be well. They continue their vigil till dawn and anticipate the reward of their alertness and wakefulness. We have heard that God, the Blessed and the Supreme, manifests Himself for those who love him. He says: "Who am I?" they answer "You are God (*anta Allāh*) [Fig. 210] ; You are our Sustainer (*māliku rizqanā*)." And He tells them, "You are my beloved ones; you are the people of my care and solicitude (*antum ahlu wilāyatī wa 'ināyatī*). This is My face; contemplate it. This is My speech; hear it. This is My cup; drink it." "And their Lord offered them a pure drink" (Qur'ān LXXVI, 21) [Fig. 211]. When they drink it they feel healthy and ecstatic; when filled with ecstasy, they stand up; having stood up, they roam about [perhaps whirl]; having roamed, they are frenzied. This frenzy brings them to Life. When the Ṣabā wind carried the scent of Yūsuf's shirt, only Ya'qūb could decipher its secret. It was not known by the Canaanites and whoever came with them nor by Yehuda, and he was the carrier [Fig. 212].

Hardly noteworthy from a literary point of view, this inscription nevertheless describes, in detail and with a great deal of passion, the actions and aspirations of the Sufis who worshiped in al-Firdaws. Their worship, which took place during a night vigil, seems to involve readings from the Qur'ān, the drinking of wine or a stimulant, and some form of dancing, all orchestrated by a Sufi leader. The ultimate reward is nothing less than a vision of God. Quoting al-Hujwīrī, one of the first Sufis, Schimmel explains:

> It is the custom of God to let the hearts of those who love Him to have a vision of Him always, in order that the delight thereof may enable them to endure every tribulation; and they say in their orisons: We deem all torments more desirable than to be veiled from Thee. When Thy beauty is revealed to our heart, we take no thought of affliction.[32]

What is the source of this type of worship and meditation? More specifically, can these practices and aspirations be attributed to any one particular Sufi group? Unfortunately,

32. Annemarie Schimmel, *Mystical Dimensions of Islam* (Chapel Hill: University of North Carolina Press, 1975), 131.

Sufi literature, though exceedingly rich in biographies and genealogies, yields scant description of specific practices in the *khānqāhs*. It is thus impossible to attribute these practices definitively to any particular Sufi group. Yet intriguing historical circumstances point to the Suhrawardiyya, specifically the teachings of Suhrawardī Maqtūl. This great Sufi philosopher, "*shaykh al-ishrāq*," "the master of the philosophy of illumination,"[33] had been drawn to the court of al-Ẓāhir Ghāzī, who was known for his fondness of Sufis and scholars. Suhrawardī's fame and heterodox teachings, however, soon brought upon him the wrath of orthodox scholars, who prevailed upon Ṣalāḥ al-Dīn to convince his son to punish the great mystic. He was thereupon put in prison, where he died in 1191 at the age of thirty-eight.

Was Ḍayfa Khātūn, who cherished and supported Sufis, attempting to revive interest in Sufism four decades after the execution of one of its greatest leaders? Specifically, does the unique inscription at al-Firdaws, with its evocations of specific mystical practices, relate in any way to the mystical writings or poetry of Suhrawardī Maqtūl? The answer to the second question is a qualified yes: one of the most popular Arabic poems by Suhrawardī Maqtūl does indeed refer to practices and ideas quite similar to those in the Firdaws inscription:

> The Caller to the Truths offered them an invitation
> by which they became quite intimate, and they went on
> They rode upon the paths of fulfillment: their tears
> were the sea while the strength of their will was the captain
> By God! They did not demand to stand by His door
> till they were invited and a key was offered to them
> They are not delighted without the remembrance of their beloved
> ever, so that all their times are joyful
> They were present while the witnesses of their being had disappeared
> they broke down when they saw Him and they wailed
> He annihilated them and uncovered for them
> the veils of immortality, and the spirits disintegrated
> Follow their example, if you are not like them
> for imitating the honorable is salvation
> Arise! Oh boon companion and bring us the wine
> in whose chalice has turned the divining arrows
> From a vineyard of generosity, in a vessel of religion:
> not a wine that has been trampled by a farmer[34]

This is a much finer piece of literature than the inscription, which has a distinct vernacular quality. But the two texts are otherwise closely related in the practices and concepts they espouse. Both are simultaneously descriptive and prescriptive: they evoke a

33. Schimmel, *Mystical Dimensions*, 260.

34. Al-Hīb, *Al-ḥaraka al-shiʿriyya*, 147; my translation.

mystical ritual while invoking an imaginary group of mystics to cling to their beliefs. Ritual practices of night worship and the imbibing of a sacred wine are common to both, and these practices are motivated by divine love and longing for God. Having attained this overwhelming love, they are rewarded by a vision of the divine, which leads them to *tahattuk* (breaking down) and *talāshi* (disintegration). These close connections can hardly be accidental: they suggest that the mystical practices at al-Firdaws were closely related to the Suhrawaridyya.

Is it possible to be any more specific about the nature of the rituals revealed in the inscription? Does this text describe the general course of activities at al-Firdaws or a specific yearly event during which emotions were especially heightened? Without in any way dismissing the general implications of the text, a deeper reading suggests that it refers to the night vigils of Ramaḍān. It is well known that the month of Ramaḍān was a time of heightened piety and awareness of proximity to God, for both the lay Muslim and the mystic. Many of the faithful would gather in the mosque after *Iftār*—as they still do today— to perform the special prayer of *Tarāwīḥ*, whose length and rhythmic repetitions may in fact be influenced by Sufi practice. The intensity of this ritual increases in the last ten days of the month, a time when the most pious and the mystics would spend the entire night in *dhikr* and contemplation. These days were specially designated by a number of *ḥadīths* as *ayyam al-tahajjud* (days of vigil), after the practice of the Prophet Muhammad, who used to spend these nights entirely in prayer and contemplation. 'Ā'isha said, "when the Ten [last ten days of Ramaḍān] arrive, the Prophet would not taste any sleep. He would pack his bedding; desert his wives; and stay up the whole night."[35]

The high point of these vigils came on the Night of Power (Laylat al-Qadr), the night when "the angels and the Spirit descend" « تنزّل الملائكة والرُّوح فيها », the night that is "peace till the rising of the dawn," « سلام هي حتّى مطلع الفجر » (Qur'ān, xcvii, 4–5). There is no consensus about the exact date of this night within Ramaḍān; the twenty-first, the twenty-third, and the twenty-seventh are often proposed, although many theologians favor the last date. Even these theologians, however, avoid possible error by stressing that the entire last third of the month is especially sacred.

A number of treatises that prescribe the pious observances for Muslim occasions set forth desirable practices for the month of Ramaḍān.[36] These are not only remarkably close in spirit to the inscriptions at the *madrasa* al-Firdaws, but even use some of the same lines of poetry. Two of the rhymed couplets (the first and the second) are repeated verbatim by two of these treatises,[37] and the ideas of the drinking of sacred wine and the vision of God are vividly detailed:

35. Shaykh 'Ali al-Nāṣir Abū Wādī, *Waẓā'if al-'ashr al-akhīra min Ramaḍān*, bound together with Abū Bakr Muhammad al-Ḥanafī, *Hādī al-'anām ilā dār al-salām* (Cairo: Maktabat Dar al-'Urūbah, 1960s), 158. I was not able to find any biographies for these two theologians, but they probably lived recently. The first set of rhymed couplets is also mentioned in Abū Shāma, *Dhayl*, 28, as a poem recited by the *mu'adhdhin* at night during Ramaḍān in order to awaken the fasters for the

night supper (*saḥūr*).

36. Abū Wādī, *Waẓā'if*; and al-Ḥāfiẓ b. Zayn al-Dīn al-Ḥanbalī, *Laṭā'if al-ma'ārif fīmā li-mawāsim al-'ām min al-waẓā'if* (Beirut: Dar al-Jil, 1975). Al-Ḥanbalī died in 795/1393; that is, he postdates the *madrasa* al-Firdaws by about one and a half centuries.

37. Ḥanbalī, *Laṭā'if*, 204, and Abū Wādī, *Waẓā'if*, 164, 182, 188.

> God has loved a people, and so they took the straight
> path of affection, and they did not sleep
> He offered them from His love a drink
> so that they were lost in His love, and they were ecstatic
> They are from the wine of His love drunken
> they have a place in their Lord's tavern[38]

The description of these nights of ecstatic worship inevitably calls up the joys of Paradise, particularly the vision (al-ru'yah) of God. Most theologians accept the possibility of this vision since it is justified by the Qur'ān (LXXV: 22–23): "Upon that day faces shall be radiant, gazing upon their Lord." The thirteenth-century theologian al-Turkumānī therefore unequivocally states that "the Vision is a right to all the people of Paradise, but without cognizance or explanation."[39]

Abū Wādī expatiates upon this vision:

> A light which brightens heavens shines upon them. They raise their heads; and Lo! it is the Almighty (His majesty be greater and His names be sacred) looking at them. He says: "O people of Paradise, peace be upon you!" . . . [They answer] "You are peace, and from You comes peace; Blessed be You, the Glorious and Beneficient." And God the Blessed and the Supreme manifests Himself (yatajallā) for them . . . and says: "This is the day of excess, ask of me." They all agree on one word: "Reveal for us Your face so that we may contemplate it." And the Lord . . . removes the veils and manifests Himself for them, overwhelming them with His light. They would burn [in his light] were it not for His mercy.[40]

It is clear from these Sufi, populist, and eschatological treatises that the vision of God described in al-Firdaws, spectacular as it is, was not without precedent. Indeed, it was one of the ultimate objectives of the Sufi ascetic, a sincere wish of lay worshipers during Laylat al-Qadr, and one of the most cherished rewards of entering paradise.

The last two sentences of the inscription are the most enigmatic: "When the Ṣabā wind carried the scent of Yūsuf's shirt, only Ya'qūb could decipher its secret. It was not known by the Canaanites and whoever came with them nor by Yehuda, and he was the carrier" (Fig. 212). Clearly, the reference is to sūrat Yūsuf in the Qur'ān, the long, complicated, and multilayered story of Joseph—a story that the Qur'ān proclaimed as aḥsan al-qiṣaṣ, the best of stories. The inscription is closely related, though not identical, to a group of verses near the end of the sūra when the caravan of Joseph's brothers was on its way back from Egypt (where Joseph had become vizier to the Egyptian Pharaoh) to Canaan. They carried with them Joseph's shirt as a sign to his father Jacob that Joseph was still among the living.

38. Abū Wādī, Waẓā'if, 182; my translation.

39. Idrīs b. Baidakīn b. 'Abdallah al-Turkumānī al-Ḥanafī, Kitāb al-luma' fī'l-ḥawādith wa'l-bida', ed. Subhi Labib (Wiesbaden: Franz Steiner, 1986), 484 and 490. No biography of al-Turkumānī exists, but the editor of

this text suggests that he lived between the second half of the thirteenth century and the first decades of the fourteenth.

40. Ḥanafī, Hādī al-'anām, 152.

Go, take this shirt, and do you cast it on my father's face, and he shall recover his sight; then bring me your family all together. So, when the caravan set forth, their father said, "surely I perceive Joseph's scent, unless you think me doting." They said, "By God, thou art certainly in thy ancient error." But when the bearer of good tidings came to him, and laid it on his face, forthwith he saw once again. He said, "Did I not tell you I know from God that you know not?" (Qur'ān, XII: 92–94)

The inscription differs from the Qur'ānic *sūra* in that it further enhances the miraculous nature of the event by claiming the wind carried the scent of Joseph's shirt to Jacob, who immediately recognized in it the aroma of paradise and realized that his beloved son was still alive.

Why was this portion of *sūrat* Yūsuf used at the end of the inscription, and how does it relate to the overall meaning of the inscription and the paradisiac imagery in the *madrasa*? Tha'ālibī, Kisā'ī, and later anthologists of *Qiṣaṣ al-Anbiyā'* (Histories of the prophets) all proclaimed the incident of the wind carrying the scent of Joseph's shirt to Jacob as a miracle from God.[41] This miracle in fact foreshadowed a second miracle: Jacob regaining his sight as soon as he rubbed his face in Joseph's shirt.

The story also assumed mystical proportions among the Sufis, who saw in the tale of Jacob's suffering and God's ultimate mercy on him an exemplar of their own condition. According to Suhrawardī Maqtūl, Jacob was the quintessence of grief (*ḥuzn*), a condition that placed him in the eighth and most sublime of the spiritual climes (*al-Iqlīm al-thāmin*), also called *hūr qalyā*. Finally, Jacob's miracle was sung by Sa'dī, one of the greatest Persian Sufi poets. A couplet in Bābi Darwīshān of his Gulistan sounds in translation quite like our inscription:

یکی پرسید از ان گم کرده فرزند
که ای روشن گهر پیر خردمند
ز مصرش بوی پیراهن شنیدی
چرا در جاه کنعانش ندیدی

(One asked the man who had lost his son
O honorable and intelligent man
Since you smelled the scent of his shirt from Egypt
Why is it that you could not see him in Canaan's well?)

Sa'dī seems to suggest here that before his devastating experience Jacob could not find his son Joseph in the nearby well in which his brothers threw him, but after his grief and

41. Al-Ḥanbalī, *Laṭā'if*, 218, also emphasizes the miraculous nature of this event. For him, however, the main moral of the story is that one should not make public one's deep love for God. Indeed, this is the same interpretation that I received from Baba Rexheb, the Shaykh of the Bektashi tekke near Detroit. I am grateful to Francis Trix for showing these inscriptions to Baba Rexheb.

suffering, he was able to smell the scent of his son's shirt from a great distance. The belief in the cleansing power of suffering seems very much in keeping with Sa'dī's ascetic nature.

These roughly contemporary interpretations of the story support the hypothesis that the miracle awaiting the vigilant Sufis of al-Firdaws (namely, a vision of God) somehow parallels Jacob's miracle. In both situations the miracle may be understood as a reward for an unwavering belief in God's grace despite many trials and tribulations: Jacob's loss of his son and his sight and the Sufi's abandonment of the trappings of the world. In a sense, the reference to Jacob's miracle may be interpreted as a Qur'ānic precedent, validating the Sufi's vision of God. Through their night worship and other ascetic practices, the Sufis of al-Firdaws would eventually become worthy of the divine presence. Alternately, the passage could intimate Jacob's special power of intuition—a way of "seeing" undoubtedly sharpened by his blindness and tremendous suffering: he was able to discover the secret that remained hidden to the Canaanites and Yehuda. Similarly, the heightened awareness of the Sufi opens for him visions that remain hidden to the average person.

One final thought inspired by the story of Joseph in the Qur'ān and in the *Qiṣaṣ* concerns the number eleven: eleven stars prostrate themselves before Joseph in his dream, and his eleven brothers prostrate themselves before him at the end of the story. The above comparison of al-Firdaws with other *madrasas* points to perhaps its most peculiar, if not unique, feature: it did not have a second floor with student cells; instead, all its interior spaces were covered with domes—eleven domes in all. Is this a case of number symbolism, with the eleven domes referring to the eleven planets that prostrated themselves before Joseph, or simply a coincidence? Whatever the case, the use of such a large number of domes was deliberate and significant, if only in enhancing the sanctity and uniqueness of the building. More specifically, it may represent an attempt by Ḍayfa Khātūn to equal the only other building in Aleppo with as many domes—the *mashhad* al-Ḥusayn on a hill west of the city. Indeed, it seems fitting that the Sunni patron of the *madrasa* al-Firdaws might compete with the most important Shi'i institution of Aleppo by matching it in size and number of domes.

The *miḥrāb* inscription

The unique semicircular zone of marquetry above the *miḥrāb* is enclosed with a Qur'ānic inscription (XXXVIII, 17–22), whose legibility is greatly enhanced by the fact that it is rendered in black stone inlaid into white marble (Fig. 201).[42]

> Bismillāh . . . and remember Our servant David, the man of might; he was penitent. With him We subjected the mountains to give glory at evening and sunrise, and the birds, duly mustered, every one to him reverting; We strength-

42. This is ultimately a technique derived from the region of Mosul, where twelfth-century specimens are quite common. It seems to have entered Syria during the period of Nūr al-Dīn. For discussion, see Tabbaa, "Nūr al-Dīn," 153–54.

ened his kingdom, and gave him wisdom and speech decisive. Has the tiding of the dispute come to thee? When they scaled the Sanctuary, when they entered upon David, and he took fright at them; and they said, "Fear not; two disputants we are—one of us has injured the other; so judge between us justly, and transgress not, and guide us to the right path."

Although the reference to David's sanctuary (*miḥrāb*) might be construed as the primary motive for selecting these verses, the fact is that they are extremely rare in monumental inscriptions, including *miḥrābs*, where III:37 is far more common. Rather, it would seem that these verses were selected for the two main themes that they illustrate: David's wisdom and justice as bestowed by the grace of God; and his mystical union with the forces of nature. The first theme might refer to Dayfa's own reign, which despite its entirely unconventional nature, was generally characterized by stability, prosperity, and justice. The second theme, in which David joins the forces of nature in celebrating the praises of God, would seem to allude to the Sufis of al-Firdaws, who also aspire to this divine union. They, like the mountains and the birds, "give glory at evening and sunrise" to their Creator.

Paradisiac Imagery

With the sanctified location of the *madrasa* al-Firdaws already noted earlier, this chapter has detailed the paradisiac symbolism of its exterior iwan and garden, as well as its highly evocative mystical inscriptions. Despite the diverse nature of these topics, all of them are connected by one dominant theme: paradise. Most explicitly, the name of the *madrasa* itself alludes to paradise, perhaps uniquely among all *madrasas*. Paradise is referred to more indirectly in the exterior iwan and garden, another unique feature whose typological ancestry goes back ultimately to the paradise garden. The Qur'ānic inscription at the portal refers explicitly to paradise, and the Sufi inscriptions, while not directly mentioning paradise, describe a divine vision and an earthly paradise.

The frequent references to paradise in Islamic architecture are not surprising since the reward of heaven is central to the Islamic belief. Indeed, the prevalence of this motif in itself seems to have contributed to its general and overspiritualistic treatment by historians of Islamic art. Like all other important concepts, however, the theme of paradise was not only deeply rooted in ancient cosmology but was also nuanced in response to social and historical circumstances. Thus, the earliest reference to paradise in Islamic architecture—at the Great Mosque of Damascus—is a literal depiction of its rivers and pavilions using the figurative language of the Byzantines.[43] Later structures allude to Paradise either through Qur'ānic inscriptions or perhaps by means of abstracted foliage and arabesque.

43. For a short but convincing interpretation of the Barada mosaics at the Great Mosque of Damascus, see Klaus Brisch, "Observations on the Iconography of the Mosaics in the Great Mosque at Damascus," in *Content* *and Context of Visual Arts in Islamic World*, ed. Priscilla P. Soucek (University Park: Pennsylvania State University Press, 1988), 13–24.

Only gradually and through a process whose outlines remain obscure do architectural as opposed to pictorial or epigraphic allusions to paradise appear in the Islamic world. It is generally believed that this did not take place until the later medieval period, especially in Timurid Iran, with its self-conscious architectural representations of paradise, usually through the *jahār bāgh*, or quadripartite garden divided by water channels.[44] By the postmedieval period, especially in Safavid Iran and Mughal India, these paradise gardens—whether surrounding pavilions or mausoleums—so increased in size and magnificence that they constituted separate worlds through which sovereigns walked as actors on a divine stage.

The *madrasa* al-Firdaws forces us to project these paradisiac architectural concepts back to at least the Ayyubid period. It sits somewhere in the middle of this developmental scheme, combining the functional aspects of a *madrasa-khānqāh* with symbolic and allegorical allusions to paradise. The paradise it promises is not the serene, effortless, and elitist one of the Timurids and Safavids but rather a paradise that rewards those who suffer and persevere in God's worship. This mixture of agony and ecstasy, toil and transcendence—though common to most Sufi experiences—might also register the need to present a Sunni alternative to the highly impassioned Shi'i ceremonies.

Not solely a monument to highlight the glory of the rulers and their semidivine nature, as many later Islamic buildings were, the *madrasa* al-Firdaws taps the collective spiritual power of the Sufis to cross the divide between this and the other world, between mystic practice and paradise. Through their generous patronage of mystics and scholars, the Ayyubid sultans, in particular their sole female ruler Ḍayfa Khātūn, hoped to ensure the allegiance of this influential sector of society while also joining the Sufis in their journey toward heaven.

44. On the symbolic aspects of *jahār bāgh* gardens, see Ralph Pinder-Wilson, "The Persian Garden: *Bagh* and *Chahar Bagh*," in *The Islamic Garden* ed. E. B. MacDougall and R. Ettinghausen (Washington, D.C.: Dumbarton Oaks, 1976), 69–86.

Conclusion

The Ayyubid architecture of Aleppo offers the full gamut of monumental types generally associated with the medieval Islamic period: mosques, *madrasas*, Sunni and Shi'i shrines, Sufi *khānqāhs*, mausoleums, and a palatial citadel. These monumental types exist in several other contemporary Syrian and Anatolian cities, but nowhere, not even in Ayyubid Damascus, do their number, variety, and quality equal those erected in Aleppo during the Ayyubid period. Beyond their sheer number, extraordinary in itself, these monuments stand out for their links with urban society, the originality of their functions, the innovation of their design, and the excellence of their craftsmanship. The following remarks therefore assess, first, the underlying factors that contributed to the number and variety of these institutions and the role of these structures within a medieval city; second, the monumentalization and formal development of these institutions in the Ayyubid period; and third, the legacy of Ayyubid architecture in the Islamic world.

The twenty-odd Ayyubid monuments directly discussed in this book form but the peak of a pyramid whose base is composed of hundreds of *masjids* and mausoleums, dozens of *madrasas* and *khānqāhs*, and a substantial number of shrines. What lies behind this single-minded preoccupation with building? What explains the spread of this building mania from the Ayyubid sultans to their officials, to their wives and sisters, and to the patrician

urban class? Indeed, what could have been the overriding concern of these patrons, and what did these newly developed extra-Islamic institutions mean to them? Economic factors are certainly at the root of this phenomenon, and there are strong indications that Aleppo had a vibrant economy under the Ayyubids (see Chapter 2). But while a prosperous economy may account for the availability of surplus capital and even for the means by which this capital was used for architectural patronage, it does not in itself explain why pious architecture was so consistently and pervasively the object of patronage.

Rather, the most fundamental factor was sociopolitical, arising from the very nature of post-Seljuq dynasties and their links with the urban population. Unlike the early Islamic empires, whose grandeur and imperial ambitions were usually articulated in the foundation of new cities with vast palaces and spacious congregational mosques, the Seljuqs and their successor states instead asserted their hegemony through the rehabilitation and modernization of preexisting towns. Whether in Iranian, Anatolian, or Syrian cities, this civilizing process (*tamaddun*) rested primarily on the creation of a variety of foundations: military foundations to defend the city and house its foreign military aristocracy, as well as pious foundations to insinuate the authority of the state deep into the recesses of the quarters and neighborhoods.[1] These institutions helped to bridge the enormous gap between the ruler and the ruled by creating pockets of allegiance to the sovereign among the population.

Culturally, these institutions had an equally important function: the creation, or perhaps re-creation, of a shared culture between ruler and ruled. In the ninth and tenth centuries, "the high-point of the Muslim intellectual movement . . . *adab* as a cultural ideal connected and tied together the courtly circles, the ruling circles, and the intellectual circles."[2] By the twelfth and thirteenth centuries this courtly culture had lost much of its former appeal and resonance and was supplanted by a multicentered but highly regulated system of Islamic knowledge that prospered within the confines of newly created institutions. Focusing their energies on the creation of colleges, convents, and shrines, the Ayyubids and other contemporary Islamic dynasties hoped to gain through architectural patronage some of what had been lost by the disappearance of a common culture and a central Islamic state. The multiplication of these institutions played a central role in fostering new ties between the ruler and various segments of the population, whose allegiance could be gained through specific acts of patronage. Through these institutions, rulers were able to garner the favor of the patrician and learned classes, from among whom they would recruit their court officials, judges, and chroniclers.

Although undeniably educational and charitable, these institutions were also instruments of the state, who supervised their functioning and exerted substantial influence on their curriculum.[3] These institutions, in turn, contributed to the creation of a large body of juridical, literary, and historical texts that constitute the main component of what is

1. Rogers, "Samarra," 154–55.
2. Excerpted from comments by Gustave von Grunebaum on a paper by Oleg Grabar, "The Architecture of the Middle Eastern City: The Case of the Mosque," in *Middle Eastern Cities*, ed. Ira Lapidus (Berkeley and Los Angeles: University of California Press, 1969), 42–43.
3. See in particular my remarks concerning the institutionalization of the *madrasas*, Chapter 7, 237–41. See also Gilbert, "Institutionalization of Muslim Scholarship," passim.

often call the "silver age" of Islam. As architectural monuments of increasing size and refinement, these structures also contributed to a fundamental shift in late medieval patronage, from idea to object, and from literature to monument.

Ayyubid Aleppo epitomizes the Islamic "city-states" of the twelfth and thirteenth centuries. Although it shared a number of important physical features—most notably the fortifications and the citadel—with its medieval European counterparts, unlike them it was neither autonomous nor self-ruled. Instead, it was ruled by a military aristocracy who belonged, and at times paid homage, to a larger dynasty. Even more distantly, Ayyubid Aleppo belonged to a larger Islamic world which, despite its irreparable fragmentation, still exerted a Neoplatonic pull on all its constituent parts. Aleppo and other capitals of medieval Islamic petty dynasties were, therefore, in some respects city-states; in other equally important respects, however, they were shrunken Islamic empires containing within their diminished territory all the components of the larger whole.

Power was primarily centered within the citadel, which in Aleppo contained the royal palace, the military garrison, and the administration, in addition to a congregational mosque and an important commemorative shrine. Furthermore, just outside its ramparts stood the tribunal (dār al-'adl), which was physically, legally, and authoritatively tied to the Ayyubid palace inside the citadel. By means of this complex organism the Ayyubids were able to assert a measure of control over nearly all aspects of Islamic rule: firepower, the dīwān, justice, religion, and even popular piety. In a very real sense, therefore, the citadel of Aleppo represents a compressed version of the vast early Islamic palaces, such as those at Samarra or Fatimid Cairo.[4]

Interestingly, the cruciform plan of the Ayyubid palace in the citadel was itself derived from the plans of classical Islamic palaces, such as those that still remain at Kufa and Sāmarrā and may have existed at the time in Syria as well. This was not the only Ayyubid palace to adopt the cruciform four-iwan plan; nine other little-known Ayyubid and Artuqid palaces also use this plan in its pristine state. Thus, the continuity of this palatial form, albeit on a greatly diminished scale, represents not so much an external influence as the appropriation and perpetuation of an important aspect of classical Islamic royal iconography.

The power and authority concentrated within the citadel served as a pole of attraction for the urban upper classes, who established their large residences in its vicinity. In Aleppo, the Farāfra quarter, north of the citadel, became the favored location for aristocratic residences in this period, a privilege it retained until quite recently. Court officials and patricians also built a number of pious foundations—with special emphasis on khānqāhs—to the south and west of the citadel. In the process of seeking protection from and paying homage to the Ayyubid court, these foundations further expanded the rings of authority emanating from the citadel. This reciprocal relationship between a dynasty possessing power but lacking legitimacy and a patrician class lacking power but possessing the means of legitimation characterizes most medieval Islamic city-states.

4. The same arrangement of functions was duplicated in Ayyubid Damascus and somewhat later in Cairo, where even the dār al-'adl was subsequently brought into the citadel. See Rabbat, "The Cairo Citadel," 237–41.

The development of Ayyubid religious architecture was closely tied to the monumentalization of the various pious institutions of the twelfth and thirteenth centuries, particularly the *madrasa*. As with the palace, the Ayyubid *madrasa* owed its internal monumentalization to the use of the cruciform four-iwan plan. The use of this and other components of palatial architecture—including the *muqarnas* portal, the tripartite courtyard facade, and elaborate fountains—seems to confirm and reinforce the progressive institutionalization of the *madrasa* and its increasing subjugation to state authority.

But whereas the plans of Ayyubid palaces were uniformly cruciform, those of Ayyubid *madrasas*, while still betraying their ultimate origin in the four-iwan design, display considerable variation and no strict canon. Responding to the religious and functional requirements of the institution, the southern iwan is invariably replaced by a triple-bay prayer hall; one or two lateral sides are occupied by student chambers or domed spaces; and only a single side contains an iwan. What might otherwise be an incoherent plan is given a substantial measure of unity through the use of central pools, tripartite courtyard facades, colonnaded porticos, and domes. These diverse elements create balance without symmetry and coherence without strict adherence to a formula. While demanding more from the viewer than their Iranian counterparts, these *madrasas* are in the end more fully developed and represent "higher organisms."[5]

The newness of Ayyubid religious institutions and the still-flexible system of charitable endowments permitted a relatively large sector of the upper classes to participate in architectural patronage. The individualized nature of this patronage and the urban location of the monuments both seem to have contributed to their greater degree of exterior monumentalization. Thus, whereas the congregational mosques of the classical Islamic period were nearly always large, inward-facing monuments, Ayyubid institutions tended to be smaller structures with complex plans, elaborate *muqarnas* portals, multiple domes, exterior inscriptions, and in some cases, minarets. In addition to being constituent elements of the medieval Islamic city and of the new cultural ideal, these were also monuments created by individuals for whom visibility and recognizability were paramount.

In Aleppo, the increasing elaboration of Sunni institutions, in particular *madrasas* and *khānqāhs*, was also related to sectarian competition. Indeed, the grandeur of the Shi'i *mashhad* al-Husayn and its apparent success in attracting a sizeable number of pilgrims might explain the flurry of *madrasa* building activity near the *maqām* Ibrāhīm.[6] More specifically, such significant architectural and decorative features as multiple domes and interlaced polychrome masonry was first perfected in the *mashhad* al-Husayn before being introduced into *madrasa* architecture. This kind of sectarian rivalry can also be seen in Ayyubid Cairo, where a variety of Shi'i Fatimid architectural and decorative forms and epigraphic formulas found their way into Sunni pious institutions.[7]

Despite all these motivating factors, the exterior monumentalization of Ayyubid pious institutions proceeded at a much slower rate than their internal development. Indeed,

5. Herzfeld, "Damascus-III," 37.

6. See Chapter 6, where I surmise the existence of a pilgrimage to this site from specific architectural features in the shrine.

7. For example, the keel arch, the radiating niche, floriated Kufic, and even some Shi'i pious formulas. See, for example, Behrens-Abou Seif, *Islamic Architecture*, 12–14; Williams, "Tabut al-Husayn," passim.

until the very end of the period *madrasas* continued to display a plain fortress-like exterior, ornamented almost solely by a single *muqarnas* portal. Originating in the brick architecture of Iran and Iraq sometime in the second half of the eleventh century,[8] *muqarnas* vaulting underwent substantial development in Ayyubid architecture. It was transformed into stone and immediately used as a portal vault.[9] In translating this complex form from light, pliable materials such as brick and stucco to a heavy, hard material such as stone, the masons had to cope with complex geometric and structural problems that seem to have stretched their skill and creativity to its limit. Employing deeply rooted stereotomic techniques and a newly acquired knowledge of practical geometry, they succeeded in creating vaults characterized by the massiveness of their stone blocks, the complexity and organic unity of their design, and their perfect integration with the surrounding structure.

These *muqarnas* portal vaults embellished the facades of a wide variety of institutions—palaces, *madrasas*, *khānqāhs*, and *bīmāristāns*—calling attention to these structures and helping to differentiate them from their vernacular surroundings. As a form capable of carrying both secular and religious meanings—and used in both contexts from the very start—the *muqarnas* vault imparted a sense of unity to the architectural production of the period. In a palatial setting it suggested ingenuity and luxury; in a religious setting, mysterious support and otherworldliness; in both it showcased the skill of the mason and the discriminating taste of the patron.

Whereas the stone *muqarnas* vault is far too widespread always to attribute to Aleppo or even Damascus, the unmistakable organic quality of Aleppine and Damascene vaults clearly distinguishes them from the rest.[10] Composed of fairly large curvilinear cells, Syrian *muqarnas* vaults spring from a well-defined transition zone and end in a scalloped half-dome, creating a canopy effect that cannot be achieved by the linear and triangular vaults of medieval Anatolia. Syrian *muqarnas* vaults retain these qualities until the Mamluk period and beyond; even today Egyptian masons still use the terms Ḥalabī (Aleppine) and Shāmī (Damascene) to refer to *muqarnas* with curvilinear cells.[11]

If Seljuq Iranian architecture is the celebration of brick, then the Ayyubid architecture of Aleppo is the celebration of stone. With the exception of wooden marquetry and the occasional use of decorative inlays, every structural and decorative component of these buildings is made of stone. Ambiguities between structure and decoration and between load-bearing elements and surface embellishments are played out in Ayyubid architecture, much as in the Seljuq Iranian architecture of the preceding century. In addition to *muqarnas* vaulting, the masons also excelled in creating foliate and pendant arches, as well as *miḥrābs* with polychrome interlacing spandrels. These devices emphasize and embellish the most significant parts of otherwise plain buildings without abandoning the overall restraint of the architectural style.

8. Tabbaa, "The Muqarnas Dome," passim.

9. Jean Sauvaget, "L'Architecture musulmane en Syrie: Ses caractères—son évolution," *Revue des arts asiatiques* 8 (1933–34): 37–38.

10. Michael H. Burgoyne, *Mamluk Jerusalem* (Essex, England: Scorpion, 1987), 98, has also noted this

feature and used it in his basic classification of *muqarnas* vaults into Syrian and Egyptian.

11. See M. M. Amin and Laila A. Ibrahim, *Architectural Terms in Mamluk Documents (648–923H) (1250–1517)* (Cairo: The American University in Cairo Press, 1990), 113.

The subtle beauty and superb design of the Ayyubid architecture of Aleppo assured its spread to surrounding regions and the survival of some of its elements long after the decline of the dynasty itself. Monuments extending from central Anatolia in the north to Cairo in the south and spanning the thirteenth and fourteenth centuries display a number of the characteristic features of Aleppine design, including foliate and pendant arches, stone *muqarnas* vaulting, and polychrome interlaced spandrels. Foliate and pendant arches and vaults, which exist in northern Syria early and plentifully enough to be called indigenous, begin to appear in other parts of the Islamic world from the last decades of the twelfth century. Thus, two Artuqid *madrasas*, al-Zinjiriyya (1198) and al-Mas'ūdiya (1198–1223) in Diyarbakir, contain foliate and pendant arches in their main iwans and in their *miḥrābs*. The latter was built by Ja'far ibn Maḥmūd al-Ḥalabī, a mason whose *nisba* clearly designates him as Aleppine by birth or origin.[12] Pendant vaults are known in Qal'at Ṣahyūn; in a number of examples from Damascus (e.g., the *madrasas* al-'Ādiliyya [c. 1220] and al-Qillīijiyya [1253]); and in Jerusalem (e.g., the portal vault of the *khānqāh* al-Dawādāriyya [1295]).[13]

Possibly the most characteristic design feature of the Ayyubid architecture of Aleppo, interlaced polychrome masonry, also had the widest dissemination. Examples from Konya (the mosque of Alaeddin and the Karatay *madrasa* [1270]; the Sultan Khans at Kayseri and Aksaray [early thirteenth century]);[14] Tripoli (the *madrasa* and mosque of al-Burṭāsī [1325] and the Jāmi' al-'Aṭṭār [1350]);[15] Damascus (the *madrasa* al-Ẓāhiriyya [1269] and al-Jaqmaqiyya [1421]);[16] Jerusalem (Qubbat al-Silsilah [c. 1262]);[17] and Cairo (the Great Mosque of Baybars [1266] and the funerary complex of Qala'ūn [1285])—all attest to the popularity of this motif. More important, the wide dispersion of this hallmark of Ayyubid architecture testifies to the great fame achieved by the architects of Aleppo in the thirteenth and fourteenth centuries. Meinecke summarizes the contribution of Aleppine masons to later Islamic architecture:

> The development of the Syrian branch of Mamluk architecture . . . is dominated by the superior masonry of the Aleppo tradition. Both Damascus and the regional centers of lesser importance benefited from the expertise of the Aleppo masons. Their hand is especially evident in Tripoli; a town newly founded by Sultan al-Mansur Qala'un after the defeat of the Crusaders, where the Friday mosque, inaugurated in 693/1293 clearly derives from Aleppo's Great Mosque. Cross vaults . . . the multicolored stone intarsia with geometric design developed in Aleppo also occurs there frequently, further indicating the dependence of this provincial school on Aleppo tradition.[18]

12. Aslanapa, *Turkish Art and Architecture*, 128–29.

13. Burgoyne, *Mamluk Jerusalem*, 137–38.

14. Aslanapa, *Turkish Art and Architecture*, figs. 17, 35, and 87.

15. Hayat Salam-Liebich, *The Architecture of the Mamluk City of Tripoli* (Cambridge, Mass.: Aga Khan Program for Islamic Architecture, 1983), frontispiece,

figs. 37 and 56.

16. 'Abd al-Qādir al-Rīḥāwī, "Al-madrasa al-Jaqmaqiyya," *AAS* 10 (1960): 69–87.

17. Burgoyne, *Mamluk Jerusalem*, 48.

18. Michael Meinecke, "Regional Mamluk Architecture," 171.

But the legacy of the Ayyubid architecture of Aleppo is not just limited to vaults and stereotomic details; indeed, it can also be traced along broader monumental types. Of these, perhaps the most noteworthy and least studied is the medieval four-iwan palace, a palatial type of ancient origins that seems to have been revived—albeit on a greatly diminished scale—in the late twelfth century. Existing primarily in Syria and the Jazīra, this palace type is known in just one other external example, the late Ayyubid palace at the Roda Island in Cairo. Curiously, very few four-iwan palaces seem to have been built after this period, and even the later Mamluk palace perched on top of the entrance block of the Aleppo citadel follows an entirely different design. This important transformation, which so far has received little serious attention,[19] might be related to the increasing complexity of the ceremonial in the Mamluk period.

Better known are the Ayyubid *madrasas* of Aleppo, whose highly individualized plans enjoyed considerable influence over a region extending from Mardin in the north to Tripoli in the southwest. Fourteenth-century *madrasas* in both of these cities commonly employ the triple-bay mosque, with a central dome flanked by barrel or cross-vaults.[20] In addition, some of the *madrasas* in Mardin display a similarly flexible sense of design that shuns cruciform regularity for a more functional spatial arrangement.[21] The serialized domed bay with a fronting arcade, as seen in the *madrasa* al-Firdaws, does not reappear until the Ottoman period, for example, in the courtyard of the hospital complex of Beyazid at Edirne, built in 1436. While this architectural idea could have derived from other sources, it is important to note that Aleppo was one of the prime regions of early Ottoman architectural patronage.[22]

Even without these extensive influences and important connections, the place of Ayyubid Aleppo remains secure within the history of Islamic architecture. Flexibility of patronage, the imperatives of newly developed institutions, a high level of craftsmanship and design, and still-vibrant links with classical Islamic culture conjoined to produce a distinguished and distinctive architectural style. The Mongol invasion, which afflicted Aleppo in the year 1260, not only damaged the infrastructure and monuments of the city, but it also forever dismantled the intricate sociopolitical system that stood at the foundations of Ayyubid architecture.

19. See, meanwhile, Rabbat, "The Citadel of Cairo," 131; and Hazem Sayed, "The Development of the Cairene Qa'a: Some Considerations," *An. Is.* 23 (1987): 31–53. Both of these works deal exclusively with the Egyptian evidence, completely ignoring the earlier Syrian development.

20. Salam-Liebich, *Tripoli: the madrasas al-Burṭāsiyya and al-Qarṭāwiyya*, figs. 30 and 97. For Mardin, see Michael Meinecke, *Die mamlukische Architektur in Ägypten und Syrien*, 2 vols. (Glückstadt: J. J. Augustin, 1992), 1:fig. 92 (Mosque of Malik Mahmud, 1363); and figs. 95 and 96 (*madrasas* of Sultan 'Isa, 1385, and Sultan Kasim). Curiously, similarly disposed mosques are also

seen in Yemen, such as the Rasulid Citadel Mosque at Zabīd. This presents the possibility that Syrian architects may have been involved there as well. See, for example, Edward J. Keall, "A Preliminary Report on the Architecture of Zabīd," *Proceedings of the Seminar for Arabian Studies* 14 (1984): 51–65, fig. 4.

21. This attitude toward design is especially clear in the closely related *madrasas* of Sultans 'Isa (1385) and Kasim (1387), as illustrated in Meinecke, *Mamlukische Architektur*, 1:figs. 95 and 96.

22. This idea has in fact been raised in passing by John Hoag, *Islamic Architecture*, 221.

Appendix

Table 1. Architectural Patrons Among Court Women

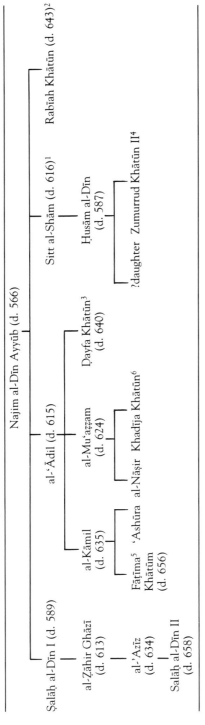

Najim al-Dīn Ayyūb (d. 566)

Ṣalāḥ al-Dīn I (d. 589)

al-ʿĀdil (d. 615)

Sitt al-Shām (d. 616)[1]

Rabiah Khātūn (d. 643)[2]

al-Ẓāhir Ghāzī (d. 613)

al-Kāmil (d. 635)

al-Muʿaẓẓam (d. 624)

Ḍayfa Khātūn[3] (d. 640)

Ḥusām al-Dīn (d. 587)

al-ʾAzīz (d. 634)

Fāṭima[5] ʿAshūra al-Nāṣir Khadija Khātūn[6]

Khātūm (d. 656)

?daughter Zumurrud Khātūn II[4]

Ṣalāḥ al-Dīn II (d. 658)

1. Founder of the madrasa al-Shāmiyya, Damascus (married to Ṣalāḥ al-Dīn)
2. Founder of the madrasa al-Ṣāḥibiyya, Damascus
3. Founder of the madrasa al-Firdaws and khānqāh al-Farāfra, Aleppo (married to al-Ẓāhir Ghāzī)
4. Founder with unnamed sister of a khānqāh in Darb al-Banāt, Aleppo
5. Founder of a khānqāh in al-Qaṭīʿa quarter, Aleppo (married to al-ʿAzīz Muḥammad)
6. Founder of the madrasa al-Murshidiyya, Damascus

Table 2 Courtyard Dimensions of Some Early and Medieval Islamic Palaces

Medieval Palaces		Early Palaces	
Palace	Court Dimen.	Palace	Court Dimen.
1. Banāt	9.95 × 9.15	1. Kūfa	37 × 37
2. Ṣahyūn	6.65 × 9.73	2. Ukhaidir	32.70 × 29
3. Aleppo	9.72 × 9.49	3. Jawsaq	110 × 62
4. Diyarbakr	3.50 × 3.80	4. Balkuwāra	105 × 67
5. ‘Ajami	9.10 × 9.90	5. al-‘Āshiq	40 × 23
6. Najm	7.05 × 7.05	6. Lashkari S. Palace	60.5 × 47.5
7. Boṣra	8.05 × 6.38	7. Ghazna Pal. Mas‘ūd III	50 × 23
8. Roḍa	6.50 × 5.50		
Average linear dim.	7.57 × 7.25	Average linear dimen.	62.17 × 42.50
Average area	54.88 sq. m.	Average area	2642.23 sq. m.

Table 3 Patronage, Size, and Type of Medieval Syrian Madrasas

Madrasa/Location	Date	Patronage	Dimensions: int. / ext.	Plan
Gümüshtekin, Boṣra	530/1136	Prince	6 × 6/ 17 × 20	Axial/4-iwan cruciform
Nūriyya, Damascus	567/1172	Royal	19.20 × 17.45/ 39 × 42	Non-axial/3-iwan cruciform
Shādbakhtiyya, Aleppo	589/1192	Official	9.21 × 8.23/ unknown	Non-axial/1-iwan
Ẓāhiriyya, Aleppo	616/1219	Royal	14.75 × 18.39/ 29.35 × 36.05	Axial/1-iwan
Sulṭāniyya, Aleppo	618/1221	Royal	16.80 × 19.67/ 24.55 × 26.15	Axial/no iwans
‘Ādiliyya, Damascus	619/1222	Royal	13.60 × 14.60/ 30 × 34	Non-axial/3-iwan cruciform
Kāmiliyya, Aleppo	624–636/ 1227–39	Princess?	14.12 × 16.23/ 29.56 × 31.55	Non-axial/1-iwan
Firdaws, Aleppo	633–34/ 1236–37	Royal/Queen	13.15 × 17.35/ 43.5 × 56	Non-axial/1-iwan cruciform
Sharafiyya, Aleppo	c.620–40/ c.1223–42	Notable	13.16 × 18.47/ 25 × 38	Non-axial/1-iwan
‘Adīmiyya, Aleppo	c.639–49/ c.1241–51	Notable	10.80 × 14.47/ 28 × 36	Non-axial/1-iwan
Ṣāḥibiyya, Damascus	630–643/ 1233–45	Princess	10.85 × 14.45/ 21.70 × 28.90	Axial/4-iwan cruciform

Table 4 Portals of *Madrasas* and Related Buildings in Medieval Aleppo

Building (*madrasa* unless otherwise noted)	Date of portal	Portal vault type
1. Ḥallāwiyya	543/1149	Cloister
2. Bimāristān al-Nūri	c. 545/1150	Cloister
3. Muqaddamiyya	564/1169	Trilobed/cross
4. Mashhad al-Dikka	585/1189	Muqarnas -M-
5. Shādbakhtiyya	589/1193	Muqarnas -M-
Mashhad al-Ḥusayn		
6. sanctuary portal	596/1200	Muqarnas -I-
7. annex portal	613–34	Muqarnas -M-
8. Sayfiyya	606/1209	Muqarnas -I-
9. Ẓāhiriyya, e.m.	c. 610/1213	Muqarnas -I-
10. Sulṭāniyya	fin. 618/1221	Cloister
11. Atābikiyya	620/1223	Muqarnas -I-
12. Sharafiyya	631/1234	Muqarnas -I-
13. Kāmiliyya	624–636/1227–39	Muqarnas -I-
14. Firdaws	633/1236	Muqarnas -I-
15. Khānqāh al-Farafra	635/1238	Muqarnas -I-
16. 'Adīmiyya: west portal	639–649/	Muqarnas -I-
17. 'Adīmiyya: south portal	1241–1251	Muqarnas -I-
18. Karīmiyya	654/1256	Muqarnas -I-
19. Asadiyya	early 13th century	Muqarnas -I-

I = Iranian M = Mediterranean

Table 5 Configuration of Courtyard Facades in Ayyubid *Madrasas*

Madrasa	Porticos	South	North	East	West
Muqaddamiyya, 1168	—	Tripartite/equal	Destroyed	Destroyed	Doors to cells
Shādbakhtiyya, 1192	—	Tripartite/unequal	Iwan/2 niches	Doors to cells	Doors to cells
Kāmiliyya, 1227–39	—	Tripartite/unequal	Iwan/2 doors	Double tripartite comp.	Double tripartite comp.
Sharafiyya c. 1223–42	—	Tripartite/unequal	Tripartite/equal	Iwan/2 large doors	Portal iwan/arcade
'Adīmiyya, c. 1241–51	East and west	Tripartite/unequal	Iwan	Cells on 2 levels	Cells on 2 levels
Sulṭāniyya c. 1200–1221	—	Tripartite/unequal	Portal iwan/cells each side	Doors to cells	Doors to cells
Ẓāhiriyya, 616/1219	North and south	Tripartite/equal	Portal iwan and 2 small iwans	Iwan/2 doors each side	Cells on 2 levels
Firdaws, 1236–37	East, west, and south	Tripartite/equal	Iwan/2 doors	3 arched doors	3 arched doors
Khānqāh al-Farāfra	—	Tripartite/unequal	Iwan/2 doors	Cells on 2 levels	Cells on 2 levels

Table 6 Mosque Forms in the Ayyubid *Madrasas* of Aleppo

Madrasa	Mosque	Minaret	*Miḥrāb*
Muqaddamiyya, 1168	Cross-vault, 2 barrel vaults	—	Marble-paneled, 2 lozenges
Shādbakhtiyya, 1192	Dome on pyramid pendts. 2 sail vaults	—	Marble-paneled, Interlace
Kāmiliyya, 1227–39	Dome on *muqarnas,* 2 barrel vaults	—	Orig. marble-panel, 2 lozenges
Sharafiyya c. 1223–42	Dome on wide *muqarnas* zone, 2 sail vaults	—	Destroyed
ʿAdīmiyya, c. 1241–51	Dome on pyramid pendts. 2 sail vaults	Short octagonal	Unornamented
Sulṭāniyya c. 1200–1221	Dome on pyramid pendts. 2 sail vaults	Short octagonal	Marble-paneled, Interlace
Ẓāhiriyya, 616/1219	Three domes on pyramid, pendentives	—	Marble-paneled, 2 geom. panels
Firdaws, 1236–37	Three domes: 1 *muqarnas* and 2 on pyramid. pendts.	Short circular	Marble-paneled, Interlace
Khānqāh al-Farāfra, 1238	Dome on *muqarnas* and 2 barrel vaults	—	Marble-paneled, 2 lozenges

Works Cited

'Abbo, 'Ādil N. "Al-Madrasa fi'l-'imāra al-ayyū-biyya fī Sūriya." *AAS* 34 (1974): 75–112.

———. "Al-Turba fi'l-'imāra al-ayyūbiyya fī Sūriya." *Sumer* 30 (1974): 273–81.

Abū Shāma, Shihāb al-Dīn 'Abd al-Raḥmān. *Al-Dhayl 'alā al-rawḍatayn.* Edited by M. al-Kawthari. Cairo: Dar al-Kutub al-Malikiyya, 1947.

———. *Kitāb al-rawḍatayn fī akhbār al-dawlatayn al-nūriyya w'al-ṣalāḥiyya.* Edited by M. H. Ahmad. 2 vols. Cairo: Wizārat al-Thaqāfa w'al-Irshād al-Qawmī, 1956–62.

Abū Wādī, Shaykh 'Ali al-Nāṣir. *Waẓā'if al-'ashr al-akhīra min Ramaḍān.* Bound together with Abū Bakr Muhammad al-Ḥanafī, *Hādī al-anām ilā dār al-salām.* Cairo: Maktabat Dar al-'Urūbah, 1968.

Ali, Saleh Ahmad. "The Foundation of Bagh-dad." In *The Islamic City,* edited by A. H. Hourani and S. M. Stern, 88–91. Oxford: Bruno Cassirer, 1969.

Allen, Terry. "Some Pre-Mamluk Portions of the Courtyard Facades of the Great Mosque of Aleppo." *BEO* 35 (1983): 6–12.

———. "Notes on Bust." *Iran* 26 (1988): 55–68.

———. *A Revival of Classical Antiquity in Syria.* Wiesbaden: Ludwig Reichert, 1989.

Alsayyad, Nezar. *Cities and Caliphs: On the Genesis of Arab Muslim Urbanism.* Westport, Conn.: Greenwood, 1991.

Altun, Ara. *Anadolu'da Artukulu devri Turk Mimarisi'nin Gelişmesi.* Istanbul, 1978.

Amiet, Pierre. *Art of the Ancient Near East.* New York: Abrams, 1980.

Amin, Hussein. *Al-Madrasa al-Mustanṣiriyya.* Baghdad, 1980.

Amin, Muhammad M. *Al-Awqāf w'al-ḥayāt al-ijtimā'iyya fī miṣr, 648–923/1250–1517.* Cairo: Dar al-Nahdha al-'Arabiyya, 1980.

———. *Al-Muṣṭalaḥāt al-mi'māriyya fi'l-wathā'iq al-mamlūkiyya, 1250–1517.* Cairo: American University of Cairo Press, 1986.

Amin, Muhammad M., and Laila A. Ibrahim. *Architectural Terms in Mamluk Documents (648–923H) (1250–1517).* Cairo: American University of Cairo Press, 1990.

The Arts of Islam: Hayward Gallery, 8 April–4 July 1976. London: Arts Council of Great Britain, 1976.

Ashtor, Eliyahu. *A Social and Economic History of the Near East in the Middle Ages.* Berkeley and Los Angeles: University of California Press, 1976.

Aslanapa, Oktay. "Erster Bericht über die Ausgrabungen des Palastes von Diyarbakir." *IM* 12 (1962): 115–28.

———. *Turkish Art and Architecture.* New York: Praeger, 1971.

Atil, Esin. *Art of the Arab World.* Washington, D.C.: Smithsonian Institution, 1975.

———, ed. *Patronage of Women in Islamic Art.* *Asian Art* 6, no. 2 (Spring 1993).

Atil, Esin, W. T. Chase, and Paul Jett. *Islamic Metalwork in the Freer Gallery of Art.* Washington, D.C.: The Gallery, Smithsonian Institution, 1985.

Bacharach, Jere L. "Administrative Complexes, Palaces, Citadels: Changes in the Loci of Muslim Rule." In *The Ottoman City and Its Parts,* edited by I. A. Bierman, R. Abou-El-Haj, and D. Preziosi, 111–28. New Rochelle, N.Y.: A.D. Caratzas, 1991.

Al-Balawī, Abū Muḥammad ʿAbdullah. *Sīrat Aḥmad Ibn Ṭūlūn.* Edited by Muhammad Kurd ʿAli. Damascus: al-Maktabah al-ʿArabiyyah, 1939.

Al-Bayhaqī, Abu al-Faẓl Muhammad. *Taʾrīkh-ī Masʿūdī.* Edited by A. A. Fayyāḍ. Mashhad: Mashhad University Press, 1971.

Behrens-Abouseif, Doris. *Islamic Architecture in Cairo: An Introduction.* Leiden: E. J. Brill, 1992.

Braudel, Fernand. *On History.* Translated by S. Matthews. Chicago: University of Chicago Press, 1980.

Bell, Gertrude. *Amurath to Amurath.* London: Macmillan, 1924.

Bellafiore, Giuseppe. *La Zisa di Palermo.* Palermo: S. I. Floccovio, 1978.

Berchem, Max van. "Origine de la Madrasah." *MMAF* 19, no. 2 (1894): 254–69.

———. *Opera Minora.* 2 vols. Geneva: Editions Slatkine, 1978.

Berchem, Max van, and E. Fatio. *Voyage en Syrie.* 2 vols. *MIFAO* 37–38 (1914–15).

Bloom, Jonathan. "The Mosque of al-Hakim in Cairo." *Muqarnas* 1 (1983): 15–36.

———. "The Mosque of Qarafa in Cairo." *Muqarnas* 4 (1986): 7–20.

———. *Minaret: Symbol of Islam.* Oxford: Oxford University Press, 1989.

Bosworth, C. E. "The Political and Dynastic History of the Iranian World (A.D. 1000–1217)." In *The Cambridge History of Iran,* vol. 5, *The Saljuq and Mongol Periods,* edited by J. A. Boyle. Cambridge: Cambridge University Press, 1968.

———. *The Ghaznavids.* 2d ed. Beirut: Librarie du Liban, 1973.

Brentjes, Burchard. "Karawanserail und Ribat in Mittelasien" *AMI* 21 (1988): 209–21.

Briggs, M. S. *Muhammadan Architecture in Egypt and Palestine.* London, 1924.

Brinner, W. M. "Dar al-Saʿāda and Dar al-ʿAdl in Mamluk Damascus." In *Studies in Memory of Gaston Wiet,* edited by M. Rosen-Ayalon, 235–47. Jerusalem: Hebrew University Press, 1977.

Brisch, Klaus. "Observations on the Iconography of the Mosaics in the Great Mosque at Damascus." In *Content and Context of Visual Arts in Islamic World,* edited by Priscilla P. Soucek, 13–24. University Park: The Pennsylvania State University Press, 1988.

Broadhurst, R. J. C. *A History of the Ayyūbid Sultans of Egypt.* Boston: G. K. Hall, 1980.

Bulliett, Richard. *The Patricians of Nishapur: A Study in Medieval Islamic Social History.* Cambridge: Harvard University Press, 1972.

Burgoyne, Michael H. *Mamluk Jerusalem.* Essex, England: Scorpion, 1987.

Cahen, Claude. "Ayyubids." *EI²* 1 (1954): 796–807.

———. "Réflexions sur le waqf ancien." *SI* 14 (1961): 37–56.

———. "L'Évolution de l'iqtāʿ du IXᵉ au XIIIᵉ siècle, Contribution à une histoire comparée des sociétés médiévales." In *Les peuples musulmans dans l'histoire médiévale,* 231–69. Damascus: Institut français de Damas, 1977.

———. *Les peuples musulmans dans l'histoire médiévale.* Damascus: Institut français de Damas, 1977.

———. *Introduction à l'histoire du monde musulman médiéval, VIIe–XVe siècle.* Paris: Maisonneuve, 1982.

Canard, Marius. "Le cérémonial fatimide et le cérémoniale byzantin; essai de comparaison." *Byzantion* 21 (1951): 355–420.

Casimir, M. J., and B. Glatzer. "Shah-i Mashhad: A Recently Discovered Madrasah of the Ghurid Period in Gargistan (Afghanistan)." *East and West* 21 (1971): 53–68.

Chamberlain, Michael. *Knowledge and Social Practice in Medieval Damascus.* Cambridge: Cambridge University Press, 1994.

Clevenger, William M. "Some Minor Monuments in Khurāsān." *Iran* 6 (1968): 57–64.

Colledge, Malcolm A. R. *Parthian Art.* Ithaca: Cornell University Press, 1977.

Creswell, K. A. C. "The Origin of the Cruciform Plan of Cairene Madrasas." *BIFAO* 21 (1922): 1–54.

———. *Early Muslim Architecture.* 2 vols. Oxford: Clarendon Press, 1932 and 1940.

———. *Muslim Architecture of Egypt.* 2 vols. Oxford: Clarendon Press, 1952–59.

Diwaji, Sa'id. "Madāris al-Mawṣil fi'l-'ahd al-atābikī." *Sumer* 13 (1957): 101–18.

Dodd, Erica Cruikshank, and Shereen Khairallah. *The Image of the Word: A Study of Quranic Verses in Islamic Architecture.* Beirut: American University of Beirut, 1981.

Duby, Georges, ed. *A History of Private Life.* Vol. 2, *Revelations of the Medieval World.* Cambridge: Belknap Press of Harvard University Press, 1988.

Ecochard, Maurice. "Notes d'archéologie musulmane. I, Stéréotomie de deux portails du XIIe siècle." *BEO* 7–8 (1937–38): 98–112.

———. *Filiation de monuments grécs, byzantin et islamiques: Une question de géométrie.* Paris: Librarie Orientaliste Paul Geuthner, 1977.

Eddé, Anne-Marie. "Une grande famille de Shafiites alépins, les Banū al-'Aǧamī aux XIIe–XIIIe siècles." *Revue du monde musulman et la mediterranée* 62 (1991–94): 61–71.

Elisséeff, Nikita. "Les monuments de Nur ad-Din: inventaire, notes archéologiques et bibliographiques." *BEO* 13 (1951): 5–49.

———. "La titulature de Nur ad-Din d'après ses inscriptions." *BEO* 14 (1952–54): 115–96.

———. *Nūr al-Dīn un grand prince musulman de Syrie au temps des Croisades (511–569/1118–1174).* 3 vols. Damascus: Institut français de Damas, 1967.

Ertuǧ, Ahmet, ed. *The Seljuks.* Istanbul: Ahmet Ertuǧ, 1991.

Ettinghausen, Richard. *Arab Painting.* New York: Rizzoli, 1977.

———. "Originality and Conformity in Islamic Art." In *Individualism and Conformity in Classical Islam,* edited by Amin Banani and Speros Vryonis Jr., 95–103. Wiesbaden: Otto Harrassowitz, 1977.

Ettinghausen, Richard, and Oleg Grabar. *The Art and Architecture of Islam, 650–1250.* Harmondsworth: Penguin, 1987.

Ettinghausen, Richard, and Grace Guest. "The Iconography of a Kashan Luster Plate." *AO* 4 (1961): 25–64.

Fāris, M. Kāmil. "Ma'ādhin Ḥalab wa taṭawwurihā al-'imrānī." *'Adiyyāt* 3 (1977): 119–77.

Frankfort, Henri. *The Art and Architecture of the Ancient Orient.* London: Penguin, 1970.

Franz, Heinrich G. *Palast, Moschee und Wüstenschloss. Das Werden der islamischen Kunst, 7–9 Jahrhundert.* Graz (Austria): Akademische Druck, 1984.

Frye, Richard N. *The Golden Age of Persia: Arabs in the East.* London: Weidenfeld and Nicolson, 1988.

Gabriel, Albert. *Monuments turcs d'Anatolie.* 2 vols. Paris: Boccard, 1934.

Gabrieli, Francesco, ed. *Arab Historians of the Crusades.* Translated by E. J. Costello. Berkeley and Los Angeles: University of California Press, 1969.

Gaube, Heinz, and Eugen Wirth. *Aleppo: Historische und geographische Beiträge zur baulichen Gestaltung, zur sozialen Organisation und zur wirtschaftlischen Dynamik einer vorderasiatischen Fernhandelsmetropole.* Wiesbaden: Ludwig Reichert, 1984.

Al-Ghazzī, Kāmil. *Nahr al-dhahab fī ta'rīkh Ḥalab.* 3 vols. Aleppo, 1922–26. Aleppo: Dār al-Qalam al-'Arabī, 1991.

Ghirshman, Roman. *Persian Art: The Parthian and Sassanian Dynasties, 249 B.C.–A.D. 651.* New York: Golden, 1962.

Gibb, H. A. R. "The Armies of Saladin." In *Studies on the Civilization of Islam,* edited by S. J. Shaw and W. R. Polk, 74–90. London: Routledge and Kegan Paul, 1962.

Gilbert, Joan. "Institutionalization of Muslim Scholarship and Professionalization of the 'Ulamā' in Medieval Damascus." *SI* 52 (1980): 90–135.

Godard, André. "L'Origine de la madrasa, de la mosquée et du caravanserail à quatre iwans." *AI* 15–16 (1951): 1–9.

Goitein, S.D. *A Mediterranean Society.* Vol. 4, *Daily Life.* Berkeley and Los Angeles: University of California Press, 1983.

Golombek, Lisa, and Donald Wilber. With contri-

butions by Terry Allen et al. *The Timurid Architecture of Iran and Turan*. Princeton: Princeton University Press, 1988.

Gorbea, Antonio Almagro, *El Palacio Omeya de Amman*. Madrid: Instituto Hispano-Arabe de Cultura, 1983.

Grabar, Oleg. *Sasanian Silver*. Ann Arbor: The University of Michigan Museum of Art, 1967.

———. "The Visual Arts." In *The Cambridge History of Iran*. Vol. 5, *The Saljuq and Mongol Periods*, edited by J. A. Boyle, 631–37. Cambridge: Cambridge University Press, 1968.

———. "The Illustrated Maqāmāt of the Thirteenth Century: The Bourgeoisie and the Arts." In *The Islamic City*, edited by A. H. Hourani and S. M. Stern, 207–22. Oxford: Cassirer, 1970.

———. "Survivances classiques dans l'art de l'Islam." *AAS* 21 (1971): 371–85.

———. *The Formation of Islamic Art*. New Haven: Yale University Press, 1973.

———. *The Alhambra*. Cambridge: Harvard University Press, 1978.

———. "La Place de Qusayr Amrah dans l'art profane du Haut Moyen Age." *Cahiers archéologiques* 36 (1988): 75–83.

Al-Ḥajjī, Ḥayat. *Aḥwāl al-ʿāmmah fī ḥukm al-mamālīk*. Kuwait: Kadhima, 1984.

Al-Harawī, Alī. *Kitāb al-ishārāt ilā maʿrifat al-ziyārāt*. Edited by Janine Sourdel-Thomine as *Guide des lieux de pélerinage*. Damascus, 1953.

Harb, Ulrich. *Ilkhanidnische Stalaktitengewolbe: Beiträge zu Entwurf und Bautechnik*. Berlin: Reimer, 1978.

Hartner, Willy. "The Pseudoplanetary Nodes of the Moon's Orbit in Hindu and Islamic Iconographies." *AI* 5 (1938): 113–54.

Al-Hassan, Ahmad Yahya, and Donald R. Hill. *Islamic Technology: An Illustrated History*. Cambridge: Cambridge University Press, 1986.

Al-Hayb, A. F. *Al-Ḥaraka al-shiʿriyya zaman al-ayyūbiyyīn fī Ḥalab al-shahbā'*. Kuwait: Maktabat al-Muʿalla, 1987.

Herzfeld, Ernst. "Mitteilungen über die Arbeiten der zweiten Kampagne von Samarra." *Der Islam* 5 (1914): 196–204.

———. "Damascus: Studies in Architecture—I." *AI* 9 (1942):1–53.

———. "Damascus: Studies in Architecture—III." *AI* 11–12 (1946): 1–71.

———. "Damascus: Studies in Architecture—IV." *AI* 13–14 (1948): 120–23.

———. *MCIA: Syrie du Nord*. Part 2, *Monuments et inscriptions d'Alep*. 3 vols. Cairo: Institut français d'archéologie orientale, 1954–56.

Hill, Donald R. *Kitāb al-Ḥiyal: The Book of Ingenious Devices of Banu Mūsā b. Shākir*. Boston: D. Reidel, 1979.

Hillenbrand, Robert, "Eastern Islamic Influences in Syria: Raqqa and Qalʿat Jaʿbar in the later 12th century," in *The Art of Syria and the Jazīra 1100–1250*, edited by Julian Raby Oxford: Oxford University Press, 1985.

———. "Madrasa, III. Architecture." *EI*² 5 (1986): 1136–54.

Hinz, W. "Dhirāʿ." *EI*² 2:231–32.

Hoag, John. *Islamic Architecture*. New York: Abrams, 1977.

Hodgson, Marshall G. S. *The Venture of Islam*. 3 vols. Chicago: University of Chicago Press, 1974.

Humphreys, R. Stephen. "The Expressive Intent of the Mamluk Architecture of Cairo: A Preliminary Essay." *SI* 35 (1972): 69–119.

———. *From Saladin to the Mongols: The Ayyubids of Damascus, 1193–1260*. Albany: State University of New York Press, 1977.

———. "Politics and Architectural Patronage in Ayyubid Damascus." In *The Islamic World from Classical to Modern Times: Essays in Honour of Bernard Lewis*, edited by C. E. Bosworth, et al., 151–74. Princeton, N.J.: Darwin, 1989.

———. *Islamic History: A Framework for Inquiry*. Princeton, N.J.: Princeton University Press, 1991.

———. "Women as Patrons of Architecture in Ayyubid Damascus." *Muqarnas* 11 (1994): 35–54.

Hutt, Anthony, and Leonard Harow. *Iran 1*. London: Scorpion, 1977.

Ibn al-ʿAdīm, Kamāl al-Dīm ʿUmar. *Zubdat al-ḥalab fī ta'rīkh Ḥalab*. Edited by Sāmī Dahhān. 3 vols. Damascus: Institut français de Damas, 1951–68.

Ibn al-Athīr, ʿIzz al-Dīn. *Al-Ta'rīkh al-bāhir fi'l-dawla al-atābikiyya bi'l-Mawṣil*. Edited by A. A. Tulemat. Cairo, 1963.

————. *Al-Kāmil fi'l-ta'rīkh.* Edited by C. J. Tornberg. 13 vols. Leiden, 1851–76. Reprint, with new pagination, Beirut, 1965.

Ibn al-Jawzī, Abu'l-Faraj. *Al-Muntaẓam fī ta'rīkh al-mulūk wa'l-'umam.* 6 vols. Hayderabad, 1938. Reprint, Beirut, 1960.

Ibn al-Shiḥna, Muḥibb al-Dīn Abu'l-Faḍl Muḥammad. *Al-Durr al-muntakhab fī ta'rīkh Ḥalab.* Translated and edited by Jean Sauvaget as *"Les perles Choisies" d'Ibn ach-Chihna, Matériaux pour servir à l'histoire de la ville d'Alep.* Vol. 1. Beirut: Institut français de Damas, 1933.

Ibn Jubayr. *Riḥlat Ibn Jubayr.* Beirut: Dar Sader, 1980.

————. *The Travels of Ibn Jubayr.* Translated by R. J. C. Broadhurst. London: Jonathan Cape, 1952.

Ibn Khallikān. *Wafiyyāt al-a'yān.* 8 vols. Edited by Iḥsān 'Abbas. Beirut: Dar Sader, 1978.

Ibn Qāḍi Shuhba, Badr al-Dīn. *Al-Kawākib al-durriyya fi al-sīra al-nūriyya.* Beirut: Dar al-Kitab al-Jadid, 1971.

Ibn Shaddād, 'Izz al-Dīn. *Al-A'lāq al-khaṭīra fī dhikr umarā' al-Shām wa'l-Jazīra. Ta'rīkh Ḥalab.* Edited by D. Sourdel. Beirut: Institut français de Damas, 1953.

————. *Al-A'lāq al-khaṭīra fī dhikr umarā' al-Shām wa'l-Jazīra: Ta'rīkh Dimashq.* Edited by Sāmī Dahhān. Damascus: Institut français de Damas, 1956.

————. *Al-A'lāq al-khaṭīra fī dhikr umarā' al-Shām wa'l-Jazīra. Ta'rīkh Lubnān w'al-Urdunn wa Filasṭīn.* Edited by Sāmī Dahhān. Damascus: Institut français de Damas, 1963.

————. *Al-A'lāq al-khaṭīra fī dhikr umarā' al-Shām wa'l-Jazīra. Ta'rīkh al-Jazīra.* Edited by Yaḥya 'Abbāra. 2 vols. Damascus: Wizārat al-Thaqāfa w'al-Irshād al-Qawmī, 1977–78.

Ibn Shakir. *Fawāt al-wafiyyāt.* Edited by Ihsan 'Abbās. 5 vols. Beirut: Dar Sader, 1973.

Ibn Wāṣil, Jamāl al-Din Muḥammad. *Mufarrij al-kurūb fī akhbār Banī Ayyūb,* vols. 1–3, edited by Jamāl al-Din al-Shayyāl. Cairo: Wizārat al-Thaqāfa wa'l-Irshād al-Qawmī, 1953–56. Vols. 4–5, edited by S. A. F. 'Āshūr and H. M. Rabī'. Cairo, Wizārat al-Thaqāfa, 1972–77.

Al-Iṣfahānī, 'Imād al-Dīn al-Kātib. *Kharīdat al-'aṣr wa jarīdat al-qaṣr, Shu'arā' Miṣr.* Edited by Shawqi Ḍayf, et al. Cairo, 1951.

————'Imād al-Dīn al-Kātib. *Kharīdat al-'aṣr wa jarīdat al-qaṣr, Shu'arā' al-Shām.* Edited by Shukri Fayṣal. 4 vols. Damascus: al-Maṭba'ah al-Hāshimiyya, 1955–68.

————. *'Imād al-Dīn al-Kātib. Kharīdat al-'aṣr wa jarīdat al-qaṣr, Shu'arā' al-'Iraq.* Edited by M. Bahjat al-Athari. 4 vols. Baghdad: Matba'at al-Majma' al-'Ilmi, 1955–81.

Jones, Dalu. "The Cappella Palatina in Palermo: Problems of Attribution." *AARP* 21 (1972): 41–57.

Juha, Farid. "Qal'at Ḥalab." *'Ādiyyat* 2 (1976): 105–9.

Al-Janabi, Tarek A. "Recent Excavations at Samarra." *Sumer* 37 (1981): 188–211.

Al-Jumaylī, Rashīd. *Dawlat al-atābikah fi'l-Mawṣil ba'da 'Imād al-Dīn Zankī, 541–631 H.* Beirut: Dar al-Nahḍah al-'Arabiyyah, 1970.

K. A. C. Creswell and His Legacy. Muqarnas 8 (1991).

Keall, Edward J. "A Preliminary Report on the Architecture of Zabīd." *Proceedings of the Seminar for Arabian Studies* 14 (1984): 51–65.

Khalpakhchian, O. Kh. *Architectural Ensembles of Armenia.* Moscow: Iskusstvo, 1980.

Al-Khalīl, 'Imād al-Dīn. *Al-Imārāt al-Artuqiyya fi'l-Jazīra wa'l-shām (564–812 H./1072–1409).* Beirut: Mu'assasat al-Risalah, 1980.

Al-Kisā'ī, Muḥammad b. 'Abdullah. *Kiṣaṣ al-anbiyā'.* Edited by I. Eisenberg. Leiden: E. J. Brill, 1922.

Kitāb al-ḥawādith al-jāmi'ah w'al-tajārib al-nāfi'ah f'il-mi'ah al-sābi'ah. Edited by Mustafa Jawad. Baghdad: al-Maktaba al-'Arabiyyah, 1931.

Kleiss, Wolfgang. "Typen iranischer Karawanserails." *Architectura* 11 (1981): 111–28.

————. "Die Karawanenwege in Iran aus früh-islamischer Zeit." In *Transition Periods in Iranian History.* Freiburg, 1987.

Lambton, A. K. S. "The Internal Structure of the Saljuq Empire." In *The Cambridge History of Iran,* vol. 5, *The Saljuq and Mongol Empires,* edited by J. A. Boyle. Cambridge: Cambridge University Press, 1968.

————. "The Dilemma of Government in Islamic Persia: The Siyāsat-nāma of Niẓām al-Mulk." *Iran* 22 (1984): 55–66.

————. *Continuity and Change in Medieval Persia: Aspects of Administrative, Economic and Social*

History, 11th–14th Century. Columbia Lectures on Iranian Studies, no. 2. Edited by Ehsan Yarshater. Bibliotheca Persica, 1988.

Lapidus, Ira M. *Muslim Cities in the Later Middle Ages.* Cambridge: Harvard University Press, 1967.

Lassner, Jacob. *The Topography of Baghdad in the Early Middle Ages.* Detroit: Wayne State University Press, 1970.

———. *The Shaping of ʿAbbāsid Rule.* Princeton: Princeton University Press, 1980.

Lauffray, Jean. "Une madrasa ayyoubide de la Syrie du Nord. La Soultaniya d'Alep." *AAS* 3 (1953): 49–66.

Leiser, Gary. "The *Madrasa* and the Islamization of the Middle East, the Case of Egypt." *JARCE* 22 (1985): 29–74.

———. "Notes on the Madrasa in Medieval Islamic Society." *IC* 76, no. 1 (January 1986): 16–23.

Lyons , Malcolm Cameron, and D. E. P. Jackson. *Saladin: The Politics of the Holy War.* Cambridge: Cambridge University Press, 1982.

Maʿrūf, Naji. *Al-madāris al-sharābiyya.* 2d ed. Baghdad, 1976.

MacKenzie, Neil D. *Ayyubid Cairo: A Topographical Study.* Cairo: American University in Cairo Press, 1992.

Makdisi, George. "Muslim Institutions of Learning in Eleventh-Century Baghdad." *BSOAS* 24 (1960): 1–56.

———. "The Sunni Revival." In *Islamic Civilization, 950–1150,* edited by D. S. Richards. Oxford: Cassirer, 1973, 155–68.

———. *The Rise of Colleges: Institutions of Learning in Islam and the West.* Edinburgh: Edinburgh University Press, 1981.

Mango, Cyril. *The Art of the Byzantine Empire, 312–1453: Sources and Documents.* Englewood Cliffs, N.J.: Prentice-Hall, 1972.

Marçais, George. "Salsabīl et Ṣādirvan." In *Mélanges d'histoire et d'archéologie de l'occident musulman,* vol. 1. Algiers, 1957.

al-Masʿūdī. *Murūj al-dhahab wa-maʿādin al-jawhar,* 4 vols. Beirut: Dar al-Andalus, 1973.

Mazloum, Subhi. *L'ancienne canalisation d'eau d'Alep.* Damascus: Institut français de Damas, 1959.

Meinecke, Michael. "Mamluk Architecture. Re-gional Architectural Traditions: Evolution and Interrelations." *DM* 2 (1985): 163–75.

———. "Ruckschlusse auf die Form der seld-schukischen Madrasa in Irān." *DM* 3 (1988): 185–202.

———. *Die mamlukische Architektur in Ägypten und Syrien.* 2 vols. Glückstadt: J. J. Augustin, 1992.

Migne, J.-P. *Patrologie Graecae.* Vol. 132. Paris, 1864.

Al-Muqaddasī. *Aḥsan al-taqāsīm fī maʿrifat al-aqālīm.* Edited by M. J. de Goeje. Leiden, 1906.

Al-Māwardī, ʿAli b. Muḥammad. *Al-Aḥkām al-sulṭāniyya waʾl-wilāyāt al-dīniyya.* Edited by M. Fahmi al-Sirjani. Cairo: al-Maktabah al-Tawfiqiyya, 1978.

Nagel, T. "Ḳiṣaṣ al-Anbiyāʾ." *EI*² 4:180–81.

Naṣrallah, Ibrāhīm. *Ḥalab waʾl-tashayyuʿ.* Beirut: Muʾassasat al-Wafāʾ, 1983.

Niẓām al-Mulk. *The Book of Government or Rules for Kings: The Siyāsat-nāma or Siyar al-Mulk of Niẓām al-Mulk.* Translated by Hubert Drake. New Haven: Yale University Press, 1960.

Northedge, Alastair. "Creswell, Herzfeld, and Samarra." *Muqarnas* 8 (1991): 74–93.

———. "An Interpretation of the Palace of the Caliph at Samarra (Dar al-Khilafa or Jawsaq al-Khaqani)." In *Pre-Modern Islamic Palaces,* edited by Gülru Neçipoğlu, 143–70. *AO* 23 (1993).

Nājī, Maʿrūf. *ʿUlamāʾ al-niẓāmiyyāt wa-madāris al-mashriq al-islāmī.* Baghdad: Matbaʿat al-Irshad, 1973.

Öney, Gönül. *Anadolu Selçeku Mimarisinde Susleme ve El Sanatlari.* Ankara: Turk Matbaacilik Sanayii, 1978.

Onians, John. *Bearers of Meaning, The Classical Orders in Antiquity, the Middle Ages, and the Renaissance.* Princeton: Princeton University Press, 1988.

Pedersen , J. "Masdjid." *EI*² 6:656.

Pellat, Charles. "Al-Khālidiyyān." *EI*² 4:936–47.

Pinder-Wilson, Ralph. "The Persian Garden: Bagh and Chahar Bagh." In *The Islamic Garden,* edited by E. B. MacDougall and R. Ettinghausen, 69–86. Washington, D.C. Dumbarton Oaks, 1976.

Preusser, Conrad. *Nordmesopotamische Baudenk-*

mäler altchristlischer und islamischer Zeit. Leipzig, 1911.

Qal'ajī, 'Abd al-Fattāḥ. *Ḥalab al-qadīmah wa'l-ḥadīthah.* Beirut: Mu'assasat al-Risālah, 1989.

Al-Qazzāz, M. S. D. *Al-Ḥayāt al-siyāsiyyah fi'l-'Irāq fi'l-'aṣr al-'abbāsiyy al-'akhīr.* Najaf: Matba'at al-Qaḍā', 1971.

Ra'ūf, 'Imād 'Abd al-Salām. *Madāris Baghdād fi'l-'aṣr al-'abbāsī.* Baghdad: Dar al-Basri, 1966.

Rabbat, Nasser. "Mamluk Throne Halls: *Qubba* or *Iwān?*" In *Pre-Modern Islamic Palaces,* edited by Gülru Neçipoğlu, 201–18. AO 23 (1993).

———. "The Ideological Significance of the Dār al-'Adl in the Medieval Islamic Orient." *IJMES* 27 (February 1995): 3–28.

Raymond, André. *The Great Arab Cities in the 16th–18th Centuries.* New York: New York University Press, 1984.

———. "The Population of Aleppo in the Sixteenth and Seventeenth Centuries According to Ottoman Census Documents." *IJMES* 16 (November 1984): 477–90.

Redford, Scott. "Thirteenth-Century Rum Seljuq Palaces and Palace Imagery," In *Pre-Modern Islamic Palaces,* edited by Gülru Neçipoğlu, 219–36. AO 23 (1993).

Rice, Tamara Talbot. *The Seljuks in Asia Minor.* New York: Praeger, 1961.

Al-Riḥāwī, 'Abd al-Qādir. *Al-'imāra al-'arabiyya al-islāmiyya, khaṣā'iṣuhā wa-āthāruhā fī Sūriya.* Damascus: Wizarat al-Thaqafa, 1979.

Rogers, Michael. "Sāmarrā: A Study in Medieval Town Planning." In *The Islamic City,* edited by A. Hourani and S. M. Stern, 154–55. Oxford: Cassirer, 1970.

———. "The 11th Century—A Turning Point in the Architecture of the Mashriq?" In *Islamic Civilization, 950–1150,* edited by D. S. Richards, 211–50. Oxford: Cassirer, 1973.

———. "Waqf and Patronage in Seljuk Anatolia." *AS* 26 (1976): 72–73.

Salam-Liebich, Hayat. *The Architecture of the Mamluk City of Tripoli.* Cambridge: Aga Khan Program for Islamic Architecture, 1983.

Sanders, Paula. "From Court Ceremony to Urban Language: Ceremonial in Farimid Cairo and Fusṭāṭ." In *The Islamic World from Classical to Modern Times: Essays in Honor of Bernard Lewis,* edited by C. E. Bosworth, et al., 311–21. Princeton, N.J.: Darwin, 1989.

Sarre, F., and E. Herzfeld. *Archäologische Reise im Euphrat und Tigris-Gebiet.* 4 vols. Berlin: Dietrich Reimer, 1911–20.

Sauvaget, Jean. "Deux sanctuaires chiites d'Alep." *Syria* 9 (1928): 224–37 and 320–27.

———. "L'enceinte primitif de la ville d'Alep." *Mélanges de l'Institut Français de Damas* 1 (1929): 148–49.

———. "Inventaire des monuments musulmans de la ville d'Alep." *REI* (1931): 59–114.

———. "L'Architecture musulman en Syrie: Ses caractères—śon évolution." *Revue des arts asiatiques* 8 (1933–34): 19–51.

———. "Esquisse d'une historie da la ville de Damas." *REI* 8 (1934): 421–80.

———. "Alep au temps de Sayf al-Dawla." *Mémoires de l'Institut français de Damas.* Beirut, 1936.

———. "La tombe de l'ortokide Balak." *AI* 5 (1938): 207–15.

———. *Alep: Essai sur le développement d'une grande ville syrienne des origines au milieu du XIXᵉ siècle.* 2 vols. Paris: Paul Geuthner, 1941.

———. "Notes sur quelques monuments musulmans de Syrie à propos d'une étude recente." *Syria* 24 (1945): 211–31; 25 (1946–48): 159–67.

Sauvaget, J., M. Ecochard, and J. Sourdel-Thomine. *Les monuments ayyoubides de Damas.* 4 fascs. (continuous pagination). Paris: Klinksieck, 1938–50.

Sayed, Hazem. "The Development of the Cairene Qā'a: Some Considerations." *An Is* 23 (1987): 31–53.

Schimmel, Annemarie. *Mystical Dimensions of Islam.* Chapel Hill: University of North Carolina Press, 1975.

Sha'th, Shawqi. *Qal'at Ḥalab, dalīl atharī tārīkhī.* Damascus: Ministry of Culture Publications, 1986.

Shāfi'ī, Farīd. "The Mashhad al-Juyūshī (Archaeological Notes and Studies)." In *Studies in Islamic Art and Architecture in Honour of Professor K. A. C. Creswell,* Cairo: American University in Cairo Press, 1965, 237–52.

Shmaysānī, Ḥassan. *Madāris Dimashq fī al-'aṣr al-ayyūbi.* Beirut: Dar al-Afaq al-Jadida, 1983.

Sibṭ Ibn al-'Ajamī, Abū Dharr Aḥmad b. Ibrāhīm. *Kunūz al-dhahab fī ta'arīkh Ḥalab.* Translated and edited by Jean Sauvaget as *"Les trésors d'or" de Sibṭ Ibn al-'Ajamī, Matériaux pour servir à l'histoire de la ville d'Alep,* vol. 2. Beirut: Institut français de Damas, 1950.

Sinclair, Tom. "Early Artuquid Mosque Architecture." In *The Art of Syria and the Haẓīra, 1100–1250,* edited by Julian Raby, 49–68. Oxford: Oxford University Press, 1985.

Sobernheim, Moritz. "Das Heiligtum Schaikh Muhassin in Aleppo." *Mélanges H. Derenbourg,* 370–90. Paris, 1909.

———. "Die arabische Inschriften von Aleppo." *Der Islam* 15 (1926): 161–210.

Sourdel, Dominique. "Les professeurs des madrasas à Alep aux XIIᵉ–XIIIᵉ siècles." *BEO* 13 (1947–50): 85–115.

———. "Esquisse topographique d'Alep *intra-muros* a l'époque ayyoubide." *AAS* 2 (1952): 109–33.

———. "Questions des cérémonial 'abbaside." *REI* 28 (1960): 121–48.

———. "Réflexions sur la diffusion de la madrasa en Orient du XIᵉ au XIIIᵉ siècle." *REI* 44 (1976): 165–84.

———. "Kal'at Nadjm." *EI²* 4:487.

Sourdel, Dominique and Janine Sourdel. "Notes d'épigraphie et de topographie sur la Syrie du Nord." *AAS* 3 (1953): 81–105.

———. *La civilization de l'Islām classique.* Paris: Arthaud, 1976.

Sourdel-Thomine, Janine. "Les anciens lieux de pélerinage damascains d'après les sources arabes." *BEO* 14 (1952–54): 65-85.

———. "Une inscription inédite de la madrasa Sultaniyya a Alep." *AAS* 3 (1953): 67–70.

———. "La mosquée et la madrasa." *Cahiers du Monde médiévale* 13 (1970): 97–115.

———. "Renouvellement et tradition dans l'architecture saljūqides." In *Islamic Civilization, 950–1150,* edited by D. S. Richards, 251–64. Oxford: Cassirer, 1973.

———. "Locaux d'enseignement et madrasas dans l'Islam médiéval." *REI* 44 (1976): 185–97.

———. "Al-Harawī al-Mawṣilī." *EI²* 3:178.

Sözen, Metin. *Anadolu Medreseleri Selçuku ve Beyleker Devri.* 2 vols. Istanbul: Istanbul Technical University Press, 1970.

Strika, Vicenzo. "The Turbah of Zumurrud Khātūn in Baghdad: Some Aspects of Funerary Ideology." *Annali dell'Instituto Orientali di Napoli,* n.s., 28 (1978): 283–96.

Al-Ṣābi', Hilāl. *Rusūm Dār al-Khilāfa.* Edited by Mikhā'il 'Awwād. Baghdad, 1964.

Tabbaa, Yasser. "The Architectural Patronage of Nūr al-Dīn Maḥmūd ibn Zangī, 1146–1174." Ph.D. diss., New York University, 1982.

———. "The Muqarnas Dome: Its Origin and Meaning." *Muqarnas* 3 (1985): 61–74.

———. "Monuments with a Message: Propagation of Jihād under Nūr al-Dīn." In *The Meeting of Two Worlds: Cultural Exchange between East and West during the Period of the Crusades,* edited by Vladimir P. Goss and Christine V. Bornstein, 223–40. Kalamazoo, Mich.: Medieval Institute Publications, Western Michigan University, 1986.

———. "Toward an Intepretation of the Use of Water in Courtyards and Courtyard Gardens." *Journal of Garden History* 7, no. 3 (1987): 197–220.

———. "Geometry and Memory in the Design of the Madrasat al-Firdows in Aleppo." In *Theories and Principles of Design in the Architecture of Islamic Societies,* edited by Margaret Ševčenko, 23–34. Cambridge, Mass.: The Aga Khan Program for Islamic Architecture, 1988.

———. "Typology and Hydraulics in the Medieval Islamic Garden." In *Garden and Landscape History: Issues, Approaches, Methods,* edited by John Dixon Hunt, 303–29. Washington, D.C.: Dumbarton Oaks, 1992.

———. "Circles of Power: Palace, Citadel, and City in Ayyubid Aleppo." In *Pre-Modern Islamic Palaces.* Edited by Gülru Neçipoğlu, 181–200. *AO* 23 (1993).

———. "Survivals and Archaisms in the Architecture of Northern Syria, ca. 1080–ca. 1150." In *Essays in Honor of Oleg Grabar,* 29–41. *Muqarnas* 10 (1993).

———. "Muqarnas." *Dictionary of Art.* London: Macmillan, 1997.

Al-Ṭabbākh, M. Rāgheb. *I'lām al-nubalā' bi-ta'rīkh*

Ḥalab al-shahbā'. 7 vols. Aleppo, 1926. Reprint, 7 vols., with an index. Aleppo: Dār al-Qalam al-'Arabī, 1989.

Ṭalass, M. As'ad. *Al-āthār al-'islāmiyya w'al-tārīkhiyya fī Ḥalab*. Damascus: Matba'at al-Taraqqi, 1956.

Tchalenko, Georges. *Villages antiques de la Syrie du nord*. 3 vols. Paris: Librarie orientaliste Paul Geuthner, 1953.

Al-Tha'ālibī, Abū Isḥāq Aḥmad. *'Arā'is al-majālis fī ḳiṣaṣ al-anbiyā'*. Cairo, 1898.

Toueir, Kassem. "*Natā'ij al-tanqīb fī Hiraqlah*." AAS 33 (1983): 99–112.

———. "Der Qaṣr al-Banāt in ar-Raqqa. Ausgrabungen, Rekonstruktion und Wiederaufbau (1977–1982)." DM 2 (1985): 297–319.

Trimingham, J. S. *The Sufi Orders in Islam*. Oxford: Oxford University Press, 1971.

———. *Christianity among the Arabs in Pre-Islamic Times*. London: Longman, 1979.

Veccia Valgieri, L. "Al-Ḥysayn b. 'Alī b. abī Ṭālib." *EI²* 3:613.

Walls, Archibald. "Two Minarets Flanking the Church of the Holy Sepulchre." *Levant* 8 (1976): 159–61.

Wiet, Gaston. "Notes d'épigraphie syro-musulmane." *Syria* 5 (1924): 216–53; 6 (1925): 150–73; 7 (1926): 45–66.

———. "Une inscription de al-Malik Ẓāhir Ghāzī à Latakieh." *BIFAO* 30 (1931): 273–92.

Williams, Caroline. "The Cult of 'Alid Saints in the Fatimid Monuments of Cairo. Part I: The Mosque of al-Aqmar." *Muqarnas* 1 (1983): 37–52.

———. "The Cult of 'Alid Saints in the Fatimid Monuments of Cairo. Part II: The Mausolea." *Muqarnas* 3 (1985): 39–60.

———. "The Qur'anic Inscriptions in the Tabut of al-Husayn in Cairo." *Islamic Art* 2 (1987): 3–14.

Yāqūt al-Ḥamawī. *Mu'jam al-buldān*. 5 vols. Beirut: Dar al-Kitab al-'Arabi, 1971.

Index

Illustrations

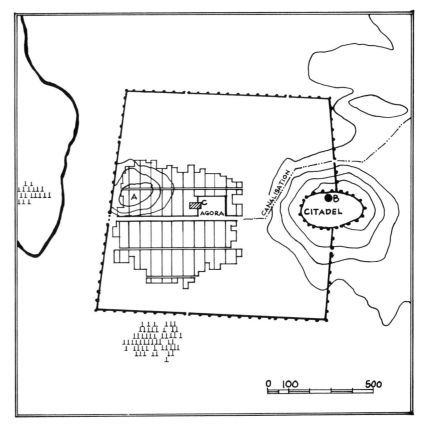

Fig. 1. Roman Aleppo (Beoria): reconstructed plan

A THE "TELL" B THE HIGH PLACE C THE MAIN TEMPLE

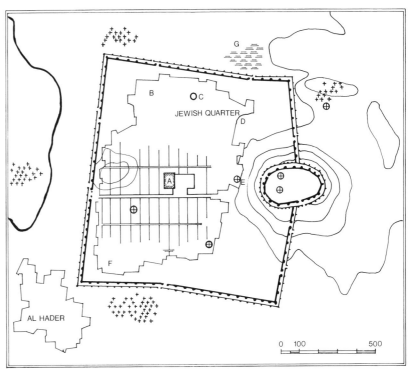

Fig. 2. Byzantine Aleppo: reconstructed plan

A CATHEDRAL E SYNAGOGUE
B BAHSITA F JALLUM
C GREAT SYNAGOGUE G JEWISH CEMETERY
D FARAFRA

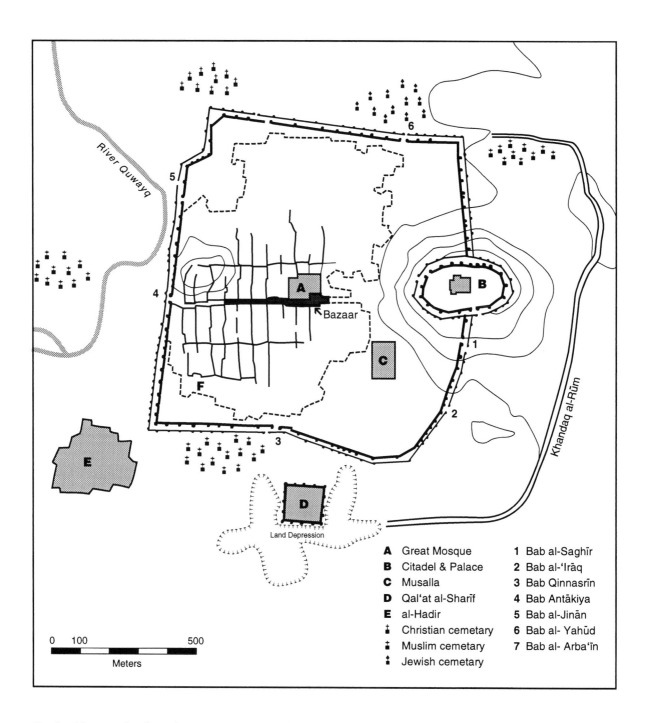

Fig. 3. Aleppo in the eleventh century: reconstructed plan

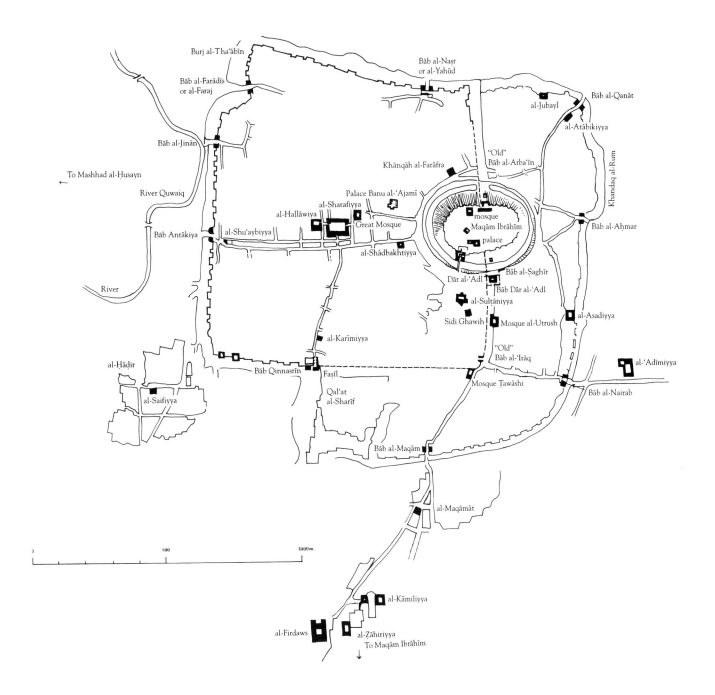

Burj al-Thaʿābīn

Bāb al-Farādīs
or al-Faraj

Bāb al-Naṣr
or al-Yahūd

Bāb al-Qanāt

al-Jubayl

al-Atābikiyya

Bāb al-Jinān

"Old"
Bāb al-Arbaʿīn

To Mashhad al-Ḥusayn

Khānqāh al-Farāfra

River Quwaiq

Khandaq al-Rum

Palace Banu al-ʿAjamī

al-Sharafiyya

al-Hallāwiya

mosque
Maqām Ibrāhīm

Bāb Antākiya

al-Shuʿaybiyya

Great Mosque

palace

Bāb al-Aḥmar

River

al-Shādbakhtiyya

Bāb al-Ṣaghīr

Dār al-ʿAdl

Bāb Dār al-ʿAdl

al-Sulṭāniyya

al-Asadiyya

Sidi Ghawih

Mosque al-Utrush

al-Hāḍir

al-Karīmiyya

al-ʿAdīmiyya

al-Saifiyya

Bāb Qinnasrīn

"Old"
Bāb al-ʿIrāq

Faṣīl

Mosque Ṭawāshi

Bāb al-Nairab

Qalʿat
al-Sharīf

Bāb al-Maqām

al-Maqāmāt

3 500 1000 m.

al-Kāmiliyya

al-Firdaws

al-Ẓāhiriyya
To Maqām Ibrāhīm

Fig. 4. Aleppo in the thirteenth century: plan with gates and major monuments

a b c 0 5 10 m

Fig. 5. Aleppo, gates in the enclosure: (a) Bāb al-Naṣr,1213 and later; (b) Bāb al-Ḥadīd, 1509 and later; (c) Bāb al-Māqam, c. 1223 and later

Fig. 6. Aleppo, Bāb al-Maqām, c. 1223 and later: elevation

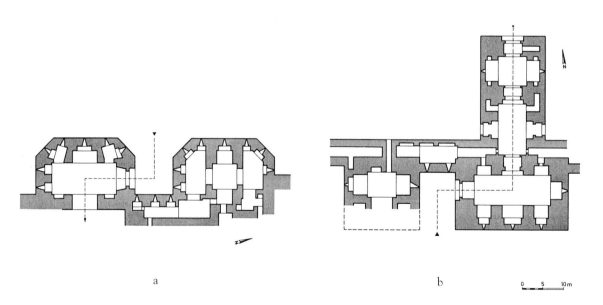

a b 0 5 10m

Fig. 7. Aleppo, gates in the enclosure: (a) Aleppo Bāb Anṭākiya, 1246 and later; (b) Aleppo, Bāb Qinnasrīn, 1256 and later

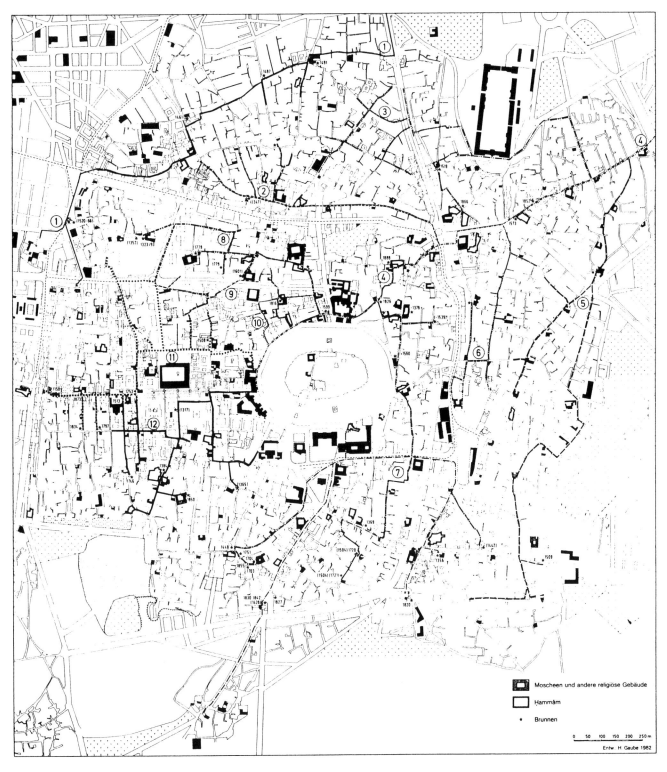

1) Niẓām Burd-Bak
2) Niẓām al-Marʿašlī
3) Niẓām ʿIzzaddīn / Aġyur
4) Hauptkanal
5) Niẓām ʿAlī-Bak
6) Niẓām Qattāna
7) Niẓām al-Mustadāmiya
8) Niẓām Šāhin-Bak
9) Niẓām Ḥammām as-Sulṭān
10) Niẓām Madrasa aš-Šaʿbāniya
11) Niẓām Moschee al Ḥaiyāt
12) Niẓām Bāb Qinnasrīn

Fig. 8. Aleppo: plan of the canalization in the sixteenth century

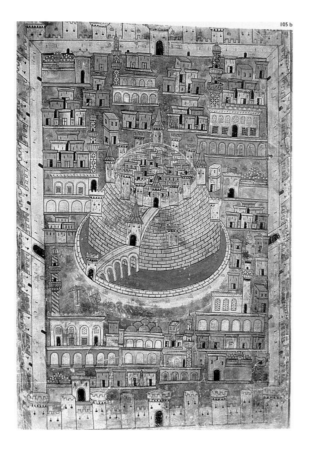

Fig. 9. Aleppo in the sixteenth century: painting

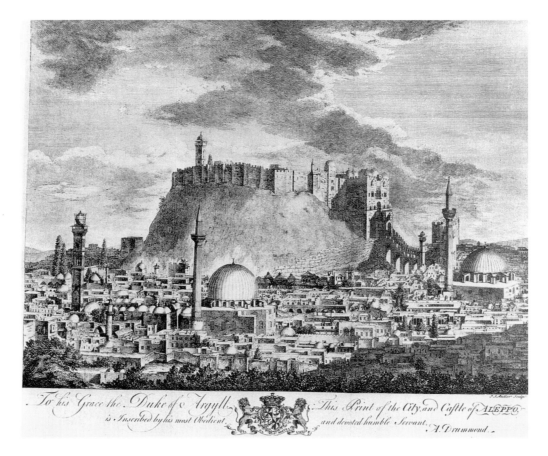

Fig. 10. Aleppo in the mid-eighteenth century: engraving

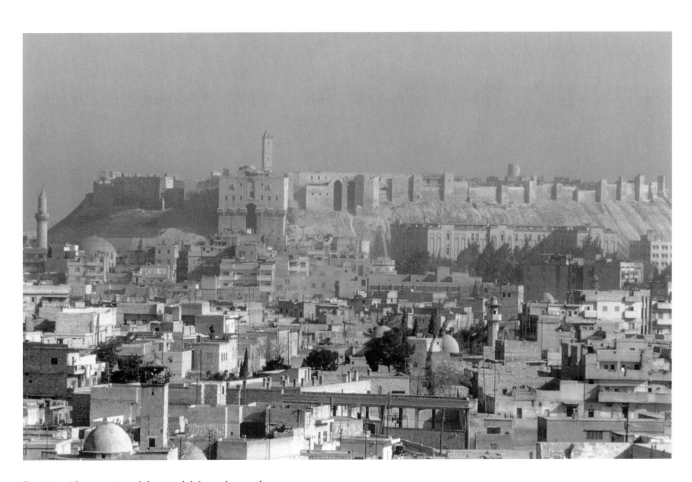

Fig. 11.　Aleppo: view of the citadel from the south

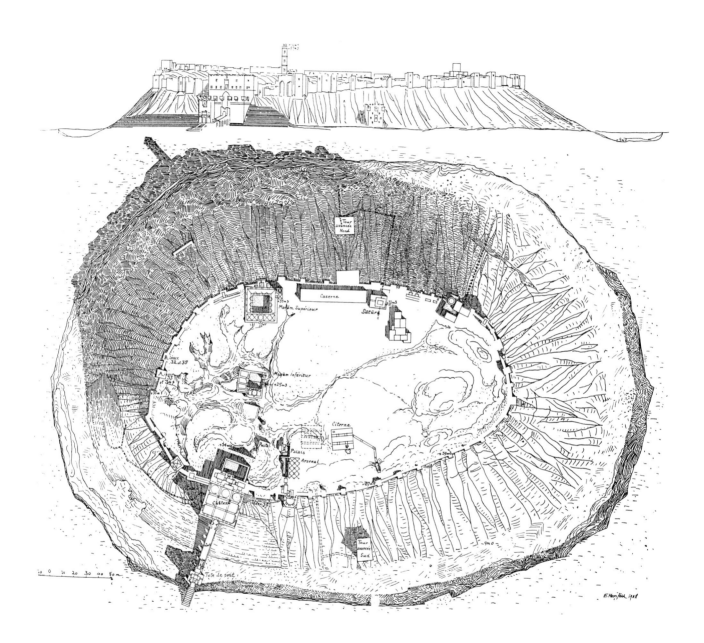

Fig. 12. Aleppo: citadel: plan and elevation

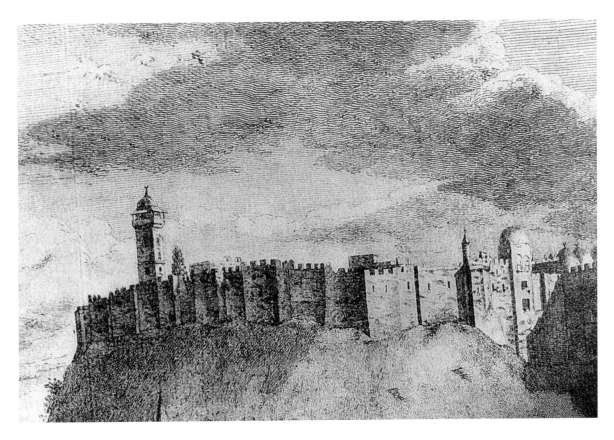

Fig. 13. Aleppo the citadel in the mid-eighteenth century: detail of Drummond engraving

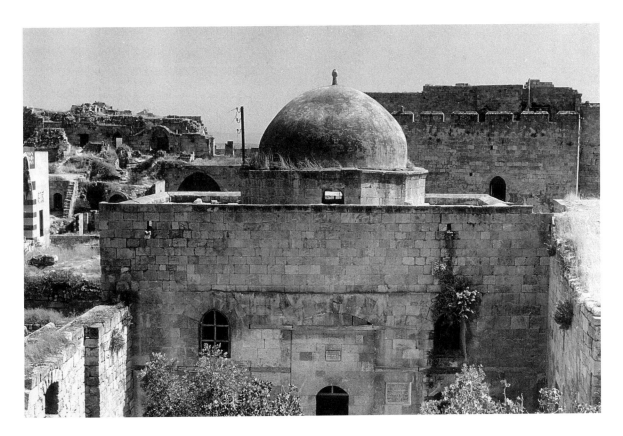

Fig. 14. Aleppo, citadel: *Maqām* Ibrāhīm, from north

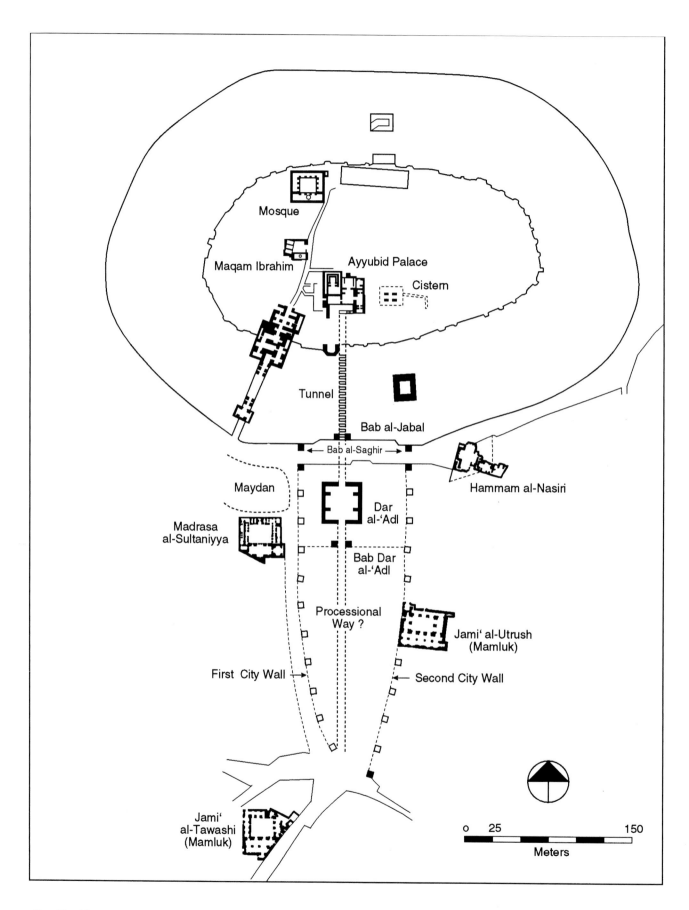

Fig. 15. Aleppo, reconstruction of *taḥt al-qalʿah* and *dār al-ʿadl*

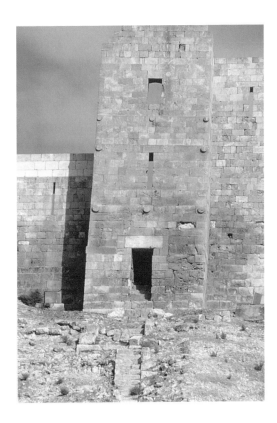

Fig. 16. Bāb al-Jabal, opening in the wall of the citadel

Fig. 17. Aleppo, *Madrasa* al-Sulṭāniyya, finished 1229: aerial view from citadel

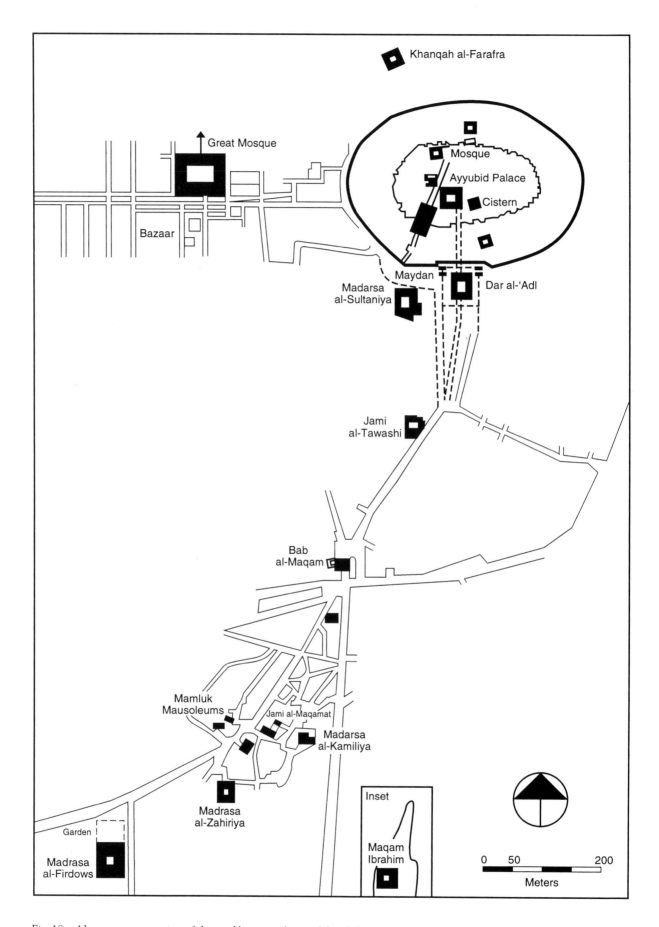

Khanqah al-Farafra

Great Mosque

Mosque

Ayyubid Palace

Cistern

Bazaar

Maydan

Dar al-'Adl

Madarsa
al-Sultaniya

Jami
al-Tawashi

Bab
al-Maqam

Mamluk
Mausoleums

Jami al-Maqamat

Madarsa
al-Kamiliya

Madrasa
al-Zahiriya

Inset

Garden

Maqam
Ibrahim

Madrasa
al-Firdows

0 50 200

Meters

Fig. 18. Aleppo: reconstruction of the road between the citadel and the *maqāmāt*

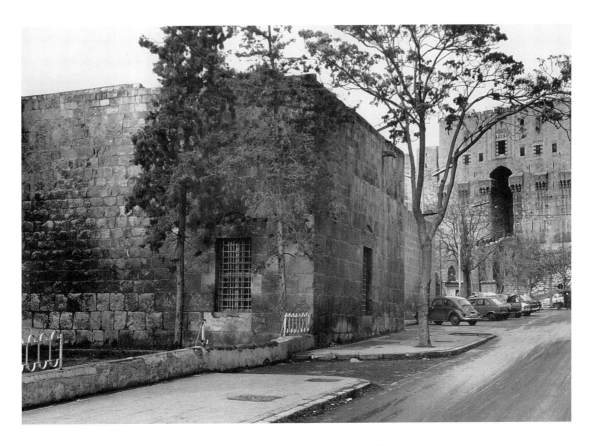

Fig. 19. Aleppo, *Madrasa* al-Sulṭāniyya and the entrance block of the citadel

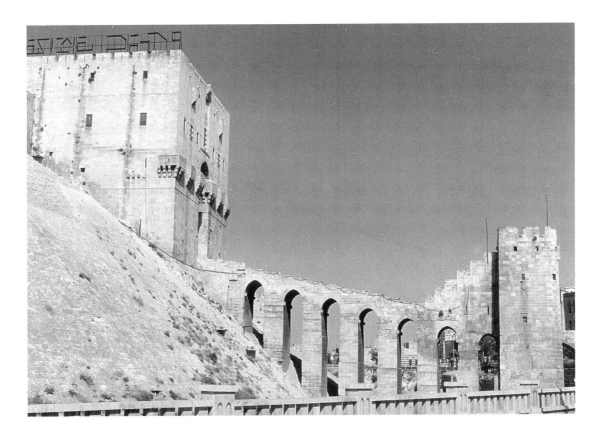

Fig. 20. Aleppo, citadel: entrance block and ramp, from west

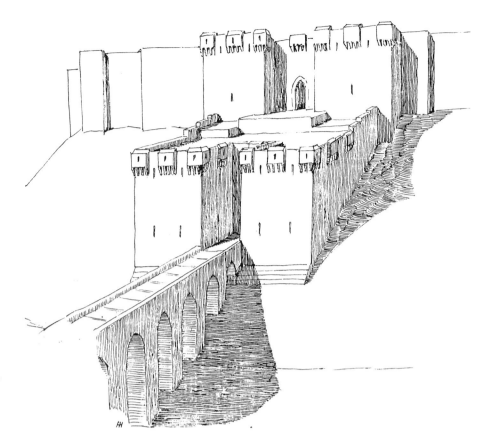

Fig. 21. Aleppo, citadel: recon-
struction of entrance block in the
Ayyubid

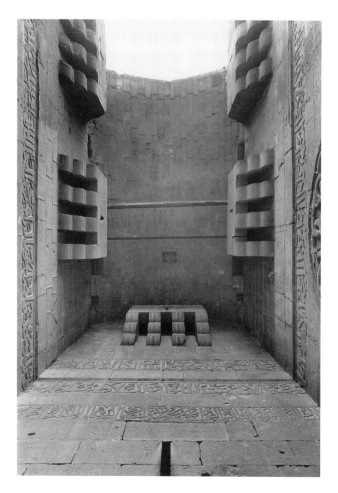

Fig. 22. Aleppo, citadel, entrance block, early thirteenth century:
view of the machicoulation

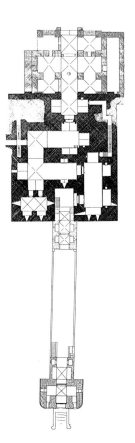

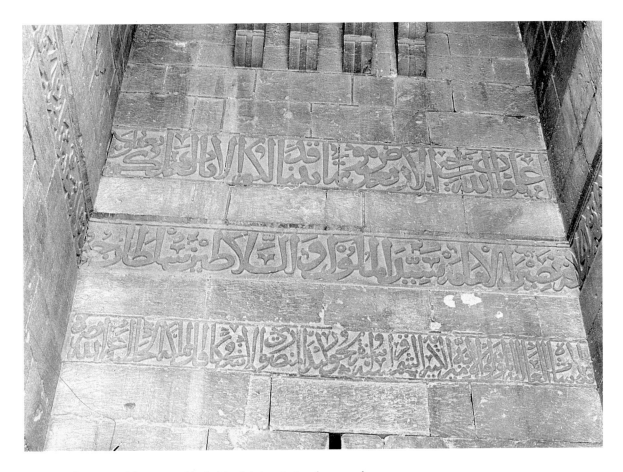

Fig. 23. Aleppo, citadel, entrance block: plan

Fig. 24. Aleppo, citadel, entrance block: Mamluk inscriptions between the two towers

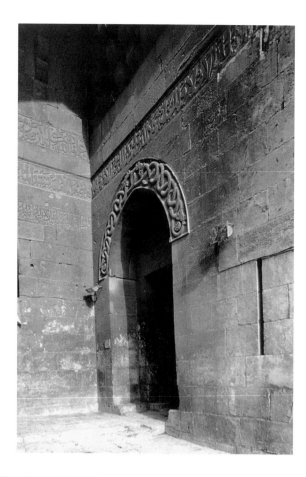

Fig. 25. Aleppo, citadel, entrance block: Gate of Serpents, early thirteenth century

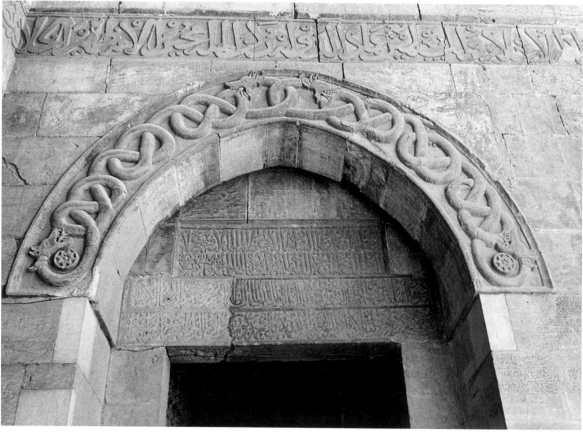

Fig. 26. Aleppo, citadel, entrance block: Gate of Serpents, detail of voussoir

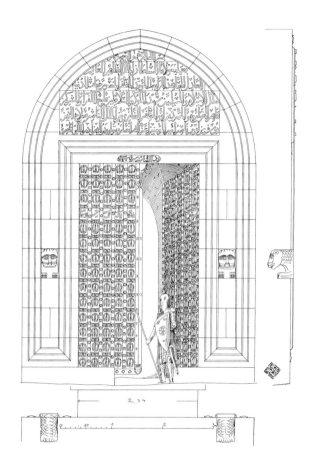

Fig. 27. Aleppo, citadel, entrance block: Gate of Lions, 606/1210

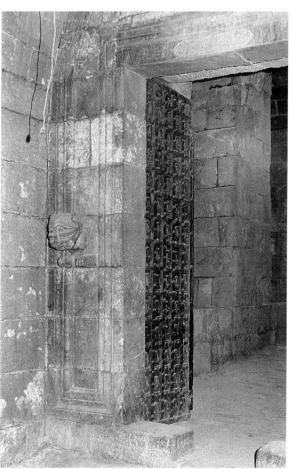

Fig. 28. Aleppo, citadel, entrance block: Gate of Lions

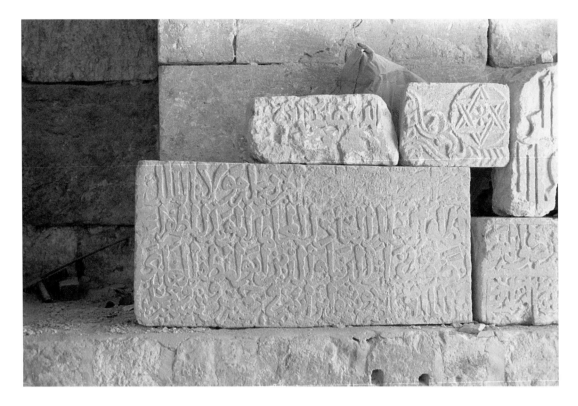

Fig. 29. Aleppo, citadel: Inscriptional plaque (not in situ), 595/1198

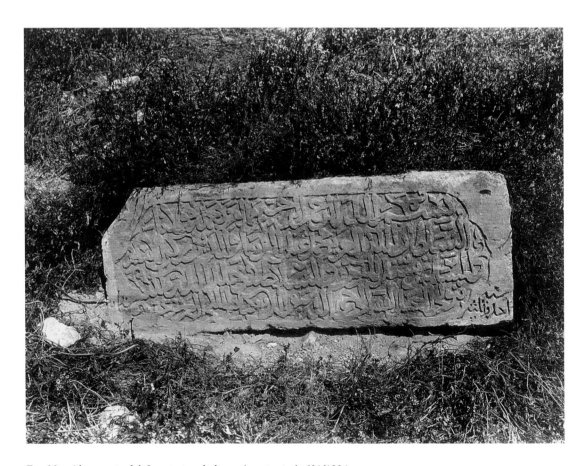

Fig. 30. Aleppo, citadel: Inscriptional plaque (not in situ), 631/1234

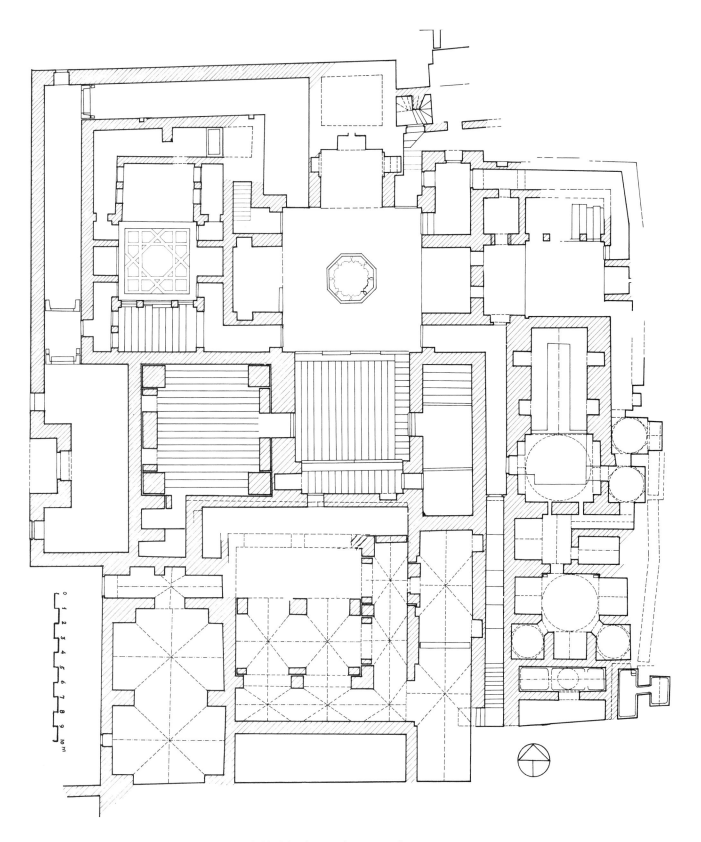

Fig. 31. Aleppo, citadel: Ayyubid palace, first half of the thirteenth century, plan

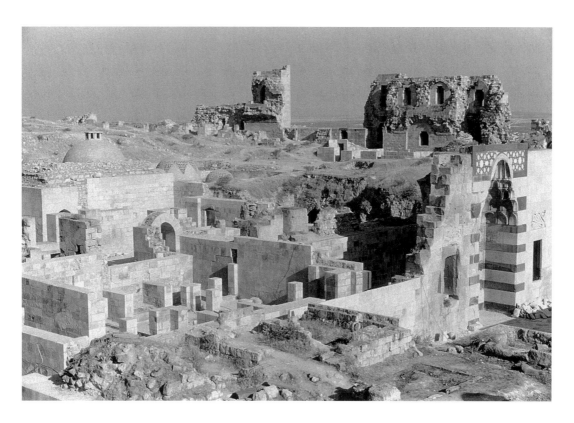

Fig. 32. Aleppo, citadel: Ayyubid palace, general view from northwest

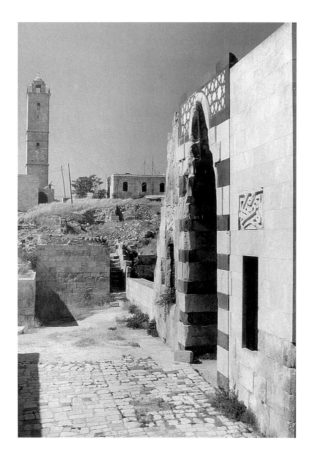

Fig. 33. Aleppo, citadel, Ayyubid palace: forecourt
in front of portal, view from south

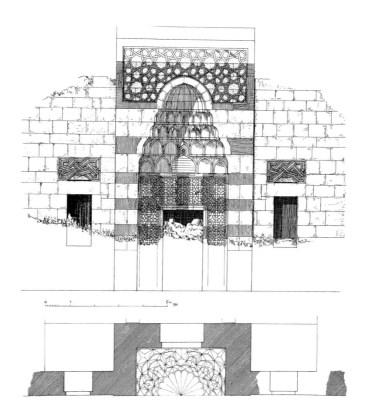

Fig. 34. Aleppo, citadel: Ayyubid palace,
facade elevation

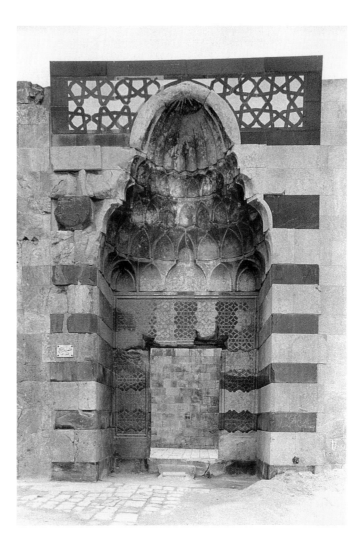

Fig. 35. Aleppo, citadel, Ayyubid palace: portal

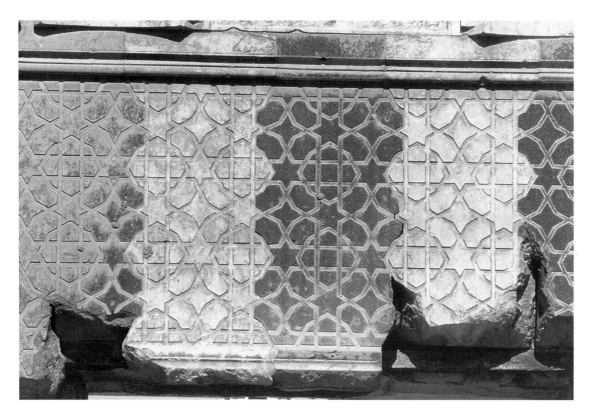

Fig. 36. Aleppo, citadel, Ayyubid palace: portal, detail of lintel

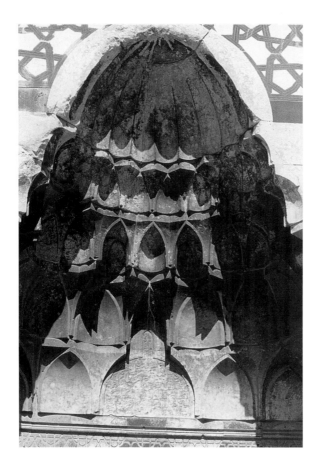

Fig. 37. Aleppo, citadel, Ayyubid palace: portal
muqarnas vault

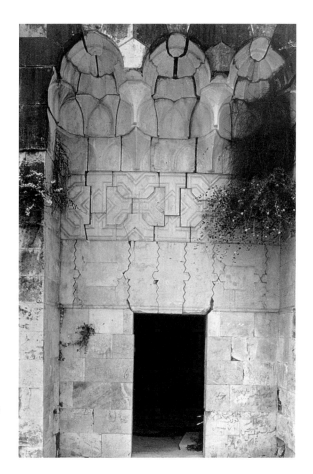

Fig. 38. Qal'at Ṣahyūn: Ayyubid palace, early thirteenth
century

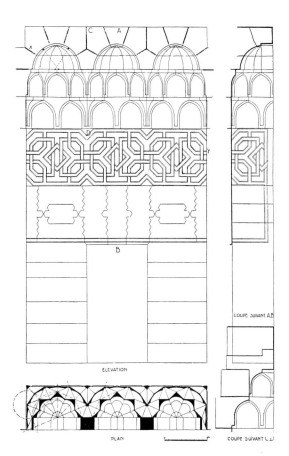

Fig. 39. Qal'at Ṣahyūn, Ayyubid palace: elevation and
section of portal

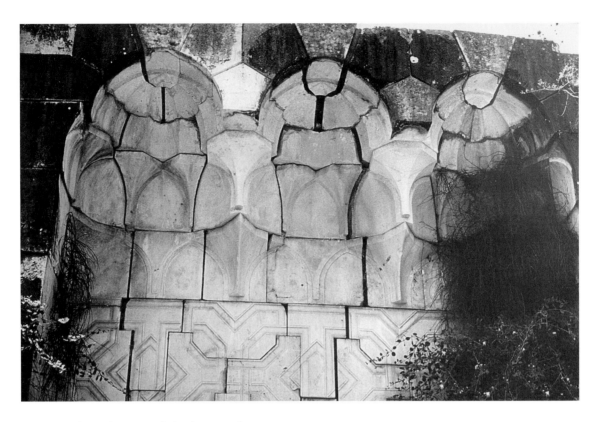

Fig. 40. Qal'at Ṣahyūn, Ayyubid palace: portal, upper portion

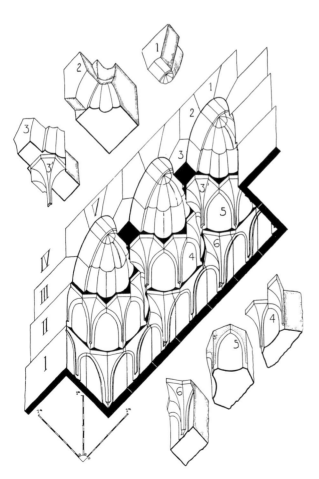

Fig. 41. Qal'at Ṣahyūn, Ayyubid palace: portal, isometric
perspective of upper portion

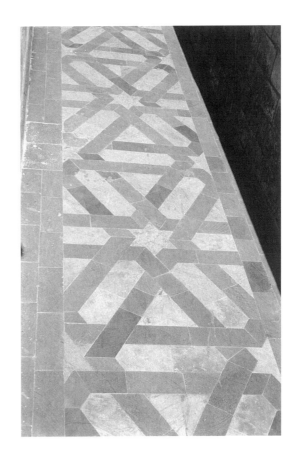

Fig. 42. Aleppo, citadel, Ayyubid palace: pavement on northern corridor

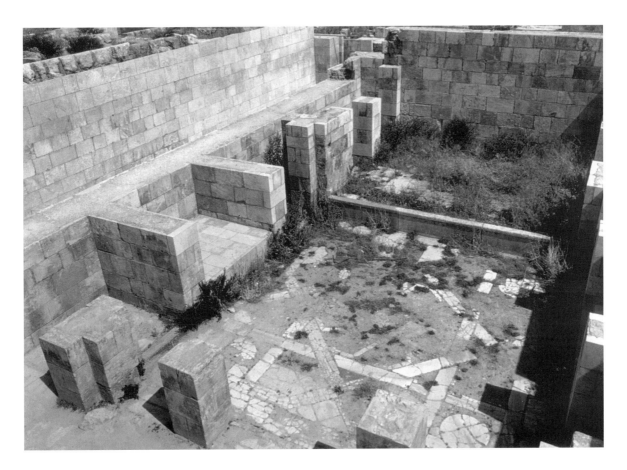

Fig. 43. Aleppo, citadel, Ayyubid palace: small courtyard, from southeast

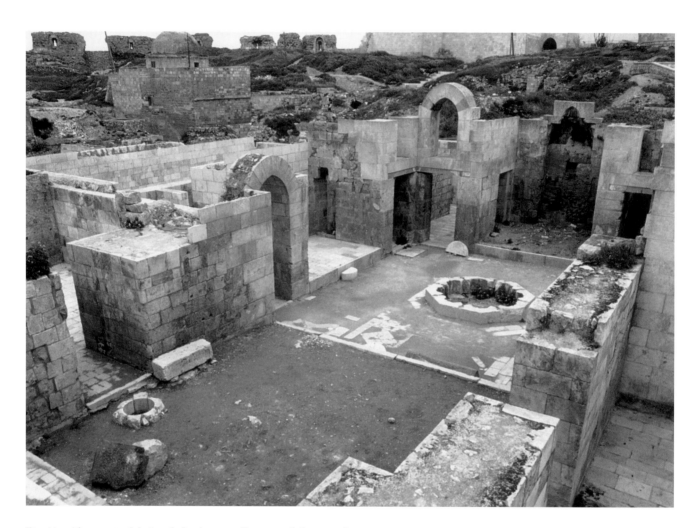

Fig. 44. Aleppo, citadel, Ayyubid palace: small courtyard, from southeast

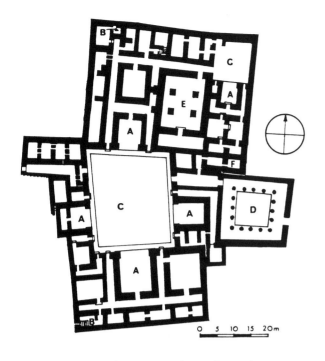

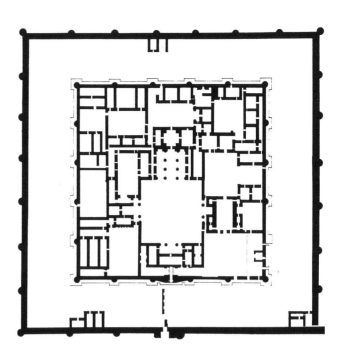

Fig. 45. Parthian palace at Assur, first and second centuries A.D.: plan

Fig. 46. Kūfa, Dār al-Imāra, c. 690: plan

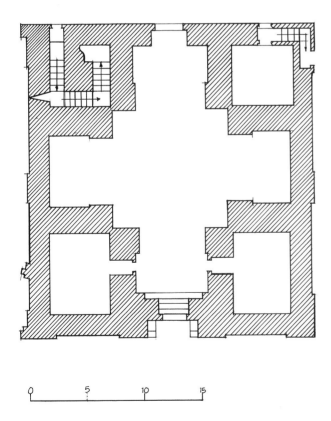

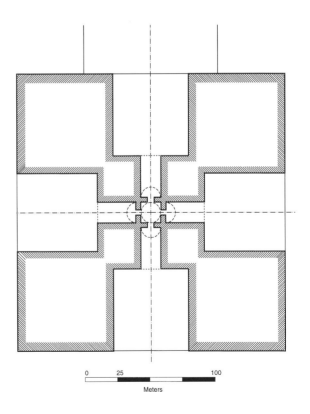

Fig. 47. Amman, citadel: Umayyad palace, plan

Fig. 48. Merv, Dār al-Imāra of Abū Muslim, c. 760: reconstruction of plan

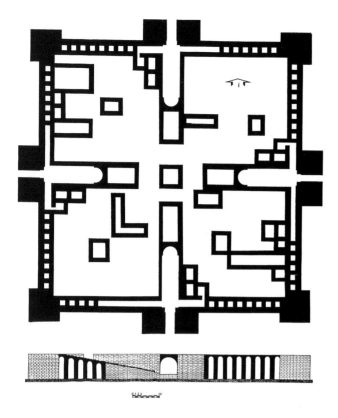

Fig. 49. Hiraqlah (Syria), "Victory Monument" of Hārūn al-Rashīd: plan and elevation

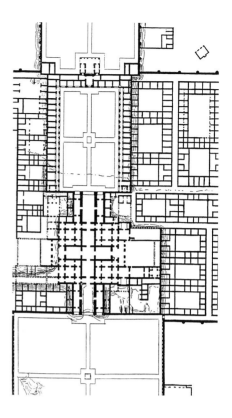

Fig. 50. Sāmarrā, Balkuwara Palace, 854–59: plan, detail of central unit

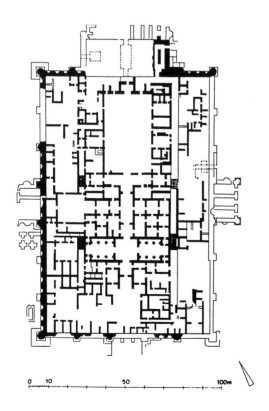

Fig. 51. Sāmarrā, Qasr al-ʿĀshiq, c. 865: plan

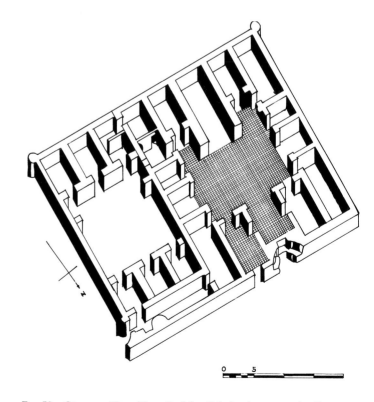

Fig. 52. Sāmarrā, "Rest House" of the Caliph adjacent to the Great Mosque of Abu Dulaf, ninth century: plan

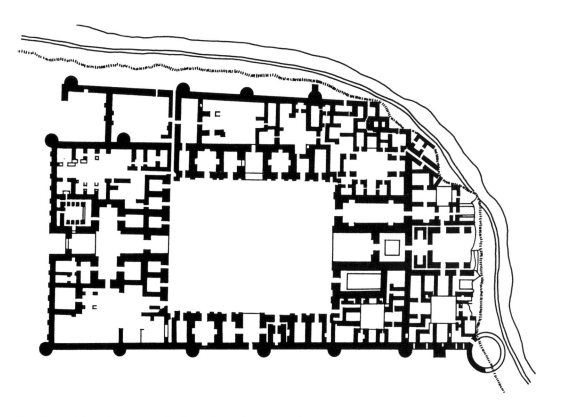

Fig. 53. Lashkār-i Bāzār, central palace, eleventh century: plan

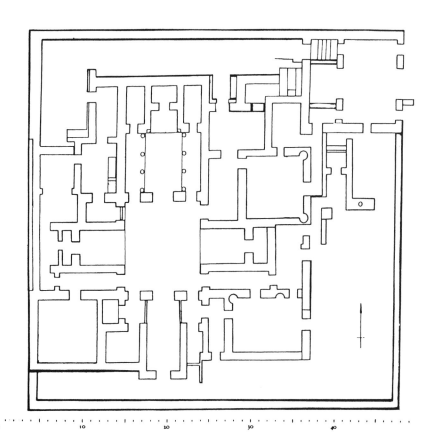

Fig. 54. Raqqa, Qaṣr al-Banāt, c. 1170: plan

0 10 20 30 40

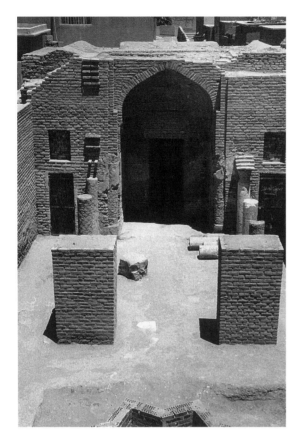

Fig. 55. Raqqa, Qaṣr al-Banāt, c. 1170: northern iwan

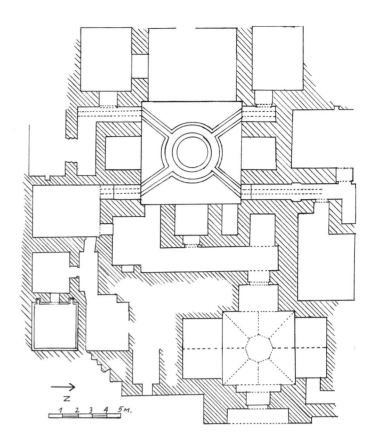

Fig. 56. Qalʿat Ṣahyūn, Ayyubid palace, early thirteeth century: plan

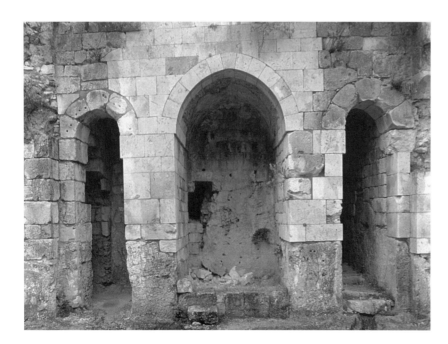

Fig. 57. Qalʿat Ṣahyūn, Ayyubid palace: view of northern facade

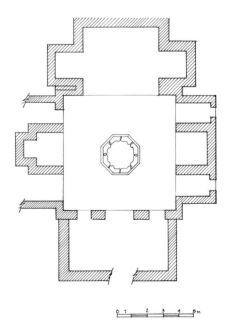

Fig. 58. Qalʿat Najm, Ayyubid palace,
c. 1210: sketch plan

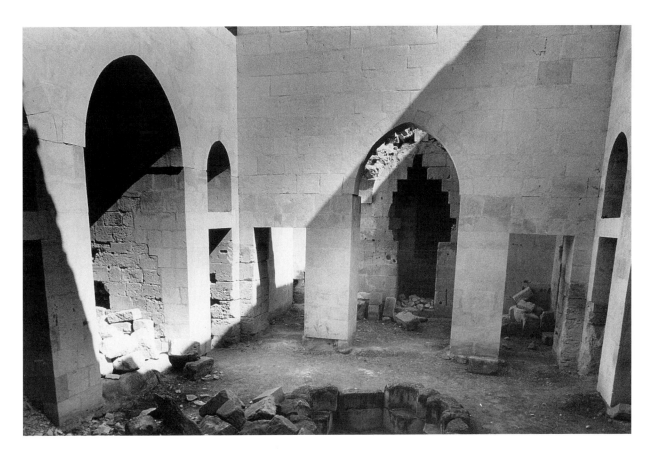

Fig. 59. Qal'at Najm, Ayyubid palace: courtyard from north

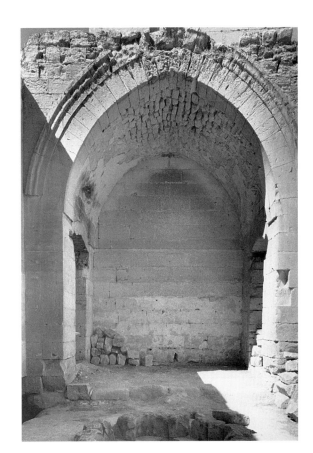

Fig. 60. Qal'at Najm, Ayyubid palace: northern iwan

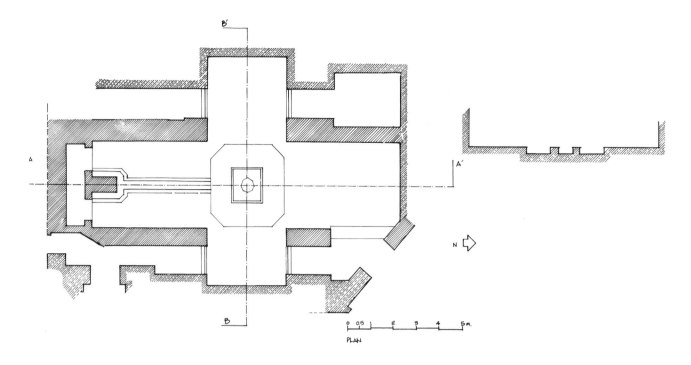

Fig. 61. Diyarbakir citadel, Artuqid palace: early thirteenth century: plan

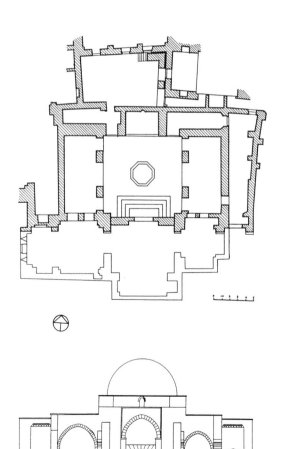

Fig. 62. Aleppo, "Matbakh" al-'Ajamī, early thirteenth century: plan and section

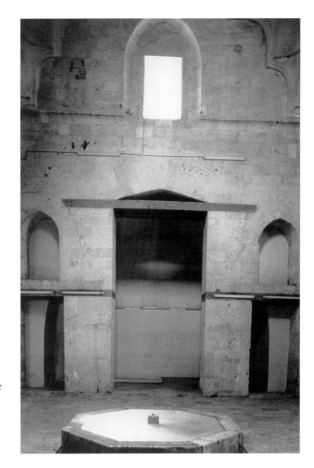

Fig. 63. Aleppo, "Maṭbakh" al-ʿAjamī: eastern facade

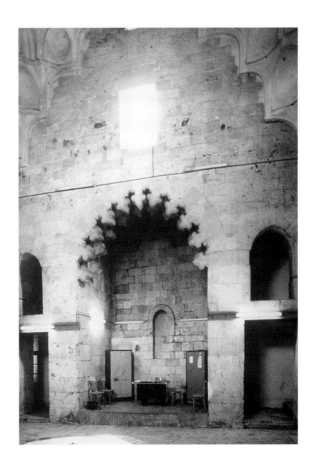

Fig. 64. Aleppo, "Maṭbakh" al-ʿAjamī: eastern facade

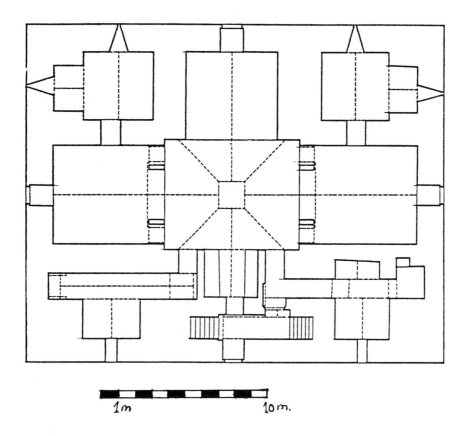

1m　　　　　　10m.

Fig. 65.　Boṣra citadel, Ayyubid palace, thirteenth century: plan

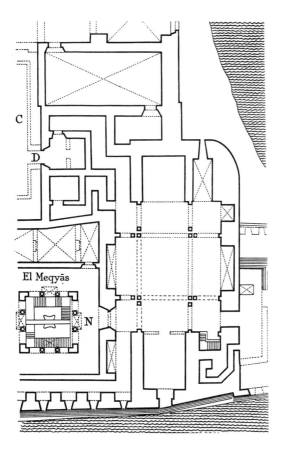

C

D

El Meqyās

N

Fig. 66.　Cairo, Roda palace, mid-thirteenth century: plan

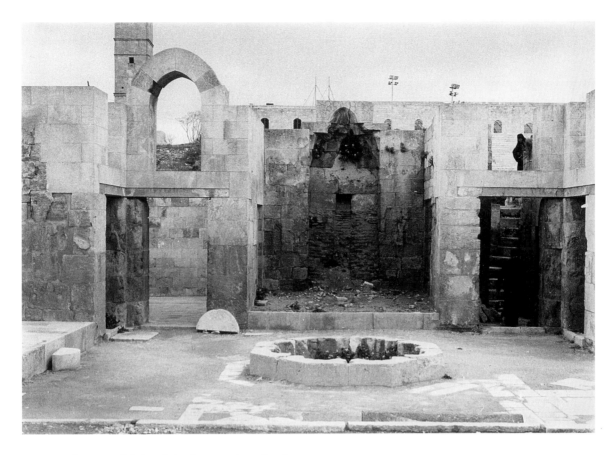

Fig. 67. Aleppo citadel, Ayyubid palace: northern facade

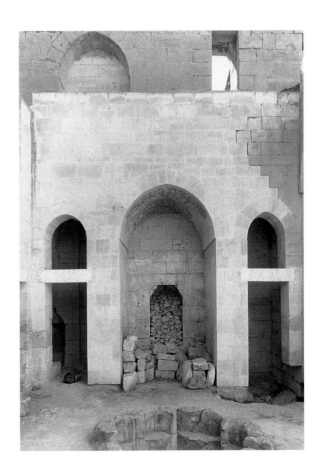

Fig. 68. Qal'at Najm, Ayyubid palace: western facade

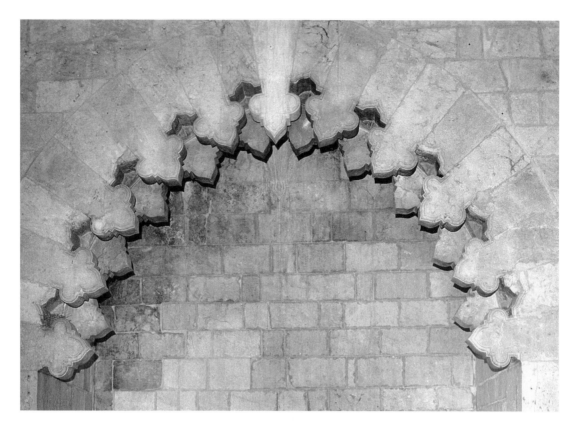

Fig. 69. Aleppo, Maṭbakh al-ʿAjamī: voussoir of northern iwan

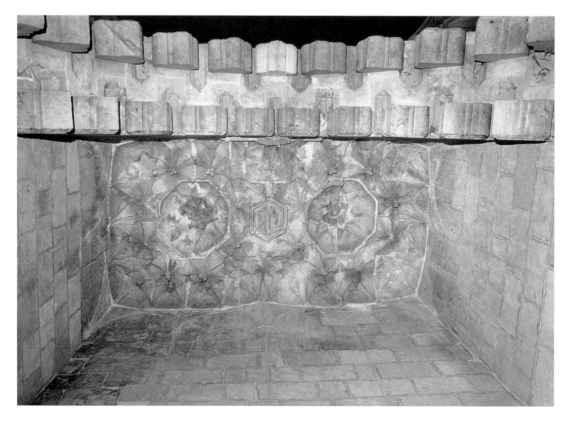

Fig. 70. Aleppo, Maṭbakh al-ʿAjamī: voussoir and *muqarnas* of northern iwan

Fig. 71. Aleppo, citadel, Ayyubid palace: *Shādirwān* in northern iwan

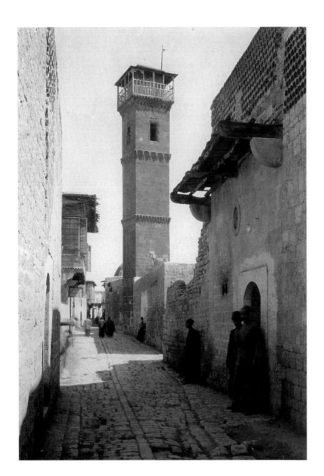

Fig. 72. Aleppo, Minaret of al-Dabbāgha al-'Atīqa

Fig. 73. Aleppo, Minaret of al-Dabbāgha al-'Atīqa, c. 1300: upper shaft

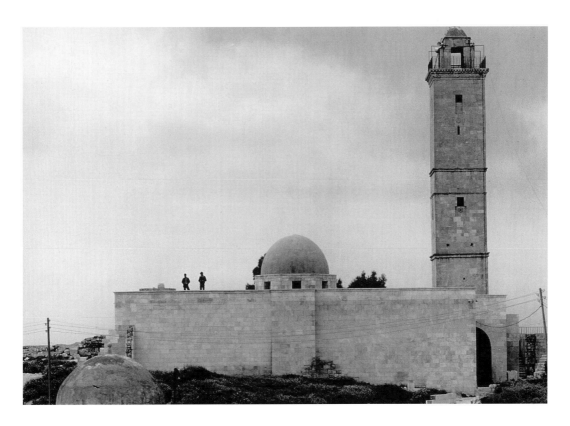

Fig. 74. Aleppo, citadel: Great Mosque, 1213: view from north

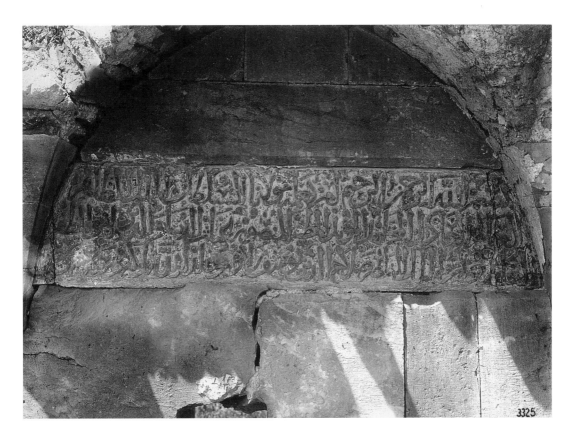

Fig. 75. Aleppo, citadel, Great Mosque: foundation inscription, 610/1213

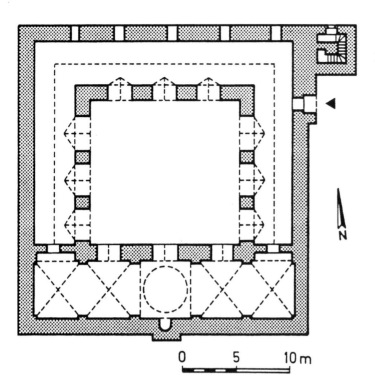

Fig. 76. Aleppo, citadel, Great Mosque: plan

0 5 10 m

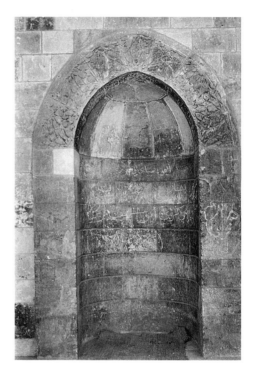

Fig. 77. Aleppo, citadel, Great Mosque: *miḥrāb*

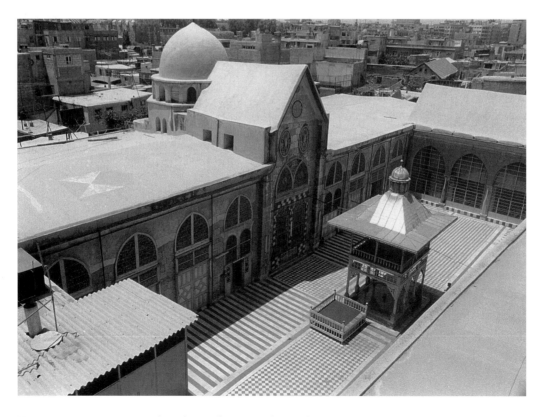

Fig. 78. Damascus, Mosque al-Tawba, 638/1240: aerial view, from northeast

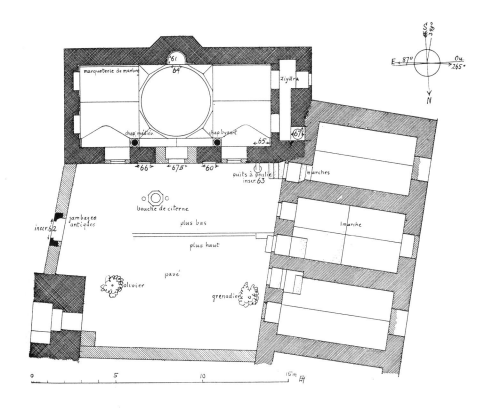

Fig. 79. Aleppo, citadel, *Maqām* Ibrāhīm 563/1168 and later: plan

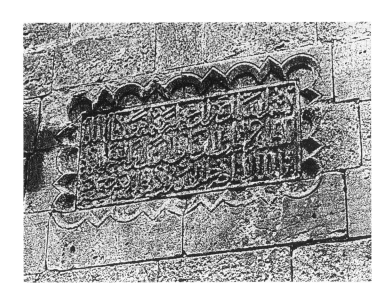

Fig. 80. Aleppo, *Maqām* Ibrāhīm at Ṣāliḥīn: inscription of al-Ẓāhir Ghāzī, 594/1198

Fig. 81. Aleppo, *Maqām* Ibrāhīm at Ṣāliḥīn: Ayyubid minaret

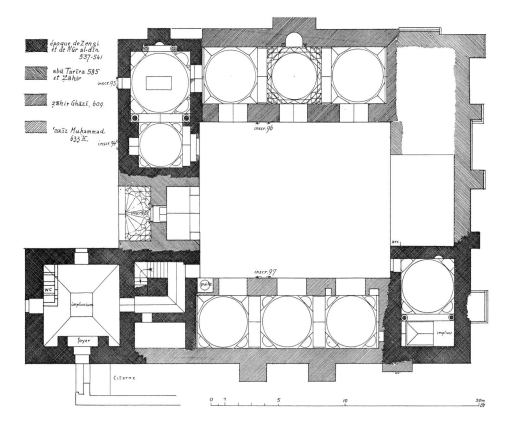

époque de Zengi
et de Nūr al-dīn
537-541

abū Tarīra 585
et Zāhir

zāhir Ghāzī, 609.

ʿazīz Muhammad
633 H.

inscr.93

inscr.94

inscr.96

inscr.95

inscr.97

arc

impluvium

impluv

WC

foyer

puits

Citerne

0 1 5 10 20m

Fig. 82. Aleppo, *Mashhad* al-Dikka: plan

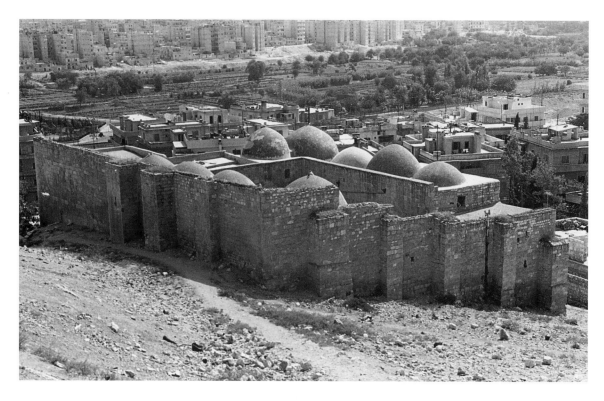

Fig. 83. Aleppo, *Mashhad* al-Dikka: aerial view, from northeast

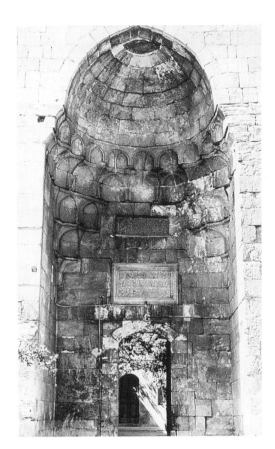

Fig. 84. Aleppo, *Mashhad* al-Dikka: portal

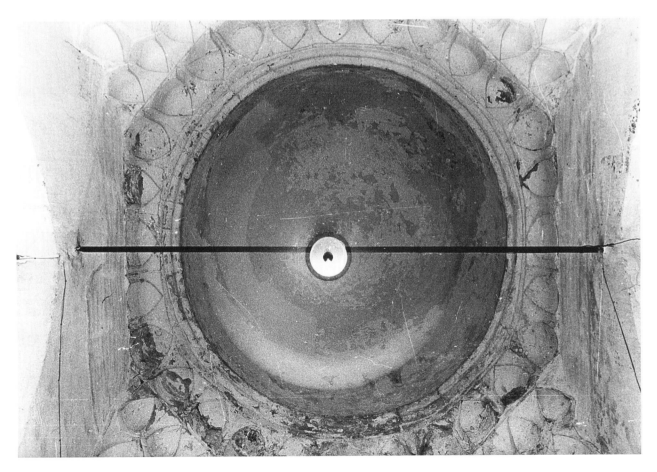

Fig. 85. Aleppo, *Mashhad* al-Dikka: dome over central bay of sanctuary

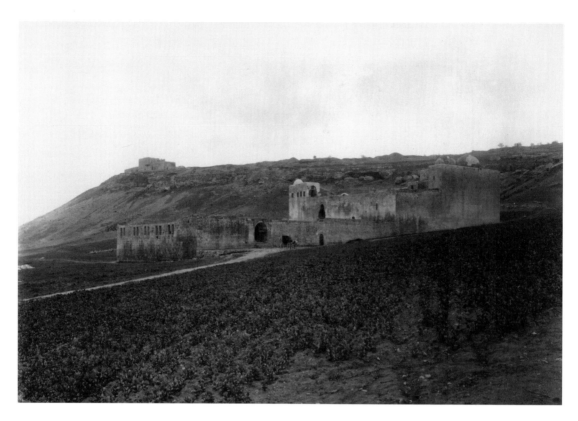

Fig. 86. Aleppo, *Mashhad* al-Ḥusayn: view from north prior to destruction

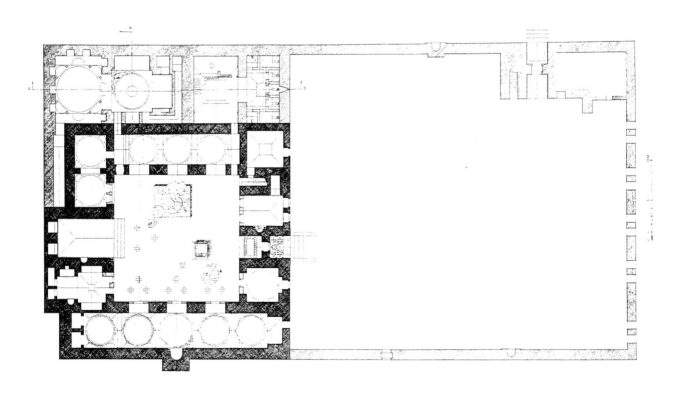

Fig. 87. Aleppo, *Mashhad* al-Ḥusayn: view from north prior to destruction

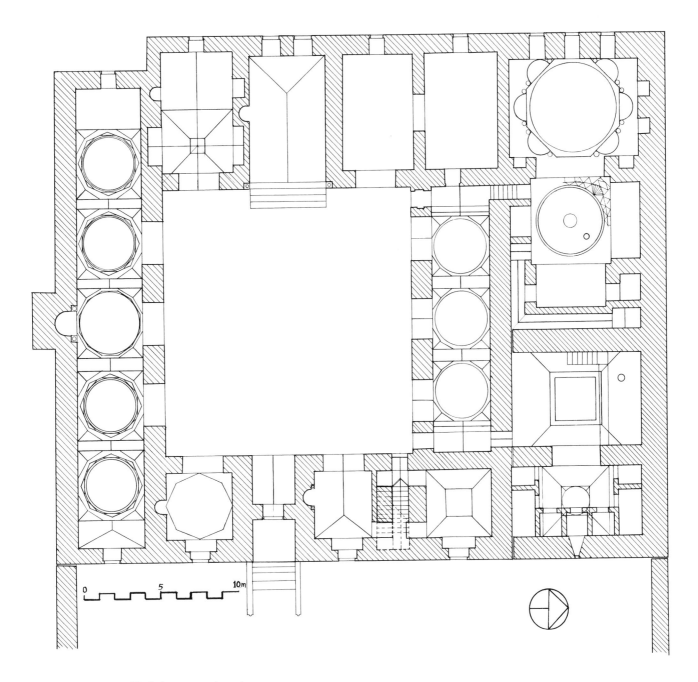

Fig. 88. Aleppo, *Mashhad* al-Ḥusayn: plan of main structure

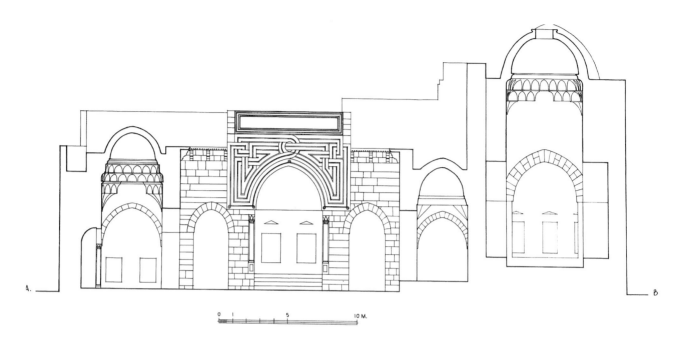

Fig. 89(a). Aleppo, *Mashhad* al-Ḥusayn: across Phase I

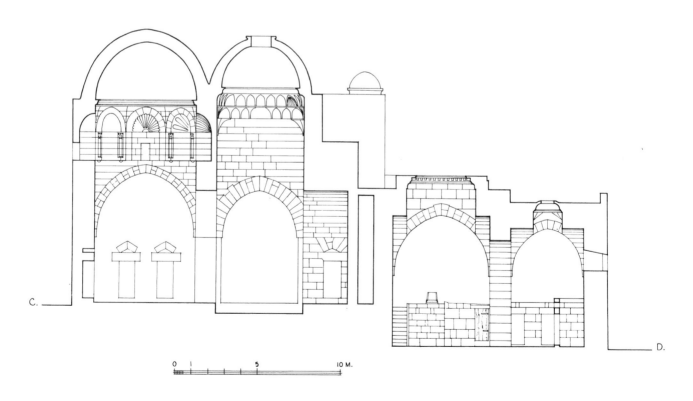

Fig. 89(b). Aleppo, *Mashhad* al-Ḥusayn: across Phase II

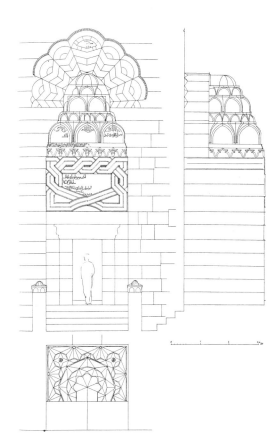

Fig. 90. Aleppo, *Mashhad* al-Ḥusayn: elevation of portal

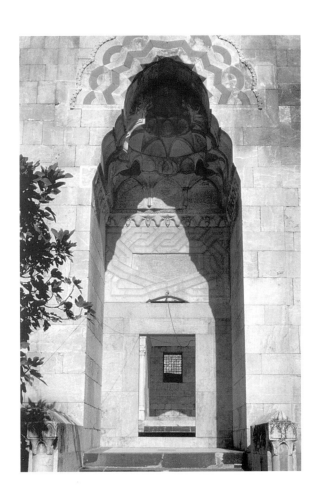

Fig. 91. Aleppo, *Mashhad* al-Ḥusayn: portal

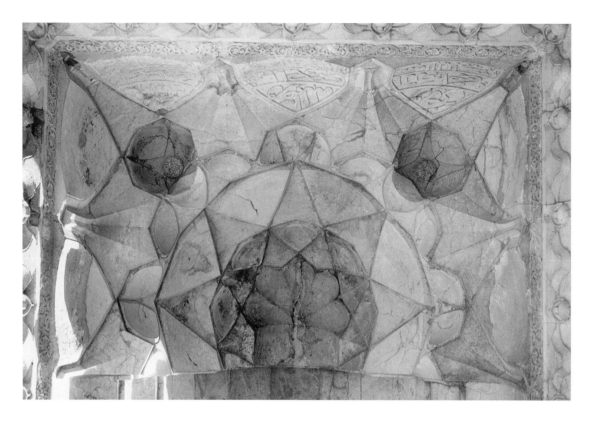

Fig. 92. Aleppo, *Mashhad* al-Ḥusayn: portal

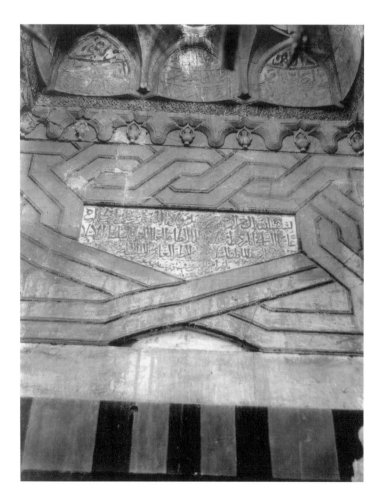

Fig. 93. Aleppo, *Mashad* al-Ḥusayn: foundation
inscription on portal, 596/1200

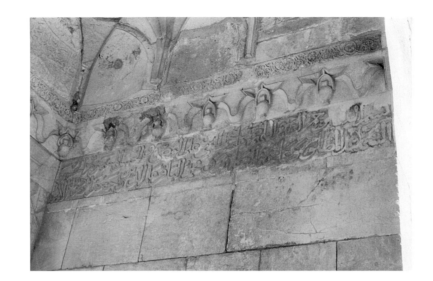

Fig. 94. Aleppo, *Mashhad* al-Ḥusayn,
portal: Shiʻi inscription, right portion

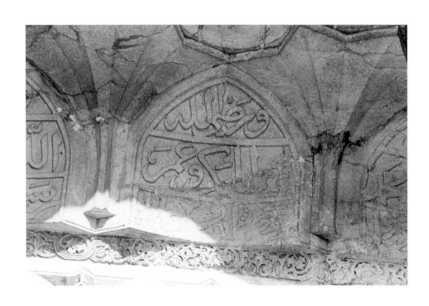

Fig. 95. Aleppo, *Mashhad* al-Ḥusayn,
portal: Sunni inscription, middle cell

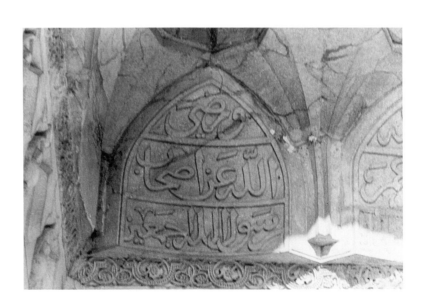

Fig. 96. Aleppo, *Mashhad* al-Ḥusayn,
portal: Sunni inscription, left cell

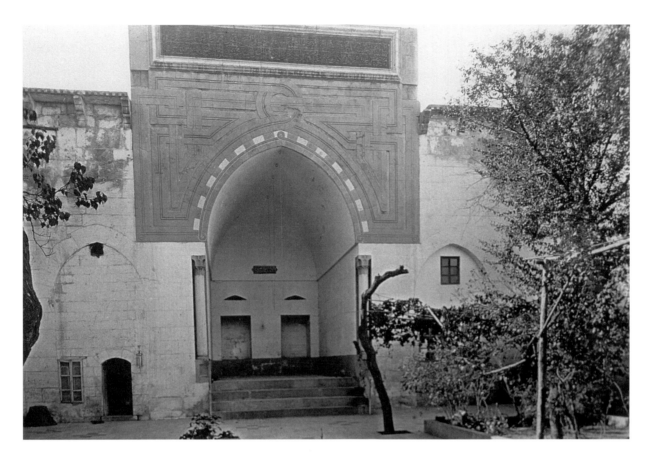

Fig. 97. Aleppo, *Mashhad* al-Ḥusayn: west court facade, before destruction. (Note the darker color of the limestone, most probably caused by the application of shellac)

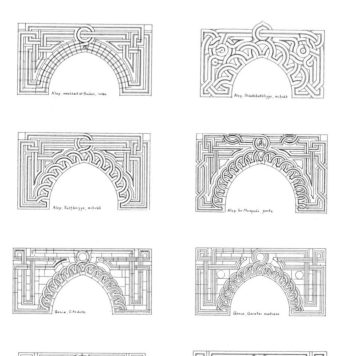

Fig. 98. Eight spandrels with interlaced masonry

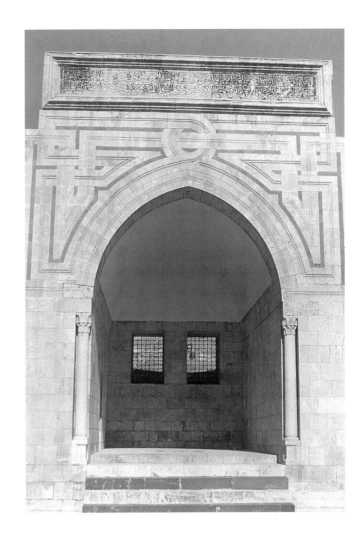

Fig. 99. Aleppo, *Mashhad* al-Ḥusayn, main iwan

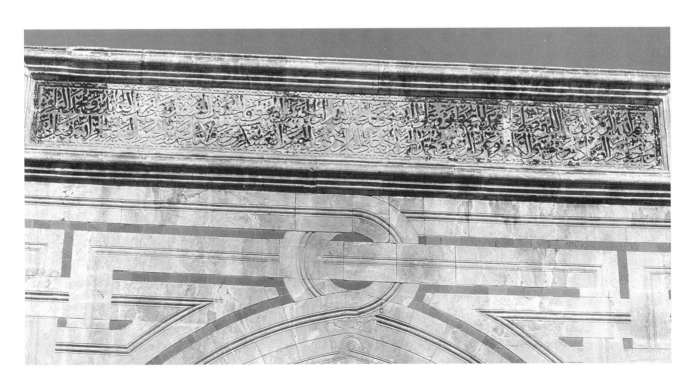

Fig. 100. Aleppo, *Mashhad* al-Ḥusayn, main iwan: Shiʻi inscription

Fig. 101. Aleppo, *Mashhad* al-Ḥusayn: prayer hall from east

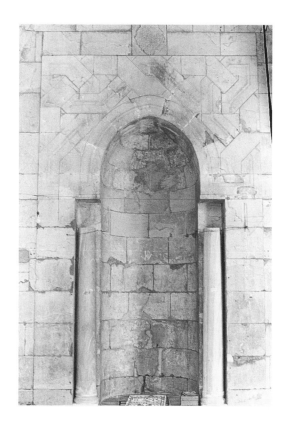

Fig. 102. Aleppo, *Mashhad* al-Ḥusayn: *miḥrāb*

Fig. 103. Aleppo, *Mashhad* al-Ḥusayn: artisan signature above *miḥrāb*

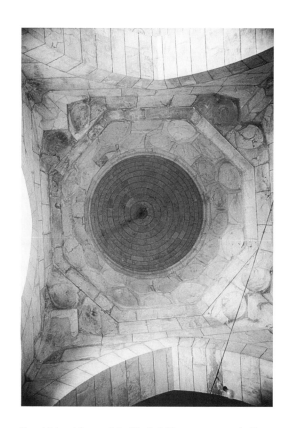

Fig. 104. Aleppo, *Mashhad* al-Ḥusayn: prayer hall: central dome

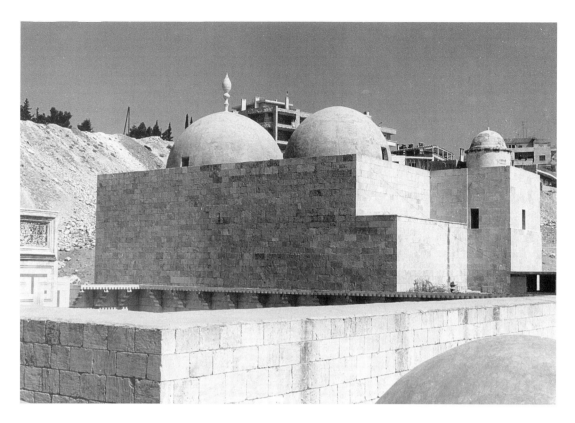

Fig. 105. Aleppo, *Mashhad* al-Ḥusayn: prayer hall: exterior view of Phase II

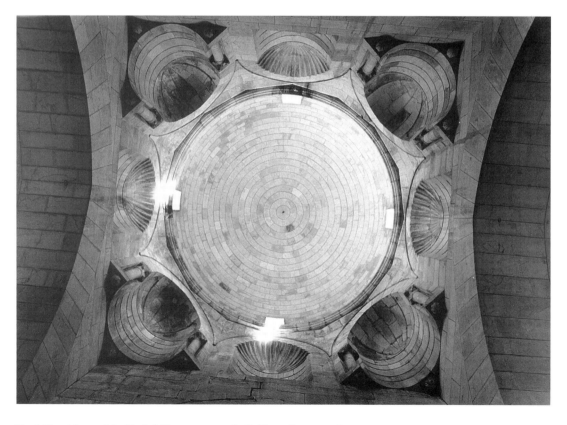

Fig. 106. Aleppo, *Mashhad* al-Ḥusayn: prayer hall: Phase II: corner dome

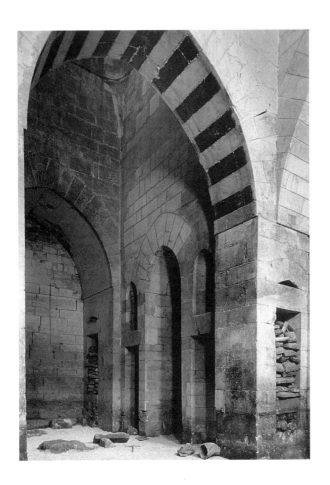

Fig. 107. Aleppo, *Mashhad* al-Ḥusayn: corner dome: view into middle bay

Fig. 108. Aleppo, *Mashhad* al-Ḥusayn: Phase II: middle dome

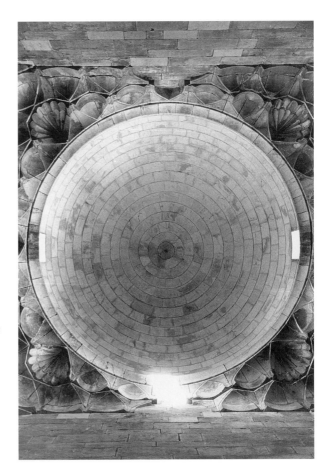

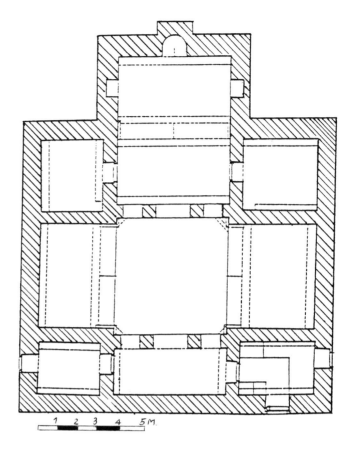

Fig. 109. Boṣra, *Madrasa* of Gümüshtekin, 1136: plan

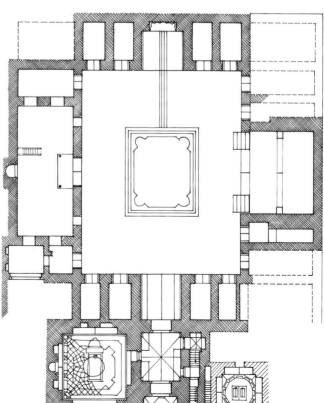

Fig. 110. Damascus, *Madrasa* al-Nūriyya, 1172: plan

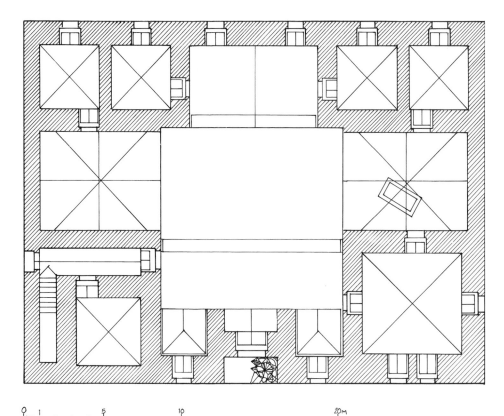

Fig. 111. Damascus, *Madrasa* al-Ṣāḥiba: plan

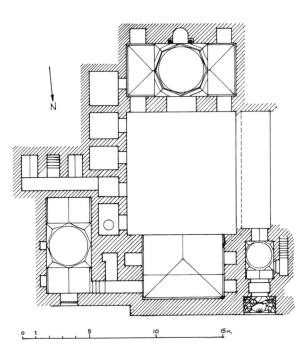

Fig. 112. Aleppo, *Madrasa* al-Shādbakhtiyya, 589/1193: plan

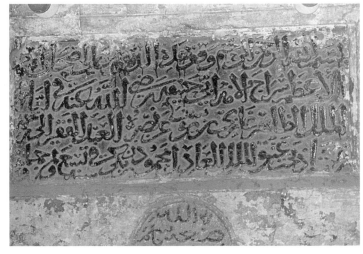

Fig. 113. Aleppo, *Madrasa* al-Shādbakhtiyya, 589/1193: foundation inscription

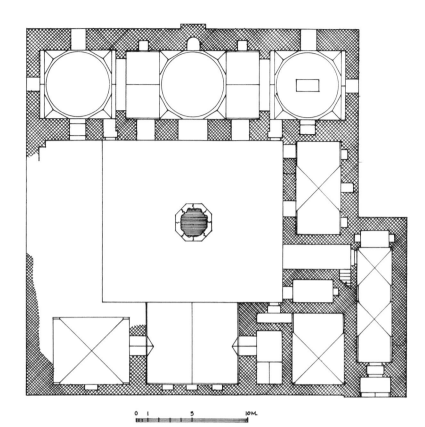

Fig. 114. Aleppo, *Madrasa* al-Kāmiliyya, 1230-37: plan

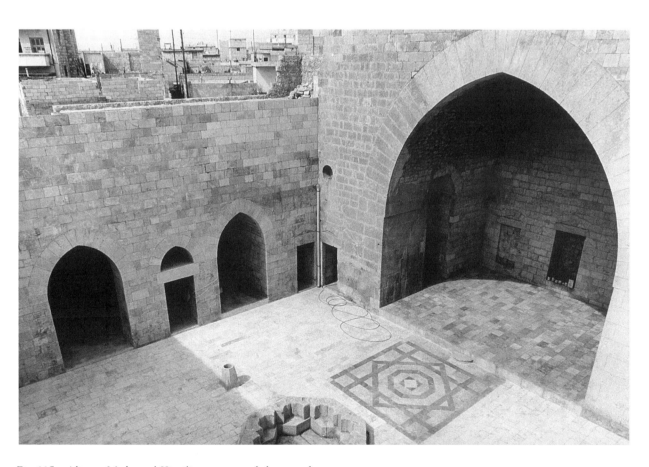

Fig. 115. Aleppo, *Madrasa* al-Kāmiliyya: courtyard, from southeast

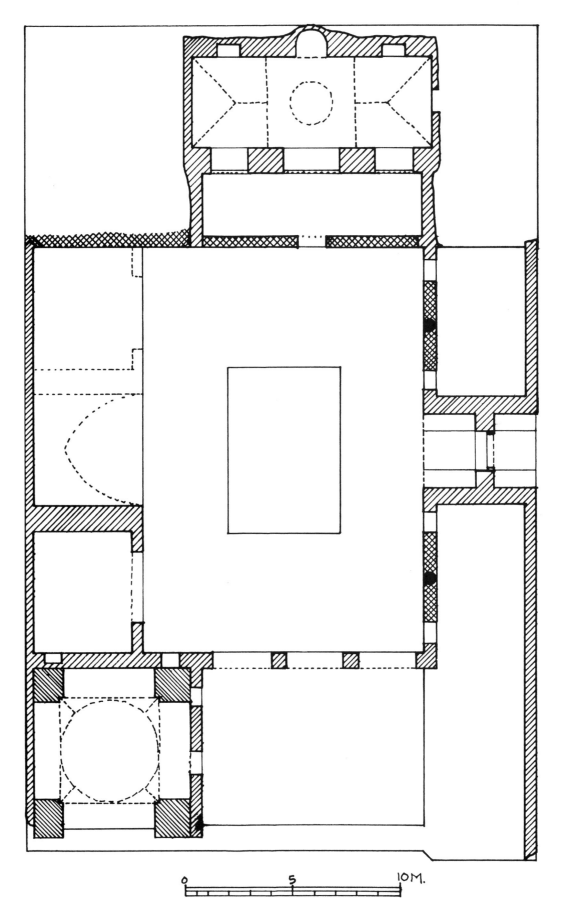

0 5 10M.

Fig. 116. Aleppo, *Madrasa* al-Sharafiyya, completed 1242: plan

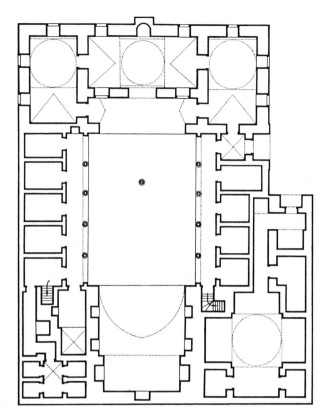

Fig. 117a,b. Aleppo, *Madrasa* al-ʿAdīmiyya, 1241–
51: plan of first and second levels

a

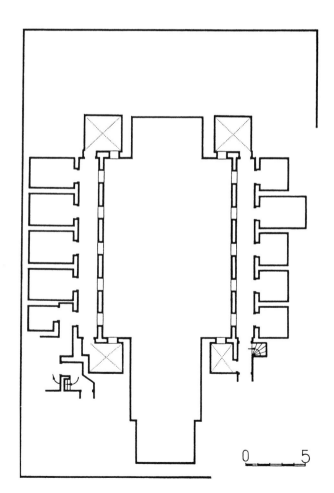

b

0 _____ 5

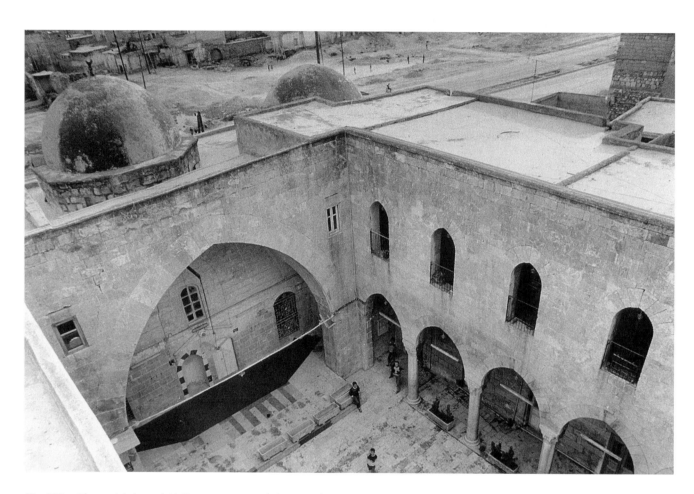

Fig. 118. Aleppo, *Madrasa* al-'Adīmiyya: courtyard, from northeast

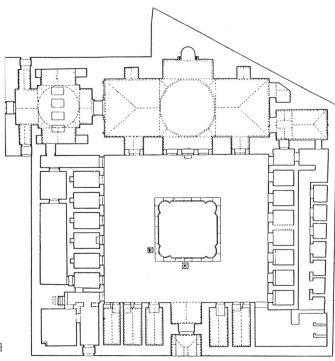

Fig. 119. Aleppo, *Madrasa* al-Sulṭāniyya, completed
1233: plan

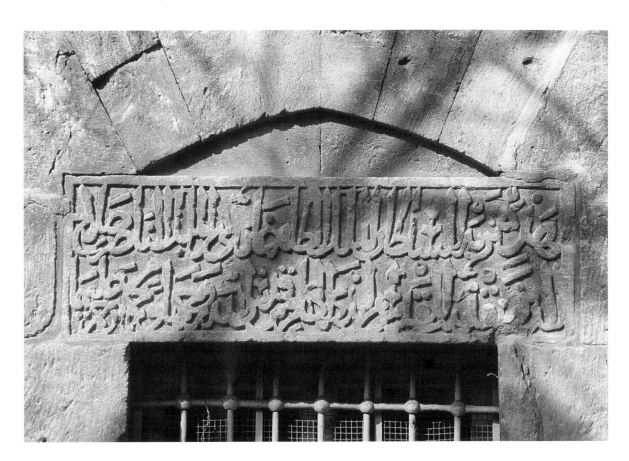

Fig. 120. Aleppo, *Madrasa* al-Sulṭāniyya: inscription on window of
mausoleum

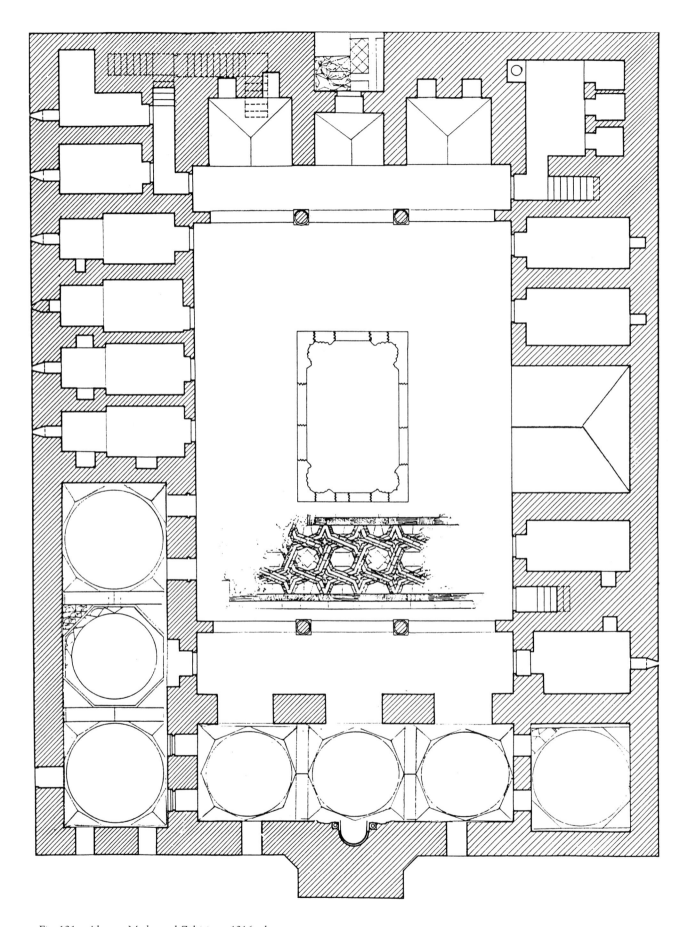

Fig. 121. Aleppo, *Madrasa* al-Ẓāhiriyya, 1216: plan

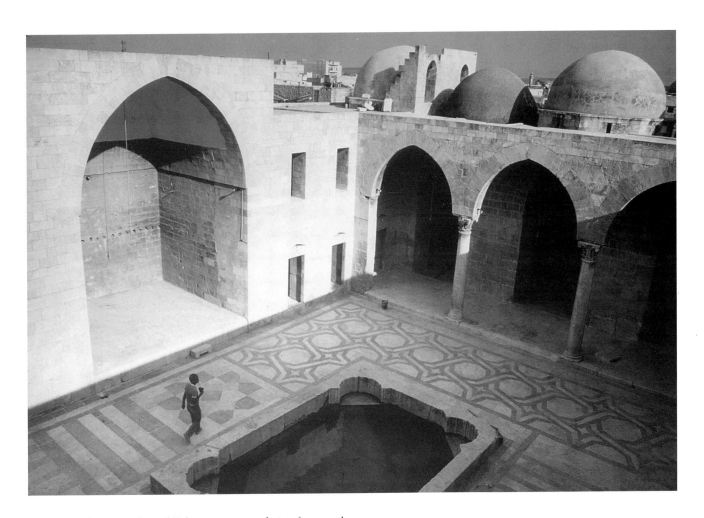

Fig. 122. Aleppo, *Madrasa* al-Ẓāhiriyya: courtyard view from northeast

Fig. 123. Aleppo, *Madrasa* al-Kāmiliyya: exterior, view from southeast

Fig. 124. Aleppo, *Madrasa* al-ʿAdīmiyya exterior, view from south

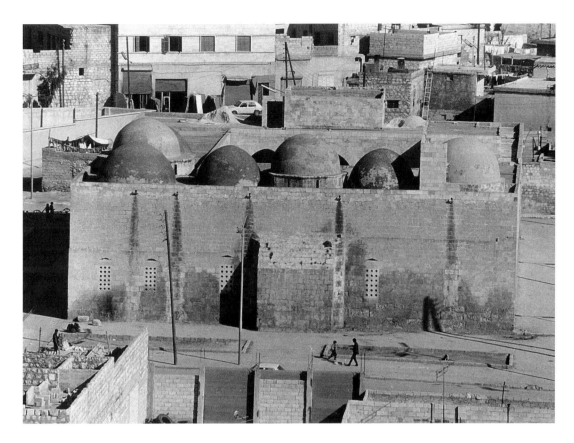

Fig. 125. Aleppo, *Madrasa* al-Ẓāhiriyya: aerial view, from south

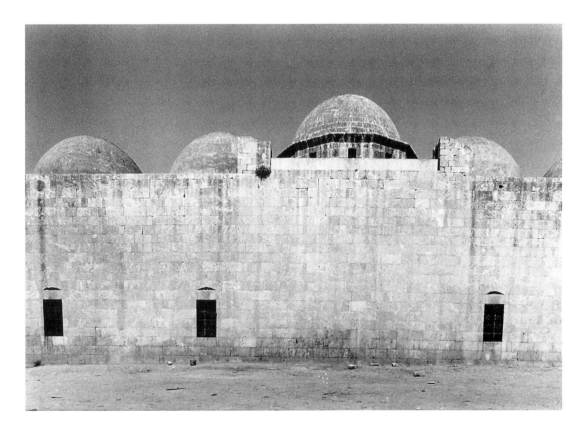

Fig. 126. Aleppo, *Madrasa* al-Firdaws: exterior, from south

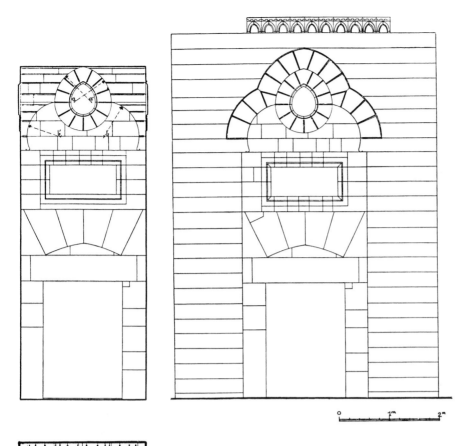

Fig. 127. Aleppo, *Madrasa* al-Muqaddamiyya, 1168: portal elevation, section, and vault plan

Fig. 128. Aleppo, *Madrasa* al-Muqaddamiyya: portal vault

Fig. 129. Aleppo, *Madrasa* al-Shādbakhtiyya: portal

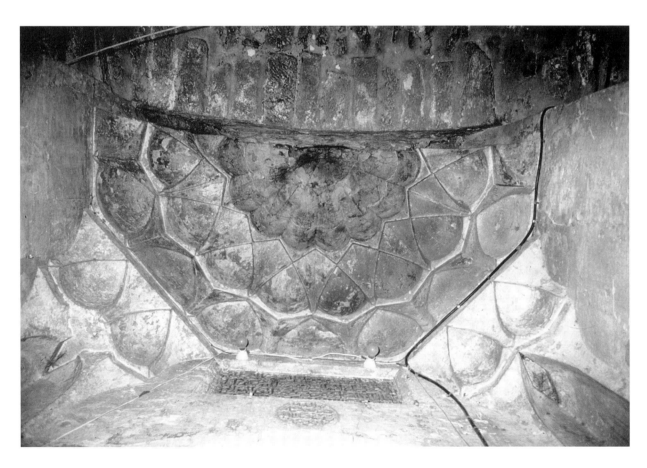

Fig. 130. Aleppo, *Madrasa* al-Shādbakhtiyya: portal vault

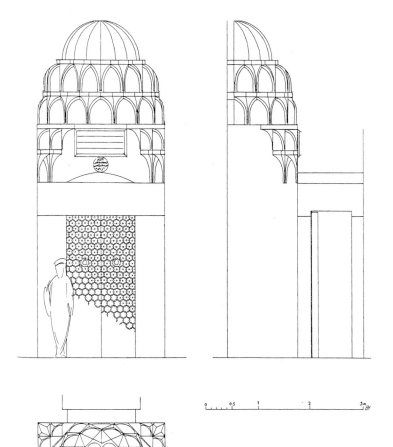

Fig. 131. Aleppo, *Madrasa* al-Shādbakhtiyya:
portal elevation, section, and vault plan

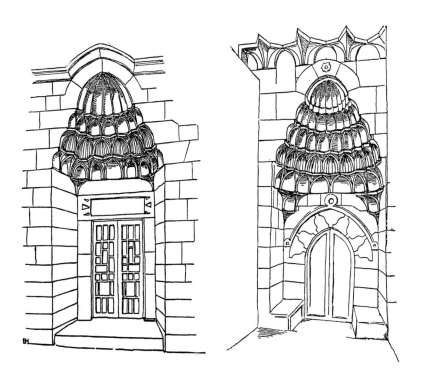

Fig. 132. Damascus, *Madrasa* al-Ṣāḥiba
and al-Atābikiyya: elevation of portals

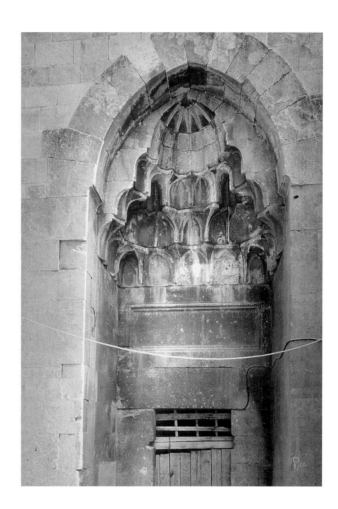

Fig. 133. Aleppo, *Madrasa* al-Kāmiliyya: portal

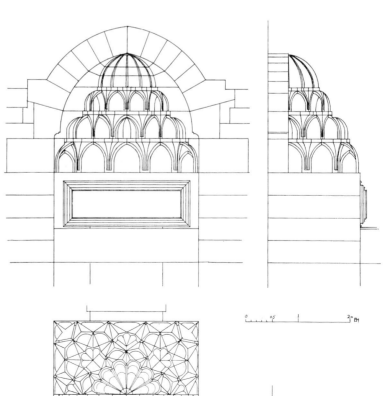

Fig. 134. Aleppo, *Madrasa* al-Kāmiliyya:
portal elevation, section, and vault plan

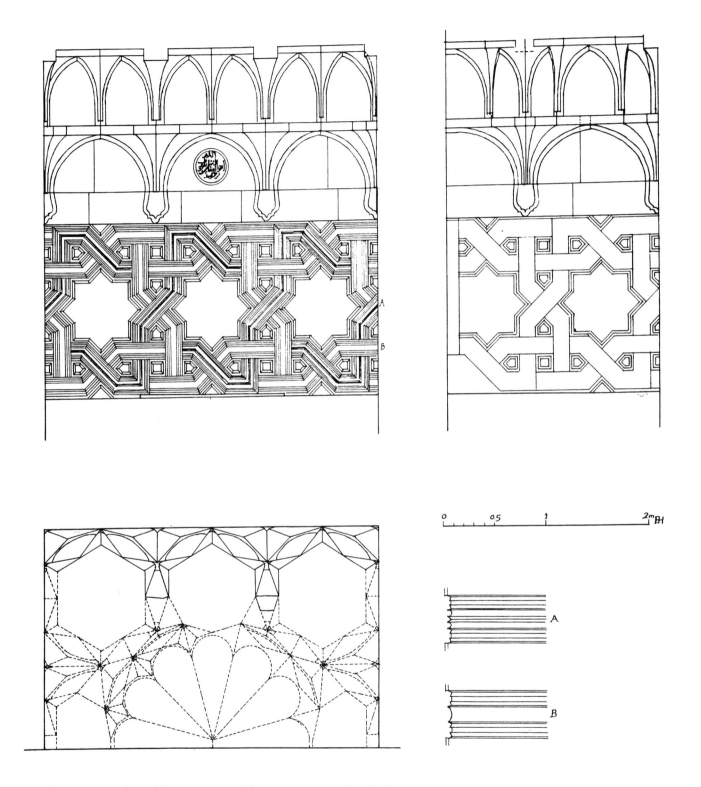

Fig. 135. Aleppo, *Madrasa* al-Sharafiyya: portal elevation, section, and vault plan

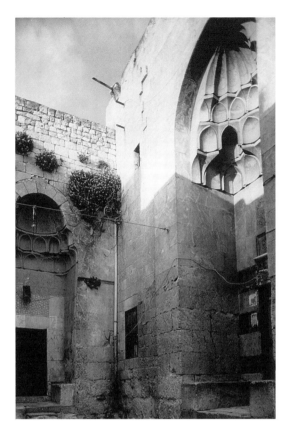

Fig. 136. Aleppo, *Madrasa* al-ʿAdīmiyya: portals to
madrasa and residence

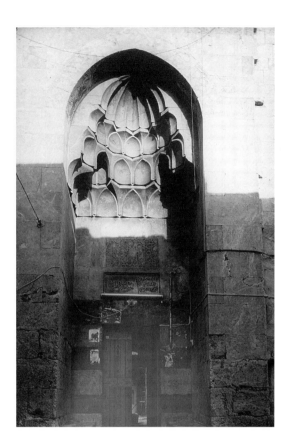

Fig. 137. Aleppo, *Madrasa* al-ʿAdīmiyya: portal to
madrasa

Fig. 138. Aleppo, *Madrasa* al-Sulṭāniyya: portal

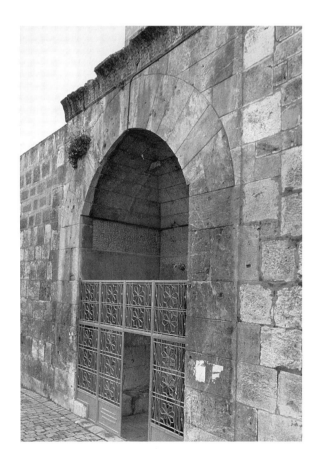

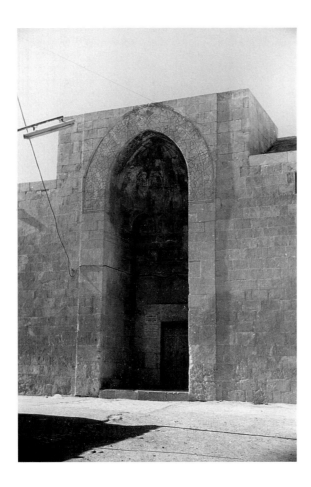

Fig. 139. Aleppo, *Madrasa* al-Ẓāhiriyya: portal vault

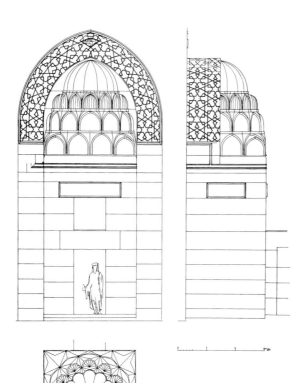

Fig. 140. Aleppo, *Madrasa* al-Ẓāhiriyya: portal elevation, section, and plan

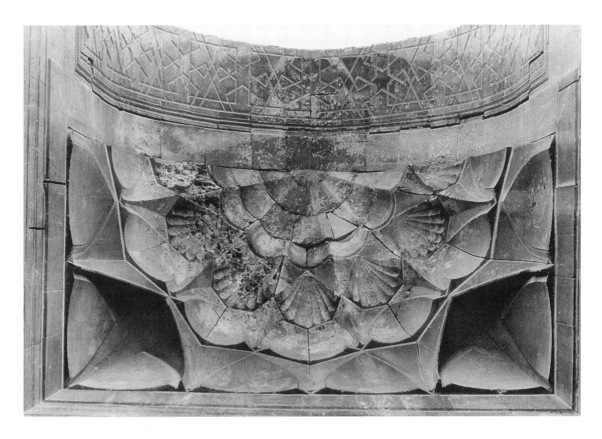

Fig. 141. Aleppo, *Madrasa* al-Ẓāhiriyya: portal vault

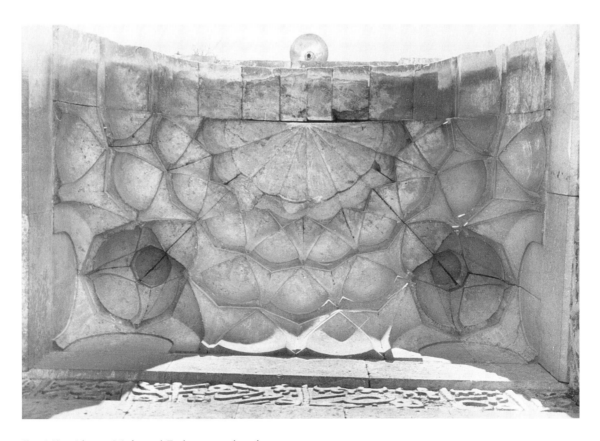

Fig. 142. Aleppo, *Madrasa* al-Firdaws: portal vault

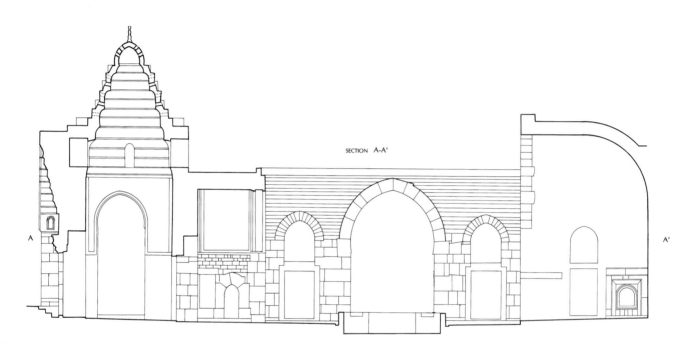

SECTION A-A'

Fig. 143. Damascus, Bīmāristān al-Nūri: east-west section

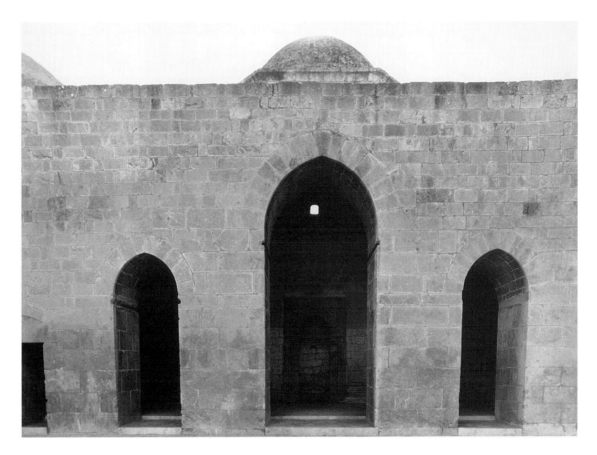

Fig. 144. Aleppo, *Madrasa* al-Kāmiliyya: facade of prayer hall

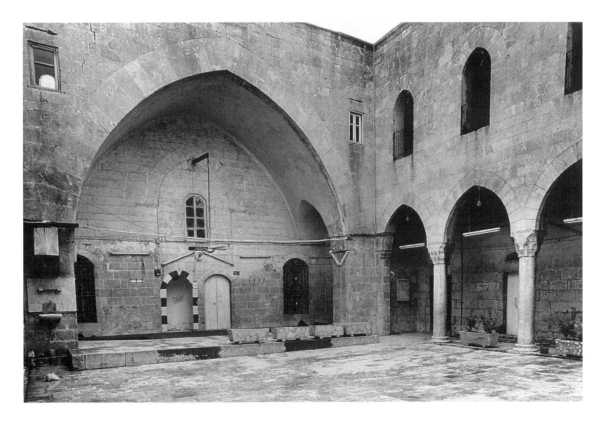

Fig. 145. Aleppo, *Madrasa* al-ʿAdīmiyya: southern iwan

Fig. 146. Aleppo, *Madrasa* al-Sulṭāniyya: facade of prayer hall

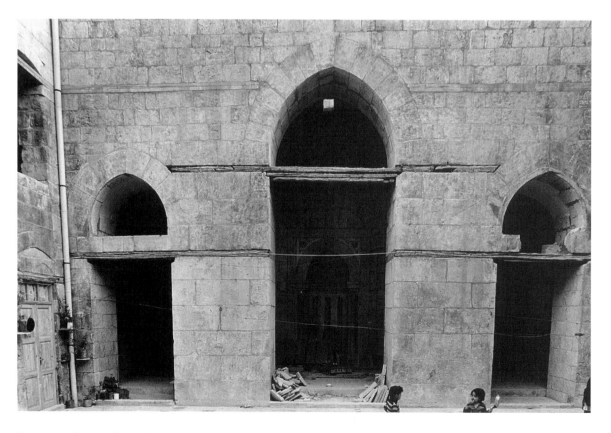

Fig. 147. Aleppo, *Khāanqāh* al-Farāfra: facade of prayer hall

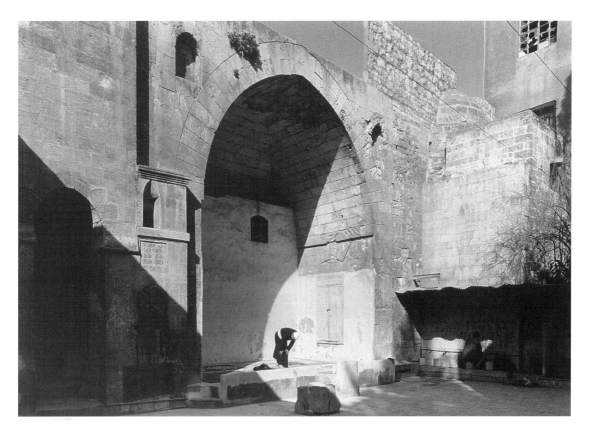

Fig. 148. Aleppo, *Madrasa* al-Shādbakhtiyya: northern iwan

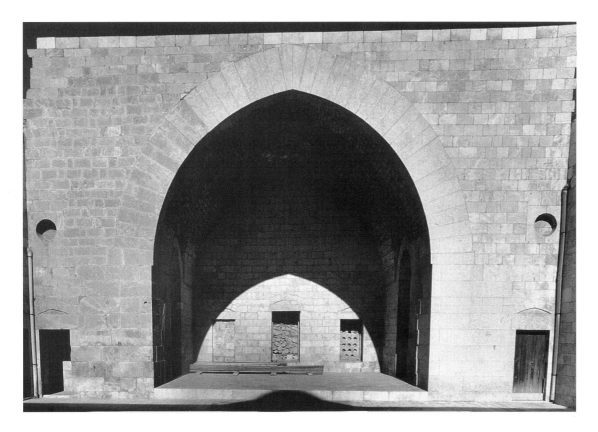

Fig. 149. Aleppo, *Madrasa* al-Kāmiliyya: northern iwan

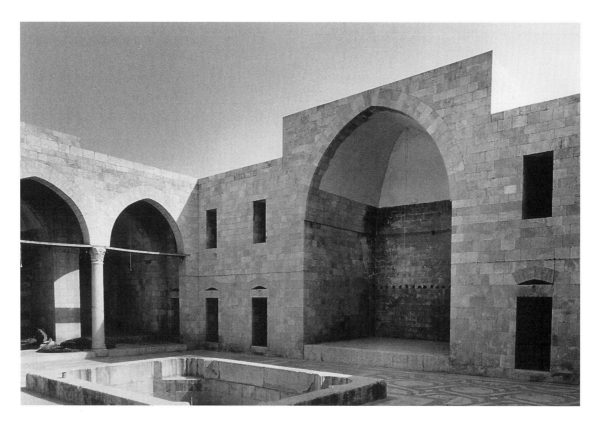

Fig. 150. Aleppo, *Madrasa* al-Ẓāhiriyya: eastern iwan

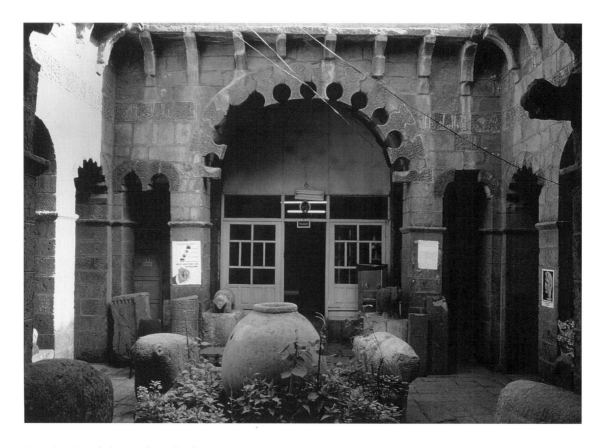

Fig. 151. Diyarbakir, *Madrasa* al-Ẓāhiriyya: 1198: northern iwan with pendant voussoir

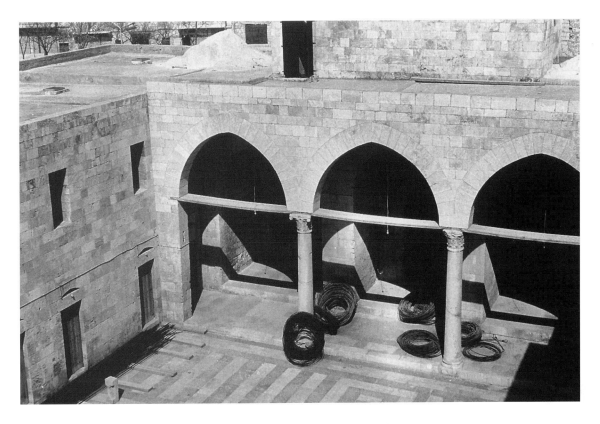

Fig. 152. Aleppo, *Madrasa* al-Ẓāhiriyya: western and northern courtyard facade

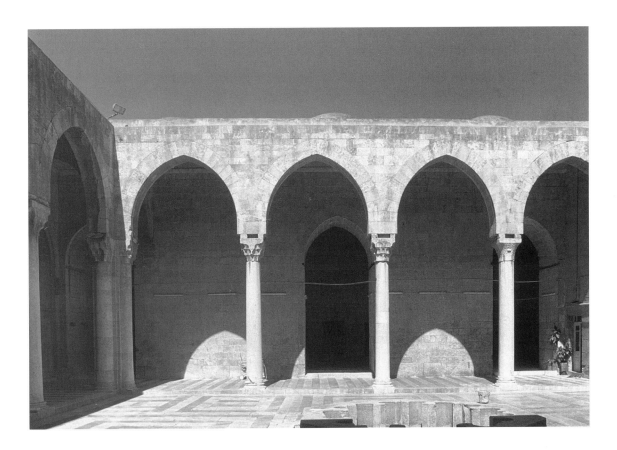

Fig. 153. Aleppo, *Madrasa* al-Firdaws: western courtyard facade

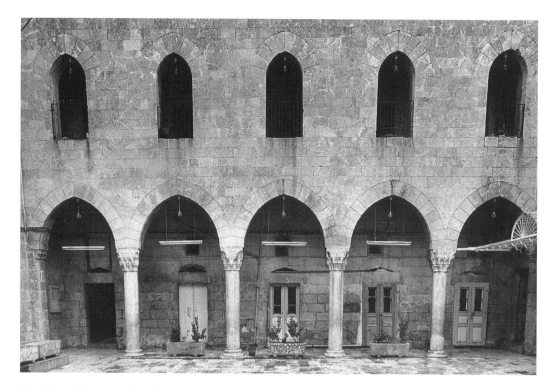

Fig. 154. Aleppo, *Madrasa* al-'Adīmiyya: eastern courtyard facade

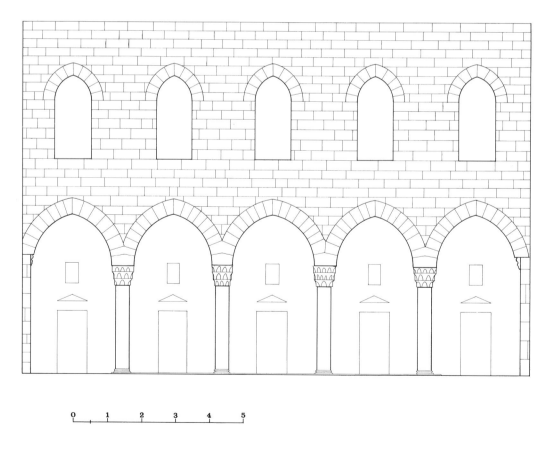

Fig. 155. Aleppo, *Madrasa* al-'Adīmiyya: elevation of eastern courtyard facade

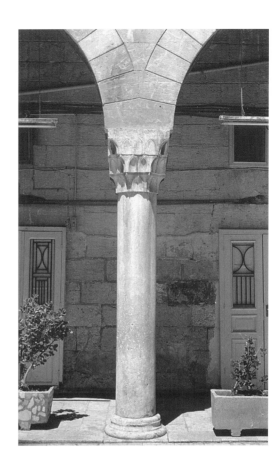

Fig. 156. Aleppo, *Madrasa* al-'Adīmiyya: column in western portico

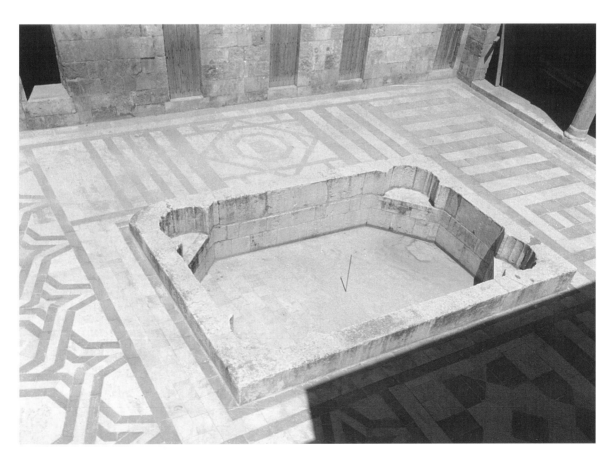

Fig. 157. Aleppo, *Madrasa* al-Ẓāhiriyya: pool

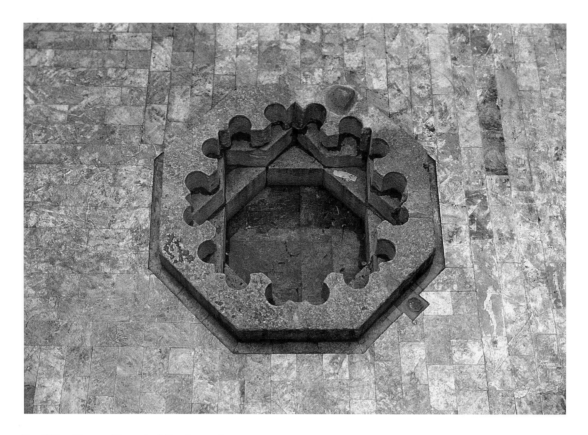

Fig. 158. Aleppo, *Khānqāh* al-Farāfra: pool

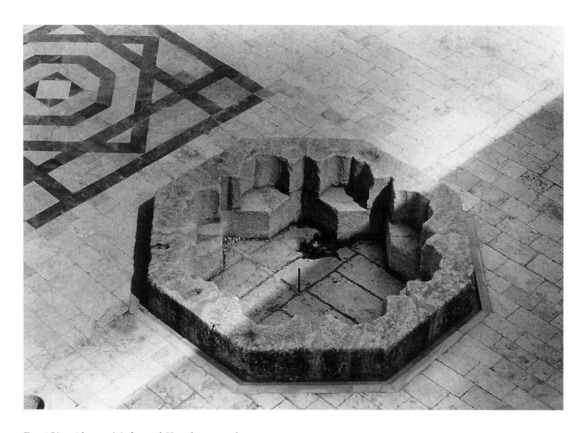

Fig. 159. Aleppo, *Madrasa* al-Kāmiliyya: pool

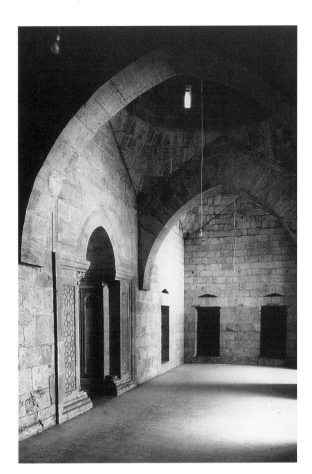

Fig. 160. Aleppo, *Madrasa* al-Ẓāhiriyya: prayer hall, from east

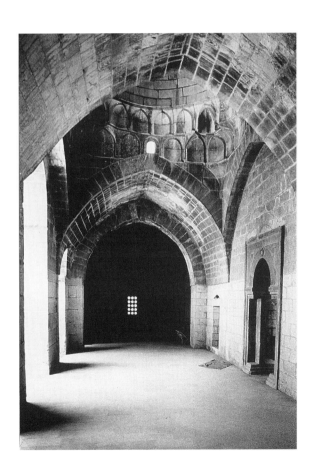

Fig. 161. Aleppo, *Madrasa* al-Kāmiliyya: prayer hall, from west

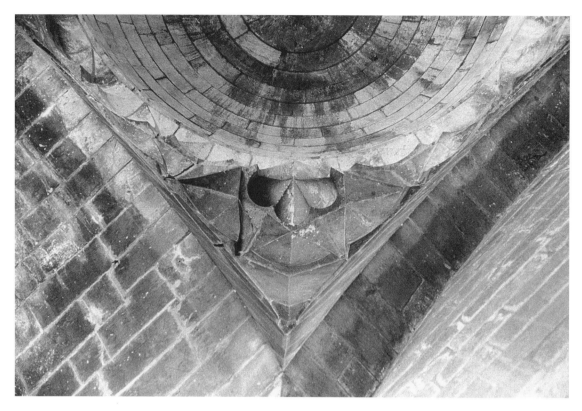

Fig. 162. Aleppo, *Madrasa* al-Kāmiliyya, dome over *miḥrāb*: *muqarnas* pendentive

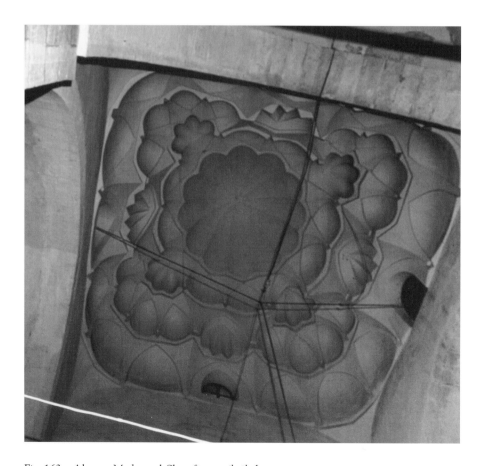

Fig. 163. Aleppo, *Madrasa* al-Sharafiyya: *miḥrāb* dome

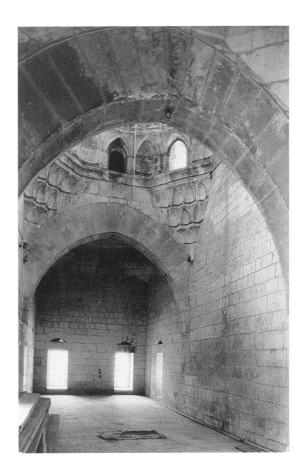

Fig. 164. Aleppo, *Madrasa* al-Ẓāhiriyya: three domed bays on western side

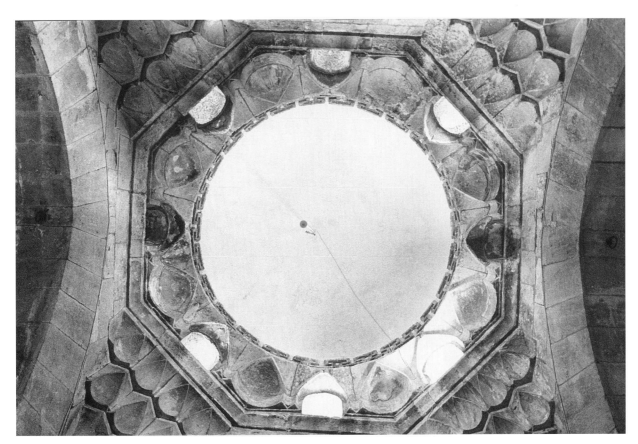

Fig. 165. Aleppo, *Madrasa* al-Ẓāhiriyya: dome above central western bay

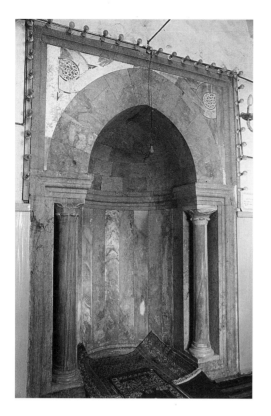

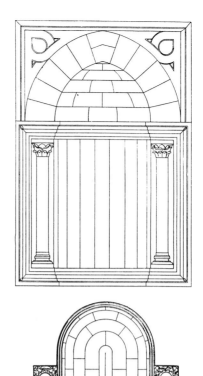

Fig. 167. Aleppo, *Madrasa*
al-Muqaddamiyya: eleva-
tion and plan of *miḥrāb*

Fig. 166. Aleppo, *Madrasa* al-Muqaddamiyya:
miḥrāb

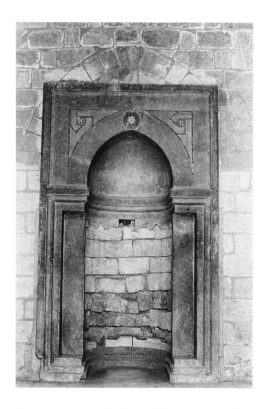

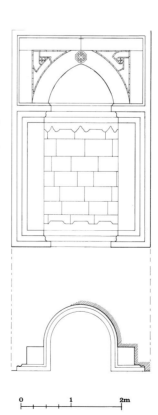

Fig. 169. Aleppo, *Madrasa* al-
Kāmiliyya: *miḥrāb* elevation and plan

Fig. 168. Aleppo, *Madrasa* al-Kāmiliyya: *miḥrāb*

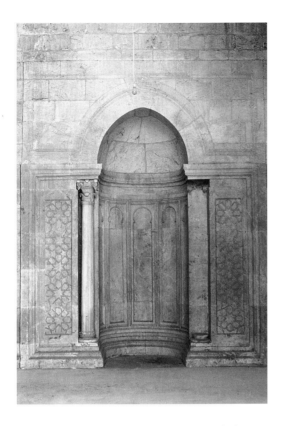

Fig. 170. Aleppo, *Madrasa* al-Ẓāhiriyya: *miḥrāb*

Fig. 171. Aleppo, *Madrasa* al-Shādbakhtiyya: *miḥrāb*

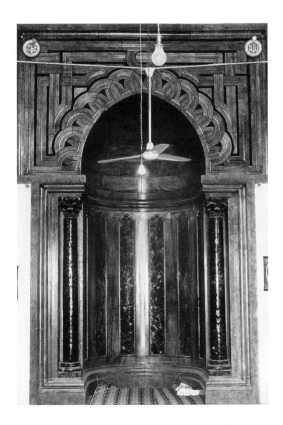

Fig. 172. Aleppo, *Madrasa* al-Sulṭāniyya: *miḥrāb*

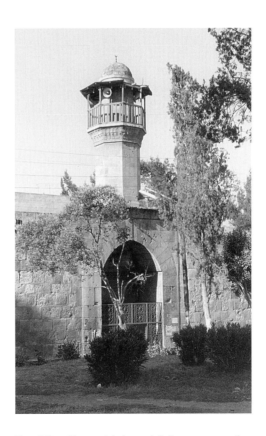

Fig. 173. Aleppo, *Madrasa* al-Sulṭāniyya: portal and minaret

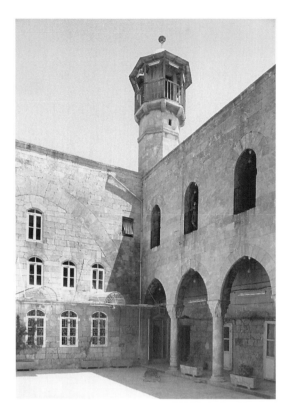

Fig. 174. Aleppo, *Madrasa* al-ʿAdīmiyya: northeastern corner of courtyard and minaret

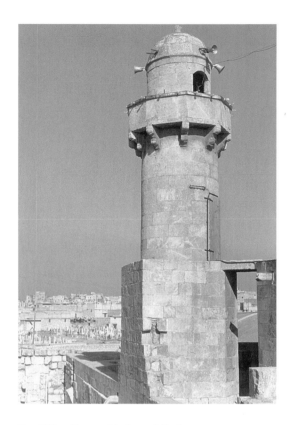

Fig. 175. Aleppo, *Madrasa* al-Firdaws: minaret

Fig. 176. Aleppo, *Madrasa* al-Ẓāhiriyya: corridor on second level

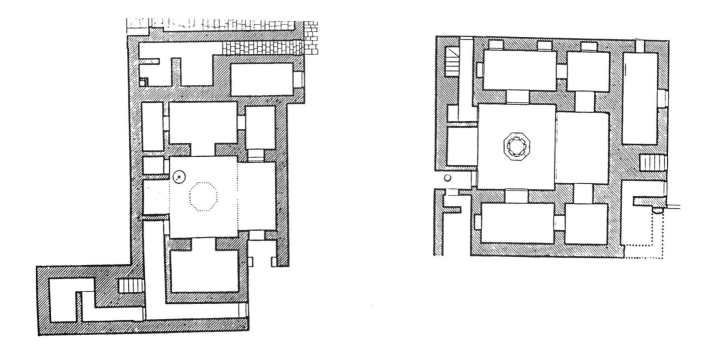

Fig. 177. Aleppo, *Madrasa* al-Firdaws: plans of residential units on (a) northeastern and (b) northwestern ends

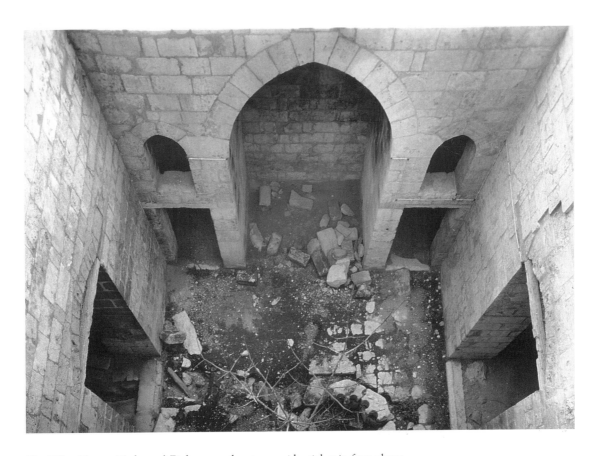

Fig. 178. Aleppo, *Madrasa* al-Firdaws, northeastern residential unit, from above

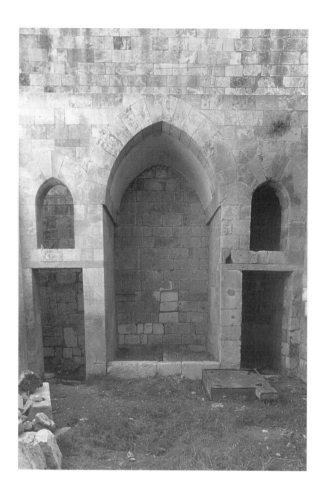

Fig. 179. Aleppo, *Madrasa* al-Firdaws, northwestern unit: east courtyard facade

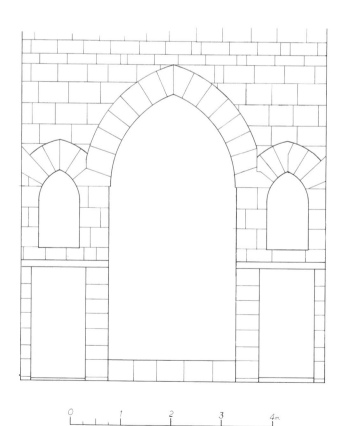

Fig. 180. Aleppo, *Madrasa* al-Firdaws, northwestern unit: elevation of eastern facade

0 1 2 3 4 m.

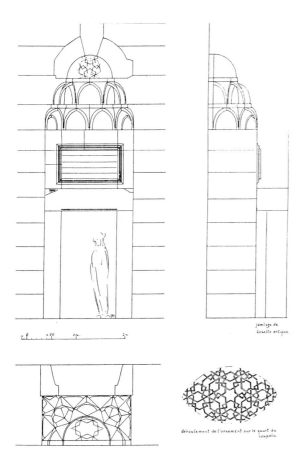

Fig. 181. *Khānqāh* al-Farāfra: portal elevation, section and plan of vaulting

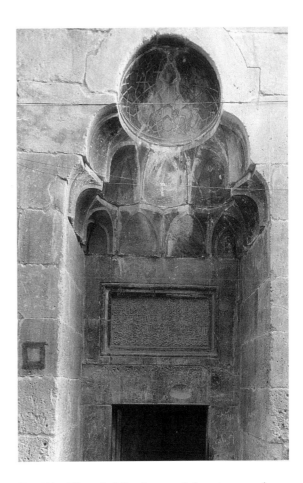

Fig. 182. *Khānqāh* al-Farāfra: portal elevation, portal

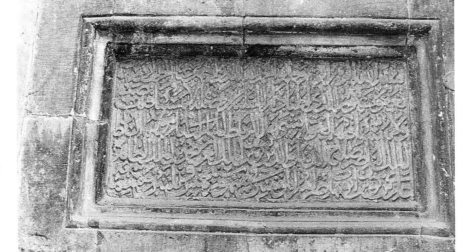

Fig. 183. *Khānqāh* al-Farāfra: foundation inscription

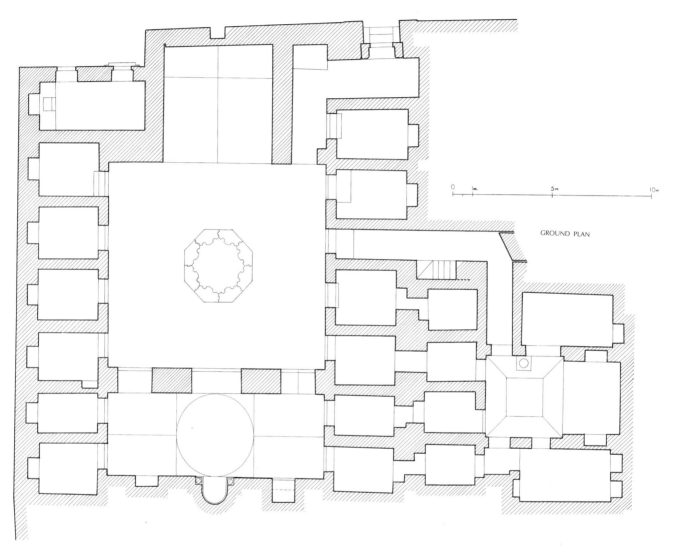

Fig. 184. Aleppo, *Khānqāh* al-Farāfra: plan

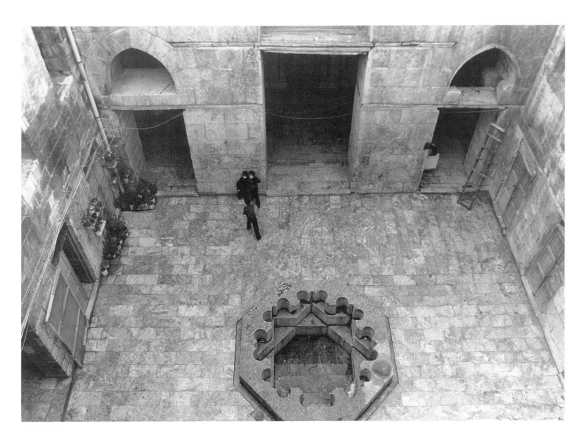

Fig. 185. *Khānqāh* al-Farāfra: courtyard from above

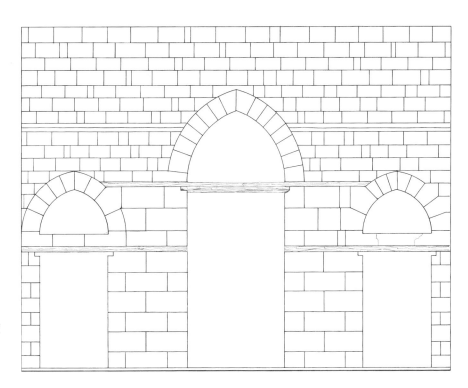

Fig. 186. *Khānqāh* al-Farāfra: elevation of
southern facade

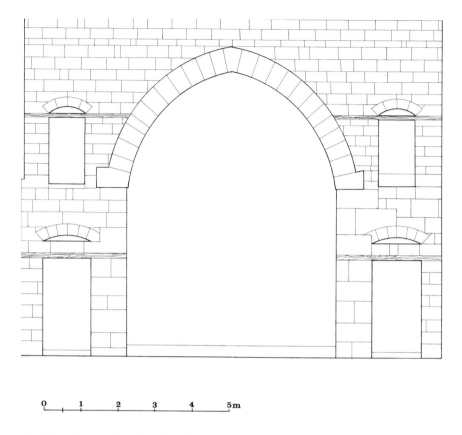

Fig. 187. Aleppo, *Khānqāh* al-Farāfra: northern iwan

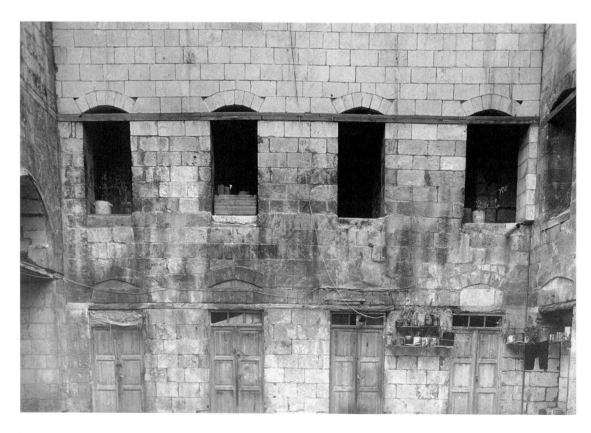

Fig. 188. Aleppo, *Khānqāh* al-Farāfra: western facade

Fig. 189. Aleppo, *Khānqāh* al-Farāfra: prayer hall, from east

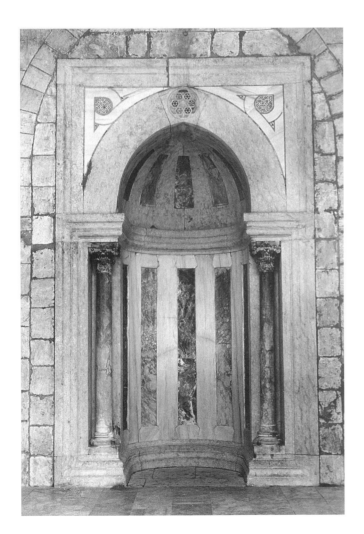

Fig. 190. Aleppo, *Khānqāh* al-Farāfra: prayer hall: *miḥrāb*

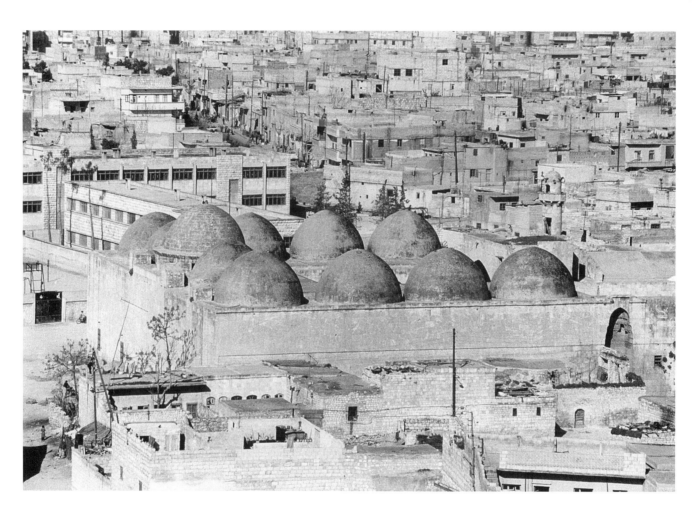

Fig. 191. Aleppo, *Madrasa* al-Firdaws: 633/1235: aerial view, from east

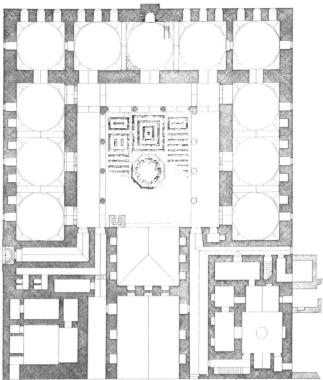

Fig. 192. Aleppo, *Madrasa* al-Firdaws:
plan

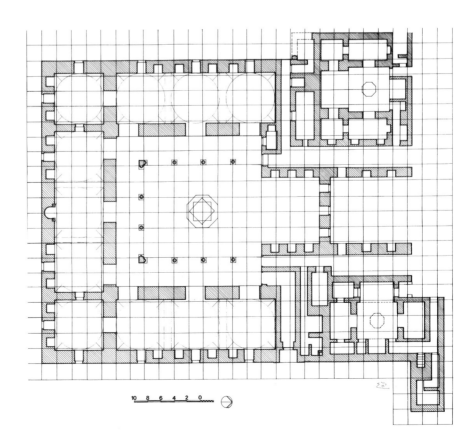

Fig. 193. Aleppo, *Madrasa* al-Firdaws:
plan with applied grid (adapted from a
plan of Syrian Dir. Gen. of Antiquities
and Museums)

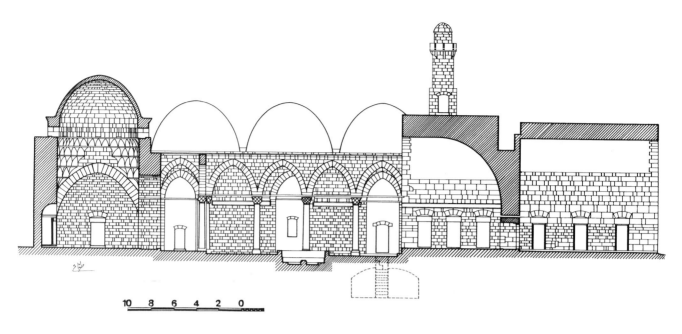

Fig. 194. Aleppo, *Madrasa* al-Firdaws: north-south section

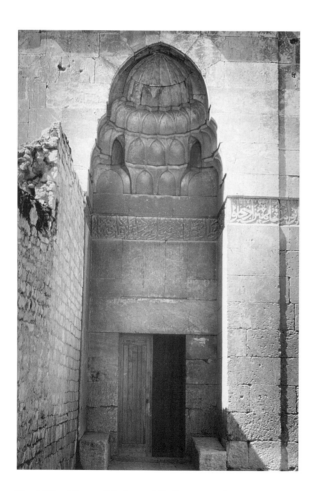

Fig. 195. Aleppo, *Madrasa* al-Firdaws: portal

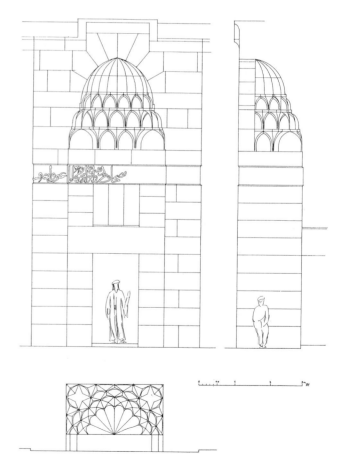

Fig. 196. Aleppo, *Madrasa* al-Firdaws: portal elevation, section, and plan of vaulting

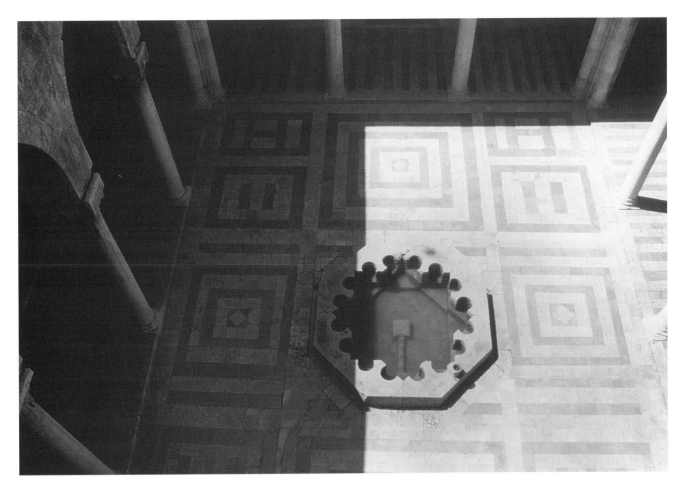

Fig. 197. Aleppo, *Madrasa* al-Firdaws: courtyard from above

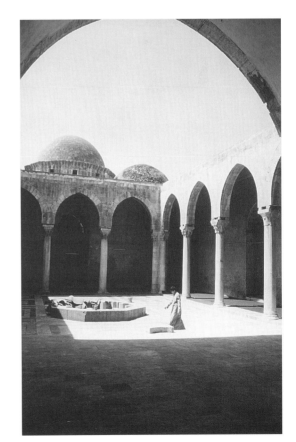

Fig. 198. Aleppo, *Madrasa* al-Firdaws: courtyard and facade of prayer hall

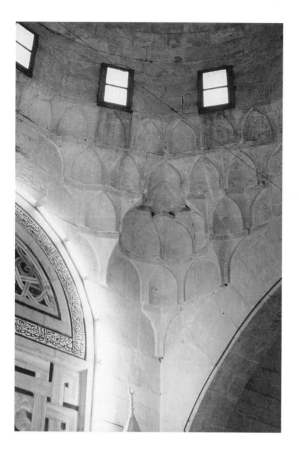

Fig. 199. Aleppo, *Madrasa* al-Firdaws: transition zone of central dome

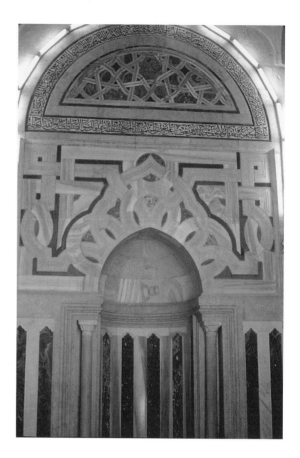

Fig. 200. Aleppo, *Madrasa* al-Firdaws: *miḥrāb*

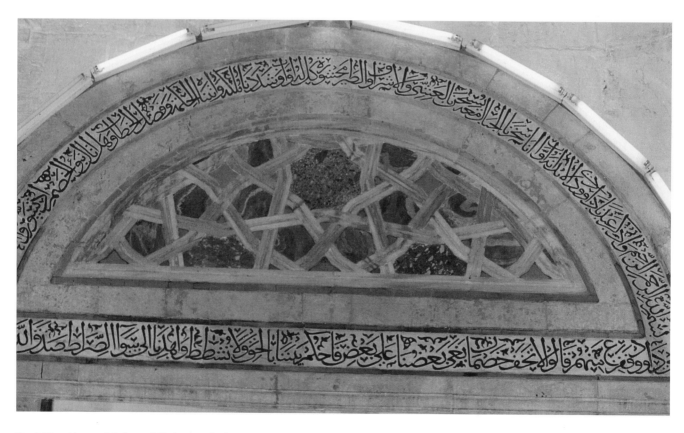

Fig. 201. Aleppo, *Madrasa* al-Firdaws: *miḥrāb*: upper position

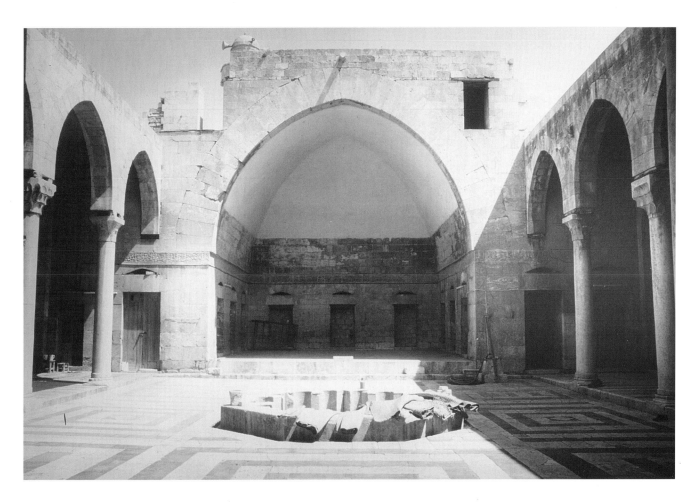

Fig. 202. Aleppo, *Madrasa* al-Firdaws: southern iwan

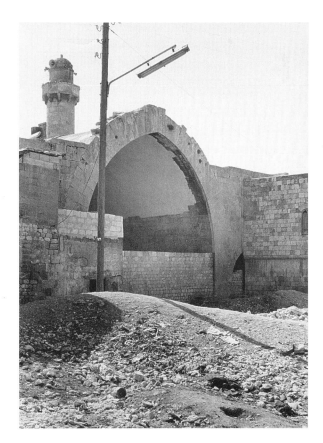

Fig. 203. Aleppo, *Madrasa* al-Firdaws: exterior iwan

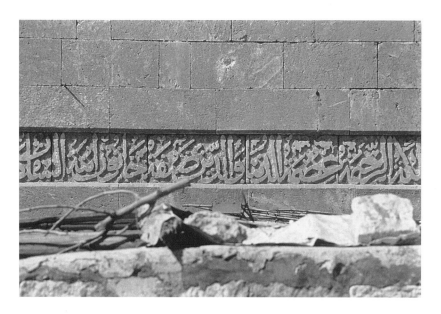

Fig. 204. Aleppo, *Madrasa* al-Firdaws: exterior inscription: Qur'ānic

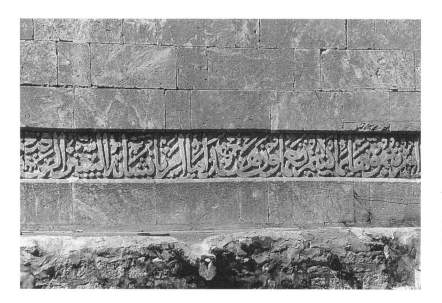

Fig. 205. Aleppo, *Madrasa* al-Firdaws: exterior inscription: titles of Ḍayfa Khātūn

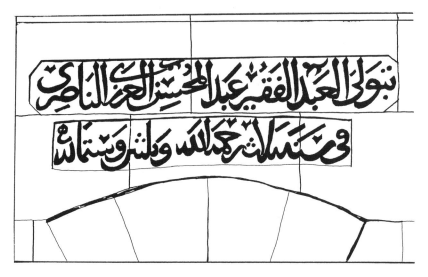

Fig. 206. Aleppo, *Madrasa* al-Firdaws: drawing of cartouche with name of building supervisor and date of building, 633/1235

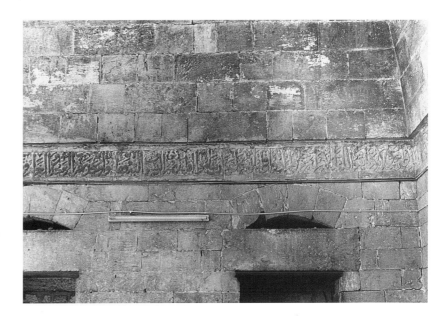

Fig. 207. Aleppo, *Madrasa* al-Firdaws: start of courtyard inscription

Fig. 208. Aleppo, *Madrasa* al-Firdaws: courtyard inscription: portion on right rear of main iwan

Fig. 209. Aleppo, *Madrasa* al-Firdaws: courtyard inscription: portion on the left rear of main iwan

Fig. 210. Aleppo, *Madrasa* al-Firdaws: courtyard inscription. (Note the sentence "*anta Allāh*" [You are God] above the middle of the flourescent light)

Fig. 211. Aleppo, *Madrasa* al-Firdaws: courtyard inscription: portion above the prayer hall

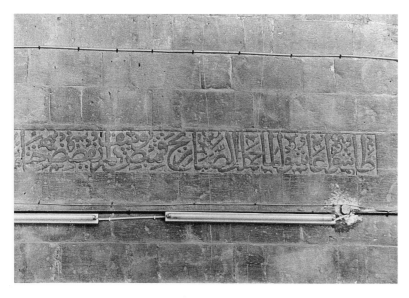

Fig. 212. Aleppo, *Madrasa* al-Firdaws: courtyard inscription. (Note the name of Yūsuf just above the gap between the two lights)